CONTEMPORARY ART

FROM CRESCENT MOON PUBLISHING

D0911675

Andy Goldsworthy

Touching Nature

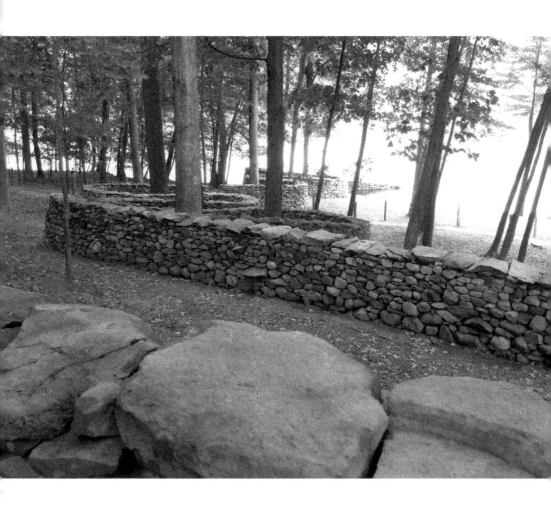

ANDY GOLDSWORTHY
TOUCHING NATURE

William Malpas

Crescent Moon

CRESCENT MOON PUBLISHING
P.O. Box 1312, Maidstone
Kent, ME14 5XU
Great Britain, www.crmoon.com

First published 1995. Second edition 1998. Third edition 2005. Fourth edition 2007.
Fifth edition 2013.
© William Malpas 1995, 1998, 2005, 2007, 2013.

Printed and bound in the U.S.A.
Set in Rotis Semi Sans 10 on 14pt.
Designed by Radiance Graphics.

British Library Cataloguing in Publication data

Malpas, William
Andy Goldsworthy: Touching Nature. – 5th ed. – (Sculptors Series)
1. Goldsworthy, Andy, 1956 – Criticism and interpretation
2. Outdoor sculpture – Great Britain
I. Title

730. 9'2

ISBN-13 9781861714404 (Pbk)
ISBN-13 9781861714138 (Hbk)

Contents

Acknowledgements

Thanks to Andy Goldsworthy.

Thanks also to: Ellie Hall; Viking Press, London; Penguin, London; Thames & Hudson, London; Cameron Books, Moffat; Harry N. Abrams, New York; Michael Hue-Williams Gallery/ Albion, London; Anthony d'Offay Gallery, London; Henry Moore Centre for Sculpture, Leeds; Storm King Art Center, New York; Old Museum of Transport, Glasgow; Common Ground, London; Fabian Carlsson, London; Galerie Lelong, New York; Galerie S65, Aalst; Galerie Aline Vidal, Paris; Haines Gallery, San Francisco; Yorkshire Sculpture Park; the British Museum, London.

Thanks to the authors quoted and their publishers.

Illustrations by Andy Goldsworthy © Andy Goldsworthy.

Thanks to the copyright holders of the illustrations:
Musée d'Art Moderne de la Ville de Paris. Tate Modern, London. Royal Mail Group. John Weber Gallery, New York. Chinati Foundation, Texas. Lisson Gallery, London. Howard Lipman, Connecticut. Richard Long. Hamish Fulton. Chris Drury. Anthony Gormley. Nancy Holt. Carl Andre. Peter Randall-Page. James Turrell. Christo. Walter de Maria. David Nash. Michael Heizer. Robert Morris. Frank Stella. Gordon Matta-Clark. Alexander Calder.

Andy Goldsworthy's art dealers: Fabian Carlsson, London; Galerie Lelong, New York; Galerie S65, Aalst; Haines Gallery, San Francisco; Springer und Winckler, Berlin; and Michael Hue-Williams Gallery, London.

Abbreviations

ANDY GOLDSWORTHY

S	*Andy Goldsworthy: Stone*
AG	*Andy Goldsworthy,* 1990
HE	*Hand to Earth: Andy Goldsworthy, Sculpture, 1976-1990*
SS	*Snowballs in Summer Installation*
RSS	*Rain sun snow hail mist calm*
WH	*Winter Harvest*
MC	*Mountains and Coast, Autumn into Winter*
Sh	*Sheepfolds*
W	*Wood*
BS	*Black Stones*
TM	*Time Machine*
Wall	*Wall*
A	*Arch*
MS	*Midsummer Snowballs*
T	*Time*
RA	*Réfuges d'Art*
P	*Passage*

RICHARD LONG

IC 1/2	*Richard Long: In Conversation,* Parts 1 & 2
OW	*Old World New World*
WC	*Richard Long: Walking in Circles*
SF	*An Interview with Richard Long*
FC	*Fragments of a Conversation I-VI*

OTHERS

RS	Robert Smithson, *Writings*

Illustrations

Some of Andy Goldsworthy's recent works in the United States of America
are shown on this page and the followng pages.

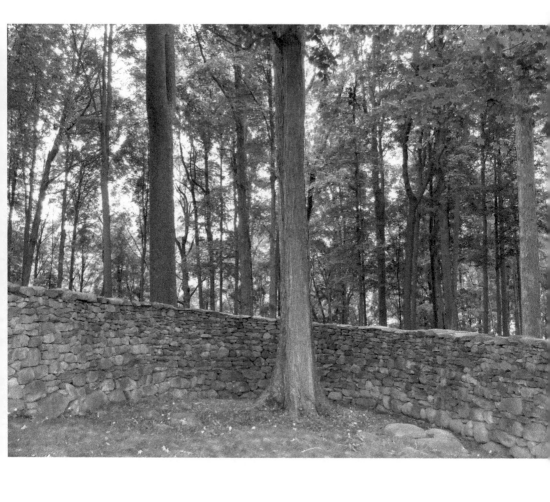

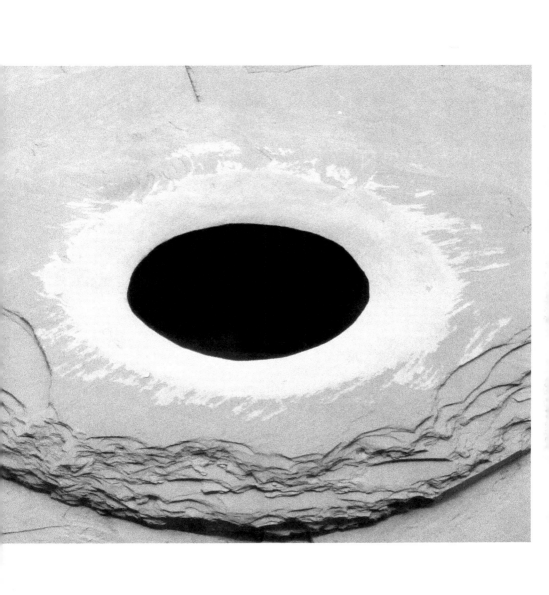

Introduction

In the best landscapes we are fascinated by the mysterious shiftiness of the scene under our eyes; it shifts about as we watch it. And we realize, with a sort of transport, how intuitively true this is of landscape. It is not still. It has its own weird anima, and to our wide-eyed perception it changes like a living animal under our gaze.

D.H. Lawrence, "Introduction To His Paintings"

The subject of this study is a contemporary artist, Andy Goldsworthy (born 1956). Known as a 'land', 'earth', 'nature' or 'environmental' artist, Goldsworthy works with nature. He uses natural materials in natural shapes and forms (and also geometric patterns) often set in natural contexts (but also in cities, towns, parks, sculpture parks, and many spaces created or adapted by people).

Andrew Charles Goldsworthy was born in Sale Moor, Cheshire, in the North of England, on July 25, 1956. He studied at Harrogate High School, Bradford College of Art (after being rejected from the Jacob Kramer College of Art, Leeds), and Preston Polytechnic, where he studied on the BA (Bachelor of Arts) Fine Art course, graduating in 1978 (Preston was a last minute possibility, because Goldsworthy hadn't got into Leeds, Nottingham and Hull Polytechnics, his first choices). At the colleges, archetypal British art school ethics prevailed: liberalism, experimentation, art history discussions, visiting lecturers, and the embrace of *avant garde* art (with an emphasis on modern art).

Andy Goldsworthy has always lived in the North of Great Britain: Bentham and Ilkley (Yorkshire), Brough (Cumbria) and Penpont (Dumfriesshire). Many of Goldsworthy's site-specific works and commissions have been in the North of the country: the giant *Maze* and *Lambton Earthwork* (at County Durham, 1988-89), the Grizedale Forest site works (1984 onwards through the eighties), artist's residencies at Yorkshire Sculpture Park (1987), the Lake District National Park (1988), *Sheepfolds* (1996 to the present) in Cumbria and South-West Scotland, and so on. The North of Albion has always been absolutely fundamental to Andy Goldsworthy's art, a place he always returns to, a region that is the heartland of Goldsworthy's *œuvre*. Goldsworthy may now be a successful international artist, but he always comes back to Northern Britain. It might make more practical sense to live in New York, California or London, say, but the more modest, provincial terrain of South-West Scotland and Cumbria always wins out.

Andy Goldsworthy spoke nostalgically of the areas in Cumbria, Yorkshire and Lancashire that he knew well. At Clougha Pike, near Lancaster, Goldsworthy ruminated in 1999 on places that had long been part of his art and personal life: the Lune valley, where he made sculptures along the river;

Caton, where his wife was born; Brookhouse church, where he was married; Hutton Roof, where he worked in a lime kiln; Clapham Scar, where he made a sculpture; Heysham Head and Morecambe Bay, where many of his early works were made; and the Langdale Pikes and Lake District.

On the international front, Andy Goldsworthy has worked at the Venice Biennale; in Grise Fiord and the North Pole; in Japan; in Digne, Castres, La Rochelle and Sidobre in France; in Australia; in Virginia, Missouri, California, Iowa and New York (among other states) in the U.S.A.; and in Haarlem, Holland. He has had one-man shows in France, Japan, Holland, the U.S.A. and Britain, and participated in groups shows in Italy, Germany, and the U.S.A.. A major retrospective, *Hand to Earth: Andy Goldsworthy: Sculpture: 1976-1990*, was held at the Henry Moore Centre for the Study of Sculpture, Leeds City Art Gallery: the show also travelled to the Royal Botanic Gardens in Edinburgh, Stedelijke Musea, Gouda and Centre Regional d'Art Contemporain Midi-Pyrenées in Toulouse. This show also produced the most useful and detailed publication to date on Goldsworthy, *Hand to Earth*.[1] Other major shows include London in 1994, 2000 and 2005; Storm King and New York in 1998 and 2000;[2] New York City in 2003 and 2004; Washington, DC in 2005; Yorkshire Sculpture Park in 2007; a Provence art trail in 2009; and a *Clay Dome* in Rio de Janiero in 2012.

Andy Goldsworthy has not created art everywhere. There are plenty of countries where Goldsworthy had not made work. Even in the British Isles, Goldsworthy has not made much art in Cornwall or Devon or the South-West, or the East (Norfolk, Suffolk, the Fens), not much in the English Midlands, only a few works in Wales, and hardly any in Ireland. If Goldsworthy creates sculpture in Great Britain, it's usually Scotland, Northern Britain (Cumbria and Yorkshire, but not so much the North-East), or London.

Around the world, Andy Goldsworthy has concentrated on Westernized territories: on America, of course (it's the centre of land art, and the whole contemporary art industry), Western Europe, Australia and Japan (with the odd excursion to exotic spots, such as the North Pole). Goldsworthy has not made much art in Eastern Europe, in Russia, in mainland China, in India, in Africa or South America (a *Clay Dome* was shown in Rio in 2012).

Andy Goldsworthy's work has appeared on TV (in Britain, as expected, Channel Four documentaries, *The Late Show*, an Arts Council film (*Two*

Autumns), BBC documentaries, and regional news programmes), as well as a couple of Japanese broadcasts), also the ubiquitous appearances on BBC Radio 4's arts show *Kaleidoscope* and BBC Radio 3's arts interview slot, *Third Ear*. *Flow of Earth* (1992) was made for Granada TV's *Celebration* programme. (For a much more detailed account of Goldsworthy's shows, residencies, awards and projects, see my book *The Art of Andy Goldsworthy*).

As well as commissions, installations, TV and radio programmes, and books, Andy Goldsworthy has also produced limited edition prints (for instance, the pictures of cairns were made with UK company Eyestorm, in editions of 500, priced at $720 each).

A photograph of one of Andy Goldsworthy's leaf-wrapped rocks adorned the cover of one of the main books on land art (John Beardsley's *Earthworks and Beyond*) when it was issued in a third edition in 1998. This showed how much more popular or well-known Goldsworthy's art had become (i.e., Goldsworthy was selected above Walter de Maria, Robert Smithson, Michael Heizer, the Christos *et al*).

In the 1990s, Andy Goldsworthy's art began to rise in popularity: the glossy coffee table book *Stone* became a bestseller (bear in mind it was then priced at $55). In 1994 Goldsworthy took over some West End galleries in Londinium with a large one-man show. In 1995 he was part of an intriguing group show at the British Museum (*Time Machine*), creating sculptures, along with Richard Deacon, Peter Randall-Page and others, in amongst the monumental statuary of the famous Egyptian Hall. Also in 1995, Goldsworthy designed a set of Royal Mail postage stamps (and again in 2003). Digne in France became an increasingly important Goldsworthy location, with shows in 1995, 1997 and 2000). Prestigious commissions occurred in the U.S.A. from the mid-1990s onwards. For instance: the giant *Wall* at Storm King Art Center in 1998 in upstate New York; the *Three Cairns* on the East and West Coasts and Iowa in 2001-02; the 'stone houses' at the Metropolitan Museum in Gotham in 2004; the monument to the Holocaust (also in New York) in 2003; and the slate domes in Washington, DC in 2005. Goldsworthy continues to work in countries such as Japan, Australia, Holland, Canada, North America and France (with France and the U.S.A. becoming primary centres of

Goldsworthy activity), but his home ground of Dumfriesshire in Scotland remains (at) the heart of his work.3

As a young student, Andy Goldsworthy spent much of his time outside school, working in Northern Britain, on the beaches at Morecambe and Heysham, as well as trips to the Pennines. Goldsworthy preferred to learn by direct experience, finding out about leaves, mud, stone, rivers and tides by living amongst them. Goldsworthy would go into art college for one or two days a week, for the art history classes. This was not enough for the lecturers, who suggested that he spend more time in college, including attending life drawing classes (attendance being one of education's eternal bugbears – especially for bohemian students). Little did Goldsworthy's tutors know – that their errant student, who spent hours clambering around the muddy reaches of Heysham Head and Morecambe Bay instead of dutifully attending Polytechnic classes, would one day become an artist of international renown, with exhibitions and commissions around the world. At the time (circa mid-1970s), Goldsworthy must have seemed just another crazy art student in long hair and jeans among the many thousands in institutions up and down the land, pursuing his own wacky ideas (isn't that what college or university seems to be so often about – pursuing ideas to the point of the completely unfathomable?). Hearing of his antics with beaches, mud, stones and tides, Goldsworthy's tutors must have sighed heavily and put another stroke through the 'absent' column on his attendance record. Amazing to think that this artist-in-the-making in a provincial art school would one day be exhibiting at the most prestigious museums in the world (the British Museum, the National Gallery of Art in Washington and the Metropolitan Museum in the Big Apple), creating Holocaust memorials at the Jewish Museum, rebuilding a hundred sheepfolds, and designing Royal Mail stamps.

Andy Goldsworthy's wife, Judith Gregson (who died in a car crash in 2008, aged 48), was a ceramics teacher (she studied at Ilkley Teachers Training College in Yorkshire, and later taught at St Aidan's, Carlisle, Cumbria). Goldsworthy met her at Ilkley in late 1979; they were married on July 17, 1982 (at Caton, Lancashire). Goldsworthy's children include Jamie (b. 1987), Holly (b. 1990), Anna (b. 1993), and Thomas (b. 1994). Goldsworthy's wife Judith occasionally accompanied the artist on his art-making

trips into the wilds (though not as often as his assistants). Sometimes his children would come too (as in New Mexico in 1999), but one would expect that children might eventually get bored with dad constructing ridges with sand or pinning leaves together. You can see Judith Gregson and Goldsworthy's children in the 2001 documentary *Rivers and Tides.*

Judith Gregson's influence on Andy Goldsworthy's art would probably include his use of ceramics (such as working with clay), and several collaborations. Gregson has probably had all manner of influences difficult to adjudge exactly. Goldsworthy, however, seldom speaks of personal influences on his work. In fact, he rarely mentions other artists or writers in his writing or interviews (there are favourites, like Yves Klein, David Nash, Ben Nicholson and Christo, and the odd writer or poet, like D.H. Lawrence or Norman Nicholson). Rather than cultural matters, Goldsworthy's writings and interviews are more likely to contain discussions on the quality of stone on a wall or whether it rained or snowed today.

Apart from his wife and family, important people in Andy Goldsworthy's life include land artist David Nash, Steve Chettle (Public Arts Officer for Cumbria County Council), stone waller Joe Smith, the Earl of Dalkeith (Scottish land-owner), gallery owners Fabian Carlsson and Michael Hue-Williams, filmmaker Thomas Riedelsheimer, dance director Régina Chopinot, assistants Ellie Hall and Andrew McKinna, and art critics Terry Friedman and Andrew Causey (one-time Chair of North West Arts). (The first work that Goldsworthy sold was a bunch of photographs to the Arts Council (via Causey at North West Arts).)

The most useful books by Andy Goldsworthy are *Hand To Earth* (1990) and *Time* (2000). To date, there are no full-length studies of Goldsworthy's output other than this book and its companions (*The Art of Andy Goldsworthy* [2005/ 08/ 12] and *Andy Goldsworthy In Close-Up* [2001/ 08]). There are many articles about Goldsworthy (most of them are listed in the bibliography).

<center>✸</center>

Before discussing Andy Goldsworthy's art, I look at sculpture in the modern era; at Goldsworthy's contemporaries, including fellow British sculptors; at female and feminist sculptors; and at what is called 'land art' or 'earthwork art'. 1960s art movements – Minimal art, Conceptual art,

Process art (also called Serial or ABC art), and performance or body art are also important cultural reference points, especially in regard to land art.

Romanticism: Andy Goldsworthy, Richard Long, Hamish Fulton, David Nash, Anish Kapoor, Alison Wilding, Barry Flanagan, Richard Deacon and Stephen Cox (among British artists) are sometimes termed 'Romantic' sculptors, and part of this book relates their art to British Romanticism, as found in the literature of William Wordsworth, J.M.W. Turner, Percy Bysshe Shelley, John Keats and others, and the visual art of J.M.W. Turner, John Sell Cotman, Thomas Girtin *et al*. The British novelist John Cowper Powys (1875-1963) and the British poet Peter Redgrove (1932-2003) are used as reference points for a poetic equivalent of land art and nature mysticism. Powys's and Redgrove's works evoke a sensitivity which is close to the land art of Andy Goldsworthy.

Andy Goldsworthy's sculpture grew out of modernism and, in particular, 1960s art, the era of Henry Moore, Robert Morris, Robert Smithson, Yves Klein, Michael Heizer, Anthony Caro, William Tucker, Tony Smith and Phillip King. It was the age of 1970s 'expanded field' sculpture (Rosalind Krauss's term [1978]). The artists that impressed Goldsworthy at art college included Gordon Matta-Clark, Mark Boyle, Christo, Ben Nicholson and Yves Klein. Goldsworthy attended lectures by Richard Long and David Nash at Polytechnic in 1978. Goldsworthy's sculpture has æsthetic affinities with a variety of sources or influences, including 1960s British sculpture (dubbed the 'New Sculpture'), as developed by the sculptors associated with St Martin's School of Art; Anthony Caro; American Minimal sculpture; performance art; body art; Joseph Beuys; Yves Klein; *avant garde* art; Conceptual art; Italian *Arte Povera*; and New Realism.[4] Goldsworthy's art, like all land art, works within a culture and tradition and history of contemporary art. But tracing the links with Minimalism, *Arte Povera*, serial art, process and Conceptualism, for instance, is only one way of looking at Goldsworthy's art.

Throughout this study I make comparisons between the art of Andy Goldsworthy and Richard Long and Chris Drury, fellow British land artists/ sculptors both a few years older than Goldsworthy. Goldsworthy, Drury and Long are similar artists, and I discuss their differences as well as their

similarities. It is worth looking at contemporary sculpture since WW2 for a while, to see where Goldsworthy fits in, and thus the first chapters of this book explore modern/ contemporary sculpture, women sculptors, kinetic sculpture, hyperrealist sculpture and 1960s sculpture (including Minimal, Conceptual, Process and Serial art).

In this study I have concentrated on some of the more well-known land artists, such as Walter de Maria, Michael Heizer, Richard Long, Dennis Oppenheim, David Nash, Hamish Fulton, Ana Mendieta, Nancy Holt, Alice Aycock, Mary Miss, Carl Andre, Robert Smithson, Chris Drury, Christo and James Turrell. There are, of course, many more artists working with place, site, landscape and the environment: Robert Adzema, Vijali, Tom Van Sant, Sherry Wiggins, Charles Simonds, Isamu Noguchi, Richard Serra, Tony Smith, Daniel Buren, Gutzon Borglum, Hans Haacke, Betsy Damon, Andy Lipkins, Keith Arnatt, Herbert Bayer, Newton Harrison, Helen Myer Harrison, Charles Ross, Peter Erksine, Jody Pinto, Donna Henes, Phyllis Yampolsky, Ian Hamilton Finlay, Douglas Huebler, Barry Flanagan, Mierle Laderman Ukeles, Viet Ngo, Mel Chin, Agnes Denes, William Jackson Maxwell, Constance DeJong, Reiko Goto, Michelle Oka Doner, Buster Simpson, Peter Richards, Douglas Hollis, Patrick Zentz, Othello Anderson, Fern Shaffer, Lynne Hull, Patricia Johanson, Dominique Mazeaud and Alan Sonfist. What is written here about the key land artists also applies to the other artists cited above, plus many others.

❀

This book uses some of the material in companion monographs on Richard Long and land art.5 For more analysis of Andy Goldsworthy, please see the companion book *The Art of Andy Goldsworthy*.

Some of the artworks cited in the text are listed in the "List of Works".

This new edition has a new bibliography and introduction, new illustrations, and a completely corrected and rewritten text. The hardback edition has been re-set, and new material has been added.

PART ONE

I

Sculpture in the Contemporary Era

Sculpture is a three dimensional projection of primitive feeling: touch, texture, size and scale, hardness and warmth, evocation and compulsion to move, live and love.

Barbara Hepworth (in A.M. Hammacher, 1968, 99)

Contemporary sculpture so often out-shines contemporary painting. How-
ever exciting a painting by, say, A.R. Penck, Georg Baselitz, Francesco
Clemente or Philip Taaffe may be, sculptures by artists such as Nancy
Graves, Rebecca Horn, Tony Smith, Mark di Suvero, Eva Hesse, Louise
Nevelson, Robert Smithson and Andy Goldsworthy out-dazzle the painters
in so many respects. While Renaissance painting may represent the
apotheosis of high art, and ancient Greek sculpture may be the height of
'high sculpture', modern and contemporary sculpture really is some of the
most startling in the history of sculpture. Part of the reason is, of course,
scale. Postwar artists, of all kinds, have made massive art. David Smith's
Wagon I and his *Cubi* (1965), the Christos' wrapped buildings and running
fences, or Michael Heizer's vast earthwork mounds, are huge, heavy, truly
colossal pieces which dominate their surroundings. Donald Judd wrote:
'[t]his scale is one of the most important developments in twentieth century
art'.[1] Andy Goldsworthy's art is not monolithic in scale, usually: his pieces
are, typically, small-scale (right down to the scale of a single leaf). The
stone walls and some of Goldsworthy's commissions are large: the *Night
Path* running through a wood, for instance, or the Montréal *Arch*.

The Abstract Expressionist painters, such as Mark Rothko, Franz Kline,
Helen Frankenthaler and Barnett Newman, produced huge paintings, which
swallow up the spectator when s/he moves close to them. The viewer can
get up close to a Morris Louis or Ellsworth Kelly canvas and be enveloped
by it (creating a sense of intimacy, rather than domination, was one of the
chief motives for employing large scale, Rothko asserted).[2] Similarly,
contemporary sculptors have made massive works. The Christos built pieces
that were 24 miles long (Andy Goldsworthy has produced art trails running
over miles). Even medium-sized sculptures, such as Donald Judd's wooden
or aluminium boxes, are sometimes seen as monumental. A critic on *The
New York Times* called Judd's 1977 installation at the Heiner Friedrich
Gallery a 'majestic and finely measured presence'.[3]

Lucy Lippard (consistently one of the most impressive of art critics)
described scale not just as something mathematical, optical, *seen*:

Most discussions of scale consider it a strictly optical experience... But a sense of scale is also a sense proper. Scale is felt *and cannot be communicated either by photographic reproduction or by description.*[4]

The bombastic, monumental, massive and brash 3-D art of contemporary sculpture was not made exclusively by male artists. Land artists Mary Miss, Nancy Holt, Sherry Wiggins, Donna Henes, Lynne Hull, Patricia Johanson, Alice Aycock and Agnes Denes (among many others) have all made very large works. Mary Miss created a 5 acre scale work in Illinois,[5] Patricia Johanson designed a large lagoon park in Dallas (1981-86), while Nancy Holt produced gigantic *Sun Tunnels*, 18 foot long pipes that were 9 feet high with many holes punched in the side, to let light in.[6] Holt's art, with its large, heavy landscaping gestures (such as her *Dark Star Park*), is comparable with the male earth artists. The globes and pools of water, though, are traditional 'feminine' volumes, here given a new, monumental turn.

Helen Escobedo built some huge concrete and steel sculptures which 'attempt to fuse hard-edge geometric forms with nature's organic manifestations' as she put it. Works such as *Snake* (1980-81) rise impressively from the Earth, celebrating the flux and movement of organic forms (Andy Goldsworthy has produced many serpentine forms, of course, but has never used the title 'snake' or 'serpent', preferring to keep the interpretation of his works more open than that). Beverly Pepper's large, curving mirrored slabs of wood buried in sandy beaches (*Sand Dunes*, 1985) might be seen as a type of 'Earth Mother art', art which worships and works with the Earth, rather than, as in some of masculinist land art, cutting or penetrating it, phallically (as Michael Heizer, Robert Smithson and Walter de Maria did in America's deserts).

Many of the celebrated products of contemporary sculpture, however, have been made by male artists: Donald Judd's 'specific objects', stacks of aluminium and Plexiglas that climb gallery walls[7] • Tony Smith's monumental black cubes with their *thereness* (celebrating the primacy of presence, not effect)[8] • Dan Flavin's mesmeric fluorescent tubes, a sculpture of light and space[9] • Sol LeWitt's Conceptual white wooden cubes like mathematical puzzles, and wall drawings like enormous graphs • Richard Serra's huge props of steel leaning together[10] • and Carl Andre's flat, square plates of steel, copper and zinc laid on the floor.[11]

One of the most exciting developments of contemporary sculpture and art is the installation, the taking over of a whole space or environment – the floor, walls and ceiling of a gallery, as in Rebecca Horn's *Ballet of the Woodpecker* (1986-87), a room full of mirrors, or Sylvia Stone's *Crystal Palace*. Andy Goldsworthy's art, like many land artists' works, is clearly related to the art installation (and often it *is* an installation): it is an art of environments, where the relatively small addition of a stack of stones forming a cairn sets alive the surrounding landscape. One sees the land-scape in a new way: context is all-important. (Sometimes, Goldsworthy has created installations, such as *Snowballs in Summer* on the streets of London in 2000, or the slate domes in Washington, DC in 2005. Given the time, space and schedule, Goldsworthy increasingly opts to construct at least one installation for his exhibitions).

ALEXANDER CALDER AND BARNETT NEWMAN 1.2

The affinities between Alexander Calder's (1898-1976) mobiles and Andy Goldsworthy's sculptures include a delicacy of touch, a love of thin, spindly shapes (stalks and leaves in Goldsworthy's art, wire in Calder's), inspiration from the natural world, the use of natural forces like gravity and the wind, and an actualization of time and motion. Calder's constructions are slender filaments of wire, with the distinctive 'leaf', teardrop or circle shapes at the end of each tendril. The facture of the mobiles is dazzling in itself. In *Thirteen Spines*, Calder fixed one wire to another, near the end, forming a chain of spines rather like the quills of some mechanical armadillo.

Andy Goldsworthy's sculptures dazzle with their sense of balance; Alexander Calder's mobiles mystify with their extraordinary balancing acts. The mobile, as a form, is taken for granted now, so obvious does its composition seem. Mobiles are everywhere, as toys, with teddy bears, whales, fairies, clowns, stars, moons, cars, trains and Pierrots hanging from them. Yet, before Alexander Calder, there were no mobiles – not in the form

they're known today. Sculptors before Calder had employed balance in sculpture, but not quite in his way. When an object balances it sets up an immediate, physical tension.

What is most fascinating about Alexander Calder's skeletal mobiles, though, is their motion, or their potential to move. Calder's mobiles drift slowly, each arm moving at different speeds from the others. They are powered by the spontaneous, natural energy of the breeze; thus, they could be seen as environmental artworks, because they are dependent for part of their impact on natural forces such as wind, air, temperature and air pressure. The balancing acts of Calder's mobiles are playful – the sculptures set alight the space around them with their gravity-shaping design and movement.

All sculpture exists in a space, whether virtual, artificial or actual. Norbert Kricke created sculptures which looked like frozen lightning strikes, all spikey and angular, the thin rods of steel being set at different angles to each other.[1] Alexander Calder does not have a monopoly on thin, spindly sculptures made of steel: David Smith, Hans Uhlmann, Eduardo Chillida, Nancy Graves, Jean Tinguely, Alberto Giacometti and Kricke all produced sculptures in this manner.

American Abstract Expressionist Barnett Newman (1905-70) was an important influence on Minimal art. Like Andy Goldsworthy, Newman emphasized religious awe in art (though he made much more of religion than Goldsworthy has done). Newman traded on the mystifying, gravity-defying aspect of sculpture in his *Broken Obelisk* (1963-67), which is a pillar balancing on the tip of a pyramid (a good example is in the Sculpture Garden of MOMA in Gotham). The balancing of the steel pillar is a technical *tour-de-force*, a piece of bravado that seems macho because Newman conceived of the two forms as masculine and feminine. Guess which one is on top: the male. In a similar way, Constantin Brancusi conceived his *Adam and Eve* (1916-21) sculpture as one form on top of the other. Guess which one was on top. In Newman's and Brancusi's sculpture, the male element is nearer the sky, it is spiritual, transcendent, ascendant, superior. The feminine element is underneath, close to the earth, a squat, nurturing figure which holds up the male's balancing act – which seems like showing off, an unquestioned hierarchy which evokes patriarchal

power.

Like so many of Barnett Newman's paintings, his *Broken Obelisk* sculpture is conceived as an act of faith, a flame in the darkness. Newman's sculpture aims (like Constantin Brancusi's *Birds in Space*) to soar heavenward in some ultimate act of earthly transcendence. The religious aspect of Newman's sculpture is a part of his overall religious sensibility: in his *œuvre* he used elements of the *Qabbalah*, he created a *Stations of the Cross* series of canvases, and his paintings have titles such as *Vir Heroicus Sublimis, Cathedra* and *Onement*[2] Part of Newman's artistic project was to investigate ways of creating a spiritual art in a secular, Godless age. Andy Goldsworthy certainly has no such over-arching spiritual (or ideological or political or social) project in his art. He is exploring 'big themes' in his art (time, change, cycles) but not in the same way as Newman, or Mark Rothko, or Ad Reinhardt.

SCULPTURE IN MOTION 1.3

Andy Goldsworthy's sculptures often move: the leaves shift in the breeze; the stalks bend in the wind; the snow melts; the tide crashes into rock cairns; the arches collapse (the motion of many of his sculptures leads directly to their collapse: you move, you die). Time extends outwards from Goldsworthy's sculptures, much as in Alexander Calder's mobiles. No matter what the scale, Calder's mobiles extend far beyond themselves, by virtue of their construction and motion. Like optical and light sculptures (such as those of Dan Flavin or James Turrell), Calder's mobiles and Goldsworthy's installations create spaces around themselves which act on the viewer in a palpable manner, quite distinct from the relatively staid and stolid approach to sculpture of, say, Antonio Canova or Luca della Robbia (not precisely a fair comparison, of course: some of the most kinetic sculptures have been immobile marble statues).[1] Indeed, Goldsworthy's installations, like all art installations, *are* spaces in themselves.

The kinetic dimension would be out of place in the sombre religiosity of Barnett Newman's or Constantin Brancusi's sculptures. There are some sculptors' work which just seems to be fixed and rock solid. If Michelangelo Buonarroti's statues of *Moses* (1513-16) or the *Pietà* (1498-99) were mobile, it would be utterly out of keeping with the tone and theme of these solemn, awe-inspiring sculptures. Other sculptors, though, actively developed motion in sculpture: Naum Gabo in his *Kinetic Construction* (1920), with its oscillating rod; Len Lye's magnetized steel *Loop* (1963) and his *Fountain* (1959), which wafts from side to side; Marcel Duchamp with his *Rotorelief* (1920), which span around, creating a circle; Andy Warhol with his room full of silver balloon-pillows, which drifted about (1966); and George Rickey with his swaying rods of steel, as in *Peristyle III* (1966).

But the master of kinetic sculpture must be the rebellious Jean Tinguely, whose motorized sculptures gleefully and mischievously created chaos. Tinguely's sculptures don't just move – in all directions – they are very noisy, with clatterings, bangs, pants, grinds and wheezes. The most famous, *Hommage à New York* of 1960, was a sculpture 'created for self-destruction'.[2] (Tinguely's assemblages are not in constant motion in some museums, but it's worth waiting around to see one if they are on a timed system).

NOGUCHI, SUGARMAN, POMODORO, SAMARAS 1.4

Andy Goldsworthy's stone walls resemble serpent-like forms, curling around trees, following the contours of the landscape. Sculptor George Sugarman (b. 1912) has created similar forms, with his erotic, flowing sculptures. Like Lynda Benglis's or Gio Pomodoro's sculptures, Sugarman's works are twisting, entwined shapes painted in red, white, green and yellow. Sugarman fashioned a series of objects, interlinked spatially and thematically, set end to end, a chain of mystery. Sugarman's seemingly disparate collections of objects were united in part by his use of colour.

Taking his cue from the artist Stuart Davis, Sugarman used colour spatially. In Sugarman's sculpture, the flat colour – all-over red, or yellow, or green – tended to suppress the irregularity of his peculiar shapes. Goldsworthy favours red and yellow as all-over colours. This use of colour to flatten things, to give a collection of objects a unity, is found also in Tony Cragg's *New Stones* (1978), where all the kitchen utensils, household items, children's toys and bits and pieces are painted with the colours of the spectrum in a uniform manner, going from red through yellow to blue. (Goldsworthy has often employed the colour change in his art, most commonly in his leaf sculptures, which use the different colours of Fall leaves – typically yellow through orange and red to brown – to unify the forms, the lines, or ovals, or circles).

When bright, primary colours are employed in sculpture, as in the grand scale of Minimal sculpture, such as in Isamu Noguchi's huge *Red Cube* (1969) (or Andy Goldsworthy's poppy-covered stone or beech tree leaf shields), the result has a formal simplicity that borders on the child-like. How simple and 'right' seem these bold, sunny colours appear when combined with the simplicity, self-assurance and exactness of basic geometric shapes such as cubes, spheres, cones or pyramids. One might see this indulgence in purity and precision combined with vivid colouration as an erotic pleasure. One finds this simplicity of colour and formal purity in Philip King's orange and green painted blocks (such as *Call*), the powder colour on Anish Kapoor's semi-organic shapes (such as *Half*), Joan Miro's later works, and the green lacquer on John McCracken's *Untitled*. Some Minimal and Conceptualist sculptors, though, such as Sol LeWitt, only permitted themselves white (like Robert Ryman among Minimal painters).

Gio Pomodoro's (b. 1930) sculptures comprised crumpled sheets of fibreglass which directly recall the fields of unbroken colour of the Abstract Expressionists, in particular Barnett Newman, Franz Kline and Mark Rothko (as in *Tensione*, 1959). Lucas Samaras's (b. 1936) works were the flipside of Sugarman's sensual forms. Samaras deliberately subverted the eroticism of sculpture by furnishing his sculptures and assemblages with pins, nails, razor blades, knives and scissors, as in his vicious *Book 4*, which is stuffed with knives, nails and razor blades. For Samaras, as for so many Western artists from Petronius through the Marquis de Sade to Georges Bataille and

William Burroughs (most of 'em do tend to be male), sex (pleasure) is intermixed with death. Or, as Samaras put it: 'I cannot separate beauty from pain.'[1]

HYPERREALIST SCULPTURE 1.5

Land artists work with real objects – for instance, Andy Goldsworthy with his leaves and stalks, Agnes Denes with her wheatfields, Alison Wilding with her meteorites, and Walter de Maria with his soil. There is a different kind of 'reality' in the figures of hyperrealist sculpture (also known as realist, Superrealist or photorealist sculpture). The viewer encounters people frozen in often bizarre attitudes and poses, as in Duane Hanson's *The Tourists* and other works (guards in art museums like to play jokes with first-time visitors, pretending the statues' re real). The strangeness comes from the absolute stillness of these near-waxworks (dummies, dolls, puppets, waxworks and animatronics have similar properties – with the uncanny (Sigmund Freud's *unheimlich*, uppermost)). Hanson's figures are sarcastic and ironic, while George Segal's explore the alienation of modern life (in particular, the American way of life – too easy, really, for a contemporary artist to satirize).

Some Superrealist or hyper-realist sculptors have turned in sexist figurations: Anthony Donaldson has produced a truly horrible photorealist *Girl Sculpture*, a plastic red and gold model of a woman – naked, of course – set in a 'streamlined' mould, rather like those 3-D logos beloved of entertainment organizations, where the letters are drawn in exaggerated perspective. (of the 1960s thru 1980s – in the 2000s/ 10s, logos glow with myriad digital and optical effects) Donaldson's sculpture is the diametric opposite of Andy Goldsworthy's: this kind of bitter satire on materialism is not the Goldsworthy's form of art at all. Apart from the green/ ecological subtext, there is hardly any socio-political discourse in Goldsworthy's art.

Reg Butler's bronzes of naked women are 'exquisitely crafted', to use

terms typical of art criticism,[1] but in fact turn out to be very sexist representations of women. John De Andrea also explored 'the resignation, emptiness and loneliness'[2] of postwar life, that emotional territory of Middle America that Raymond Carver so successfully explored in his short stories. But De Andrea's nudes turn out to be just as reductive as other high art nudes. His *Reclining Woman* (1970) is a Superrealist version of the high art 'reclining nude', a life-size and seeming 'life-like' rendition of a person.

By employing non-figurative subjects, Andy Goldsworthy neatly sidesteps many of the usual charges of sexism in his art. It's harder for art critics to find something masculinist or sexist in a sculpture composed of stones in the form of a cairn or a wall (the issue of gender is simply not included in most of his works). Sometimes Goldsworthy has produced sculptures which make explicit references to masculinity and femininity in terms of sexuality (his hole sculptures, or his vulvic stick sculptures, for instance). But they are in the minority. It's possible to critique Goldsworthy's art in terms of feminism, though, in its subtler manifestations: the emphasis on macho, heroic art-making, for instance (like going to the North Pole, or staying out all night in Winter to create a sculpture, and including the elements of heroism in the autobiography of the work).

DAVID NASH AND ANDY GOLDSWORTHY 1.6

One of the most intriguing and sensual of British land artists is David Nash (b. 1945), with whom Andy Goldsworthy worked early on in his career. David Nash was – is – an important artist for Goldsworthy. The younger artist had first encountered Nash when the sculptor visited Preston Polytechnic (along with Richard Long) in 1978, to give a lecture. Nash invited Goldsworthy to look after his studio, Capel Rhiw, in Blaenau Ffestiniog, while he was away for a while in Summer, 1980. Nash would become one of the few artists with whom Goldsworthy formed a long-lasting friendship. Nash helped Goldsworthy gain his first one-man show

(at LYC Museum and Art Gallery, Banks, Cumbria, in July, 1980, when Goldsworthy was 24).

David Nash's æsthetics chime with those of Andy Goldsworthy, Richard Long and Hamish Fulton among British artists.[1] Critic Hugh Adams saw David Nash as a kind of 'fixed abode Richard Long', working from one place (North Wales), while Long travels the globe, regarding the whole world as his studio, as material for making art. Hugh Adams wrote:

> *Nash is Long in microcosm: the sensibility is the same but, whereas Long travels the world, making, marking, and recording, in distant places, Nash is more sedentary, and content to do the same thing where he has made his home.*[2]

David Nash has built a number of 'stoves' and 'hearths', out of natural materials – snow, slate, wood. These structures burn away – fire as 'living' sculpture. Andy Goldsworthy has built similar structures – in particular his cairns (though Goldsworthy hasn't used fire nearly as much as other sculptors). *Snow Stove,* made in Japan in 1982 (like Goldsworthy, Chris Drury, Long and other land artists, Nash went to Japan) burns beautifully – a snow pyramid, fusing those two eternal mysteries – fire and snow, fire and ice. Nash has also created a *Wood Stove* (1979), a *Slate Stove* (1981) and also a *Sea Hearth* (see List of Works). Anyone who's lit a fire right next to the ocean will know what a magical experience it can be (mixing fire and water), and Nash's *Sea Hearth* is certainly rich in magic. Nash set his fire built of large stones inches from the waves, to accentuate the contrast between the two elements (as well as the affinities). Nash's stoves and hearths are heavy with alchemical and elemental allusions: they are a poetry of elements, the basic elements out of which everything is made.

David Nash loved to work with wood; it became his primary sculptural material: his *Wooden Boulder* is exactly that – a huge, near-spherical chunk of oak. Nash tipped the boulder into a stream near his studio at Blaenau Ffestiniog, Wales. His idea was for the sculpture to make its way to the ocean. Instead, it stayed put in a pool, and interacted continually with the environment; eventually, it travelled down to the estuary (but took years to do so).

The delicious brooks of Wales, with their chilly, clear water, mossy granite boulders and constant noise, are one of the most poetic environments

Britain possesses. Andy Goldsworthy, like David Nash, makes many works near these streams (though Goldsworthy's streams – Scaur Water and Townhead Burn – are in Scotland). Nash's art, like Goldsworthy's, is respectful of water and the landscape. It's a gentle art, and based firmly in a reverence for nature.

In the Forest of Dean, as part of a commission for the sculpture park, David Nash built a circular mound of larch poles charred at the end. He spent two weeks charring nine hundred pieces of wood, which were then stuck together in a 'wide circular hole in the ground'.3 Nash wanted to have his *Black Dome* as a mound of nothing but charcoal, but realized it would not last long enough for the public to see it. He wanted to use charcoal because it was a part of the industry of the forest (a regular link sculptors forge with landscapes is with the earlier industries in those areas; Andy Goldsworthy is always making links with agriculture, for instance. Not prehistoric agriculture, though, but – generally – farming from the 19th and early 20th centuries). It was important too that Nash's large sculpture would decay away and become integrated into the forest again (i.e., that it was fashioned from organic elements). Nash envisaged his *Black Dome* 'gradually reintegrating with its environment, rotting down gradually – fungus, leaf-mould, plants adding to its process of 'return" (ib., 66).

David Nash makes fascinating pieces, works which are instantly appealing, partly because of the materials, the natural materials which urban-based cultures are so thirsty for: wood, stone, water, fire. Land artists make one aware, again, of nature, of natural materials. In the city, these materials are subsumed into the giant machine of a technological, late capitalist environment. How refreshing it is, after being encased in grey concrete and a maze of straight lines in the city, to imbibe these works of Nash, Andy Goldsworthy and Richard Long. What a wonder, really, is Nash's marvellous *Fletched Over Ash Dome*. This is a circular group of trees in Wales which Nash planted in 1977: it is a 'living' sculpture, which, over thirty years, will be trained into a dome. It will be not only a circle of trees, but a dome of trees. Nash explained:

> A circle of young ash trees fletched and woven into a thirty foot dome fletched
> three times at ten year intervals then left alone. A silver sculpture in winter, a
> green canopy space in summer, a volcano of growing energy. (1978)

While Andy Goldsworthy uses dead leaves, David Nash's use of living trees (such as in his *Fire Engine Sweep*, planted in 1980), creates a new form of sculpture, a sculpture which is alive, which changes over decades, rather than seconds (or as well as over seconds). Goldsworthy's water splashes last moments, while Nash's fires last a few hours. *Fletched Over Ash Trees*, though, is a sculpture that persists for decades, and changes year in year out. Goldsworthy created sculptures with logs stuck together, which will decay gradually, but Nash's trees will grow and develop for a long time before they decay, which will make them a particularly exciting type of sculpture. Nash has also made waterfalls and streams from hollowed-out tree trunks, entitled *Wooden Waterways* (1978, Grizedale and 1982, Japan), in which water from a stream was diverted along the trunks of a fallen oak tree, an ash, a sycamore, and onto more troughs.

Many of David Nash's later sculptures have continued with the techniques, forms and themes of his earlier work. He has continued to place wood, for instance, at the centre of his art. He has also continued to create large versions of everyday objects. The links with gardens and gardening have also been maintained (for instance with the *twmps* that Nash produced, inspired by the giant hedges at Powis Castle, a famous garden in Wales). The social dimension is also to the fore in Nash's later work.

ANDY GOLDSWORTHY AND CHRIS DRURY 1.7

Of all the land artists, in Britain and elsewhere, who have affinities with Andy Goldsworthy, there is one who appears very close to Goldsworthy: Chris Drury. Born in 1948 (in Sri Lanka) and educated at Camberwell School of Art in London, Drury is a British artist who has made work with numerous links with that of Goldsworthy. Drury is 8 years older than Goldsworthy and belongs to the generation of Alan Sonfist, Charles Simonds, Michael Heizer, William Furlong, Alice Aycock, Mary Miss, David

Nash and Richard Long (all born in 1944-46). Drury began to make land art at about the same time as Goldsworthy (in the mid-Seventies); he had begun with figurative sculpture.

The art of Chris Drury and Andy Goldsworthy share so many elements: they are both British land artists, both emphasize spirituality, both use similar forms (cairns, shelters, globes, spirals, circles), use similar materials (boulders, grass, willowherb, wood, snow, clay), and both have worked and exhibited in similar territories: Japan, the U.S.A., Scotland (Drury has made works, though, in places Goldsworthy has not been associated with, such as Ireland, Italy, Denmark and Spain. Drury has created many works near his home in Lewes, Sussex). They also share the same book publishers (Thames & Hudson and Cameron Books), the same art critics (Paul Nesbitt, Terry Friedman) who've written about their art, and have worked with the same institutions (such as the British Council, Common Ground, the Henry Moore Foundation, Sustrans, the Scottish Arts Council and the Arts Council).

Basket weaving is one of Chris Drury's passions, and he has created many forms using weaving, including a large open dome from hazel branches (*Cuckoo Dome*, 1992), and kayak forms (*Kayak Bundles,* 1994). Boats, kayaks and 'vessels' are another recurring form in Drury's art. Some of the vessels are enormous cannibalized stone walls (such as *Long Vessel*, 1995) or heaps of stones willow and reeds woven on top of them (such as *Shelter Vessel*, 1988, made in County Galway). (Some of Andy Goldsworthy's key works are stone walls). Another distinctly Goldsworthyan form of Drury's is the globe set on the ground. Drury has created spheres from pine cones (1984), deer bones and deer scats (1984), and bamboo, ginkgo, vines, moss and seeds (1997, Japan). Drury has created circular mazes (some of which are reworked dew ponds); Goldsworthy has only made one maze so far (*Maze*, in Durham).

Chris Drury has reclaimed and reworked dew ponds, mainly in Sussex, some of which are quite ancient. An off-shoot of Drury's penchant for weaving is the interlacing of maps (maps being one of the key components of land art). Thus, Drury has interwoven a map of Manhattan with one of the Hebrides (1996), West Cork with New Mexico (1995). Like Tony Cragg, Drury has collated found objects into patterns (such as *Tidelines,* 1985,

made from pieces of plastic, metal, rubber, driftwood and feathers).

As with Andy Goldsworthy, cairns are another form Chris Drury employs; he has treated his cairns in different ways: many of the stone cairns have had fires lit inside them, such as *Falling Water Fire Cairn* (1997, Norway), *Fire Mountain Cairn* (1996, Japan), and *Fire Cairn* (1989, Colorado). Some cairns have been enclosed with basket weaving (such as *Basket Cairn*, 1991) and *Covered Cairn* (1993, Denmark). Like Goldsworthy's cairns, Drury's stone cairns are usually erected in wilderness or spectacular scenery: Norway (1988), New Mexico (1993), De Lank River, Cornwall (1990), Lappland (1988), Wester Ross, Scotland (1992), Ladakh (1997) and Colorado (1989). Like Drury, Goldsworthy has occasionally enclosed his cairns with other materials, such as the slabs of ice surrounding a stone cairn (1996), and the stone spire inside a stick cairn (1995).

Another favourite Chris Drury motif is the shelter: low, squat structures, sometimes like teepees or witches' hats, some like prehistoric beehive huts. The shelters were often made from stone (but also in chalk, turf, ice, wood and coal). The shelters are usually (but not always) constructed at human scale. That is, in the correct scale for someone to enter them. Some of the shelters, such as *Shelter For the Winds That Blow From Siberia*, made near Drury's home in Lewes in 1986, have a distinctly Goldsworthyan flavour: blocks of ice mounted on a hazel frame, looking like an igloo. Some, as with the cairns, have had fires lit inside them (*Shelter For Dreaming*, 1985). Some of the shelters are open structures, without a covering (rather like a frame tent before the canvas is pulled on top). Others are a frame which's wrapped with ice, or turf, or reeds.

Chris Drury's shelter sculptures have all sorts of connotations, stretching back thousands of years (shelters must have been one of the first structures that humans ever built – shelter being one of the primal human needs). Drury's shelters have obvious affinities (with Celtic and Bronze Age huts and houses in Britain, for example), but they are also about 'organic' forms, forms which repeat endlessly, and geometrically, like crystals. The shelters are also about the landscapes in which they are constructed, like land art in general. They tend to be built in rural or wilderness zones, and are the only structures of that kind in the area (they stand out as artworks, not as part of agricultural machinery, for instance). The shelters are thus

also free-standing sculptures, artworks which draw attention to themselves. The shelters are also about land art concerns, such as the tensions between what's inside and what's outside, between the humanmade structure and a 'natural' context (the landscape), about the relation between form and function, æsthetics and use. The shelters draw attention to the landscape around them.

Like Andy Goldsworthy, one of Chris Drury's concerns was human history (British land art is acutely conscious of history, maybe because it infuses every single square foot of Britain): his artworks re-use dew ponds and stone walls, draw attention to tumuli by building domes over them, and altering maps, one of the most elegant manifestations of human history. *A Dense History of Place* (1996) was one of Drury's map works which combined maps with written text (a common motif in land and Conceptual art). Dense lines of text spread outwards in a circular pattern from an area near the coast in Sussex depicted in an Ordnance Survey map, an area which has many personal associations for Drury.

Some of Chris Drury's most appealing sculptures are 'cloud chambers': these are basically stone shelters with holes in the roof which act as lenses. In these *camera obscuras*, the spectator can observe the sky above projected onto the floor below. The cloud chambers articulate classic land art concerns: the dialectic between inner and outer, indoor and outdoor, stillness and movement, nature and culture.

Chris Drury's art departs from Andy Goldsworthy's art at many points, however: the use of materials such as animal bones, antlers, and feathers, the basket weaving, the spherical 'baskets' like pots, the kayaks, and the cloud chambers. Drury is much more inclined than Goldsworthy to use in his sculpture material from animals, such as whale bones, or reindeer antlers, or gull's feathers, or cow dung. Some of Drury's larger works, such as *Vortex* (an enormous hollow cone of woven hazel and willow made at Lewes Castle in 1994), have more in common with artists such as Tony Cragg or Richard Deacon than Andy Goldsworthy.

2

Women and Feminist Sculptors

Sculpture is a three dimensional projection of primitive feeling: touch, texture, size and scale, hardness and warmth, evocation and compulsion to move, live and love.

Barbara Hepworth[1]

Andy Goldsworthy is one of the contemporary male sculptors sympathetic to exploring 'feminine' themes (one thinks also of Peter Randall-Page, Stephen Cox and Richard Deacon among British sculptors). Goldsworthy employs feminine shapes and motifs, such as the vulva, globe and circle. At Goldsworthy's 1994 exhibition *Stone* in London, was a stone with a vulva-shape carved out of it (*Split sandstone*, 1990). The opening was in layers, receding into the stone, so that the effect was distinctly labial, suggesting the inner folds of the vagina. For Peter Gabriel's 1992 album *Us*, Goldsworthy created a vulvic shape out of twigs, placed in some mossy rocks. *Slate hole* was a vaginal shape made from slabs of slate arranged into a low mound. Another sculpture, *Hard Sand* (1991), was a labial form fashioned from red sand in Australia. In 1992 Goldsworthy carved clay embedded in a hollow tree trunk in California into labial slits. Richard Long also spoke in gendered terms of his lines and circles: the lines are 'male things', while the circles and water are 'a sort of female'.[2] As a footnote: Goldsworthy has tended to avoid the vulvic shape since the early 1990s works – perhaps the connotations are too explicit, or the form is linked to what feminist artists (such as Judy Chicago) termed 'cunt art' in the 1970s (he has returned to the form, or something close to it, from time to time, though it's not a central form like the circle, the serpent or the cairn).

Many women sculptors have explored 'feminine' imagery and 'female' issues. Lila Katzen set alive public spaces with her flowing, curling forms (such as *Guardian*, 1979). Louise Bourgeois (rightly regarded as one of the key female voices in the modernist era, and an important sculptor) explored the relations between form and eroticism, volume and psychology, shape and nature. Bourgeois' forms often dealt with eroticism – her *Nature Study* (1984), for instance, featured the bulbous volumes which are practically Bourgeois' trademark, echoing breasts, clitorises, vulvas, buttocks, heads, hands, knees, tongues, all the parts of the eroticized body.

Alison Wilding, a British artist a little older than Andy Goldsworthy (whose art has affinities with Goldsworthy's), directly embraced the potential for sculpture to be supremely sensual. Her abstract forms hint at alchemical transformations, intimate experiences, investigations of sexuality and the relations between space, imagination, fantasy and the body.[3] Wilding's *Hemlock III* (1986), for example, was, like her *Blueblack* (1984), a

wooden dish containing hemlock, lead, lime and beeswax, allusive of arcane or alchemical experiments. The dish with its dangerous substances is a kind of womb, a motif or experience that appears in much of modern sculpture, from Judy Chicago's *Dinner Table* to the womb interiors of Louise Bourgeois and others.

Alison Wilding's sculpture often featured two elements, one is usually large, the other, small. These two elements are luscious and mysterious, beyond interpretation, though some view them as masculine and feminine elements, the twin poles of heterosexuality, which are involved in some arcane dance or dalliance.[4] Wilding herself stresses the enigmatic nature of her work: '[t]he obverse of making is looking, not telling',[5] and she emphasizes, as so many artists do, the making of the sculpture: '[t]he making and doing processes...[are] always the mainspring of the work'.[6] Richard Long, David Nash, Bill Woodrow and Andy Goldsworthy, among many other sculptors, also stress the making of sculpture (it's the part of the art that the artist gets hooked on – actually making the thing. And it's also the part of the art that the spectator can never experience for themselves: they are always on the outside, looking in).

The eroticism of Andy Goldsworthy's sculpture is of a different order from traditional, figurative sculpture, the sculpture of, say, Michelangelo Buonarroti and Gianlorenzo Bernini. Due to the 'abstract' nature of Goldsworthy's sculpture, his work generally escapes obvious categorizations of sexism or gender stereotyping. The famous sexist and heterosexist depictions of people in modern sculpture include Alberto Giacometti's *Spoon Woman* (1926, Zurich), a view of woman as Earth Mother, a totemic figure; Gaston Lachaise's *Standing Woman* (1912-27, Whitney Museum of American Art), one of those smooth, curvy Goddess types, also favoured by Aristide Maillol; Hans Bellmer's bizarre *Dolls* (1936), where the slit of a vulva is where the head would be, and set amidst exaggerated, bulbous forms; Henri Gaudier-Brzeska's *Red Stone Dancer* (1914, Tate Gallery, London), though it attempts a new way of depicting gesture and posture in space, is still stereotypical; Elie Nodelman's *Dancer* (1918, New York), like Paul Manship's *Dancer and Gazelles* (1916, Smithsonian Institute, Washington, DC), and Edgar Degas' *Dancer* sculptures (Metropolitan Museum of Art, New York), is also sexist; and Ernst Ludwig

Kirchner's *Standing Nude* (1908-12, Stedelijk Museum, Amsterdam) also affirms gender stereotypes.

Important contemporary women sculptors include Nancy Graves, Eva Hesse, Niki Sant-Phalle, Mary Miss, Rebecca Horn and Louise Nevelson. Eva Hesse is one of the most inspiring of women artists, whose artworks have an immediate, unforgettable impact that challenges the viewer. They hang from ceilings, in rows, made of rubber, latex, cloth, wire, fibreglass, evoking organic forms in ambivalent, sensual ways.[7] Pieces of Hesse's such as *Ingeminate* offer up a mysterious affirmation of life in the form of two coils of cord connected by a long piece of surgical hose. *Sans II,* meanwhile, is a dozen rectangular 'compartments' made from fibreglass which hints at some obscure systematization of flesh and organic form.

Eva Hesse's forms externalize the spaces of dreams in an idiosyncratic and stylized manner, as if she were recording her responses to a series of unsettling visions or dreams in which unexplainable but mesmerizing events were taking place. You don't understand Hesse's sculptures in the direct, assimilable way you can take in an Auguste Rodin sculpture; occasionally Andy Goldsworthy's sculptures have that air of enigma, but they are generally far more literal or literary than Hesse's sculptures.

Eva Hesse wrote: '[i]f I can name the content... it's the total absurdity of life.'[8] (A not uncommon view in the intelligentsia of the mid-20th century – the 'absurdist' playwrights – Samuel Beckett, Eugene Ionesco – and the Existential philosophers – Jean-Paul Sartre, Albert Camus – had a similar view).

One of Louise Nevelson's signature forms were huge reliefs or structures which were like Cubist or Constructionist altarpieces, full of objects, several articles made of wood, all painted in one colour, black, white or gold: chair legs, railings, door knobs. Her sculptures resembled magical cupboards, vertical dreamscapes made of boxes stacked on top of each other. Nevelson turned the grey desert visions of Surrealist painter Yves Tanguy into a vertical wall, as if by painting everything in a single colour it could somehow be controlled or assimilated.

Rebecca Horn's sculptures are based, like Andy Goldsworthy's, on natural forms, but also on movement, dance, time and environments (and Horn delved much further into abstraction). Horn's wonderful *Peacock Machine*

(1982) is an exuberant activator of space, one of those pieces that aims for the essence of a natural form and captures it: a peacock's magnificent tail.9 It was one of Constantin Brancusi's tasks to strip away the detritus that had accumulated around sculpture, sculptor Henry Moore said, and to give viewers a pure, simple shape (Andy Goldsworthy has acknowledged Moore's art; he's taken visitors to look at Moore's sculptures, for instance). What Brancusi did, Moore asserted, was 'to concentrate on very simple shapes, to keep his sculpture, as it were, one-cylindered, to refine and polish a single shape to a degree almost too precious.'10 This is what many contemporary sculptors have done, keeping their shapes simple and purified: Andy Goldsworthy, Richard Long, Alison Wilding, Richard Deacon, Richard Serra, Donald Judd and Robert Smithson.

Barbara Hepworth's organic forms, as with Constantin Brancusi's, hover between subjectivity and objectivity, between natural form and æsthetic abstraction (as in her *Two Forms*, for example.) Like Brancusi, Hepworth maintained that she always returned to nature, and took her inspiration from nature. For her, nature meant the (Cornish) landscape, and the human body. 'We return always to the human form – the human form in the landscape', she remarked. Her sculpture stems from emotion and expression, from feeling: 'I rarely draw what I see – I draw what I feel in my body', she said.11 Hepworth's distinctive forms, with their smooth curves and holes, are clearly sensual objects. Hepworth acknowledged the sensuality of sculptural forms. Andy Goldsworthy has acknowledged the significance of Hepworth's art, and has visited Hepworth's studio in St Ives (Cornwall), one of the most attractive spots to visit in Great Britain.

Alice Aycock, using science as her Muse, has produced some wonderfully fantastical machines, such as *The Angels Continue Turning the Wheels of the Universe*, or the marvellous, massive piece *The Miraculous Machine In the Garden (Tower of the Winds)*, which features 268 antenna and bells ringing in a vacuum. Impressive as Andy Goldsworthy's installations are, he has not yet ventured into the complex, multi-layered world of an artist like Aycock or Rebecca Horn. By contrast with Aycock and Horn and artists of that kind, Goldsworthy's art is clear and unambiguous. The viewer always knows what Goldsworthy is aiming for or dealing with in his art. While the *themes* may be ambiguous (the big themes with capital letters like 'Time',

'Change' or 'Transformation'), Goldsworthy's presentation is rarely (if ever) deliberately ambiguous or ironic or 'difficult'. But many contemporary artists revel in making the viewer do some work in decoding or unravelling the artwork (and they often retain their right to be enigmatic, and to leave large chunks of a work unexplained).

Andy Goldsworthy sometimes employs 'feminine' modes of art-making: *weaving* stalks, or *pinning* thorns or *stitching* leaves together. Weaving, sewing, stitching – these are regarded as feminine means of production (in both feminist and masculinist art criticism). Goldsworthy has also worked with clay, firing sculptures in kilns, activities often associated with female artists. Miriam Schapiro has taken up materials branded 'feminine' by patriarchy (cotton, taffeta, burlap, wool, sequins, buttons, thread), and has created artworks (she calls them 'femmages') that deal with notions of the home, feminist iconography, abstraction and the æsthetics of 'Pattern and Decoration'. Schapiro said: 'I wanted to explore and express a part of my life which I had always dismissed – my home-making, my nesting'.[12]

A number of male artists have explored traditionally 'feminine' notions of pattern, decoration and colour, among them Robert Zakanitch, Lucas Samaras, Robert Kushner, Rodney Ripps, Kim MacConnel, Frank Stella and Ned Smyth. But it is female artists who make the most flamboyant and intricate artworks in these areas, such as Joyce Kozloff or Valerie Jaudon. The traditional 'women's' arts and crafts of textiles, pattern, sewing, decoration, pottery, etc, are bound up with the economies of labour, race, class, identity, patriarchy, politics and finance, for feminist art criticism. They are modes of production and art that are regarded as secondary by patriarchal culture, not as high art, such as painting or sculpture. The economics of artistic production are embedded with patriarchal slants, just as much as the images themselves. The piece of textiles, the decorative tile, the pot, are objects that in the patriarchal system speak of their second-rate mode of production. As Catherine King wrote, '[m]edia associated with 'malestream' codes, like bronze, marble, or oil, have been regarded with suspicion' by women artists.[13] Although Goldsworthy uses impermanent materials such as leaves and snow, he also uses traditional, 'masculine' media such as stone. This helps his art to be regarded as 'high', 'serious' art (even though there are many detractors, who continue to refuse to

recognize Goldsworthy as a major artist).

One aspect of feminist or women's art explores the figure of the Goddess, the ancient and primæval Great Mother of all, celebrated in the ancient world – as now – as Isis, Ishtar, Demeter, Kali, etc. The Goddess is now variously interpreted as fact, experience, idea, æsthetic, cult, religion, pagan emblem and many other things by women artists (and hippies, neo-pagans and New Agers). There are a host of artists who have made what one might call 'Goddess art', art that employs the figure of the Goddess as an embodiment of female being or experience. Judy Chicago, Mary Beth Edelson, Ana Mendieta, Miriam Schapiro, Niki de Sant-Phalle, Louis Bourg-eois and Helen Chadwick.

Mary Edelson engaged in the resurgence of interest in the Goddess (in the era of second wave feminism), in her *Great Goddess* series (1975). Edelson has also produced a piece on menstruation entitled, appropriately, *Blood Mysteries*. In a work of performance art, Catherine Elwes sat in an enclosed studio space and menstruated. That was the performance: menstruation.14 Judy Chicago looked to the flowers of Georgia O'Keeffe in her famous *Dinner Party*, which, she said, 'stand for femininity'.15 Ana Mendieta used her naked body as the foundation for some of the finest feminist Goddess-related performance and body art of recent years, in which she reproduced the hieratic pose of an ancient female deity in elemental environments of mud, water, snow, leaves and fire (Mendieta's art might be regarded as a feminist, political correspondence with Andy Goldsworthy's art: Golds-worthy 'prints' his body on the ground during rainfall, but Mendieta took the Goddess-form and recreated in muddy riverbanks, in snow, in flowers and plants, and in fire).

As the *Rosarium Philosophorum* has it: 'make a round circle and you will have the stone of the philosophers.16 One might see Richard Long's circles as Goddess art, because circles so clearly evoke Goddess (or feminine) themes (or concerns) such as time, cycles and (Moon) phases, dance, transformation, ritual, initiation, astronomy, etc. The circle is also a profound shape for mediæval alchemists. Long created, in Ireland, an ancient maze form out of small stones set on grass. The shape of Long's labyrinth directly recalls the Cretan labyrinth of initiation and ritual, and the spirals at the entrance to Newgrange in Co. Meath, a huge passage grave

some 4,500 years old.

Andy Goldsworthy has drawn lines on sand, or with grass stalks pinned together, in swirling, spiralling shapes which echo the primæval forms of the snake, the spiral and the labyrinth. Richard Fleischner created a *Sod Maze* in 1974, in the turf at Newport, Rhode Island. Michelangelo Pistoletto built an interior maze from large pieces of corrugated cardboard laid out across the whole gallery (*Labyrinth*, 1991). In *Monumental Ikebana* (1990), Hiroshi Teshigahara made a giant arched path from bamboo in a gallery space. For Vong Phaephanit's bamboo installation (*What Falls to the Ground Cannot Be Eaten*, 1991), a forest of bamboo sticks was hung from the ceiling of the London gallery, approached through a monumental black doorway.

James Pierce created a series of earthworks at Pratt Farm in central Maine in the 1970s: there was a triangular turf maze; a small earth *Observatory*; a *Serpent* made from large rocks; a *Stone Ship*; a *Burial Mound*; a stone *Altar* (in the shape of male genitals); and several figures made from grass and soil: *Earthwoman* and *Suntreeman*. Pierce's *Earthwoman* (1976-77) was a recumbent female shape, with prominent buttocks, evoking the erotic gardens of the 18th century, and the links between prehistoric earth mounds, fertility and femininity.

Herbert Bayer constructed earthworks which directly evoked prehistoric structures: Bayer's *Earth Mound* (1955) in Aspen, Colorado, contained the familiar motifs of ancient religions and cultures: a circular rampart enclosing a small mound; a standing stone and a hollow were placed beside the mound. In Kent, Washington, Bayer built a series of earthworks (*Mill Creek Canyon Earthworks*, 1979-82) which featured circular ramparts, circular moats, mounds surmounted by walkways, and circular ramparts split by a path. At a quarry in upstate New York William Bennett created a *Wedge (Stone Boat)* (1976), an 80 foot long smooth-sided channel in the limestone.

Niki de Sant-Phalle produced exuberant Goddess sculptures, such as her *Black Venus*, or her marvellous *Pink Childbirth*, a Great Mother Goddess fashioned from dolls, toys, tissues and several items collected together like a totem of the prehistoric world. Sant-Phalle's *Un Ensemble de "Les Nanas"* is an effervescent – and multicoloured – representation of female forms,

dancing, cavorting, balancing.[17] Among non-figurative, abstract or partially-figurative artists, women such as Nancy Graves are astonishing, with her superb multi-media constructions.[18] Graves' skeletal, fossil-like works combine fantasy and natural forms in 'one exuberantly open-form, polychrome, freestanding construction after another'.[19]

The body features occasionally in the art of Andy Goldsworthy (it's fairly common to see the body in land art). One sees the shape of Goldsworthy's body on the ground after snowfall or rainfall (in his *Rain Shadows*), or 'printed' onto frosty ground by his shadow at sunrise, or throwing sticks and dust into the air for his *Throws*. Goldsworthy occasionally appears in photographs, beside his work. Goldsworthy's hands, and sometimes the rest of the sculptor, are seen, but there is nothing in Goldsworthy's work (or Hamish Fulton's, Richard Deacon's, Stephen Cox's or Barry Flanagan's) that is as ferocious as feminist and women's body and performance art.

Feminist and female artists have deployed the body to explore political, erotic, pornographic, æsthetic and philosophical discourses. The female nude, for so long the model and image and object of desire in so many high art paintings and sculptures, has usurped the power relation between artist and art object, and between artwork and spectator. The woman or model is no longer content to be looked at and lusted after: she is making her own art, employing her body in a radical, challenging way. The 'Old Master/ *Playboy* tradition', as Lisa Tickner called it, has been smashed (though it persists in many cultural spheres).[20]

Feminist body and performance art was a way of repossessing the body, sexuality, identity, and power. Some of the more well-known examples of feminist body and performance art include: Carolee Schneemann, who pulled a scroll from her vagina and read from it.[21] Schneemann was one of the most prominent of female performance artists; her most famous piece was *Meat Joy* in the 1960s. Her work has appeared in many of the key art history books. Chila Kumari Burman made 'body prints'. Karen Finley poured 'a can of yams over her naked buttocks'; she was 'a frightening and rare presence'.[22] In her *Cut Off Balls* Finley castrated Wall Street bankers.[23] Mary Duffy displayed her disabled body in performance and photographic sequences.[24] Jo Spence photographed the 'unhealthy and ageing female body' (foregrounding what conventional art history has tended to

suppress).[25]

The new feminist art of the 1960s and 1970s was a way of 'rewriting the body', to use the terminology of French and postmodern feminism. Rewriting, remaking, reworking. It can be an act of transgression and subversion, which usurps the long-established power relation between spectator and artwork, so that the (male) viewer's 'cloak of invisibility has been stripped away and his spectatorship becomes an issue within the work', as critic Catherine Elwes put it.[26] It was in part an aggressive reclaiming of masculinist or patriarchal economies. 'Taking back the night' was one of the phrases employed by feminists at the time.

Andy Goldsworthy has not made such social, political or ideological issues the subject of any of his works (although he has addressed social concerns from time to time, such as the environment, or working communities. Tackling the Holocaust issue, in the memorial at the Jewish Museum in New York of 2003, is not typical of his work, and if a list of possible artists had been drawn up by many art committees, Goldsworthy's name probably wouldn't be at the top). For some commentators, it's a limitation of Goldsworthy's art that he doesn't address issues of identity, body image, gender, feminism, sexuality, post-colonialism, diasporas, ethnicity, among many other socio-political affairs. For the Goldsworthy fans, it's a relief that he doesn't burden his work with such matters. Why should he? Why should an artist have to deal with every social, political, ideological or cultural issue around? The problems for the anti-Goldsworthy critics are that his art appears to be too escapist, or it too often avoids social and political issues. Although Goldsworthy is sometimes dubbed an 'ecological' artist, for instance, some critics reckon that Goldsworthy doesn't really explore ecological affairs (or not how *they* would like an artist to explore them). There's not much in Goldsworthy's art, for example, about pollution, or the greenhouse effect, or 'Third World' debt, or deforestation, or natural disasters, or the oil industry, or 'McDonaldization' and globalization, and so on. Those are the sorts of issues that an ecological artist might be expected by your average cultural pundit to address. And when Goldsworthy does take on agriculture, for instance, it is at a local, small-scale level – chiefly the agriculture of rural Britain (in the *Sheepfolds* project, for example). And Goldsworthy's artworks about farming are not attacks on

big business or government policies (which in Britain subsidize farming), or searing denouncements of multi-national, capitalist exploitation. Rather, they tend to be *hommages* to farming and farmers, or nostalgic evocations of earlier agricultural economies (like the sheepfolds and stone walls). Goldsworthy said that even farming could be regarded as a 'very sculptural activity', so that an act like making haystacks could be 'one of the biggest acts of Minimalism you've ever seen', and planting a row of potatoes could be an installation (*Wall*, 14-15).

Andy Goldsworthy's art has been criticized on a number of levels. For example, its avoidance of political or 'important' or problematic issues, such as AIDS, poverty, abortion, globalization, colonialism, war, and so on. Its romanticizing of the natural world. Its conservativism. Its nostalgia (such as for a vanished agricultural, working-class past that never existed in the first place). Its escapism. Its self-indulgence. Its elitism. Its repetition and lack of imagination. Its lack of formal experimentation. Its over-simplification of its subjects. For the nay-sayers, Goldsworthy's art is a romantic retreat into escapist, nostalgic fantasies about nature, with nothing to say about the anxieties, problems and challenges of living in the contemporary, 21st century world. For the critics who deride Goldsworthy, he's a bearded hippy in jeans who panders to the middle class's nostalgia for nature, seen from the perspective of neurotic city dwellers who hanker for the peace and quiet of the countryside. It's also an art that flatters and assuages the bourgeoisie's liberal guilt over wrecking the natural world with its ceaseless, massive consumption.

Another critic who dislikes Andy Goldsworthy's art is Jonathan Jones. In a newspaper article on Grizedale, where the director of the sculpture park, Adam Sutherland, was shifting the Grizedale Society and the park away from Goldsworthyan land art, Jones complained that 'Goldsworthy's art says nothing about the violence, hypocrisy and waste of our relationship to nature and is about as radical as the Body Shop'. While the U.S.A. had big, romantic works of (land) art, such as Robert Smithson's *Spiral Jetty* or Walter de Maria's *Lightning Field*, that were authentic attempts to grapple with the sublime in the natural world, Britain had tree huggers and Goldsworthy's 'twee arrangements of twigs and stones' (J. Jones, 2000).

Andy Goldsworthy said that when he was working outside sometimes it

was difficult to explain to the general public what he was doing there. Occasionally, he had 'to deal with the anger and bitterness that is sometimes shown towards contemporary art' (A, 74). There is a suspicion and distrust of contemporary art among parts of the population of Great Britain (*viz*, the hostile reactions to 'Young British Art' or the Turner Prize). Americans, Goldsworthy remarked, were more sympathetic and welcoming (*Wall*, 12)

3

Sculpture in the 1960s and After

I once described the change in sculpture in the 20th century as moving in its concerns from form to structure and now having a concern with place... I believe now you can make sculpture you can enter.

Carl Andre

With the rise of the 'new sculpture' in the 1960s (also dubbed Minimal, 'cool' art, Process art or Conceptual art), sculpture became all 'object'.[1] 'Objecthood' became crucial, recalling the concept in the Existential philosophy of Jean-Paul Sartre and Edmund Husserl of the 'thing-in-itself'.[2] Inner and outer space became one, objects were simply what they are, without referring to anything outside themselves. The subject *was* the object (and/ or vice versa). Critic Barbara Rose wrote that the 'thing... is not supposed to be suggestive of anything other than itself'.[3] It was Frank Stella (Rose's then husband) who had emphasized the object-in-itself of art, and the objecthood of his paintings in particular. Stella's paintings are objects which display openly their 'objecthood' (such as his *Ophir*, one of his shaped canvases, a zigzag shape with striped paint). 'What you see is what you get', ran his famous statement, and Stella influenced many of the key artists of the 1960s: Donald Judd, Carl Andre, Sol LeWitt and Robert Morris. Stella was an important artist in the art world of 1960s Minimal sculpture: '[t]he idea that a painting is primarily a thing-in-itself has been around for a long time,' wrote Mel artist and critic Bochner, 'But before Frank Stella not much was done about it'.[4] Stella developed the notion of Barnett Newman's – of the unity or 'all-overness' of an artwork, so that it strikes the spectator all at once, every part at the same time. Stella said of his 'black paintings' (which had appeared in the late Fifties, and gained Stella instant success):

> *I had to do something about relational painting, i.e. the balancing of the various parts of the painting with and against each other. The obvious answer was symmetry – make it the same all over.*[5]

This certainly applies to Andy Goldsworthy's clefts of rock or snow cairns: the viewer sees them all at once, without frames, without being 'led', illusionistically, into the work (however, Goldsworthy uses plenty of pictorial devices which have been around since Renaissance art and earlier: frontality, perspective, musical proportion, geometry, symmetry, *chiaroscuro*, and so on, as well as illusion and artifice. Although Goldsworthy's art is contemporary, it employs Classical composition, for instance, in its photography. In fact, photographically, Goldsworthy's art is quite traditional and conservative, compared with many other contemporary artists).

The influence of Constantin Brancusi is also apparent in Minimal sculpture (and in Andy Goldsworthy's art). Robert Morris, Donald Judd, Carl Andre and Dan Flavin, among Minimal artists, acknowledged Brancusi's art, in particular his *Endless Column* (for its seriality and repetition, its abstraction, its self-containment). Andre's early sculpture *Last Ladder* (1959, London) resembled Brancusi's *Endless Column*. Andre said (in an oft-quoted statement): '[a]ll I am doing is putting Brancusi's *Endless Column* on the ground instead of in the air... The engaged position is to run along the earth.'[6]

The Brancusian ethics, of simplicity, purity, smoothness, interiority and organic form are found in the Minimal and Process sculptors of the Sixties, as well as the Constructivist notion of working with materials in a 'natural' way, so that the material dictates the form the artist creates with it. Barry Flanagan has commented that sculpture works directly with materials:

> *the convention of painting has always bothered me. There always seemed to be a way of painting. With sculpture, you seemed to be working directly, with materials and with the physical world inventing your own organisations.*[7]

Andy Goldsworthy's art, needless to say, is founded on the same principles of responding spontaneously to the environment and materials.

A good example of the new sense of the sculpted object in the 1960s was Richard Serra's *Splashes* (1968, since destroyed), installed at Leo Castelli's New York gallery. With its emphasis on process and 'anti-form', *Splashes* was more like Postminimal or Process sculpture, than Minimal art. A sense of the random and immediate was central to *Splashes*, which comprised some lead that Serra splashed and poured along the join of a wall and floor. *Splashes* evoked spontaneity, waste, ephemerality and 'organic' form. It was also a work which couldn't be bought (or sold) or transported, or hung on a wall, or exhibited elsewhere.[8]

Splashes was distinctly a new kind of sculpture – it was *new* 'new sculpture', and a significant departure from the 'new sculpture' that had been heralded by Anthony Caro and David Smith:

• It didn't look like traditional sculpture, or previous sculpture (it was a splash mark on the wall and floor);

• it wasn't welded and constructed Cor-Ten steel or cast in bronze or

chiselled marble;
- it wasn't based on a clay model;
- it didn't arise from sketches or plans;
- it wasn't figurative;
- it didn't conform to traditional notions in sculpture of 'beauty', volume, form, illusion and allusion;
- the form it took was partly haphazard, and not wholly dictated by the artist;
- it wasn't placed on a pedestal;
- it could only be experienced in that particular context (it was site-specific);
- it didn't draw attention to itself (it could easily be overlooked, or mistaken for dirt);
- it wasn't permanent;
- and it could be not become another commodity in the exchange of objects in the commercial art world.

In general, Andy Goldsworthy's art is not as radical as many other contemporary artists, including Richard Serra. Probably the works of Goldsworthy's which correspond to the new way of making sculpture that Serra's *Splashes* represented are the throws and splashes, or perhaps the snowball prints, which Goldsworthy produced by allowing snowballs to melt on large sheets of paper.

Land artists work in a similar manner to the very sculptural painter Jasper Johns. Johns worked very closely with his paintings, becoming absorbed totally in the surfaces, as a critic wrote:

> when he is working, Jasper is totally concentrated on those surfaces. He lives in those surfaces. The surfaces are his whole world, they are everything. He loses himself in them. They are everything.[9]

The same could be said of Andy Goldsworthy or Wolfgang Laib: when they are working, the absorption is complete. Like a land artist, Jasper Johns wanted his materials to respond instantly to his touch: he did not want the days-long drying time of oil paint. Johns' tactile surfaces are built up using wax – the thick impasto of oil and wax is one of the keys to his textures, because when the wax cools, the artist can paint on top of it very

soon, instead of waiting for the paint to dry.[10] Johns used encaustic and oil because he wanted evidence of the gestures he made *before* and *after*, that is, a finished painting which would reveal its making. He said:

> *It was very simple. I wanted to show what had gone before in a picture, and what was done after. But if you put on a heavy brushstroke in paint, and then add another stroke, the second smears the first under the paint unless the paint is dry. And paint takes too long to dry. I didn't know what to do. Then someone suggested wax. It worked very well as soon as the wax was cool I could put on another stroke, and it would not alter the first.*[11]

These are the seemingly simple and obvious techniques and stratagems that concern artists, this dealing with such simple but important processes like drying paint. Artists are, typically, humble, and Jasper Johns here says it 'was very simple', yet it is also crucial. Land artists speak in similar terms, of keeping things simple and direct.

Minimal sculpture in its typical form was marked by the extremely hard edges, creating angular geometric, rectilinear forms (the cube was highly favoured). Suzi Gablik wrote of the Minimal artists in "Minimalism":

> *Conjugating the cube to infinity, they conveyed an impression of perfect equilibrium, and produced a visual symmetry that never deviates from its own rigidly plotted field.*[12]

Jackie Winsor made the cube one of her major forms, but she created her cubes from 'natural' materials, such as twine and wood. Winsor's cubes take the Minimal cube only as a starting point, because her series of cube sculptures are explorations of the mysteries of being. Some of Winsor's works change or decay: the *Burnt Piece* cube burnt away, alchemically, when the artist fired its interior. As with the land artists, Winsor said: 'I was unable to see how the piece would look until the moment of completion'.[13]

The new world evoked Minimal art was clean, calm, swept clean of unruliness, violence, even ambiguity. Something like an airport: white, spotless, spacious. Or a new shopping mall. A row of pristine supermarket shelves, stacked high with new cans of fruit, the labels all turned face-out (and each label screenprinted *à la* Andy Warhol). Minimal art was an art

for the 1960s and 1970s, an era of intensive commodification on a global scale, and the rising affluence in the West after the austerity of the 1950s, where mass production created a uniformity to the appearances of so much of street, home, personal, medical, transport and educational furniture (especially in Europe and America). Minimal sculpture, Barbara Rose remarked in *Art International*, looks 'machine-made, industrial, standardized, materialized or stamped out as a whole' (1964, 41). The art reflected the late capitalist, consumerist society of the time.

Other aspects of Minimal sculpture include the multiplicity of sculptural material (fluorescent lights, Plexiglas, fibreglass, Formica, chrome, plastic – many of these were relatively new materials), simplicity, surface, and the insistence on the environment and contextual space. Minimal sculptures were not set on pedestals, like Renaissance or Greek sculpture; they sit on the floor, or lean against walls (as in Robert Morris's *Floor Piece*, or Carl Andre's *Cedar Piece*). Minimal sculptures exist in the same space, on the same plane (the floor) as the viewer. They are, as Morris said, in an in-between cultural space, somewhere between being monuments and being ornaments, between being architecture and jewellery.14

In Minimal sculpture, surfaces were smooth and 'pure'. Simplicity, repetition, seriality, process, flatness were exalted, as well as volume and space. The many materials were flattened out and depersonalized. Gestures, so important to certain kinds of sculpture, such as that of Michelangelo Buonarroti (and including Andy Goldsworthy's), were suppressed. Indeed, the flatness of the surfaces, whether in the art of Robert Morris, Donald Judd, Dan Flavin, Carl Andre, Ronald Bladen or Tony Smith, is crucial. Minimal art was not 'expressive', in the modernist and traditional sense of an artist 'expressing' themselves, putting forth some aspect of their soul or inner being, or expressing their views of, or responses to, a landscape or a figure, or a subject like war or nationhood or love. Minimal and Process sculptures did not take up a subject and produce an interpretation of it. Rather, the Minimal, Process, Conceptual and ABC artists were constructing objects, or they were engaged in particular activities or experiences. The object or the experience was primary. It was an art of effects, relationships and experiences, rather than an art of making important or personal state-ments, or taking on the grand subjects of traditional art.

Some commentators called Minimal sculpture 'boring'.[15] For Peter Fuller, there is nothing 'spiritual' about Minimal art: he spoke of 'the numbing vacuity of works by artists such as Carl Andre, Agnes Martin, Ellsworth Kelly or Brice Marden' (1993, xxxv). The boringness, though, became a part of the metaphysics of Minimal sculpture, so that critic Lucy Lippard wrote in "New York Letter: Recent Sculpture as Escape":

The exciting thing about... the "cool" artists is their daring challenge of the concepts of boredom, monotony and repetition... their demonstration that intensity does not have to be melodramatic. (1966a)

And Donald Judd said about the charge of reductionism:

I object to the whole reduction idea. If my work is reductionist, it's because it doesn't have the elements that people thought should be there. But it has other elements that I like.[16]

Boring art for some is exhilarating art for others, just as erotic art for some is pornography for others. Thus, James Mellow wrote that a Donald Judd art show was 'one of the most provocative of the season',[17] while Barbara Rose described Judd's art in "Looking at American Sculpture" as 'our most radical sculpture, if not perhaps our fullest' (1965a, 34). Certainly Judd's wall reliefs and stacks are beautiful, as challenging and impressive as the greatest sculpture in the history of art. Judd combined the sensuality of industrial materials like acrylic, lacquer and aluminium with cool geometric patterns. Judd, like other Minimal sculptors, combined austerity with sensuality, producing 'minimal forms at the service of glamorous, hedonistic effects of light' (Hilton Kramer).[18] As Barbara Haskell wrote in her study of Judd:

By coupling these luxurious materials with spare forms, he exploited their inherent "language". The opposition between the inert and rigorous geometry of his forms, and the opulent hedonism and shimmering color effects of his surfaces accounted for the unexpectedly exultant lyricism of his work[19]

Donald Judd could be seen as great an artist as any of the celebrated names from the history of sculpture. At first glance, there may seem to be nothing much going on in his works (some critics have said the same of

Andy Goldsworthy), but on closer inspection, Judd's art is very varied, enormously inventive, and even deeply moving. 'I will try to have in my work only what is necessary to it', Carl Andre said (1984).

One of the triumphs of Minimal art was to make seemingly dead and uninteresting materials such as steel and plastic sensual. On 'boringness', Robert Morris wrote that sculpture is found 'boring' by those who desire 'specialness':

> Such work which has the feel and look of openness, extendibility, accessibility, publicness, repeatability, equanimity, directness, immediacy, and has been formed by clear decision rather than groping craft would seem to have a few social implications, none of which are negative. Such work would undoubtedly be boring to those who long for access to an exclusive specialness, the experience of which reassures their superior perception.[20]

Minimal artists such as Donald Judd, Robert Mangold, Sol LeWitt and Robert Morris explored the notions of 'boringness' and 'interestingness'. 'Boring art is interesting art', wrote Frances Colpitt in her excellent book on Minimalism (121). Judd, the chief explicator of Minimal æsthetics, wrote: 'I can't see how any good work can be boring or monotonous in the usual sense of those words', adding: '[a]nd no one has developed an unusual sense of them.'[21] Clearly, the Minimal sculptors thought they were making 'interesting' art. Or at least, *they* were interested in it. If art's good, it can't be 'boring', said Judd, claiming that 'a work needs only to be interesting'. The discussion of 'interesting', 'boring' and 'value' becomes a quagmire of semantics and the metaphysics of meaning. Language soon fails to describe the kinds of intentions that artists have, and the kind of responses that critics and viewers have to works (what you think is interesting some-one else will regard as dull as dishwater). Robert Mangold said 'I certainly know whether I'm interested in the work or whether I'm not interested in the work'.[22] Sol LeWitt explained his view thus:

> I wouldn't say that I wanted to like uninteresting things or to dislike interesting things. I think that's one way that you measure your response, if it interests you. 'Interests' means that it somehow makes a bridge between you and it, you and the object, you and the art object. If it hits home, it means that it's of interest. (ib., 121)

One might see Robert Ryman's white-on-white paintings as unsensual, flat, 'boring'. In fact, Ryman's paintings are very inventive and even erotic. As Ad Reinhardt painted black-on-black square canvases, so Ryman explored the mysticality of white-on-white, as the Russian artist Kasimir Malevich had done. Paintings of Ryman's such *Untitled*, a small painting by contemporary standards (53.5 inches square), or the very small *Untitled* of 1961 (12 inches square), display a sense of the tactile to rival Jasper Johns. The surfaces themselves are highly poetic, but Ryman also moved towards the state of sculpture, like Frank Stella, with his use of many different materials, from wood to steel, from fibreglass to Plexiglass, from cardboard to copper.[23]

Similarly, the grand old dame of Minimal painting, Agnes Martin, might appear to be quite 'uninteresting'. Her paintings, though, are deeply lyrical. They are, like Robert Ryman's and Ad Reinhardt's, flat squares in a human-scale (five or six foot square, for instance). They have poetic titles: *Mountain II*, *Drift of Summer* and *Night Sea*. Martin's white and off-white paintings are not all they seem at first, as with Ryman's work. They are in fact covered with a faint but strictly controlled grid, usually made with a pencil. *Night Sea* is, unusually in Martin's *œuvre*, a light blue, hinting at nature, at skies and seas. Martin's pale, painterly reductionism seems austere, but in fact poeticizes the world, as with Ryman or Brice Marden. Martin wrote:

> My paintings have neither objects, nor space, nor time, not anything – no forms. They are light, lightness, about merging, about formlessness, breaking down forms.[24]

Agnes Martin's paintings go beyond being simply pale graphs or grids made in graphite on oil paint; they shimmer, phosphoresce, they are, as Martin said, about lightness and formlessness. They embrace a physicality of light and are not 'abstract' in the sense of being 'unreal'. Rather, they are grounded in reality, in nature, as with the oil and wax panels of Brice Marden.

By limiting himself to white, Robert Ryman freed himself up for an exploration of different media: he painted in white on many kinds of material: canvas, linen, cotton, wood, paper, steel, copper, aluminium,

mylar, fibreglass, Plexiglas, cardboard, etc, and with different sorts of media: oil, baked enamel, paper, vinyl acetate emulsion, etc. As Ryman said, typically of so many postwar and contemporary artists: '[t]here is never a question of what to paint, but only how to paint'.[25] For the nay-sayers of Minimal art, that was always a problem – being more interested in the 'how' of painting rather than the 'why' or 'what'. Traditional art critics can never let subject matter go completely, can never wholly embrace abstraction or materiality. For them, even the more austerely abstract artwork must still have some connection to subject matter or to the world in some form.

It would be harder perhaps to see Sol LeWitt's cuboid, mathematical, Conceptual sculpture as sensual in the traditional sense (compared to a statue by Gianlorenzo Bernini, say). LeWitt's rectilinear objects – open-framed cubes painted white – seem to be the antithesis of sensual art.[26] His art is all about ideas – the initial idea, the conception, is everything. As LeWitt said: 'all of the planning and decisions are made beforehand and the execution is a perfunctory affair. The idea becomes a machine that makes the art.'[27] Much of contemporary sculpture from WW2 onwards consists of hard-edged cubes or rectangular slabs. Whether this use of such stark mathematical forms as cubes is rational or intuitive, it takes a scientific, numerical approach to art to extremes. The idea, Donald Judd wrote, is to simply do 'the next thing': 'one thing after another'. It is a strategy that is not called a strategy, a systemless system. Of Frank Stella's paintings, Judd wrote that the 'order is not rationalistic and underlying, but is simply order, like that of continuity, one thing after another.'[28] The notions of Minimal art – seriality, succession, progression, repetition, permutation – have been around for a long time. Leonardo da Vinci, one might say, painted the same picture in different ways, often abandoning projects before completion, while J.M.W. Turner seemed to be painting the same sky, viewing it from thousands of different viewpoints and different locations, from every coastline, riverbank and mountainside thru Britain, to France, Switzerland, Italy and Germany.

But, whether the system is serial or modular, whether there is progression or simply repetition, the notion of Donald Judd's – of 'doing the next thing' and 'one thing after another' – explains so much of Minimal art, and

contemporary art. It explains so much of Judd's work, for instance, those ladders or stacks of forms ascending to the ceiling in bronze or plastic or Plexiglas, and those long lines of curved shapes like crenellations set on a wall, each sprayed with Harley Davidson motorcycle paint. It also describes how artists simply go on making work, as variations, or repetitions, or progressions, like Mark Rothko with his many canvases that explore different combinations of purple or yellow clouds floating on oceans of red or blue, or Ad Reinhardt's seemingly repetitious but actually methodical explorations of five foot square black canvases (and also how Andy Goldsworthy will continue to make the same sort of artwork time after time: *another* cairn, *another* serpent, *another* wall, *another* lines of leaves). Minimal ethics can produce some extremes of mathematics and seriality.

Carl Andre's *37 Pieces of Work* is a good example of Minimal æsthetic permutations taken to extremes:

Taken as a whole 37 Pieces of Work *consists of 1,296 plates, 216 each of aluminium, copper, steel, magnesium, lead and zinc [wrote David Bourdon in* Carl Andre: Sculpture, 1959-1977*]. Each metal appears alone in individual six-foot square plains. Then alternates with another, checkerboard fashion, in every possible permutation. Since each of the six metals in the large piece was laid out in the alphabetical order of its chemical symbol, alternating successively with the others, there are two versions of each combination.*[29]

Some viewers might see this strand of Minimal, Conceptual or mathe-matical art as too abstract, too unreal, too dry and clinical. But critics such as Robert Rosenblum claimed that Conceptual art can be 'awesome'. Of Sol LeWitt's art, Rosenblum wrote that it

elicits... an immediate awe that... has to be translated by the same feeble words – beautiful, elegant, exhilarating – that we use to register similar experiences with earlier art.[30]

Carl Andre said his art 'has never been conceptual in any way'.[31]

One might see Minimal sculpture as so 'cool' and reductionist it's lifeless. Yet, despite the profusion of smooth white surfaces, which evoke clinics, malls, airports and hospitals, there is much sensuality in Minimal sculpture. Carl Andre's works are extremely sensuous, with their shiny or dull surfaces of copper, zinc, steel or aluminium. Andre's *Sixteenth Copper Cardinal*

(1976, Saatchi, London), sixteen square copper slabs, was a work that could be described as luscious. Viewers are used to marble and stone being beautiful, and to certain metals – bronze, silver and gold in particular have been central to sculpture for millennia. Why not zinc, aluminium and copper, too? Andre, like other Minimal artists, introduces viewers to the sensuality of copper, bronze, aluminium and zinc shaped into nothing more than... a simple shape, like a square slab, put on the floor. Andre's tiles are not 'narrative', mythological or anthropomorphic; they do not 'depict' animals or gods or people or stories; but they are no less beautiful, as objects in their own right. Spectators are invited to walk on his sculptures, offering a new relation with the work (Andre's one of the few contemporary artists who encourages that). Minimal art followed the oft-used tenet that 'less is more', or as Andre put it, 'minimal' means to me only the greatest economy in attaining the greatest ends' (ibid.).

In Minimal sculpture, the object and its 'objecthood' is primary. As sculptor William Tucker wrote of the Minimal era, it 'is the matter-of-fact 'objectness' of sculpture that has become in recent years its prime feature.'[32] The notion of 'objecthood' or 'objectness' is problematic, theoretically and artistically, for the world is full of objects, it is a continuum of objects. As critics have noted, much of what makes sculpture sculpture is that the object is contextualized, physically as well as æsthetically, culturally and psychologically, as a sculpture. Context is crucial, as the philosopher Julia Kristeva said, for context carries so much meaning. Thus, a pile of bricks on a building site is... a pile of bricks. A pile of bricks in an art gallery is... sculpture. This is what Carl Andre explored. The response, affected by so much of culture, socialization, physical context, education, etc, makes objects sculptures. As Garth Evans wrote in "Sculpture and Reality" (1969):

> What happens to a sculpture is determined largely by factors outside of itself. The fact of its being thought of as a sculpture is more critical to its existence, its life, than any other facts about it. This is a fundamental distinction between objects and sculpture[33]

Artists of the 20th century have explored this area between 'everyday' or 'ordinary' 'objects' and the 'art object' (and they continue to do so) –

Marcel Duchamp with his ready-mades, Kurt Schwitters' multi-media pieces, and, later, Jasper Johns and Robert Rauschenberg, who jammed objects onto their paintings and further explored the blurred region between painting and sculpture.

The materiality, the presence of the work of sculpture in the world [said Carl Andre], essentially independent of any single individual, but rather the residue of many individuals and the dream, the experience of the sea, the trees and the stones – I'm interested in that kind of essential thing.[34]

Minimal sculpture is certainly austere – 'cool', as some critics call it. It is very ascetic, restrained, flat, exact, with its smooth surfaces and precise square edges and angles. The body seems to have been erased from this 'cool' Minimal art. There is no space for the body, and the spectator is also 'erased', in some way. The ruthless asceticism of Minimal art denies, like early Christian theology, the body. Critic Rosalind Krauss wrote in *Passages in Modern Sculpture*:

The art of [Rodin and Brancusi] represented a relocation of the point of origin of the body's meaning – from its inner core to its surface – a radical act of decentring that would include the space to which the body appeared and the time of its appearing. What I have been arguing is that the sculpture of our time continues this project of decentring through a vocabulary of form that is radically abstract. The abstractness of Minimalism makes it less easy to recognize the human body in those works and therefore less easy to project ourselves into the space of that sculpture with all of our settled prejudices left intact. Yet our bodies and our experience of our bodies continue to be the subject of this sculpture – even when a work is made of several hundred tons of earth. (279)

The spectator can see the body written into, say, Andy Goldsworthy's delicate leaf sculptures, or Constantin Brancusi's extraordinary egg shapes, with their organic forms, but not, perhaps, in the giganticism of Michael Heizer's *Double Negative* or the Christos' *Wrapped Islands*. Yet, even here, the human body is present – if only by the way it is violently dwarfed by the scale of Heizer's famous earthwork (actually, the best way to experience Heizer's *Double Negative* is physically, with the body, by walking around and inside it). Much of earth art is vast, like Heizer's art. As Carl Andre said:

I once described the change in sculpture in the 20th century as moving in its concerns from form to structure and now having a concern with place... I believe now you can make sculpture you can enter.[35]

4

Spirit of Place in Land Art

I have always paid great attention to natural forms, such as bones, shells, and pebbles, etc. Sometimes for several years running I have been to the same part of the seashore – but each year a new shape of pebble has caught my eye, which the year before, though it was there in hundreds, I never saw. Out of the millions of pebbles passed in walking along the shore, I choose out to see with excitement only those which fit in with my existing form-interest at the time.

Henry Moore, "The Sculptor Speaks"[1]

...it is an intensely spiritual affair I have with nature: a relationship.

Andy Goldsworthy[2]

For the land artist, the whole planet is potentially an artist's studio. The land artist ranges over the whole globe. A desert, a beach, a field, a forest or a patch of waste ground can become a studio, a place of creative activity, a place where something can happen, or where something can be explored. The landscape itself is crucial in land art. That's obvious. Or is it? This means everything about a landscape, every detail of it: the very texture and colour and shape and dampness and springiness and strength and size of moss, for instance. Or a stone. Or a crevice in a rock formation. The way the light falls on a patch of grass, the little tufts of dead, yellowish grass on top of the newer, green grass. Redwood tree cones, closed-up. The sound the breeze in a pine forest compared to beech or oak. Flowers turning sunward in the late afternoon. The history of a place, its social uses, the layers of human interaction. Its accessibility. Its weather. These are the things land artists deal with in making art. These are the actualities they employ when they create artworks. To fully appreciate land art, then, one has to look really closely, to grasp the details, as well as the overall conception. This is true of Andy Goldsworthy's sculptures, as well as the larger American earthworks (where detail and nuance is still critical). Again, the *making* of the work (which the public does not see, and is not invited to participate in), consumes so much of the artist's energy (the practical challenges of making art outdoors), and the artist's interest.

For British artist David Nash, land art is close up, not distanced:

> The term "landscape" is like "portrait". It is an expression of a distancing: here I am and there it is. But what has been happening in the last twenty years or so is that artists have been getting right in there. Saying no, it is not out there. It is here. We want to make our images with what is here – here. That is why it is called land art rather than landscape art, "scape" denoting distancing.[1]

For David Nash, land art was about getting as close as possible to the natural world: the land artist does not interact with the natural world like the painter, by painting nature, at a distance, with a paintbrush or watercolour block in front of her/ him, at a distance. For the land art, the painter's sketchpad or easel is a wall between artist and world. The land

artist, rather, dives in, 'gets right in there', as Nash said. The land artist does not use oil or pastel or ink to 'represent' nature. S/he doesn't want meditation, barriers, veils, between her/ himself and her/ his subject. S/he doesn't want to create an illusion or representation or simulation of the natural world. Rather, she or he works directly with the natural world, getting her/ his fingers dirty with mud, snow, sheep droppings, stone, ferns, wood.

It is exactly the same with poetry. Poets have long written of nature in close-up, of the tiny details that go to make up an accurate (as well as lyrical or personal) description of the natural world. Land art can be seen as the sculptural equivalent, in one sense, of nature poetry, so that land artists like Alan Sonfist, Peter Hutchinson, Nancy Holt, Alice Aycock and Andy Goldsworthy are the inheritors of poets such as Matsuo Basho, Francesco Petrarch, Robert Frost, Emily Dickinson, Pablo Neruda, Rainer Maria Rilke and Aleksandr Pushkin. The nature poem itself is a piece of 'land art', a work evoking or representing or describing or situated in particular places. ('The sculpture that I do,' said David Nash, 'is appropriate to a particular place and it stays in that place. It is made from and for that place' [in ib., 22]). (And poems are sometimes seen in the contemporary era as con- cretely or literally physical objects in their own right, which can exert a tactile, sensual force on the reader akin to a 'real' physical object like a sculpture. In other words, a poem may be regarded as having a physio- logical as well as cultural effect, just like a sculpted object).

Land artists, like nature poets and nature mystics, are inspired by particular places. Richard Long opined: 'places gives me the energy for ideas'.[2] Nature poets, like religious mystics or land artists (or like all artists), can be described as 'following their bliss' (Joseph Campbell's term). When you follow your bliss 'you come to bliss'.[3] Joseph Campbell used the model or metaphor of following the 'pollen path' of the Navaho Indians. As Campbell described it:

> *The Navaho have that wonderful image of what they call the pollen path. Pollen is the life source. The pollen path is the path to the centre. The Navaho say, "Oh, beauty before me, beauty behind me, beauty to the right of me, beauty to the left of me, beauty above me, beauty below me, I'm on the pollen path".*[4]

This is one way of imagining the creative journey – towards the centre, the life source. In this mythical view, Paradise, the Golden Age, Eden, Shangri-la, was not back there then, but it is now. 'Eden *is*...this is it, this is Eden' (ib.). Paradise can only be now. There is no other time or place it can possibly be. The journey, whether physical, psychic, spiritual or imaginary, is along the *feng shui,* the 'dragon lines', ley lines, or along the 'songlines' or 'dream tracks' of the Australian aborigines, or the 'pollen paths' of the Navaho Indians.5

Where people live is both local and universal, both particular to the individual and particular to everyone. The path snaking around the hill outside that town in Iowa, Peru or India, say, where one ran and danced in childhood, is both a very particular place, with particular kinds of shadows and plants, and also a universal path, like all other paths. Mircea Eliade (who is another Jungian, like Joseph Campbell), wrote of regaining what he called the 'mythic centre', which is the spiritual core of one's life. For Eliade, the regaining of this mythic centre was spatial. That is, it pivoted around particular places: in *Ordeal By Labyrinth*, Eliade wrote:

> *Wherever one is, there is a* center of the world. *As long as you are in that center, you are at home, you are truly in the real self and at the center of the cosmos. Exile helps you to understand that the world is never foreign to you once you have a central stance in it...* (100)

For Mircea Eliade, sacred acts automatically create a 'mythic centre'. As art is a sacred act, the creation of an artwork can be seen as the creation of a sacred place or mythic centre. The piece of earth art (the boulder, hole, pillar, stone circle) are obvious forms of a mythic centre. Making land art (and making any art) can be seen as a sacramental experience – essentially one of a sacralization of life and living things. It is like the Australian Bushmen's *alchuringa* experience, the mythic dreamtime and *participation mystique* with the earth and with life. In the *alchuringa* concept of the Australian aborigines the world is sung into existence (a notion also found in Western mythology, in Western Creation myths, in Western occultism, in the 'music of the spheres' of hermetic philosophy).6 As the German poet Rainer Maria Rilke put it in his *Sonnets To Orpheus* (1922), 'song is existence', where art is life itself, and making art is not a commentary

'about' life, but is life itself.[7] This notion of art equals life (a continuum between the two, so that they are inseparable), is very much the foundation of land art, and Andy Goldsworthy's art.

Andy Goldsworthy says: '[m]y art will always be a reflection of my way of life.'[8] Brilliant late 1960s sculptor Eva Hesse spoke in Romantic, emotional terms of her art, employing words such as 'essence' and 'soul'. She talked about of wanting to emphasize 'soul or presence or whatever you want to call it.' Although Goldsworthy is not as openly emotional in his descriptions of his art, these words of Hesse's could apply, with some minor revisions, to many land artists' works:

> I think art is a total thing. A total person giving a contribution. It is an essence, a soul... In my soul art and life are inseparable.[9]

The 'sacred' or the 'mythic' aspect does not have to be extraordinary. Ordinary things can be the inspirations of sacrality, the mythical and the ecstatic. Things such as moss on a wall, or the feel of wood, or the colour of a particular patch of sky. Artists such as Leonardo da Vinci show viewers that the 'ordinary' is really extraordinary (think of Leonardo's fabulous drawings of a sprig of oak, a lily, a rain storm). The Cornish poet Peter Redgrove put it like this to me:

> ...this 'strangeness' is 'strange' because reality is so fucking extraordinary, and strange too because most of us try to live without strangeness, and construct something called the 'ordinary' which never existed. Actually, the strangeness is so ordinary as to be quite natural. The strangeness is wonder and what is wondered at is so wonderful that it is strange we do not wonder more.[10]

What happens is that these tiny sensations and feelings are sidelined, displaced, forgotten, suppressed and ignored by society, by popular culture. Hardly anyone speaks of such minute feelings, because they seem to be 'unimportant'. Poets such as Arthur Rimbaud, Marina Tsvetayeva, Louise Labé, Aphra Behn and Novalis show viewers that these sensualities are important. They don't seem to add up to much, as John Cowper Powys said in his *Autobiography*, yet they are crucial to poetic living.

Marcel Proust knew that a ray of sunshine could lift the spirits, and for John Cowper Powys, simply by seeing the sun on a wall one could have

nothing less than a 'Beatific Vision'.11 Nature poetry (and similarly land art) veers between the sensualism of the pastoral view of life, as created in the bucolic poetry of ancient poets Theocritus and Virgil, and a more intense pantheism as found in mystics such as Meister Eckhart and Jacob Boehme. The Elizabethan and Renaissance British poets (Edmund Spenser, William Shakespeare, Michael Drayton, Samuel Daniel and others) were particularly fervent about nature. Sir Philip Sidney wrote: '[o] sweet woods, the delight of solitariness!'.12 Robert Herrick devoted much of his poetic life to eulogizing his beloved Devonshire countryside (Goldsworthy's works made around South-West Scotland can be seen as a sculptural equivalent of the pæans that Herrick wrote to Devon). Later, the Metaphysical poets (John Donne, George Herbert, Richard Crashaw, Henry Vaughan), refined the fusion of nature mysticism and (Christian) spirituality, and the Romantic poets (William Wordsworth, Samuel Taylor Coleridge, Percy Bysshe Shelley, John Keats) went even further. Unlike the world of Classical pastoral verse, land art is not populated with images of satyrs, sylphs, Pan-figures, shepherds, shepherdesses and magicians, but many of the same feelings and experiences about the natural world resonate throughout land art.

DEUS LOCI IN LITERATURE AND LAND ART 4.2

Of the many writers who have explored the 'spirit of place', two of the most interesting were British authors Lawrence Durrell and D.H. Lawrence. Lawrence Durrell's notion of landscape or 'spirit of place' (or *deus loci*) was defined thus: 'I firmly believe in the theory that landscape shapes people and behaviour patterns'.1 For Durrell, landscape was one of guiding principles or forces that humans must respond to.2 For Durrell, 'man is only an extension of the spirit of place'.3 In Durrell's most famous work, *The Alexandria Quartet*, a exploration of 'modern love' set in the Egyptian city in the mid-20th century, the narratives are controlled by the city, so that the narrator of the books says '[w]e are the children of our landscape; it

dictates our behaviour and even thought' (ib., 36).

Lawrence Durrell developed D.H. Lawrence's 'spirit of place',[4] mixing it with Sigmund Freud and Oswald Spengler, folklore, and amateur anthropology. Lawrence employed landscape as a setting and a symbol: he did not choose landscapes simply for their 'beauty'. The settings of Lawrence's fictions add much to their impact and value. The snowy countryside of the short story "Wintry Peacock", for example, is central to its theme (it wouldn't be the same story in High Summer, for instance). The environs of Eastwood in Nottinghamshire (the English Midlands), lovingly evoked in *Sons and Lovers* and *The Rainbow,* form so much of the impact of the novels. As with *Wuthering Heights, War and Peace, Germinal* or *Tess of the d'Urbervilles,* one couldn't take away the settings without altering much of the meaning. Lawrence Durrell wrote in *Justine*:

> *As a poet of historic consciousness I suppose I am bound to see landscape as a field dominated by the human wish – tortured into farms and hamlets, ploughed into cities. A landscape scribbled with the signatures of men and epochs. Now, however, I am beginning to believe that the wish is inherited from the site; that man depends for the furniture of the will upon his location in place, tenant of fruitful acres or a perverted wood.* (1963, 100)

Land art gains much of its power from particular places. Most land artists, for instance, work away from densely populated zones. Some, like Michael Heizer, Chris Drury and Walter de Maria, work in what are regarded as 'exotic' locations – deserts and mountains (the American desert was probably the primary site for land in its golden age – there are legal, logistic, practical and social as well as artistic reasons). The glamour of the locations aids the sculptures. Some land art is overpowered by the Romantic settings. Some of Richard Long's stone circles, for instance, look feeble in their desert or snowscape locations.

Lawrence Durrell's fiction was set in and was an expression of what is now called the 'post-colonial' world. It's an epoch in which 'ethnic', 'national', cultural and racial boundaries are dissolving, producing uncertainty and anxiety. The upside of this post-colonial world is the ease with which artists such as Andy Goldsworthy, James Turrell, Carl Andre and others jet around the world. Land art (like Western art in general) is very much the product of the privileged, relatively wealthy First World, a world in

which the Northern hemisphere is dominant over the Southern; American-Eurocentric ethics prevail; bourgeois/ 'imperialist' ideology predominates; and the 'colour' of the art is definitely white. Though 'post-colonial', land art is distinctly not 'politically correct' when it comes to issues of ethnicity or economy (although there is a strain of land art that engages with political, economic and ecological issues).

Any number of (travel) writers (Bruce Chatwin, Paul Theroux, Julia Kristeva, V.S. Naipaul, Colin Thubron) have explored the dislocation of a contemporary, post-colonial world. The narrators of their fictions, like land artists themselves, are exiles, ex-pats, colonials, 'castaways', 'displaced persons', 'migrants'. Kristeva has written eloquently of the sense of exile and displacement that is so common these days (where everyone is a stranger, she says). While land art is about 'centring' oneself in a particular place, in contemporary fiction the sense of displacement is paramount.

In a key text, the essay "Landscape and Character", Lawrence Durrell spoke of being a 'residence writer', that is, someone who lives in a place not as a tourist or visitor (travel writers usually distance themselves from tourists and the tourist trade).[5] This is the opposite of Richard Long's and Hamish Fulton's desire, which is to pass through the world 'invisibly'. Fulton declines to make any mark on the world as he moves through it, except footprints. 'The natural environment was not built by man and for this reason it is to me deeply mysterious and religious'.[6] As with Long, Fulton rarely includes images of people in his art. Fulton separates the walk from the artwork.

Andy Goldsworthy likes both philosophies – to create ephemeral art-works, and not make a lasting mark on the world, but also to be an artist in residence, getting to know an environment over many years (indeed, when Goldsworthy visits a new place, one of the first things he says he does it to make a work there; it's his way of getting to know it. True, but that's what artists do – they make things). Areas like Dumfriesshire (Scotland) or Digne (France), the two places with the highest concentration of Goldsworthy artworks, possess many marks of the artist. Some are more 'permanent' or durable than others, but many have endured. (When we say the highest concentration of Goldsworthy's sculptures, we don't mean you could visit those places and expect to find Goldsworthy's art everywhere:

you'd still have to hunt it out, and know where to look. And only one or two works in those areas are open to the public).

THE ALCHEMY OF MATTER 4.3

Nature poetry is an ancient form of poetry: from Greek bucolic verse, epic Homeric poetry and ancient world mythologies onwards, poets have written of the natural world. Land art and land artists seem to have much in common with Romantic art and Romantic artists, in which the natural world was eulogized. The marks of late 18th/ early 19th century European Romanticism included: exalting nature; going to extremes; the cult of solitude; infinity; the predominance of subjectivity; the sublime, and so on. Post-WW2 and contemporary artists (such as Mark Rothko, David Inshaw, Thérèse Oulton, Robert Smithson and Andy Goldsworthy) express some of the elements of Romanticism cited above. The cult of solitude, for instance – as found in the work of writers like Ralph Waldo Emerson, Johann Wolfgang von Goethe, Henry Thoreau, Jean-Jacques Rousseau and Friedrich Hölderlin – is a part of contemporary art. Art in the modern era exalts the subjectivity and sovereignty of the artist creating on her/ his own (many land artists work alone, including Goldsworthy). R.W. Emerson wrote of the ecstasy of being alone in nature:

> *The lover of nature is he whose inward and outward senses are still truly adjusted to each other... His intercourse with heaven and earth becomes part of his daily food. In the presence of nature a wild delight runs through the man in spite of real sorrows.*[1]

Land art in its grander moments echoes the gestures of High Romant-icism – the Blakean, Hölderlinian, Goethean, Turnerian gestures – which have become so familiar in Western art of the past 200 years. One of the apotheoses of High Romanticism is Johann Wolfgang von Goethe's novel *The Sorrows of Young Werther*, where the soul alone actualizes the myriad

things of nature. In this passage from Goethe's volume one can see similarities with the more opulent moments in the land art of Andy Goldsworthy, Robert Smithson and James Turrell:

> Ah, to view this vast landscape from there! Oh, distance is like the future: before our souls lies an entire and dusky vastness which overwhelms our feelings as it overwhelms our eyes, and ah! we long to surrender the whole of our being, and be filled with all the joy of one single, immense, magnificent emotion.[2]

The 'Goldsworthy Sublime' includes works such as *Touching North* at the North Pole, the Durham maze, *Montréal Arch* and the stone walls (such as the *Storm King Wall*). The nature poet uses the same emotional/ cultural stuff as the land artist: the human relationship with nature. Whatever it is that the poet writes about or the land artist constructs, it is the *feeling* for the natural realm that is absolutely central, the relation between self and nature, that is employed by both poet and land artist. As Clement Greenberg, the foremost critic of postwar art in America, wrote: '[a]rt is a matter strictly of experience, not of principles', a statement which chimes with the views of Goldsworthy, Hamish Fulton, Alice Aycock, Chris Drury, James Turrell *et al*, for whom *experience* is primary.[3] Subjectivity is primary: the art must please the artist first, before anyone else.[4] Much of the time, the land artist is the only audience of the work anyway, when it's being made, before it disappears. The land artist is often the only person to experience the work in the flesh and *in situ* (everybody else has to make do with a photograph or a written text. And a photo or a text ain't the same as an experience).

Some poets regard poems themselves as physical things that affect people, just as land art is a physical thing (a stone, soil, ice, grass, leaves) that affects people. When Walter de Maria filled a gallery with soil (in 1977, later re-made – you can see it now at DIA in New York), the sensual aspects of work (smell, taste, touch, sight, sound) were crucial. Similarly, when John Keats, Walt Whitman or Arseny Tarkovsky describe a place (even its soil, perhaps), they employ synæsthetic means, in order to make the poem itself a physiological experience. As Ted Hughes wrote (in *Poetry in the Making*):

The value of [some] poems is that they are better, in some ways, than actual landscapes. The feelings that come over us confusedly and fleetingly when we are actually in the places, are concentrated and purified and intensified in these poems. (80)

Among novelists, it is John Cowper Powys who has captured more accurately than most the synæsthetic experiences of life, where so many tiny and seemingly ordinary and inconsequential sensations fuse into illumination. Powys wrote about landscape in a way wholly in tune with land artists such as Andy Goldsworthy, Patricia Johansen, Lothar Baumgarten and the Harrisons. One extract from Powys's *Autobiography* (1934), which is one long record of ecstasies and sensations, serves to introduce his highly charged, eidetic, pellucid way of seeing. The author has been out walking and is returning to Cambridge with his walking stick:

What I am revealing to you now is the deepest and most essential secret of my life. My thoughts were lost in my sensations; and my sensations were of a kind so difficult to describe that I could write a volume upon them and still not really have put them down. But the field-dung upon my boots, the ditch-mud plastered thick, with little bits of dead grass in it, against the turned-up ends of my trousers, the feel of my oak-stick "Sacred" whose every indentation and corrugation and curve I knew as well as those on my hand, the salty taste of half-dried sweat upon my lips, the delicious swollenness of my fingers, the sullen sweet weariness of my legs, the indescribable happiness of my calm, dazed, lulled, wind-drugged, air-drunk spirit, were all, after their kind, a sort of thinking, though of exactly what, it would be very hard for me to explain.[5]

Germano Celant, one of the key theorists of *Arte Povera*, likened the sculptor and land artist to an alchemist:

The artist-alchemist organizes living and vegetable matter into magic things, working to discover the root of things, in order to re-find them and extol them... What interests him... is the discovery, the exposition, the insurrection of the magic and marvellous value of natural elements. (1969)

The *Arte Povera*-type artist-alchemist uses simple, natural elements, said Germano Celant: copper, zinc, earth, water, snow, fire, grass, air, stone, gravity, growth. He rediscovers the magic of the world, its composition, growth, precariousness, falseness, reality (1969).

At the same time he rediscovers his interest in himself. He abandons linguistic intervention in order to live hazardously in an uncertain space... his availability to all is total. He accumulates continuously desire and lack of desire, choice and lack of choice. (1969)

The *Arte Povera* artist works with life, within life, Germano Celant said, discovering the 'finite and infinite moments of life', art as life, 'the explosion of the individual dimension as an æsthetic and feeling communion with nature'; making art becomes identical with living: '[t]o create art, then, one identifies with life and to exist takes on the meaning of re-inventing at every moment a new fantasy, pattern of behaviour, æstheticism, etc. of one's own life'. Celant quoted from John Cage: '[a]rt comes from a kind of experimental condition in which one experiments with the living'. What counts is to live the work, Celant said, to be open to the world, 'to be available to all the facts of life (death, illogic, madness, casualness, nature, infinite, real, unreal, symbiosis)' (1969).

AMERICAN EARTH ARTISTS 4.4

If he'd been American, Andrew Goldsworthy mused, his art would have probably developed differently. American earth art for Goldsworthy tended towards conflict, division, and the pioneering spirit (W, 11). Goldsworthy remarked that he got to know the American earth artists first (at college), and found out about Richard Long and the British land art tradition later (*Wall*, 14).

For Robert Smithson (1938-73) – chief mouthpiece of earth/ site æsthetics – Carl Andre, Walter de Maria, Michael Heizer, Dennis Oppenheim and Tony Smith were 'the more compelling artists today, concerned with 'Place' or 'Site".[1] Smithson used one of the primary forms of land art, the circle, in many works, combining it with ideas taken from science (such as in his *Gyro-stasis*, which, said Smithson, 'refers to a branch of physics that deals with rotating bodies' [ib., 37]). Smithson was not adverse to religious

feelings about art: when he visited the site of his *Spiral Jetty* (1969-70), in the Utah salt flats (a favourite destination for land artists), he experienced a feeling of 'a rotary that enclosed itself in an immense roundness' (ib., 111). The two elements – rational, mathematical, scientific precision, and intuitive, emotional, religious feeling – are two of the chief characteristics of earth-works art. On the one hand, land artists talk about measurements, practical details, transport, materials, maps and spatial data. On the other hand, they hint at religious awe, spiritual feelings, prehistoric art and the influx of the numinous into modern art. As Andy Goldsworthy said, '[a]lthough it is often a practical and physical art, it is also an intensely spiritual affair that I have with nature: a relationship.'[2] Goldsworthy admitted to a 'deep sense of spirituality', but said 'it doesn't manifest itself in any sort of religion'.[3]

Land artworks have proved to be the most arrogant, phallic and patriarchal of contemporary art's output, seen from a green, feminist or liberal viewpoint.[4] Christo and his wife Jeanne-Claude wrap buildings and bridges, stretch curtains across valleys and surround islands, and in Michael Heizer's *Double Negative* (1969-70) two chunks were cut out of the earth, a gigantic cut in the planet, in ecological or green terms.[5] *Double Negative* is a widely celebrated example of earthwork art. Photos of it have been reproduced in many art history books. *Double Negative* appeals to trendy 1960s notions of Zen Buddhism, Existentialism, negativity and emptiness. Heizer's other works include gouging huge holes in the ground and putting great chunks of rock or pieces of wood in them, and 'drawing' in the desert with a motorcycle.

Walter de Maria made a similarly deep mark in the Earth when he cut a 4.5 mile-long 'drawing' in the desert in Nevada. The ultimate in ithyphallic, masculinist land art of the heroic, grandiose type must be de Maria's *Vertical Earth Kilometer* (1977). At a cost of $500,000, the former drummer with the Velvet Underground and his team bored a hole in the ground and sunk a one kilometre brass rod vertically down it. Nothing can be seen of it now except a 2 inch brass disc on the ground. The making of de Maria's is perhaps far more interesting than the artwork itself. It could be the ultimate art statement/ non-statement. Whereas the Christos made huge gestures everyone could see, with their plastic-covered buildings (such

as the Reichstag or a Roman gateway), or their wrapped Pont Neuf or curtains hanging across Colorado valleys, de Maria's *Vertical Earth Kilometer* remained virtually invisible. It neatly melded two 1960s æsthetic movements: Conceptualism (what a cool idea, sticking a kilometer of brass into the Earth!) and Minimalism (there's nothing to see of it except... a two-inch brass disc!). Is this real art, a kilometer-long piece of metal stuck into the ground with nothing of it showing except a tiny disc? This is, in Richard Long's words, '[t]rue capitalist art', an art of excessive cost, and maybe excessive waste (it took 79 days to bore the shaft). But then, art has been full of idiotic amounts of money for eons.

What about the Christos' wrappings? They cost a bomb, for sure (but, as Christo said, he pays for them himself, with money made from selling smaller works and exhibitions). The Christos' *Running Fence* (1972-76) cost $2.5 million; *The Umbrellas* (1984-91) in Japan and California, cost $26,000,000. Christo remarked that his art 'has to do with things that are very simple'.6 This definition can also apply to Andy Goldsworthy's art, too, in which ordinary or simple things are transformed.

When these transformations of the commonplace cost so much, and require 200 rock climbers and years of planning, as the Christos' covering of the Reichstag in Berlin needed in 1995, then commentators wonder about the 'importance' or 'value' of such artistic productions. There is something 'right' and 'homely' about Andy Goldsworthy and his couple of stonewaller helpers building a wall in the Northern wildernesses of Britain. They toil away in true grimy, stalwart, craftsman style. But there's something cynical and obscene for detractors about American artists like Michael Heizer or Walter de Maria carving great gashes in the American landscape, or the Christos creating artworks that cost 26 million dollars yet only last for two weeks. Surely that money would be better spent? (How about a hospital? Or on feeding people in poverty?) Surely artworks that cost millions of dollars but only 'benefit' a (relatively) tiny amount of people are wasteful? Isn't famine relief a better alternative? Perhaps one could make famine relief, earthquake relief, medical supplies, housing, and other 'charity' and 'aid' projects, an art event? Perhaps if Christo spent 26 million dollars on providing food and shelter for the needy of building wells for clean water in Africa instead of wrapping a building in Berlin in a bit of plastic, people

would not be so angry? When artists spend such vast amounts of money on art, it's no wonder people find this obscene. But then, if spending millions of dollars on art were outlawed, there'd be no Hollywood, no movie industry, no television, no entertainment industry, no insurance industry, no sports industry, no leisure industry, no grand projects. These are the hypocrisies and ambiguities that surround art. How can one 'justify' a $26 million Christo wrapping? Or a typical Hollywood feature film (cost: $45 million, with a typical advertizing budget of $5-10 million)?

Incredible as Walter de Maria's *Lightning Field* is, or the Christos' wrapped coasts and islands, far stranger and wilder are the constructions of modern science. The gigantic particle accelerators, for instance, where quarks, strangeness and charms are examined, are truly mind-boggling structures. 'Only by battering streams of other particles together in giant underground accelerators has it been possible to generate the energies necessary to create these elusive entities', wrote Robin McKie.[7] The Large Hadron Collider (built 1998-2008), is a 17-mile tunnel deep underground in Switzerland. These particle accelerators go far beyond most land art in creating sheer astonishment. Not the least amazing aspect about these circular tunnels is that they are so large, using gigantic machines set in caverns. The ironic thing is that such massive scientific equipment is being used to explore... the tiniest, invisible objects, the most mysterious things in the New Physics: atoms, quarks, strangeness, charms, Higgs' bosons, neutrons and protons. If the Christos' artworks cost a lot – 26 million dollars or whatever – this is chickenfeed next to scientific and military experiments, which cost billions of dollars. The Large Hadron Collider, for instance, swallowed $1.5 billion.

Andy Goldsworthy had not come anywhere near the mega-budget earthworks of Walter de Maria, Michael Heizer or Christo until the late Nineties, when he undertook the *Sheepfolds* project (1996-), which had a high budget of about $480,000; and the *Garden of Stone* Holocaust memorial in Gotham (2003), which cost around a million bucks. Most of the time, Goldsworthy's art is not particularly expensive to produce: if Goldsworthy is building a small leaf sculpture near his studio in Penpont, Dumfriesshire, the costs wouldn't be too much. (Ignoring the later costs of exhibitions, printing and framing, and day-to-day overheads and admin,

the sculpture would consist of a few leaves, which are free, and the artist taking some photographs. So not massive amounts, really).

Although it may appear that land artists tour the whole globe making art, they actually stick to a small number of countries (tending towards the Northern hemisphere, and the 'First', Western world). For instance, there are few major land artists who have made significant work in Africa, or large parts of South America, or mainland China, or Russia. There are few Western land artworks in Egypt, for instance (perhaps because the competition is pretty fierce there from some of the most wonderful structures humans have ever made – the tombs, temples, cities and pyramids of ancient Egyptians. Of course, there are also social, political, cultural and ideological reasons for the lack of major land art in Islamic and Middle Eastern territories). Europe's a favourite location, but not Eastern Europe. Favourite places tend to be America and Western Europe, obviously, and Japan, and occasionally Australia. Occasionally also India (if it's India, it's usually the scenic parts to the North, in Nepal or the Himalayas). But even in America, birthplace and chief centre of land art, artworks tend to be clustered around the East (New York, Washington, DC, Chicago), the South-West (New Mexico, Arizona), the Mid-West (Colorado), or California.

JAMES TURRELL AND ANDY GOLDSWORTHY 4.5

One of the largest earthwork projects is James Turrell's (b. 1943) *Roden Crater Project,* a series of tunnels and chambers in an extinct volcano near Flagstaff, Arizona. Begun in 1974, it was funded by many different sources and administered by the Skystone Foundation.1 The first stage of Turrell's on-going *Roden Crater* project involved bulldozing 200,000 cubic yards of earth from the volcano's rim, 'so as to shape the sky'. Turrell planned tunnels, pools and viewing chambers at *Roden Crater* There were spaces where clouds were projected onto the floor during the day, which at night were related to the procession of equinoxes. Many of the spaces planned at

Roden Crater were built around celestial events, such as full moons, solstices, equinoxes, the movement of the sun, or just being able to view stars and some planets. The connection with the heavens was important for Turrell: most of his works have openings to the sky, and the relationship with the sky is the centrepiece of the works. It's important for Turrell, in short, *to see the stars*.

Similarly, Andy Goldsworthy works with light much more often than one might think. Like James Turrell, Goldsworthy had constructed works for nighttime, for moonlight, for sunrises and sunsets. But, unlike Nancy Holt or James Turrell, Goldsworthy has not yet built sculptures for particular constellations of stars, or the planets, or celestial events such as equinoxes. He has, though, celebrated Midsummer solstices in installations, and the process of moving from an old year to a new year. And the cycle of the seasons, of course, is absolutely fundamental to Goldsworthy's art.

The *Roden Crater* installations of James Turrell were about the relationship between the viewer and the elements, in particular the sky, celestial events, and light. Turrell said:

My art is made for one person. I like the solitary experience. Standing alone at night, perceiving the Roden Crater and the moon and stars, you really feel the vastness of the universe and yourself entering into it.[2]

The environment was a volcano, relating to geological time.

The work I do intensifies the experience of light by isolating it and occluding all other light [Turrell explained]. Each space essentially looks to a different portion of sky and accepts a limited number of events. (1995, 67).

Thus, each space at *Roden Crater* was designed to highlight some celestial event. The subject of some spaces was the vaulting of the sky, and the curvature of the Earth. Some were about daily events, such as sunrises and sunsets, or the movement of the stars.

The North section of *Roden Crater* is about looking North, the North Star (the land artists' favourite star by far), the rotation of the Earth, changing light, includes a *camera obscura* (which projects whatever is overhead onto a white sand floor), and a seat for viewing Polaris. The Eastern space is for witnessing sunrise, with a 'skyspace' overhead. *Bath Space* projects a

magnified image of the sky above onto a white sand floor, using a water bath above a large sphere as a lens. The *Sun and Moon Room* was constructed around the furthest south moonset (every 18.61 years), the furthest North sunrise and the Summer solstice. *Tso Kiva* is a hemispherical space in the centre of the volcano, for observing light, shadows, shapes and the horizon. The *South Space* is an astronomical observatory and star chart. The *West Space*, as one would expect, is for the sunset, and the 'twilight arch', the projection of the Earth's shadow into the atmosphere at nightfall. James Turrell said he didn't want Roden Crater to be 'a mark upon Nature, but to be enfolded in Nature in such a way that light from the Sun, Moon, and stars empowered the spaces' (1995, 66).

James Turrell's creative task as he saw it was not to impose his own vision or æsthetics on the viewer, but to encourage them to see things for themselves, to create the situation in which they could have their own experience. These were æsthetics common in much of land art. As he said in 1987, the goal was not to turn an experience into art, but

> to set up a situation to which I take you and let you see. It becomes your experience... not taking from nature as much as placing you in contact with it.[3]

James Turrell regarded his art as a 'seeing aid', as showing the observer something that was already there but that they might not have noticed. On the indoor-outdoor debate, which exercised so many land artists, Turrell said that, instead of bringing nature into the museum, the wanted to 'bring culture to the natural surround as if designing a garden or tending a land-scape' (1995, 66). The artwork became something to visit in itself, rather than one of many artworks in a museum to see. The viewer travelled specially to see the artwork, as they visited *Double Negative*, Donald Judd's Marfa in Texas, or Robert Smithson's earthworks.

James Turrell's primary material was not earth or stone or the usual materials of land art, but light itself, what he called 'light in the space itself'. Turrell wanted to use light as a thing-in-itself, which had presence, just as the sculptor used a physical object which had presence. He achieved this, he said, by setting limits on the space in which light manifested itself: 'I give light thingness by putting limits on it in a formal manner. I do not

create an object, only objectified perception' (1995, 65). Turrell was attempting to create spaces in which viewers could perceive the subject of his works, light itself, and celestial events. It was important also for Turrell that the viewer was able to enter those spaces physically, not virtually. Turrell's art was not about creating illusions or artificial scenarios or a record of the artwork. Turrell called it 'non-vicarious seeing': '[t]he subject of my work is your nonvicarious seeing. You are not looking at a record of my seeing' (1995, 64). Thus, Turrell's art was not about recording some event that took place elsewhere, or taking photographs of his art, or writing down what happened, as in some land art. Rather, Turrell wanted to place the viewer right into the artwork, to have them able to walk into and around the artwork, and to experience of the artwork for themselves.

Many of James Turrell's pieces were about working with not just light, but with the sky. The archetypal Turrell space was an enclosed area (a 'skyspace') which had an opening above onto the sky. Turrell spoke of the vaulting of the sky, how the sky looked when the viewer was standing up, or sitting down, or lying down.

Some of James Turrell's 'skyspaces' – indoor rooms or spaces which are open to the sky above – include *Spaces That Sees* (1992) in Jerusalem, *Heavy Water* (1992, Poitier) and *Razor* (1991, London). Turrell has also constructed pools of water which combine water and light: in these works (at *Roden Crater*, Poitier, France), the viewer is invited to dive under the water to reach a space beyond which's open to the sky.

James Turrell emphasized the spiritual aspects of light in his land art. 'I am interested in light because of my interest in our spiritual nature and the things that empower us. My art deals with light itself, the bearer of revelation, but as revelation itself' (1995, 64). The kind of effect Turrell was after in his light works he compared to staring into a fire, a kind of meditation or daydreaming. Turrell encouraged the viewer to sit or lie down and contemplate light itself, and the effects of light in a particular space. Thus, the spaces that Turrell constructed were furnished with viewing platforms, or benches, or places to lie down and look up at the sky. Situating the spectator in relation to the subject of the artwork (light itself) was Turrell's goal. 'My desire is to set up a situation to which I can take you and let you see. It becomes your experience' (1995, 77).

As well as drifting off by looking at a fire, Turrell also often spoke of the experience of flight, of being in a plane and rising into new zones of light, different kinds of light. Turrell also spoke of the curvature of the Earth when seen from a plane (and how, between 600 and 3,000 feet, the Earth seems to curve the wrong way). The Roden volcano was chosen partly because of its relation at that particular place in the Painted Desert to the curvature of the Earth. The low mound of the volcano and its relation to the curvature of the Earth and the sky above had the right mixture of components Turrell was seeking.

ANDY GOLDSWORTHY AND CONCEPTUAL ART 4.6

Land art is intimately connected to Conceptual art (and is partly an off-shoot of Conceptual art). It never wholly escapes its basis in Conceptual art. Much of land art exists only in photographs, memories, words – texts which are not the land art itself, but the record of it (in some cases, they are the artwork). 'Seen and unseen works have equal importance', remarked Richard Long (IC 1, 5). One of the hallmarks of the 'ideal Conceptual work', as critic and artist Mel Bochner commented, is 'an exact linguistic correlative, that is, it could be described and experienced in its data and it could be infinitely repeatable'.[1] Land art is often Conceptual art: the Christos' *Running Fence*, Dennis Oppenheim's *Time Line* and many of Andy Goldsworthy's leaf, stone, snow, mud and clay sculptures, exist now only as photographs, catalogues, memories and – Heaven forfend! – art criticism.[2]

By contrast, James Turrell wanted to place the viewer right in the midst of his artworks, so they could experience directly the subject of his art (such as light, the sky, solstices, equinoxes, celestial events and the curvature of the Earth) for themselves. It was important for Turrell that his art wasn't a *record* or a photograph of something that happened *elsewhere*, that the viewer hadn't seen or couldn't see for themselves. He wasn't creating an illusion of a record of something he had experienced; instead, he

encouraged the viewer to have the experience for themselves. Thus, at *Roden Crater*, Turrell constructed spaces that the spectator could enter physically, to experience light, stars, planets and the sky directly.

Earthwork art is meta-art, art about art, art that often relies on other art to 'exist'. Much of land art lasts but a brief moment, then becomes legend, gossip, photography, drawings, maps, words. Many of the works of Richard Long and Hamish Fulton are simply collections of words, printed in capitals, in Eric Gill's font, Gill Sans, on large pieces of paper (then framed). One of Long's works can be printed here, and this text here will be very close to being a Richard Long artwork in itself (although he likes them printed larger). Thus:

A FOUR DAY WALK

A LINE OF GROUND 94 MILES LONG

ROAD STONY TRACK ROAD GRASS FIELD
ROAD BARE ROCK LANE ROAD STONY PATH
HEATHER BURNT MOOR STONY PATH ROAD
ROUGH GRASSLAND RIVERBED SHEEPTRACKS EARTH WALL
ROUGH GRASSLAND GRASS FIELDS BRAMBLES GRASS FIELD
PATH ROAD DUSTY LANE
ROAD GRASS FIELDS EARTH PATH ROAD
SAND BEACH CLIFF PATH ROAD ROCKS
CLIFF PATH SAND DUNES SAND PATH EARTH PATH
ROAD OLD RAILWAY TRACK MUD FLATS SEA WALL
MUD FLATS ROAD RIVERBANK ROAD

ENGLAND 1980

Well, that's a Richard Long artwork right there. Entirely? Yes. It seems as if Long has nothing much to say. Well, he is a sculptor, so he wouldn't (necessarily) be so good at writing or speaking. Wrong. He's a land artist (though he dislikes the term 'land art'), and land artists are always much concerned with writing and written texts. An Andy Goldsworthy exhibition, for instance, features written texts on display, and plenty of photographs, as well as installation works and sculptures. The 2005 London show, for example (at Albion in Battersea), had some very large installations, and

sculptures in wooden display cases, but also a few groups of colour photographs).

<center>❀</center>

Andy Goldsworthy tended to add a few pages of his own writing to his art books, which mainly consisted of colour photographs of his artworks. In one or two books, such as *Time, Midsummer Snowballs* and *Arch,* Goldsworthy wrote considerably longer pieces. In *Time,* for instance, there are about 50 pages of writing by Goldsworthy.

The texts of land artists also draw on poetry, the kind of (mainly modernist) poetry sometimes termed 'concrete' or 'visual poetry' or 'typewriter art'. Richard Long, for instance, prints his laconic texts in circles (*Full Moon Circle of Ground,* 1983), or in concentric circles (*Three Moors, Three Circles,* 1982), or in vertical lines, as in trendy style magazines (*The Isle of Wight as Six Walks,* 1982), or in curved swathes of text (*A Moved Line in Japan,* 1983).

American Conceptual artist Lawrence Weiner (b. 1942) produced text works, capital letters on a wall or in a book, like Hamish Fulton, Barbara Kruger, Art & Language, Hans Haacke and many Conceptual artists. Weiner's solution to making sculpture was that a sculpture on a plinth has to be 'translated' into language, so that people can understand it. Sculpture is language, and words are language, therefore, Weiner reckoned, words themselves can be sculpture:

> when you see a piece of wood lying on the ground with a piece of stone on top of it, you must translate that in your own head into language. What I try to do is present language itself as a key to what sculpture is about... It is a presentation of a piece of sculpture in language.[3]

Like the text pieces of Barbara Kruger, Hamish Fulton, John Baldessari and Sophie Calle, Lawrence Weiner produced works comprising capital letters in short phrases on walls which are about a viewer's relationship with an object. The words were a means or the expression of a relationship with something.

THINGS PUSHED DOWN TO THE BOTTOM AND
PUSHED UP AGAIN

The above is a typical Lawrence Weiner artwork. Richard Long commented that '[t]he discovery [Weiner] made that art does not necessarily have to be made, that was a great breakthrough' (IC 2, 24). Weiner was right, of course: words alone can be sculpture, for poets have long known that language is an experience, not simply abstractions or concepts. Language really does affect people – otherwise why would they spend so much time speaking, writing, communicating – and consuming language? That is, they consume 25-40 hours of broadcasting per week (in the Western world) – that's over a day and a half spent consuming television and radio per week. So the words on a gallery wall of Weiner, Calle, Baldessari, Haacke and Fulton don't seem at first to be 'art'. They are not sensual and graspable in the physical realm, like a marble statue. Yet those words, whether photocopied on cheap paper or printed in high quality typography and lithography on deluxe paper, or painted onto the wall, are 'art', they are communication, language – even sculpture.

LAND ART AS ART-ABOUT ART 4.7

In the photographs of land art, spectators not offered a *range* of view-points of a work, although land artists clearly take more than one shot of each work they make. No artist takes just *one* photo out of a 36 exposure 35mm film or one digital image out of hundreds on a digital or video camera. No: an artist, like an photographer, takes a range of shots, at different, bracketed exposures, from different viewpoints, with different lenses or focal lengths (much as the trendy director of TV commercials of today shoots twelve hours of footage for just one thirty second advert).[1]

Andy Goldsworthy, for example, typically takes shots of his sculptures from different angles: a close-up, which is about the artist's subjective rela-tionship with his work – taken from just a few feet away. Then there is a second, more 'objective' view, showing the sculpture as the independent observer might see it. This second photograph shows the work in its

environment, which is crucial. Goldsworthy's photos are a mix of these two viewpoints, the subjective and objective: often the most powerful shots are not the close-up images, showing the detail in the sculpture, but the distant views (a snowball in the branches of an oak tree; a stone arch beside a highway). Each land artist, then, must select this or that viewpoint, behind this bush or next to that tree.

The land artist is therefore also a photographer, selecting views, re-framing their works, making choices about lighting, angles, lenses, film stock, composition, exposure, colour, contrast, scale, size, paper, etc. Land artists will make decisions about exactly *when* to photograph their work. Some pieces are ephemeral, and last only moments, so the photograph must be taken immediately (but even when a sculpture lasts only a few seconds or minutes, there are still choices about which moment to capture – a second or two either way could make a big difference). Other land artworks, such as the *Storm King Wall* or *Leadgate Maze* of Andy Goldsworthy or Nancy Holt's *Star-Crossed* (1981), last longer. The land artist as photographer can therefore wait for a certain combination of sunlight and clouds. This is particularly crucial in perennially cloudy places like Britain, where lighting can vary so dramatically over a few minutes. As anyone who has been in, say, Snowdonia or Dartmoor during low pressure weather will know, the sunlight can burst through the clouds at one moment, then a moment later there'll be dark, sombre clouds, looking as if it's going to rain. A moment later, it *will* rain, and afterwards, facing away from the sun, one might see a rainbow. Much of the world's weather is this changeable, so every land art photograph is a highly selective and subjective view of a particular place.

Another critical aspect of photographing land art is not only deciding what to *in*clude, but choosing what to *ex*clude from the composition. Visiting a land artwork in the flesh, an observer can see it from all sorts of angles, with all sorts of backgrounds, in all sorts of conditions. Knowing a land artwork only from a photograph, the spectator knows only *that* particular viewpoint, and no others. The land artist will take great care in framing the images, to show the artwork from the best vantage points. Many aspects of the surroundings might be elided from the final published photographs – an apartment block, a row of cars, trash, people, power

cables, and so on.

Land artists must also oversee the journey of the films or images they've shot from development through printing to framing. As anyone who has taken a photo will know, all manner of details can affect how one reads a photograph: how it is printed, light, dark, soft, hard, cropped, full frame, more red, more blue, burnt in, dodged, touched up, glossy or matt paper, etc. The size of the photo affects it very much, as does the frame. Go into any picture framer's store and one'll see a plethora of different types of frame. All these things the viewer might take in at one glance in a gallery, but the artist has to make decisions all the time about all these matters, and many more (the viewer is probably not aware of countless details in the journey of the work from conception to presentation, the trials and errors, the countless iterations, before the final result is achieved). Land artists and sculptors, then, must be accomplished photographers. Their work must be a high standard, for it is exhibited in high art locations, such as the city gallery, or glossy coffee table art books.

In land art, the commentary, the written records, the obsessive documentation, is just as important as the artwork itself.[2] Often, it *is* the artwork. The land artist's life becomes part of the artwork. The American sculptor David Smith spoke of this consuming aspect of sculpture, where the artist lives and breathes art.[3] But most land artists record their activities ('walk this morning; made a snow sculpture; it wasn't successful; back home for lunch'). Ultimately, *any* activity can be land art. Going to the stores can be a piece of art. One might drop a stone on the path as one goes, or perhaps not. Either way, one's just made a work of art. Is, then, walking to the deli for a pint of milk and a pack of Marlboro a fully accomplished and thoroughly authentic work of art, like Richard Long's *A Straight Northward Walk Across Dartmoor*? Where does authenticity end and artifice begin? Or, rather, where does life end and art begin? Clearly, they are a continuum in land art.

Richard Long told me that '[n]ot all walking is art', that is, a walk becomes art when it is conceived as art. The conception of the walk, made before the walk, is crucial, even if there is no 'reason' at all for the walk. 'A walk, and place, can be chosen for any reason.'[4] Long also said, though, that '[a]nything an artist makes, is art', but added '[n]ot everyone is an

artist.'5

The relation between outdoor and indoor works, between stone cairns in some remote zone and a stone cairn in a Western gallery, is resolved simply in Andy Goldsworthy's art by being regarded by the artist as a continuum. It can be seen how for Goldsworthy both indoor and outdoor works are one, i.e., part of the same thing. But the viewer might see them as separate, because the viewer (usually) can't see Goldsworthy's outdoor pieces (Richard Long, for instance, likes to keep his locations secret and anonymous [IC 1, 1]). The viewer only knows Goldsworthy's outdoor pieces from his photos. So it's always an odd relationship with Goldsworthy's work for the viewer. For the artist, it's great, because the big photos and writings relate to his own experiences, of working outdoors. He knows the work inside out: *he lived it*. The viewer, though, gets a different experience: s/he sees odd phrases, titles, dates, measurements. Odd snippets of info. Or photos.

So people love Andy Goldsworthy's work not because they love the photographs, or his writing. They love it, perhaps, because of *what it suggests*. Goldsworthy's art persuades people to look outwards, away from cities and suburbs, towards the landscape, towards stones and water and hillsides and all the rest of it. Perhaps that's why people enjoy it, and other land art, and nature poetry, and all things to with nature, from gardening and walking the dog to vacations in wildernesses. The outdoor work itself isn't present in Goldsworthy's text or photos. The work isn't 'in' the gallery. No, the work is *elsewhere*, and it is to that *elsewhere place* that people want to go. Land art creates *desire* in viewers, as the work of J.M.W. Turner or Ursula K. Le Guin creates desire – for travel, for other places. Richard Long spoke in a Santa Fe interview of feeling refreshed and renewed after a good walk: that's the experience, perhaps, that viewers wish to gain from land art, from all art.

Land art, then, whether by Alice Aycock, Kazuo Shiraga, Chris Drury, the Christos or Andy Goldsworthy, is part of a postmodern trend in self-reflexivity, the *mise-en-âbyme* commentary so familiar now. Art about (the artist's) life. It's found not only in the postmodern literature of the 1950s and 1960s, but also in the fiction of, say, André Gide. Gide's novel *The Counterfeiters* (1925) is a key text in this respect: the main character

(Edouard) is, of course, a novelist. But Edouard is more interested not in the novel he's trying to write, but in his book about the writing of his novel. Thus, the diary/ journal of the work becomes more important than the work itself; and the act of *writing about* the art becomes more important than *making* the artwork itself. Indeed, so crucial was the 'making of' the book *The Counterfeiters* to Gide that he published a book after *The Counter-feiters*, called precisely that, *The Journal of The Counterfeiters* (although he swore he'd never do that, despising artists 'explaining' their works). Land artists, like Conceptual and Process artists, steer clear of 'explaining' their works.

Many of André Gide's concerns are also those of the land artists. For, as he lived his life, Gide was conscious of *how he would write it up later*. When something extraordinary occurred, Gide would be thinking about it as an account in his journal. After living, for Gide, comes making art. Like the readymade sculptures of Marcel Duchamp, Gide's *The Counterfeiters* destroys the diegetic effect of fiction, its naturalism and suspension of disbelief. Like Jean-Luc Godard's movies and Andy Warhol's paintings, Gide's art is self-reflexive art, a Pop Art æsthetic forty years before Pop Art.

When Marcel Duchamp and Kurt Schwitters put 'real' objects into the gallery, they did so because it seemed a natural thing to do. Schwitters explained how he came to do it:

> I simply could not see any reason why old streetcar tickets, driftwood, coat checks, wire and wheel parts, buttons, junk from the attic and heaps of refuse should not be used as material for paintings, any less than colours made in a factory.[6]

It's the same with land artists: why not, they say, have an art made out of found objects, stones found on a remote path, or leaves. The use of ordinary objects in land art ushers in a new sense of the object in sculpture, a new way of looking at art (what critic Michael Fried called 'objecthood'). The 'real' objects and readymades of Marcel Duchamp and Kurt Schwitters were developed by Robert Rauschenberg and Jasper Johns, among others. The stuck-on objects in Rauschenberg's and Johns' paintings render them very different from traditional painting. Johns explained why he used 'real objects' stuck onto his paintings: '[m]y thinking is perhaps dependent on a

realization of a thing as being the real thing... I like what I see to be real, or to be my idea of what is real'.7

Easy to see how Jasper Johns' dictum applies directly to land art: Andy Goldsworthy, James Turrell and the Harrisons also like what they see to be real, to be the object in and of itself (the 'thing-in-itself' of Existentialism, or Rainer Maria Rilke's *Kunstding*, 'thing of art'). They too dislike illusionism. For Goldsworthy (and other land artists), sculpture doesn't 'symbolize' or 'represent' nature, it *is* nature. As Johns said: 'I find it more interesting to use a real fork as painting than it is to use painting as a real fork.' Similarly, one can see how, for Goldsworthy, Jan Dibbets, Alice Aycock, Nancy Holt, Michelle Stuart, etc, it's much more interesting to use a stone as a stone rather than as a representation of something else. Robert Smithson's definition of an earthwork applies here: 'instead of putting a work of art on some land, some land is put into a work of art'.8 Smithson's ethic applies directly to Goldsworthy's art.

SCALE AND GENDER 4.8

There's no denying the sensuality and eroticism of land art and earthworks. Walter de Maria filled a gallery with black soil (1977, DIA), and the effect is undoubtedly sensual. More spectacular (and with plenty of masculinist and phallic connotations with male creativity, sperm, fire, power and shamanism) was de Maria's *Lightning Field* (1977), a grid of 400 stainless steel poles, each about 20 feet high, set in the New Mexico desert.1 The sheer size of some of the works of land artists is itself visceral and erotic; the scale envelops the viewer's body and senses. The observer's invited to enter and explore land artworks, such as Alice Aycock's underground rooms and tunnels. De Maria's *Lightning Field* is so large it attracts lightning, and a storm is among the most visceral phenomenon in nature.2 Joseph Beuys produced a startling piece entitled *Lightning* (1982-85): a gigantic chunk of bronze, narrow at the top, splaying out towards the bottom, as if he was

trying to make manifest the bolt of energy leaping down to the Earth. Justin Holland too used lightning in artworks; he collaborated with Westinghouse Electric, making humanmade lightning, and 'seeded' clouds to produce storms. Peter Hutchinson created a cloud piece (*Dissolving Clouds*, 1970) using Hatha yoga meditation techniques, trying to dissolve clouds through thought. The work consisted of a sequence of 6 photographs of clouds. Alice Aycock made a *Cloud Piece* (1971), photographs of cumulus clouds which melted after a few minutes. Hans Haacke constructed fog-making sculptures (*Fog, Flooding, Erosion*, 1969), while Robert Morris made *Steam* pieces (1974).

Many poets have written of the eroticism of the natural world, among them Johann Wolfgang von Goethe, Dante Alighieri, Friedrich Hölderlin, Aleksandr Pushkin, Arthur Rimbaud, and Emilys Brontë and Dickinson. In many pieces, Cornish poet Peter Redgrove wrote of the sensualism of nature, thunderstorms being particular favourite natural phenomena. This is from Redgrove's poem 'The Pale Brows of Lightning':

> *And lightning opens its shutter but an instant,*
> *When it catches you burn like a candle,*
> *What is that lambent shadow fluttering into the woods*
> *In its own blue light that illuminates primrose*
> *The ripped tree's flesh?*[3]

Robert Smithson's famous *Spiral Jetty* (which Andy Goldsworthy admired), is another 'monumental' earthwork, though the use of the spiral motif has connotations with 'feminine', non-phallic discourses (the spiral is an ancient symbol of Goddesses).[4] Of his *Spiral Jetty*, Smithson wrote:

> *As I looked at the site, it reverberated out to the horizons only to suggest an immobile cyclone while flickering light made the entire landscape appear to quake. A dormant earthquake spread into an immense roundness. From that gyrating space emerged the possibility of the Spiral Jetty. No idea, no concepts, no systems, no structures, no abstractions could hold themselves together in the actuality of that phenomenological evidence.*[5]

Not all of 'land' or 'earth' art is phallic and bombastic. Richard Long perhaps spoke for many British sculptors when he wrote:

*In the sixties there was a feeling that art need not be a production line of more objects to fill the world. My interest was in a more thoughtful view of art and nature, making art both visible and invisible, using ideas, walking, stones, tracks, water, time, etc, in a flexible way... It was the antithesis of so-called American "Land Art," where an artist needed money to be an artist, to buy real estate to claim possession of the land, and to wield machinery. True capitalist art.*6

Although British land artists may despise the amounts of money spent by the American earthwork artists (Richard Long, for instance, leant towards Italian *Arte Povera*), they also part of '[t]rue capitalist art'. Don't they also live off (their) art? Don't they also wander around the planet making works, putting a few stones into a pile here, scratching a hole in the soil there, and taking a photo of their (to many, seemingly slight) efforts ('slight' compared to gruelling labour like cleaning out restrooms in downtown Sao Paolo or Seoul, or tending the ill and maimed in Bosnia/ Cambodia/ Afghanistan/ Iraq/ Ethiopia)? Of course British artists Andy Goldsworthy, David Nash, Bill Woodrow, Alison Wilding, Richard Long, Damien Hirst, Tracey Emin *et al* are also a part of the capitalist art world, the business of buying and selling. Don't their artworks sell for lots of money, a lot more money than the materials cost, or the amount of work expended to make them? Isn't the British artist being hypocritical when s/he criticizes the arrogant, 'commercial' aspects of (American) land art when s/he also benefits from the hugely over-priced art world, where even mundane works can be sold for hundreds of thousands of dollars? If art is bought and sold or traded, it's automatically part of the capitalist system. And British artists like Richard Long are also deeply embroiled with advanced capitalism, using technology like air travel, photography, communications and the internet to create and sell their works.

The circle motif, one of the primal symbols of eternity, cycles, time, rebirth, etc, is employed throughout the work of land artists, including Andy Goldsworthy's output. The circle shape itself speaks of organic forms, time, change, cycles, seasons, stars, astronomy, origins, and, in some religions, evokes the 'feminine' and the Goddess. Sculptors and land artists who have made the circle crucial to their works include: Alison Wilding, Barbara Hepworth, Richard Long, Mary Miss, Stephen Cox, Robert Morris, Dennis Oppenheim and Goldsworthy (it's very difficult to completely get away from the circle, like the square or rectangle). Goldsworthy's hollow globes, snowballs and spiralling walls can seem gentler, more eco-friendly kinds of sculpture than the brasher, bigger American earthworks. Land art based on circles is vast; it includes Vijali's *World Wheel* (1987), Alan Sonfist's *Circles of Life* (1987), Charles Jencks' *Snail Mound* (1992-94), Stan Herd's *The Circle* (1992) and Mel Chin's *Revival Field* (1993). Many of Nancy Holt's works are circular: *Annual Ring* (1981), *30 Below* (1980), and *Sun Tunnels* (1976).

Donald Judd produced two circular steel bands, 180 inches in diameter, as well as a concrete circular 'wall'. Carl Andre's *Glarus Copper Galaxy* (1995) was a copper band spiral. Michael Heizer 'drew' circles lines in the Nevada desert (but not with his fingers!): *Circular Surface Planar Displacement Drawing* (1970). In Dennis Oppenheim's *Annual Rings* (1968), concentric circles were carved in the snow at the U.S.A.-Canadian border. Robert Morris produced gigantic circular works, such as his *Observatory* (1971) in the Netherlands, which is a huge earthwork recalling the megalithic structures of ancient times, such as Britain's Avebury stone circle. Morris's *Labyrinth* (1974) is a maze-size sculpture, the kind of maze one finds in theme parks, zoos and country houses, except that Morris's *Labyrinth* used the ancient pattern of the Cretan labyrinth, itself a motif some critics and feminists see as distinctly 'feminine', evoking Goddess mysteries. Herbert Bayer's *Mill Creek Canyon Earthworks* (1979-82) is a series of earthworks recalling ancient monuments.

Robert Smithson's *Closed Mirror Square* (1969) is like an Aztec ziggurat, while his *Amarillo Ramp* (1973) recalled the massive embankments found

at Neolithic earthworks in Great Britain such as Maiden Castle, or Iron Age hill forts such as British Camp on the Malvern Hills.[1] Some land artists have produced stone circles which look very much like Stonehenge (or are recreations of Stonehenge), such as Nancy Holt's monumental *Stone Enclosure: Rock Rings* (1977-78). These contemporary (Minimal) sculptures are ambivalently related to ancient monuments, however, as Samuel Wagstaff remarked of Tony Smith's works:

> They are related to early cultures intentionally or through sympathy – menhirs, earth mounds, cairns... [and] to this culture with equal sym-pathy – smoke-stacks, gas tanks, dump trucks, poured concrete ramps.[2]

Land artists, then, consciously or slyly invoke ancient, prehistoric monu-ments. Michael Heizer, Roberts Smithson and Morris, Nancy Holt and others made references to ancient earthworks. Anthony Gormley likened his *Angel of the North* site in Northern Britain to a burial mound. Richard Long's walks often took him through landscapes rich in megaliths, such as the South-West of Britain. There are over nine hundred stone circles in the British Isles, a fact which surprised Richard Long when I told him ('900...? That's an amazing fact I did not know').[3] Long too has made connections with prehistoric art in terms of manufacture: the cave paintings at Lascaux, Long said, were made by people's hands on the rock. 'And my work is just the same as that. It is very positive, very exciting that I am part of the continuation of...' (IC 2, 24). Long has referred to some of the key sacred and prehistoric sites of Britain in his art: to Silbury Hill, apparently the largest ancient humanmade mound in Europe, so the textbooks say; to the ithyphallic Cerne Giant earthwork in Dorset; to Glastonbury Tor, mecca for hippies, occultists, travellers and 'New Age' devotees; and to Windmill Hill (near Stonehenge). Long even put a picture of himself with his rucksack in Africa right next to one of the famous ancient hill figures of England, the 'Long Man of Wilmington', a 231 foot tall hill figure in Sussex. This is one of those historic sites that some see as being an alien, or St Paul, or a Roman emperor, or King Harold. Long ironically compared himself with another 'Long' Man.[4]

Locations such as Silbury Hill and Glastonbury in Great Britain have long been revered by people as holy sites, 'places of power' as they are called.

Richard Long capitalized on the mystery of such places. One of his works was a walk between two prime magical centres of Britain, Stonehenge and Glastonbury, both deeply associated with prehistoric astronomy, ancient priesthoods, Arthurian legend, Merlin the Magician, the Age of Aquarius, ley lines, Druids, geomancy, etc:

ON MIDSUMMER'S DAY
A WESTWARD WALK
FROM STONEHENGE AT SUNRISE
TO GLASTONBURY BY SUNSET
FORTY FIVE MILES FOLLOWING THE DAY[5]

The photograph that accompanies this text is the sort of picture postcard view one finds in bookstores, information centres and heritage centres around the United Kingdom: Glastonbury Tor at sunset. Like St Paul's Cathedral, the Tower of London, Big Ben, Buckingham Palace, Beefeaters, the Changing of the Guard, red buses and telephone boxes, this is one of the archetypal images of Britain. And, typically, it is Glastonbury Tor that Long chooses to photograph, not the stores nearby, the electricity poles, the trash heaps behind the highways, the rows of garages and sheds, the housing estates.

Richard Long maintained that his stone circles were subjective, private, individual works, quite different from the public, social art of the prehistoric stones circles.[6] Andy Goldsworthy would probably make similar assertions of the secular, non-religious individuality of his artworks (Goldsworthy's artistic statements assert spirituality, but of a personal, vaguely pantheistic, non-institutional kind; Goldsworthy doesn't evoke Britain's prehistoric culture nearly as much as other land artists).

Britain's ancient stone rings were made by a group of people, a society, constructed, perhaps, according to the plans and organization of a priestly élite. The circles of land artists are the work (usually) of one person, but a major contemporary artist is no less a member of the cultural, æsthetic élite. Prehistoric stone circles may have been built for religious rituals, perhaps connected with the position of certain astronomical bodies. The

circles in stone, soil, snow, dandelions, trees and concrete of land art are made for private consumption, for the artist alone, or for an onlooker who wanders into a gallery then out again, back into the chaos of the city, or for groups of people to visit in public spaces. Yet the ancient sacred sites and Postminimal earthworks have much in common, because art and religion join at so many points (as they did 5,000 years ago, and as they do now).

Land artists benefit from the allusions to ancient monuments, because the atmosphere and magic of prehistoric stones rubs off on their own work. In stressing the importance of megaliths, menhirs, dolmen and burial mounds, land artists not-so-subtly imply a continuity between themselves and these prehistoric relics. The æsthetic continuity that's emphasized also implies religious affinities. Thus, the land artist is the contemporary equivalent of the priests and hieratic sects who created Stonehenge, the lines in Peru, the Pyramids, and Australian aborigine 'songlines'. A spirituality is affirmed in land art, which only a few land artists actually speak about. But this religious feeling is definitely there, definitely a part of the discourse of Richard Long, Michael Heizer, James Turrell, Robert Smithson, Nancy Holt and Andy Goldsworthy (the lines at Nazca seem to be evoked in the cuts and trenches that Walter de Maria and Heizer carved in the deserts of Nevada and California).

Not every critic exalts land art as spiritual; for some critics, it's a spurious and even offensive link. Brit critic Peter Fuller, who advocated a distinctly *British* form of modern painting, saw spiritual bankruptcy in land art. Fuller was angry that Richard Long had been invited to exhibit work in Lincoln Cathedral.[7] The idea that a Conceptual artist like Richard Long might sully the building beloved of John Ruskin, Nikolaus Pevsner and D.H. Lawrence, one of the finest English cathedrals, outraged Fuller. But surely Fuller was missing the point with Long, whose art is clearly as mystical, as in awe, as deep in its feeling for nature as Fuller's cherished artists – Cecil Collins, Henry Moore, J.M.W. Turner or Patrick Heron.

Uncomfortable as they are with notions of 'spirituality' or 'mysticism', land artists such as Andy Goldsworthy, James Turrell and Chris Drury are also religious artists, sensitive to the emanations of particular places. Goldsworthy often speaks in awed tones about nature's 'energies', and

Richard Long concedes that 'art is magical', as of course it is.[8] Land art, like all art, is full of deep emotions. These emotions collect in clusters around certain places, 'special places' ,as Long called them. It is understandable, then, that critics and the public see these emotions as potentially religious.

> *Well, sacred I suppose has particular religious meanings and my work is not about religion [Long explained]. Probably a special place would be a better word. I suppose, sacred really means a place of intense feelings. If you think of religion as being about intense feelings and emotions, art can be close to religion.* (ibid.)

Andy Goldsworthy, Constantin Brancusi, Bill Woodrow and many sculptors have spoken of the importance of materials in their work, how they learn from their materials, and 'follow' their materials. Tony Cragg spoke of 'works in which I learnt from the materials'.[9] A stone is not merely a stone for land artists: it has its own essence, its own form and presence.

> *Nothing could convince Brancusi that a rock was only a fragment of inert matter* [wrote Mircea Eliade]; *like his Carpathian ancestors, like all neolithic men, he sensed a presence in the rock, a power, an "intention" that one can only call "sacred."*[10]

Andy Goldsworthy has commented in similar tones of stones. In his 1993 book *Stone*, he speaks of a boulder 'charging a place with its presence', with time flowing around it and in it, like the sea (82).

The land artist has a special, fetishistic relation with her/ his materials: they are not simply bits of matter to be wielded in a particular way. They are treated with respect. Wolfgang Laib dusted the Earth with pollen, to form an enormous square layer of brilliant yellow. The delicacy – and potency – of the sculpture is immediately apparent. This is the sort of sculpture that exerts a synæsthetic power over the gallery-goer: the pollen affects not only the visual sense with its incandescent hues, but also affects smell, taste and touch. Goldsworthy, Laib and Drury collect leaves, berries, pollen, honey and other natural elements and weave sensuous artifacts that are ephemeral and intricate.

Dennis Oppenheim worked with snow and circles in his *Annual Rings* (a series of concentric circles that straddled the Canadian/ American border),

and with burning circles onto grass in his *Branded Mountain*, and again with snow and ice in *Accumulation Cut* (1969), made with a chain saw in Ithaca, New York. In fact, Oppenheim was the first land artist to work with snow on a grand scale. Oppenheim was making snow works in the late Sixties, years before Andy Goldsworthy (when Goldsworthy was only twelve).

TREES 4.10

Many sculptors and land artists have worked with trees as well as Andy Goldsworthy: David Nash, Giuseppi Penone, Jackie Winsor, Alan Sonfist, Harvey Fite, Peter Walker and Mel Chin. Using trees means working within a long and celebrated religious and cultural tradition.[1] For example, trees have since time immemorial been associated with spirits and religions. The Greeks believed that trees had spirits; there were the apples of immortality and trees of eternal life; Daphne turned into a tree when pursued by Zeus; Actaeon was turned into a stag in the forest when he spied Diana bathing nude; deities such as Athena, Artemis, Dionysus, Apollo, Orpheus and Cybele are associated with trees and woods. The Celts worshipped trees, and the Germanic tribes had mystical relations with trees. The Druids revered the oak, the royal tree of ancient England, and had rituals that involved oaks and mistletoe. The oak (a favourite Goldsworthy tree) was sacred to Jupiter, Hercules, the Dagda, Thor, Jehovah, Allah and other gods in their 'thunder-god' mode. Trees were associated with secret languages and religious symbolism. Fire festivals are in particular linked with trees – burning wood is central to many land artworks: there were the bonfires at the Celtic fire festivals (such as Samhain, or Hallowe'en, a fire festival inaugurating the beginning of the Celtic year which transferred to Bonfire Night); on Midsummer Day fires are lit, traditionally with oakwood; Midsummer was also the time of the sacrifice of the oak-king of Nemi. The willow is deeply associated with witchcraft (the words 'witch' and 'wicked'

are derived from the same ancient word for 'willow'); the laurel is linked with poetry – the reward for great poetic endeavour was the laurel ('Daphne', in Greek, is associated with Apollo's pursuit of the Goddess Daphne); laurel was also an intoxicant – the leaves were chewed to induce a frenzy – and the poet Francesco Petrarch revered the laurel tree, linking it with his beloved Laura de Noyes and the longed-for notion of poetic immortality which the laurel symbolized. Particular trees have been mythologized: there was the 'holy thorn' that, as legend has it, sprang from Joseph of Arithamea's staff as he planted it in the sacred ground of Glastonbury; the wood of the Sacred Tree of Creevna, at Killura, had healing properties; naked children were passed through gaps in pollard ashes before dawn as a cure for rupture; Yygdrasill was the sacred ash tree of the god Woden – he used it as his steed in Nordic mythology; in secular times trees still play a mythic role: there are the trees that hid figures such as Robin Hood and Charles I from their foes. In fairy tales, forests are places of enchantment, initiation and trial, where strange beasts are encountered, spells are undergone. The 'dark forest' or *selva oscura* occurs at the opening of the great poem of European culture, Dante Alighieri's *Divine Comedy*, where the first thing the poet-pilgrim does is enter the 'dark forest'. When land artists pick up a bit of wood, then, or use a branch in their work, they are activating a mass of associations in the fields of symbolism, legend, myth, magic and religion. Every tree and type of wood has its symbolic and poetic associations: oak, beech, laurel, willow, sycamore, ash, larch, hawthorn, holly, vine, hazel, ivy, rowan, alder and birch.

One of the most ancient religious functions of the tree was the World Tree of shamanism, the oldest of all religions (or set of practices). The World Tree was the mythic centre of the world of the community, it was the *axis mundi*, the pivot of time and space. The archaic shaman had many tasks: one of them was to travel to the Other World, to bring back news of what happened there, and to guide the souls of the departed to the Land of the Dead. The shaman did this by climbing up the Cosmic Tree: the shaman's magical flight to the Other World was linked with climbing the World Tree.

What has all this to do with contemporary land art? A lot. Constantin Brancusi, more influential on land art than Pablo Picasso, Jean Arp, Alberto

Giacometti, Auguste Rodin, Henri Matisse or Aristide Maillol, worked notions of shamanic flight into his *Birds in Space* sculptures, and most especially in his *Endless Column*, which is cited by many key sculptors (Donald Judd, Carl Andre, Robert Morris) as an important inspiration. Brancusi's *Birds in Space* aimed to express the essence of flight, the moment when a quivering verticality is released from the chains of gravity and flies upward. One only has to look at David Nash's *Tripods*, Andy Goldsworthy's towers of rocks, Barnett Newman's *Broken Obelisk*, or Judd's ladders and stacks, to see how important Brancusi's sculptures were, with their shamanic, World Tree associations.

INDOORS AND OUTDOORS 4.11

I love the land... My sculptures were mostly intended to be seen outside. The sky is the perfect background. It's space with no dimensions. I like working in the open air and seeing my things in the open.

Henry Moore (in C. Chandler, 184)

Sometimes it's odd to see land art in a gallery, because the mound of soil, the cairn of stones, or the snowball, demands viewers look outwards, to the natural world, to the wildernesses from whence this art came. Andy Goldsworthy's leaf horns or stalk drawings are familiar to viewers now, having seen them in galleries and museums (or, more likely, in books and websites), but one is always aware of the place of their origin, and how odd they look. Those sticks and stones are tiny parts of nature, bits extracted, chopped up, re-arranged, as all art is nature chopped up and reformed according to the artist's æsthetics. Land art creates an ambiguous continuity with the world of nature that exists outside the gallery (but also inside). Sometimes this ambiguity works against the work on show in the gallery space.

David Nash, one of Andy Goldsworthy's key influences, discussed this indoor/ outdoor problem in a 1978 interview:

An object made indoors diminishes in scale and stature when placed outside. The reverse happens when an object made outside is brought inside, it seems to grow in stature and presence. It brings the outside in with it. The object outside has to contend with unlimited space, uneven ground and the weather. The sculpture I show inside is meant to be seen inside, it relates to the limited space, the peculiar scale, and the still air.[1]

CHANGES, CYCLES, SEASONS 4.12

Crucial in land art is the concept and reality of change, for the land artworks in wood, snow, ice, leaves, water, slate and grass do not stay around for long. They are not 'permanent', in the way that, say, sculptures in bronze, marble, steel or stone can be (the concept of change is as significant as the reality of the piece, and often the idea is far more important). Ana Mendieta carved sand sculptures, in her familiar Goddess figure form (1983). Peter Hutchinson planted yellow flowers in sand underwater (1969). Hans Haacke released ten turtles into the wild in Southern France (1970), and balloons above New York City (1967). Richard Long has made many sculptures using water only: he has poured water in a line over stony ground, so the water darkens the stones. These pieces do not last very long. They have a 'natural' lifespan, which is in keeping with the Conceptualists' emphasis on simplicity and not interfering too much with the natural order of things. The piece is what it is, and was never intended to last longer than a short period.

Some land artists celebrated the impermanence of their art.[1] As politicians know, words such as 'permanent' are difficult to define, and even more difficult to maintain (politics changes by the day, by the hour). Artists with a large vision of life know that nothing on Earth will be truly 'perman-ent'. After all, 'civilized' humanity is only 10,000 years old, or forty thous-and, or two or three million, depending on how one measures 'civilized' (the famous civilizations of the Middle East rose around 6-10 thousand years ago). And the planet itself will not last forever: millions more years, but not forever (5 billion years, according to some estimates –

when the sun reaches its old age)₂

Some environmental/ action/ Conceptual artworks had a built-in im-
permanence, such as Allan Kaprow's *Fluids* (1967), large structures made
from blocks of ice, which were left to melt (and photographed, of course).
Barry Flanagan's *Hole in the Sea* (1969) was a cylinder embedded in a
beach: Flanagan filmed the water covering the hole as the tide came in.
Hans Haacke produced Goldsworthy-like works, such as ice freezing around
an element.₃ He wrote of an artwork which would be as majestic and as
transient as birds gathering in the sky: 'I would like to lure 1000 seagulls to
a certain spot (in the air) by some delicious food so as to construct an air
sculpture from this combined mass.'

There are bronze and marble sculptures still looking remarkable from the
ancient Græco-Roman period, and stone figurines from the Palæolithic
period. One cannot see how Andy Goldsworthy's leaves could last very long.
Indeed, ephemerality, transiency and change are key components in land
art, and in Goldsworthy's art. As Barry Flanagan wrote: '[t]ruly sculpture is
always going on. With proper physical circumstances and the visual
invitation, one simply joins in and makes the work...'₄ Goldsworthy builds
transience into some of his sculptures; indeed, the subject matter of some
works is their ephemerality. They are about the fact that they won't last very
long. In fact, the bulk of Goldsworthy's art is ephemeral, with 'permanent'
works – such as the *Storm King Wall*, the *Montréal Arch,* the Cumbrian
Sheepfolds and the Digne *Water Cairn* – in the minority.

LAND ART AS RELIGION 4.13

It's no surprise that the American form of earth art should be sympathetic
to Oriental mysticism, because Zen Buddhism, Hinduism, Shinto, Tantrism
and Taoism were particularly popular in 1960s Western culture (in the Beats
and 'dharma bums', rock musicians, or West Coast hippies, for example). It
was a logical cultural development, it seems, from Parisian Existentialism of

the 1940s to Californian Zen and Tao of the Sxities (from the Old World to the New World, from East to West). Many of the chief precepts of Taoism, Shinto and Zen Buddhism chime with those of land art, not only the American form, but also the land art of Andy Goldsworthy, David Nash, Chris Drury, Hamish Fulton and others. Matsuo Basho, an important Oriental poet, famous for his *haiku,* wrote:

> Go to the pine if you want to learn about the pine, or to the bamboo if you want to learn about the bamboo. And in doing so, you must leave your subjective preoccupation with yourself.[1]

And Makoto Ueda glossed Matsuo Basho thus: 'learn means to enter into the object, perceive its delicate life and feel its feelings.'[2] These notions of searching for the 'essence' are absolutely in tune with the æsthetics of Constantin Brancusi, Carl Andre, Donald Judd and Andy Goldsworthy. Goldsworthy speaks in exactly the same terms of trying to find the 'essence' of nature.

The Chinese Taoist mystic, Chuang-tzu (the 'Groucho Marx of Taoism' as Lawrence Durrell called him), wrote: '[l]eap into the boundless and make it your home.'[3] This statement perfectly describes the artist's act of faith and risk, which is so essential for good artistic creations. As the Existentialist philosopher Søren Kirkegaard said, without risk, life is not worth living. Again, these quasi-Existential and Taoist notions of risk are perfectly in tune with 1960s land art, and with the work of Goldsworthy. Richard Long spoke of the affinities his work has with Samuel Beckett and Zen Buddhism.[4]

Critic John White, discussing Oriental art in his excellent book on space in art, made points which can apply to land art:

> In Chinese art the surface emphasis is negative rather than positive. It is in close accordance with the calm acceptance, the contemplative natural mysticism, which reached its highest flowering in Taoism. The surface is left undisturbed. Colours are few, and soft. Ink, and delicate monotone washes are the characteristic media. Spiritual and decorative qualities are valued high above imitative naturalism, the evocative above the representational... The unmarked silk, or paper, is at once the atmosphere, the space, and the inviolate decorative surface.[5]

The relation between land art and Oriental mysticism – in particular, Taoism, Shinto and Zen Buddhism – has been noted by many commentators. Zen and Taoist spirituality, for instance, speak of concepts such as: *(1)* the 'here and now', *(2)* spontaneity, *(3)* *satori* or enlightenment, *(4)* intuition, *(5)* nature, *(6)* emptiness and the void, *(7)* change, *(8)* meditation, and *(9)* cosmic unity. All these qualities can be applied to land art, and are sometimes elucidated by land artists in their publications.

(1) Take the Zen Buddhist notion of the 'eternal now' (or 'now-streaming', *nunc fluens*, as Alan Watts called it). Zen makes the present moment primary, the only true reality, and land artists too work in the present. Sculptors such as Andy Goldsworthy continually evoke the transient nature of sculpture, its 'nowness': Goldsworthy's poppy lines are only there for an instant, then they are blown away by the wind.

(2) Spontaneity. This is as crucial in land art as it is in Zen Buddhism and Taoism. The land artist works with whatever materials are to hand; s/he has to follow the feel of the materials (malleability, accessibility, transportation); changes in weather, light (or cold, heat and wind), must be accommodated into the artwork; random, unplanned or unforeseen events must be acknowledged.

(3) The experience of viewing land art is not quite Zen Buddhist *satori*, in the strict, theological definition of *satori* or enlightenment, but certainly land artists aim for an 'epiphany' (as James Joyce called the æsthetic shock), however brief it may be. In land art as object, there are 'no strings attached', i.e., 'what you see is what you get', as Frank Stella put it. One sees the whole thing there, and that is everything one gets. This instantaneous aspect of land art, as also in postwar and contemporary painting, is a Zen-like notion. *Satori*, too, has affinities with the descriptions of land art and sculpture that some artists follow: Hui-Neng, the 8th century mystic, said that *satori* was 'seeing into one's own nature'. Richard Long, among other artists, has written of his own art as a journey towards some inner essence. D.T. Suzuki, one of the chief explicators of Buddhism in the modern era, termed Zen *satori* an 'insight into the Unconscious'. Andy Goldsworthy has said that the relation between sculpture and photography is about 'seeing and time itself' (Sh, 23).

(4) Most land artists value intuition highly, as do most poets and artists.

The land artist trusts her/ his instincts, and works grow 'organically'. Systems are adhered to, but land artists often veer off into intuitive areas.

(5) Nature dominates Zen Buddhist, Shinto and Taoist religion, as it does in land art. One is always encouraged in Taoism, Shinto and Zen to 'follow one's nature', and to co-operate with the universe. Nature is the teacher in Zen, Shinto and Taoism, as it is in land art.

(6) Easy to see the lure of the spiritual void in land art, in those wildernesses beloved of Andy Goldsworthy, James Turrell, Nancy Holt and Dennis Oppenheim. Voids are found in much of contemporary culture, from Samuel Beckett's sparse texts and 'fizzles', which painstakingly describe near-voids (the stone circle, so like a piece of land sculpture, in *Ill Seen Ill Said*, the sun setting over the hills in *Still* and the ruthless white 'inscape' of *Ping*), to Ad Reinhardt, Robert Rauschenberg and Robert Ryman painting all-black or all-white canvases.

In the paradoxical bliss of Oriental mysticism, emptiness is also fullness, and to 'have' nothing is to 'have' everything. Zen Buddhism, Shinto, Hinduism and Taoism thrive on paradox, on the 'not-this-not-that' dialectic of Eastern philosophy, as a way of getting at the unsayableness of the essence. Similarly, Andy Goldsworthy, in a paradoxical manner, speaks of the monumental aspect of sculptures made from leaves: the very small can also be very big, he said:

> some of the largest works I've ever made have been of leaves; the surface of a leaf when I am working with it, bending, folding, shaping, pinning together, has a scale which is enormous. True scale is determined by the material I'm working with.[6]

In the manner of Eastern philosophy, Andy Goldsworthy acknowledges that the very small contains the very large, another take on the cosmic unification of Oriental mysticism, where the macrocosm and microcosm are interrelated.[7]

The visual imagery of Zen Buddhism, Shintoism and Taoism is also that of land art: stones, mountains, rivers, water, flowers. China has a long tradition of landscape painting, and it is easy to see the many connections between the contemplative aspects of Chinese landscape painting (the 'floating world') and land art.

(7) Change is central to land art: all land art occurs within a changing landscape, whether it be the artificial (human-made) changes in the gallery, or the natural changes of erosion, weather, water, light, season, etc. Land art thrives on change, and many land artists have deliberately exploited time and change in their works, from Nancy Holt with her *Sun Tunnels*, which alter as the sunlight pours through the holes in the concrete tubes, to the transience of Andy Goldsworthy's *Chestnut Leaves* (1998), a pattern of leaves pinned to a tree, which the elements will swiftly erase.

In Taoist mysticism, everything changes, the *yin* and *yang* energies or principles create change, yet the Great Whole, as it's known, remains the same. In the natural world, everything is changing, transforming into something else, yet the Earth remains whole. Flow is crucial – so land art steps away from Western art, which stops life in snapshots or 'still life' paintings (and the slavish attachment to 'realism' and 'photorealism'), and produces transmuting art, art which has change built into its design. In Western culture, there is much anxiety when artworks change (when paintings decay and colours fade, for instance). On the one hand, there is the desire to keep everything 'natural', 'pure', without (too many) interventions; on the other hand, museums and galleries constantly interfere with art – 'restoring' paintings, reframing art, putting works behind glass, behind ropes, etc. The very nature of 'preserving' art is controversial – witness the anger surrounding the restoration of Michelangelo Buonarroti's Sistine Chapel or Leonardo da Vinci's *Last Supper*.

Land artists, though, relish such changes and decay in artworks. Andy Goldsworthy loves it when his sculptures collapse. He spends much of his time waiting around for the fall, so that he can photograph it (or, in the case of the ice arch on Hampstead Heath, Goldsworthy's wife, Judith, photographed the collapse). When a cairn made on the beach in Nova Scotia in 1999 didn't collapse when the tide came in (as was usual), Goldsworthy said he found the event 'profoundly altered the way I see things. My art has shown me so many things that were hidden to me' (T, 104).

Decay, decline and collapse were central elements in Andy Goldsworthy's art, especially, as he acknowledged, in his later works, which would be constructed with decay and change as 'an integral part of a work's purpose

so that, if anything, it becomes stronger and more complete as it falls apart' (T, 7).

(8) Meditation is clearly not a goal of land artists – they make no pompous claims concerning mysticism and meditation (art as therapy, relaxation, hypnosis). Yet, clearly, contemplation is a part of their work (as it is a part of most artists' work). Making land art often involves a mild form of meditation or a trance of concentration (and looking at art can induce milder forms of these altered states). Richard Long's walks, for instance, are meditations of a kind. 'A journey in the wilderness becomes a fantastic focus of concentration. I can get totally absorbed in the place and totally absorbed in my work', Long remarked (IC 1, 14). When he walks, Long explained (as so many walkers have said), '[w]hile I am in the landscape... I am in a very good state of mind' (ib., 5). Andy Goldsworthy too speaks of an intense relationship with his subject as he works. The British poet Peter Redgrove said that 'the ideal state for ordinary going about is the first stage of orgasmic arousal'.[8] This is 'walking' in the Taoist sense; that is, walking as another name for feeling ecstatic.

The very activity of walking releases chemicals in the brain that promote pleasure. Physical fitness devotees get hooked on them sometimes. 'I think the sexual energy or the energy of creativity or the adrenalin energy you get from being on a mountain, sometimes they are all very close', Richard Long remarked.[9] The physical action of walking is soothing. Since time immemorial people have 'walked off' their problems, babies are walked to calm them down, pilgrims walk sacred routes, monks circumnavigate holy hills, and many artists were famous for their walks: Thomas Hardy tramped through Dorset; Henry Miller was in ecstasy simply by walking around the backstreets of New York and Paris (as described in the *Tropic* trilogy and *The Rosy Crucifixion*); William Wordsworth and Samuel Taylor Coleridge walked in the Lake District and West Country; John Cowper Powys always took a morning walk from his home in rainy North Wales; heavyweight German philosophers Arthur Schopenhauer and Immanuel Kant took twilit walks; Bruce Chatwin made walking and nomadic existence his central theme – in his life as in his art (like Richard Long, Chris Drury and Hamish Fulton).

(9) Land art is close to Taoism in its worldview: like Taoists, land artists

believe in a holistic view of things, where each part affects the rest. This interconnected worldview (sometimes called 'Gaia-consciousness'), is also the philosophy of parts of ecology and the offshoots of the ecological/ green movement: eco-feminism, wicca religion, animal rights, eco-pagan-ism, road activism, anti-hunting lobbies, anti-capitalism, etc. In the Taoist view, inner and outer commingle, the individual and the mass interconnect.

Andy Goldsworthy is very much concerned with ecological issues, and like many land artists is careful to make sure his artworks do not scar the landscape. There is no trash in land artists' photographs of their artworks. Richard Long spoke of wanting to 'pass through life without leaving a trace'.[10] Land artists are ecologically and societally conscientious artists, and thus Goldsworthy has been hailed as Britain's primary ecological artist. Land art is about finding a harmony between the human and the natural world, between the abstractions of humanity and the reality of nature.[11]

The land artist orients her/ himself in terms of post-Renaissance space and time. The Neoplatonic, magical, neo-pagan view of the world in the Renaissance saw humanity at the centre of the cosmos, and humans were the microcosm reflecting the make-up of the macrocosm, the 'as above, so below' philosophy of occultism, Hermes Trismegistus and the alchemists. In the view of Christianity, however, God was at the centre (as in Dante Alighieri's extraordinary vision of a mechanical-mystical universe in which God is at the centre of the surrounding nine hierarchies of angels, and the rest of humanity is someplace around the edges). In Renaissance culture one sees so clearly the crumbling of the hegemony of mediæval culture, where there was an unambiguous system of good and evil, God and 'man', us and them. In the Renaissance, this worldview falls apart, moving towards an emphasis on the individual, on the Existential sense of beingness and being alone in the universe. Mircea Eliade wrote:

Because his body exists in space, any man orients himself by the four horizons and stands between above and below. He is naturally the center. Any culture is always built on existential experience. (1984, 136)

This is what the land artist does: s/he orients her/ himself to the four horizons, and to post-Renaissance time. The human level becomes the spiritual centre. The earthworks art of whoever one cares to think of – Andy

Goldsworthy, Alan Sonfist, David Nash, Sherry Wiggins, Alice Aycock, Hans Haacke – puts people, not God or deities, at the centre of the cosmos. Goldsworthy speaks of feeling 'at home' in a particular landscape, of regarding a place as his 'home'. Land art, then, can be seen on one level as the reaffirmation of 'home', a reinstatement of the notion of 'homeland'. The 'homeland', though, is not primarily a physical place, but a cultural and spiritual space. 'Homeland' is a state of mind as much as a landscape. Land art may be the manifestation of a spiritual re-orientation. In land art, the 'mythic centre' of one's life is re-affirmed.

Andy Goldsworthy always affirms the 'livingness' of his art, that he *lives* his art. His art is not (intended) to be intellectually discussed or made at a critical distance. Rather, the artist is right in the middle of her/ his art, living it. There is no separation of art and life. Land art is a way of mythicizing one's sense of being-in-the-world, a way of making presence visible, tactile, *there.* 'Presentness is grace', wrote Michael Fried in his influential essay "Art and Objecthood".12 Making land art is a religious activity because simply being in the world is religious. Land art, like all art, replays the primordial myth of Creation: each earthwork or sculpture reaffirms the Creation. 'Once the center has been reached, we are enriched, our consciousness is broadened and deepened, so that everything becomes clear, meaningful...', wrote Mircea Eliade.13

In archaic societies, through symbol and ritual, sites would become 'sacred'. For postwar, postmodern, post-everything people, any site can become 'sacred' if one thinks of it as sacred. If one thinks of this junk yard next to the car lot as a sacred space, why, then it *is* a sacred space. All that sacred spaces need is human consciousness. It is the level of *desire* that makes a place sacred. In olden times, one might have required a god or a government (or a priest or a shaman) to have the 'authority' to make something sacred. In the postwar, post-everything world, the individual is her/ his own government and God. If s/he says a place is holy, then it's holy.

Consecration of a sacred space may include any number of rituals. The simple fact of drawing out a circle in the sand on a beach isolates a sacred space in amongst profane space. By drawing the circle, one marks out a sanctuary or sacred zone. Magicians add to the glamour of creating a

magic circle by drawing it with a knife, making it nine feet in diameter, and placing candles or some ritual object at the four cardinal points (well, magicians do have a heightened sense of theatre). The magician's circle is simply a stylized, ritualized version of the land artist's circle. The religionist or magician has the weight of religion or hermetic magic behind her/ him; the modern artist has the weight of art history behind her/ him. One can't say that a church or a magic circle is 'holier' than a circle made with a stick by an artist on a sandy beach. Cathedrals simply have the 'authority' of paternal or patriarchal figures behind them. The artist making a sand circle doesn't seem to have the same 'authority', the same tradition of sombre theology and religious *gravitas* Yet the land artist on a beach is making a sacred space out of profane space.

Land artists do not think in these terms: or they may do, but they rarely admit it publicly (claiming that your sand circle is just as holy as St Peter's Cathedral in Rome or the Temple in Jerusalem probably ain't so wise). For the land artist, as for any artist, it is perhaps embarrassing to admit that much of art is about 'child-like' feelings; that is, the 'simple' pleasures of making a line out of stones, or walking at dawn, or sculpting sand. These are the basic pleasures of art, which both artist and viewer enjoy. They are, on one level, 'child-like', even 'infantile', psychologically. Sure. But many other grave, time-honoured institutions are partly founded on childish impulses: marriage, Catholicism, insurance, pop music, movies, advertizing, and the military.

The land artwork, then, remakes the sacred in a profane world: 'the manifestation of the Sacred in any space whatsoever', remarked Mircea Eliade, 'implies for one who believes in the authenticity of this hierophany the presence of transcendent reality.'[14] Not only, then, do land artists make sacred spaces, as all artists do, they also create a sense of the 'real', a sense of beingness, a reaffirmation of the transcendent:

> The Sacred [wrote Mircea Eliade] *is that something altogether other to the Profane. Consequently, it does not belong to the profane world, it comes from somewhere else, it transcends this world. It is for this reason that the Sacred* is *the real* par excellence. *A manifestation of the Sacred is always a revelation of being.*[15]

For the land artist, most, if not all, of the world is not just potential art material, but beautiful. Land artists, declining to admit to being romantic or emotional, nevertheless (usually) create art that is Earth-loving, nature-loving, ecologically-friendly – that is, in short, full of emotion. Andy Goldsworthy admitted to a 'deep sense of spirituality', but said 'it doesn't manifest itself in any sort of religion'.[16] In going out to work in the landscape everyday, Goldsworthy said he was learning, bit by bit, about the natural world, creating 'an intensely personal knowledge'. He didn't feel he was 'breaking new ground', but neither did he feel 'the weight of history' (ibid.).

There are links between land art and the theory of the sublime in the history of art. These are useful to consider. Art critic Christopher Hussey defined (in 1927) seven aspects of the sublime, derived from the philosopher Edmund Burke's *Philosophical Enquiry Into the Origin of Our Ideas of the Sublime and Beautiful* (1757): (1) obscurity (physical and intellectual); (2) power; (3) privations (such as darkness, solitude, silence); (4) vastness (vertical or horizontal); (5) infinity; (6) succession; and (7) uniformity (the last two suggest limitless progression).[17] These tenets can be applied to land art, especially that of James Turrell, James Pierce, Robert Irwin, Robert Smithson *et al,* and to Andy Goldsworthy's art (again linking the art of Goldsworthy to the British Romantic nature tradition). Goldsworthy has his own version of the Romantic 'sublime': it's not self-consciously epic, like Smithson or Michael Heizer, but has its own grandeur.

Illustrations

Works by Andy Goldsworthy • some of the forms in Goldsworthy's art • some of Goldsworthy's contemporaries, • and some of Goldsworthy's influences.

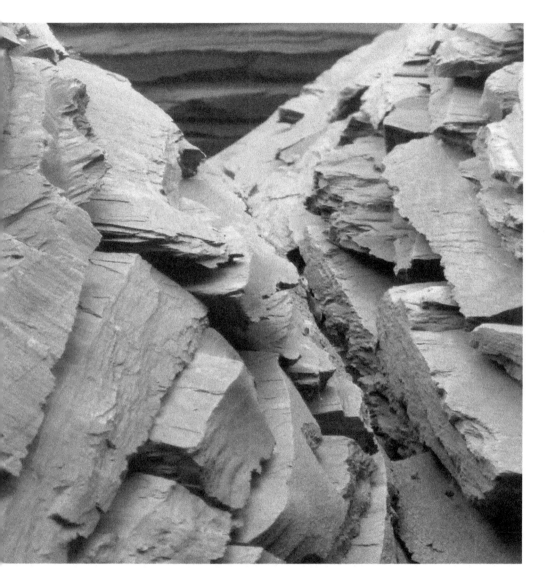

Andy Goldsworthy, Roof, 2005, Washington, DC
(this page and over. Photos: author)

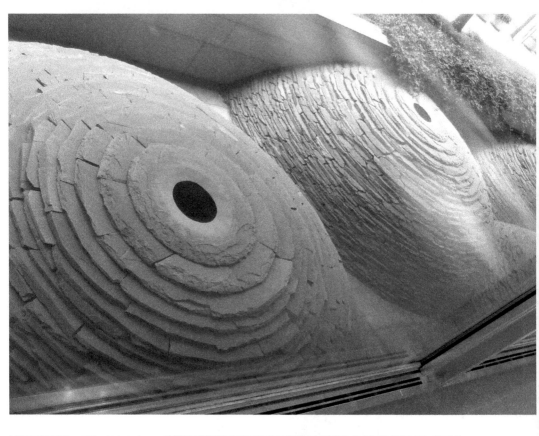

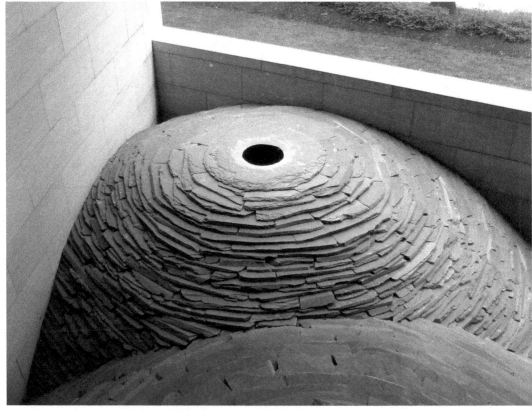

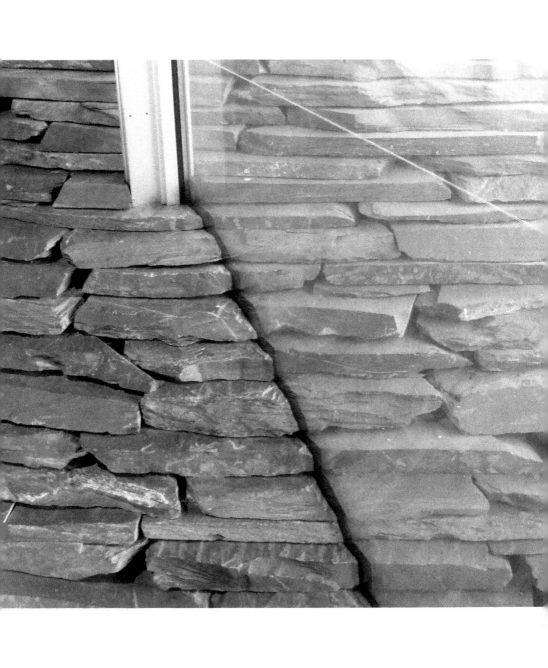

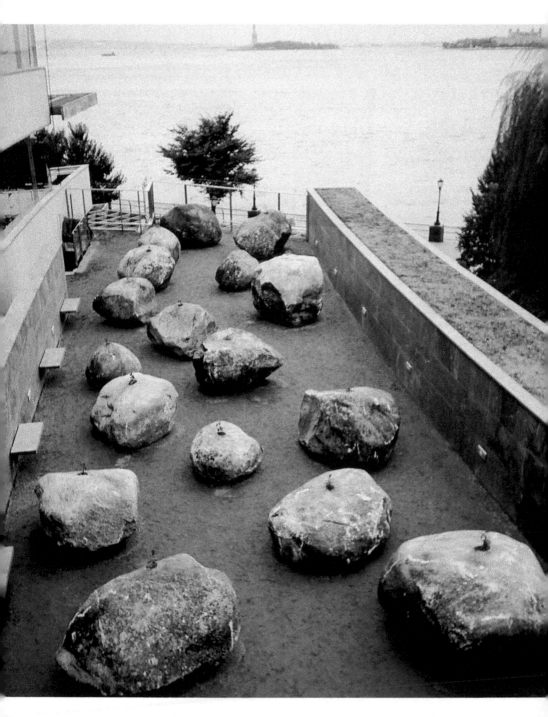

Andy Goldsworthy, Garden of Stones, New York City, 2003
(this page and over. Photos: author)

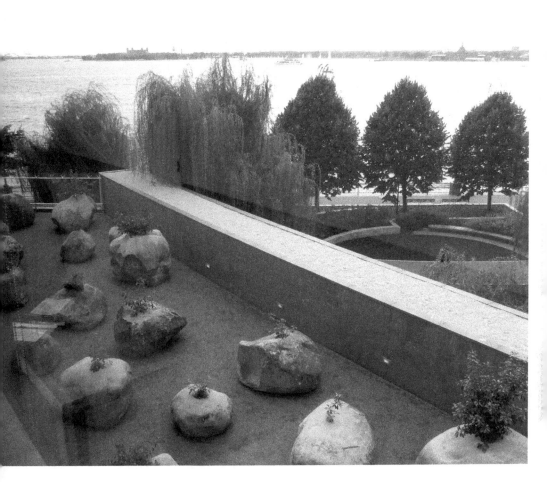

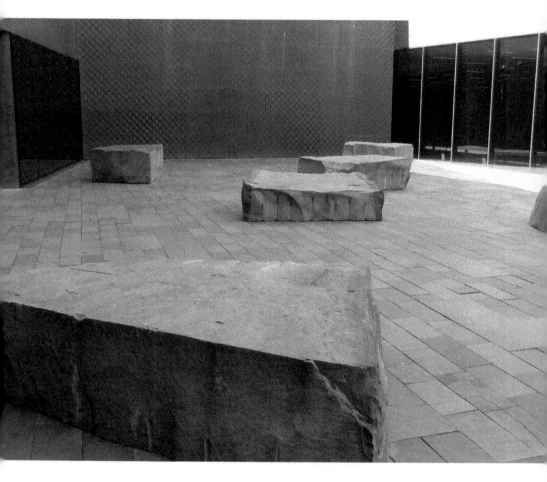

Andy Goldsworthy, Drawn Stone, 2005, San Francisco
(this page and over. Photos: author)

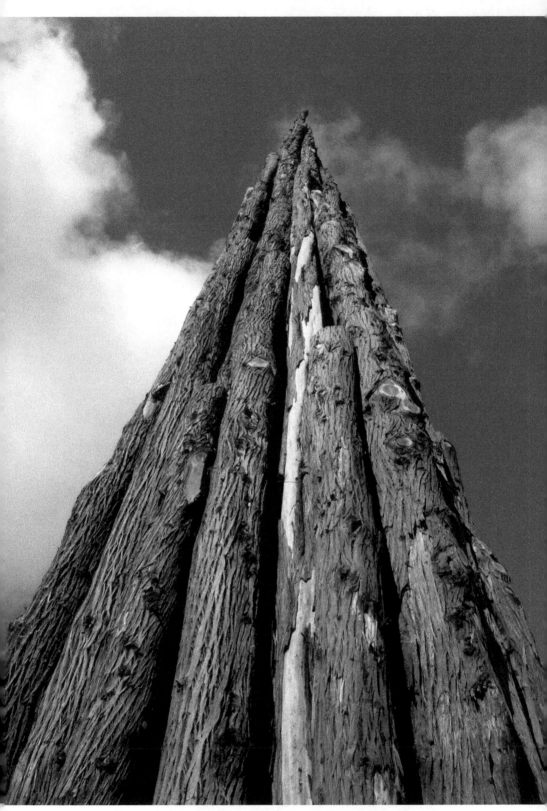

Andy Goldsworthy, Spire, 2008, San Francisco
(this page and over. Photos: author)

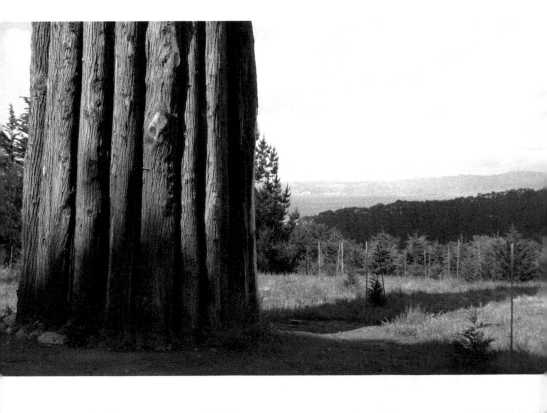

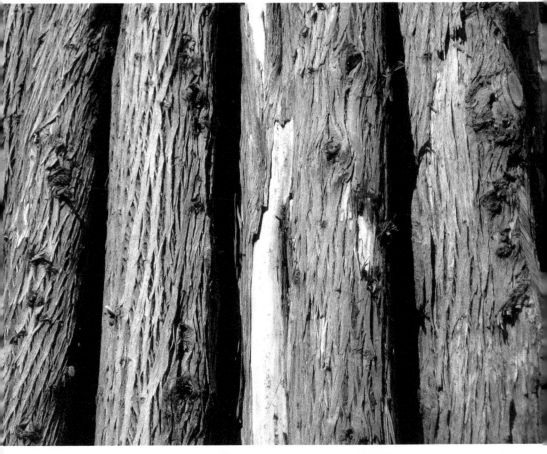

Andy Goldsworthy, Storm King Wall, 1998, New York State
(this page and over. Photos: author)

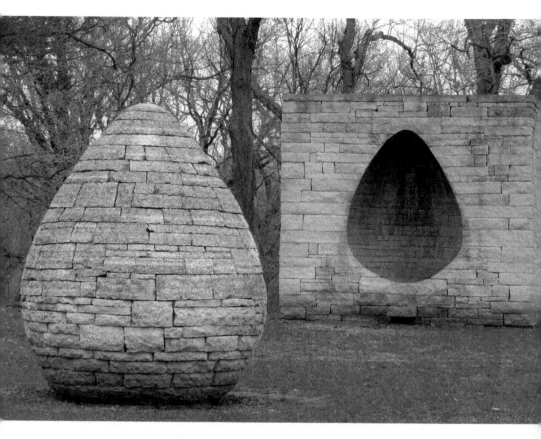

Andy Goldsworthy, Three Cairns, 2002, Des Moines, Iowa
(this page and over. Photos: author)

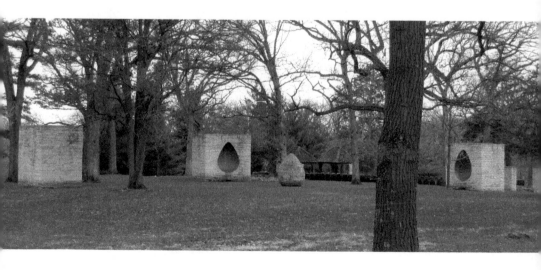

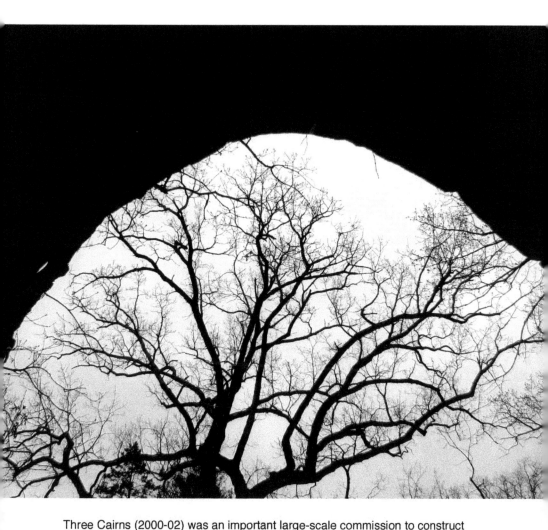

Three Cairns (2000-02) was an important large-scale commission to construct
three cairns in the United States of America: one on the West Coast (in California), one
on the East Coast (in New York state), and one in the Mid-West (at Des Moines, Iowa).
Three Cairns was a collaboration with three cultural institutions: Des Moines Art
Center, Neuberger Museum of Art, Purchase, New York, and La Jolla Museum in San
Diego. In the event, Andy Goldsworthy built six cairns: apart from the three permanent
pieces, there were three ephemeral sculptures: two were tidal, on the East and West
coasts, and the third, in Iowa, was built on the prairie, which was set alight (with fire
replacing water as the natural force which engulfed the sculpture. However, the stone
cairn survived the fire).

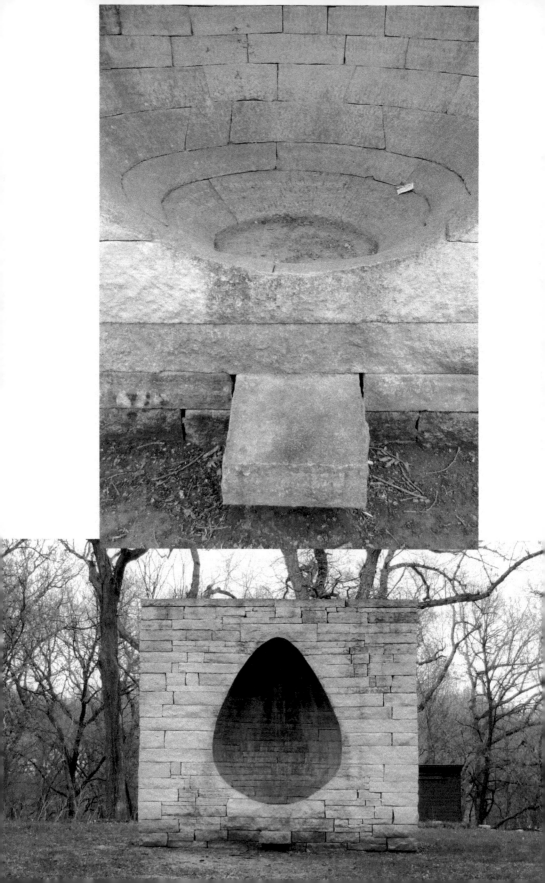

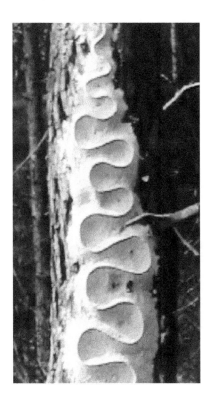

Andy Goldsworthy, Damp Sand Compacted To the Tree, 1999

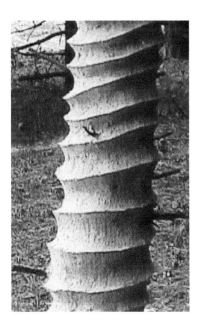

Andy Goldsworthy, Damp Sand Pressed Into Tree Trunk, 1999

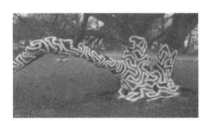
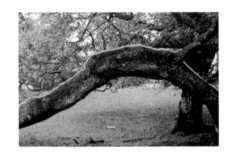

Andy Goldsworthy, from the Capenoch Tree series, 1994-96

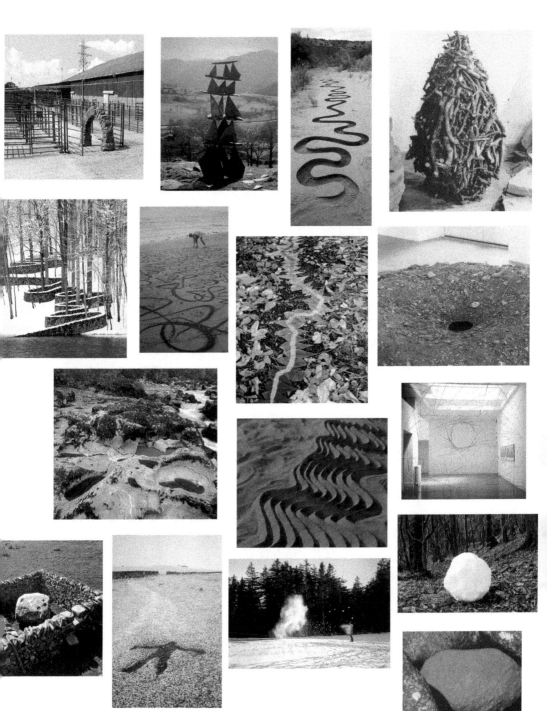

Goldsworthy's forms

The recurring forms in Andy Goldsworthy's include:

Lines. Cairns. Walls. Snowballs. Holes. Cracked lines.
Screens. Sheepfolds. Arches. Shadow prints. Throws.
Leafshields. Globes. Stained pools. Wrapped rocks.
Broken stones. Ridged sand. Sand drawings. Balanced rocks.

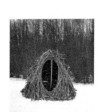

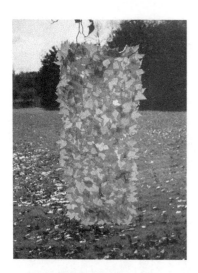

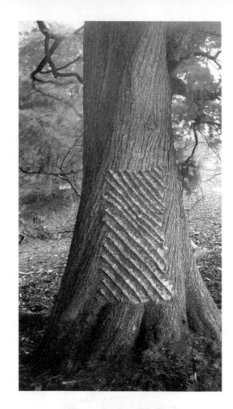

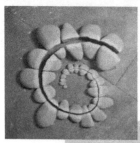

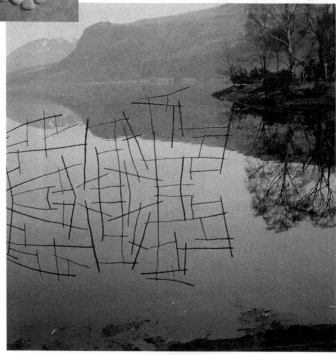

Frontality

Goldsworthy usually employs classic Renaissance space (like most
Western art since the 1300s). He often emphasizes the frontality of his
sculpture, as in the examples above: leaves pressed into the bark
of a tree; a leafshield; sticks in a lake; and broken pebbles.

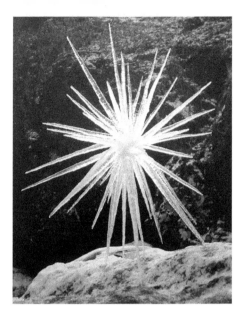

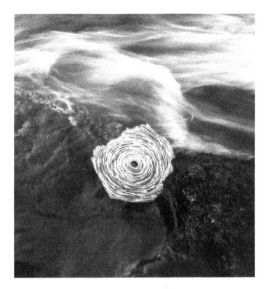

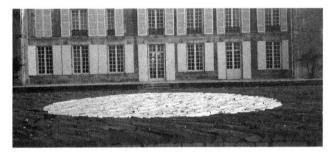

Light, shadow, contrast

Goldsworthy is often working with light as a central element
in his artworks: cloudy, shadowy light is often favoured,
as in the Roof installation; Pool of Light uses the direction
of sunlight; high contrast is deployed in the wool pieces;
and the ice pieces use backlight.

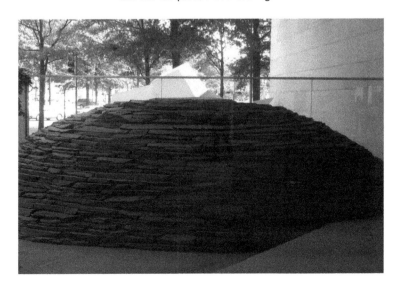

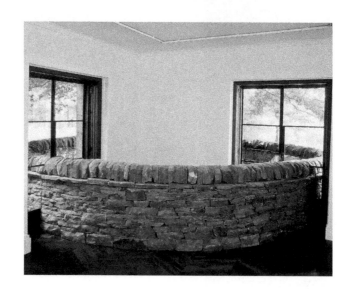

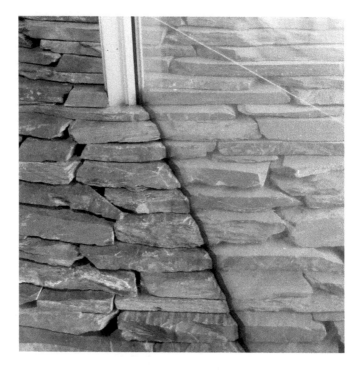

Optical illusions

Goldsworthy likes to play optical tricks from time to time:
for instance, to continue a shape or form through barriers,
as in these examples in New York state (Storm King Fold)
and the National Gallery of Art in Washington (Roof).

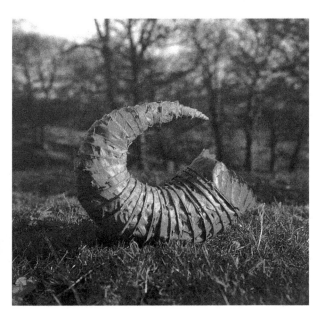

Single material

A large proportion of Goldsworthy's artworks are created from a single material: one type of stone, as in the broken pebbles; a collection of one kind of leaf, as in Autumn Horn; a Clay Wall installation; and a throw of red soil.

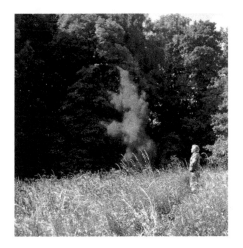

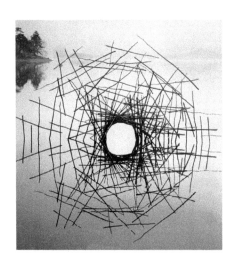

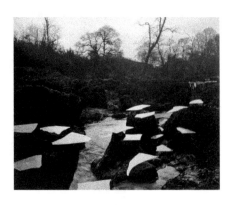

Wilderness setting

Without a doubt a central ingredient in Andy Goldworthy's art is his choice of settings, and primary among these is a wilderness setting, as in these works from Alaska; the Lake District's lakes; and Goldsworthy's homeground of Scaur Water in Scotland.

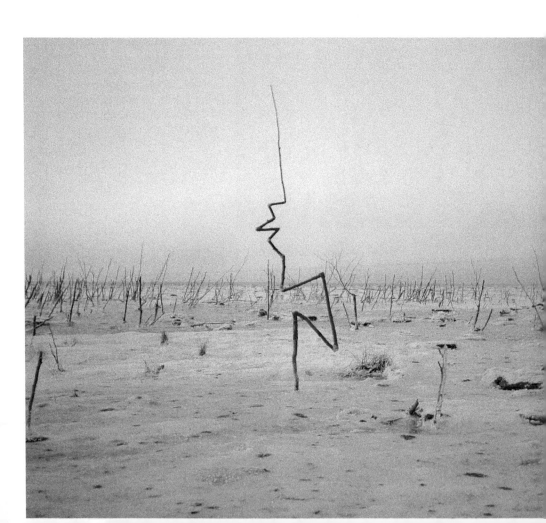

Wrapping

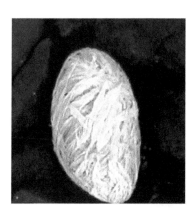

Goldsworthy has made an art of wrapping objects, though not yet on the scale of the king of wrap art, Christo. Goldsworthy has wrapped rocks, trees, branches, and other objects with leaves, wool, sticks, feathers and flower petals.

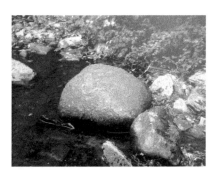

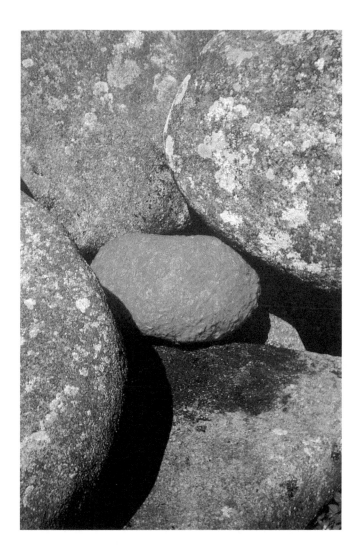

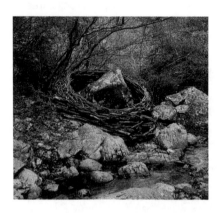

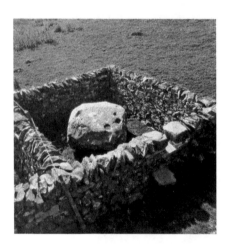

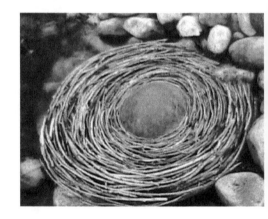

Enclosure

Enclosing an object or putting an object inside another
is a key Goldsworthy motif, occurring more and more
in his later works: such as the sheepfolds; or putting towers
of rocks inside wooden cairns, as in New York City;
or enveloping boulders with sticks.

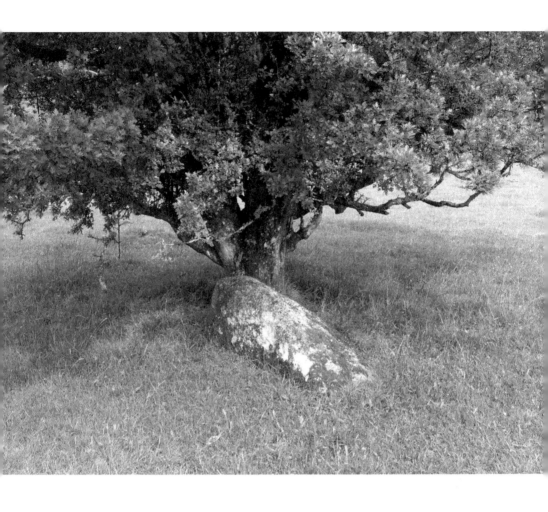

Andy Goldsworthy changes the way you see the world. For instance, I start to see Goldsworthy sculptures round and about – what you might call 'found Goldsworthy' works, like this boulder and tree I passed on a walk in Dartmoor, near Newbridge.

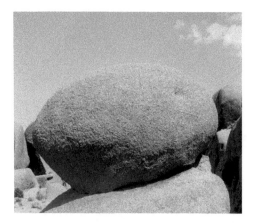

Joshua Tree National Park in the Sunshine State is a great place for finding 'found Goldworthys' – in balanced rocks, or cracked rocks, or rocks wedged into stone walls (above and left).

Sometimes you come across little sculptures made by people, like these stones in the Rocky Mountains near Estes Park, Colorado (below right).

I don't know who built the stone cairn (bottom) that I saw driving through the Rockies in Lyons, Colorado, but it must be inspired by Andy Goldsworthy.

Ana Mendieta, Blood and Feathers, 1974

Donna Dennis, Tourist Cabins On Park Avenue, 2007

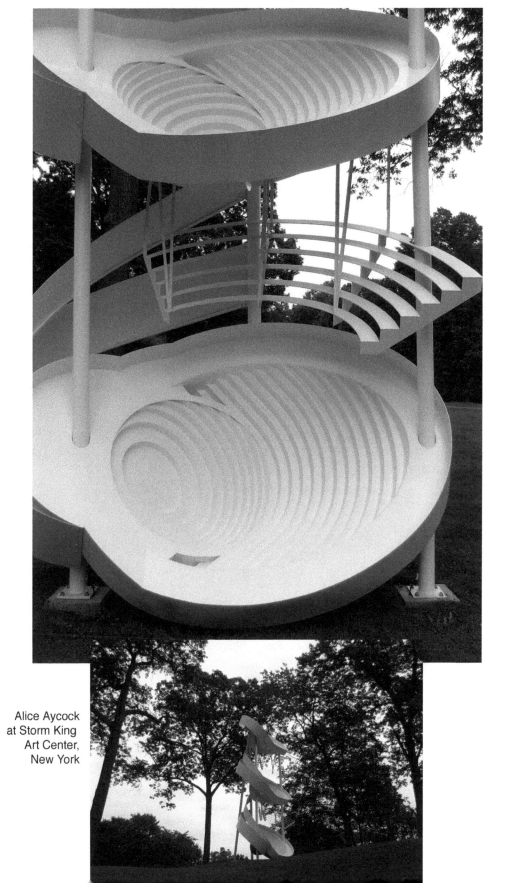

Alice Aycock
at Storm King
Art Center,
New York

Alison Wilding, Pulse, 1991

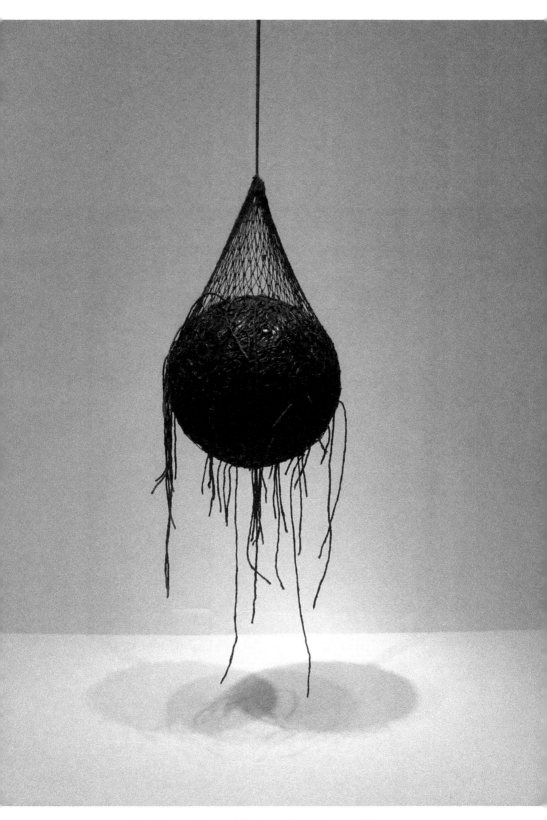

Eva Hesse, National Gallery of Washington, DC

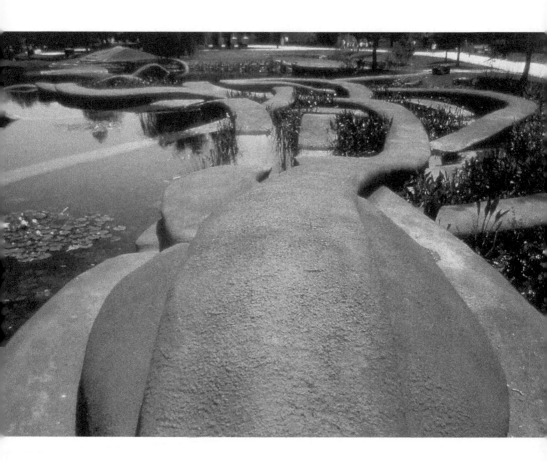

Patricia Johanson, Fair Park Lagoon, 1981-86

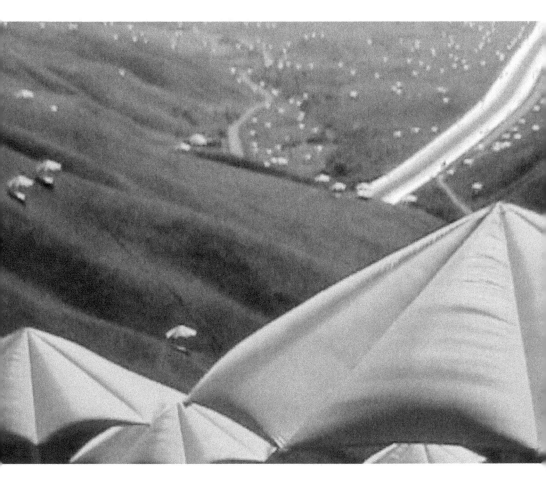

Christo, Umbrellas, 1976

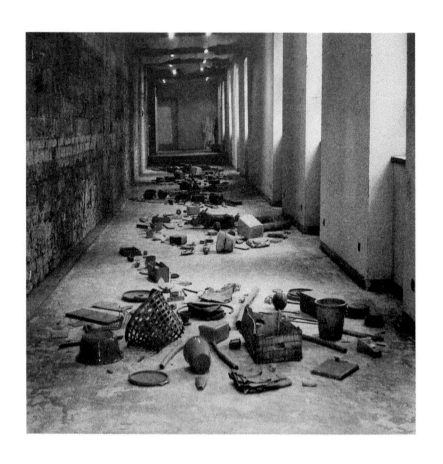

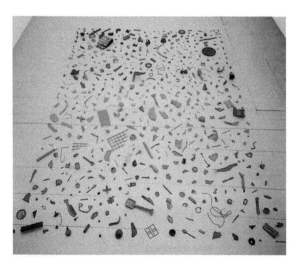

Tony Cragg

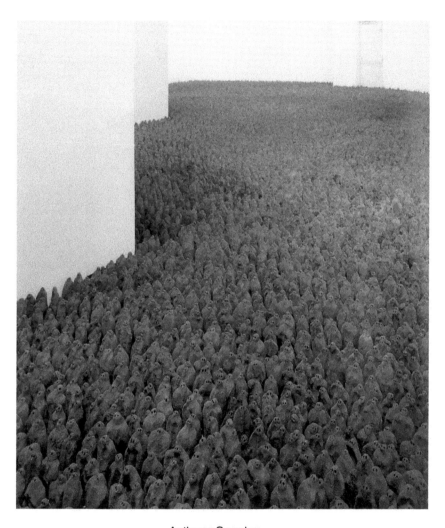

Anthony Gormley

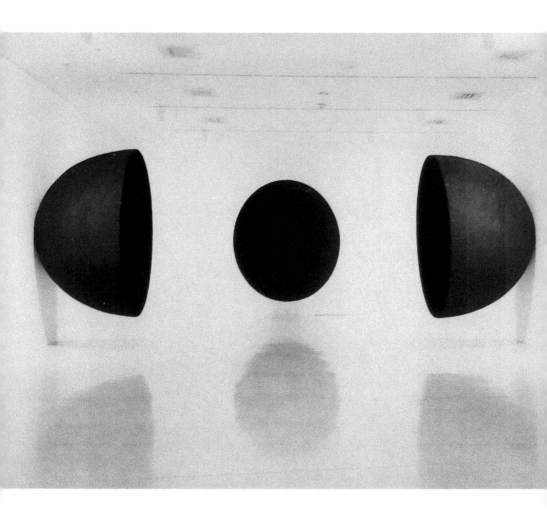

Anish Kapoor

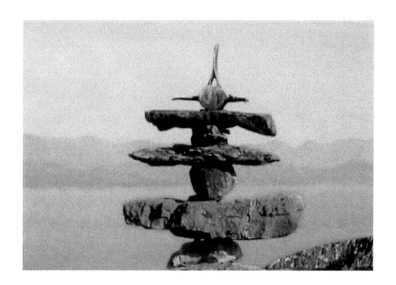

Chris Drury, Whale Bone Cairn, 1993

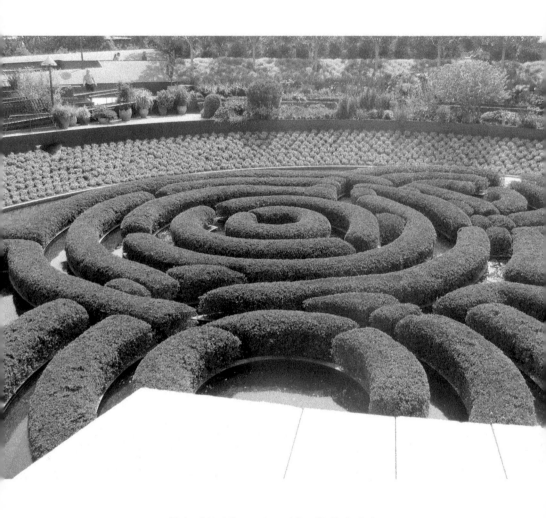

Robert Irwin's garden at the Getty in L.A.

Dennis Oppenheim, Negative Board, 1968

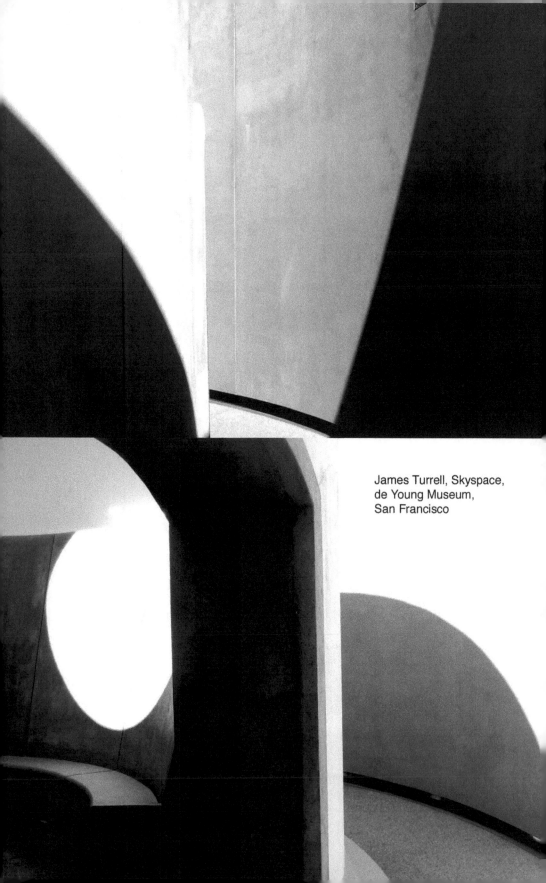

James Turrell, Skyspace,
de Young Museum,
San Francisco

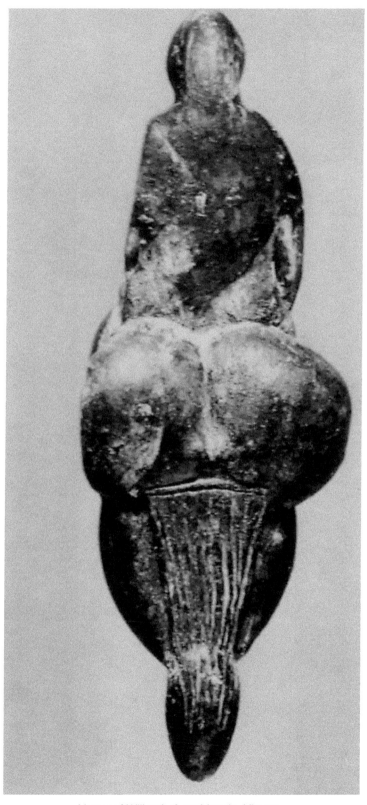

Venus of Willendorf, prehistoric, Vienna

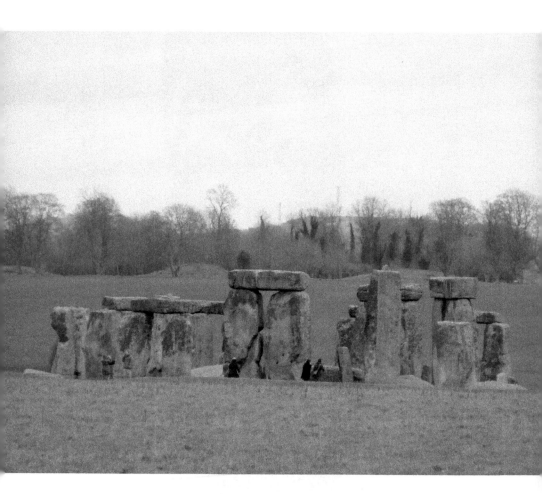

Stonehenge, Wiltshire

A modern version of the traditional Japanese Zen Garden,
in Pasadena, California

Frederic Edwin Church, Twilight In the Wildnerness, 1860,
Cleveland Museum of Art

Thomas Cole, Indian Sacrifice, 1826

John Constable, Cloud Study

J.M.W. Turner, Tintagel Castle, 1815, Boston

Henry Moore, Maquette For Recumbent Figure, 1938

Barbara Hepworth, Sculpture with Colour and String, 1939-61

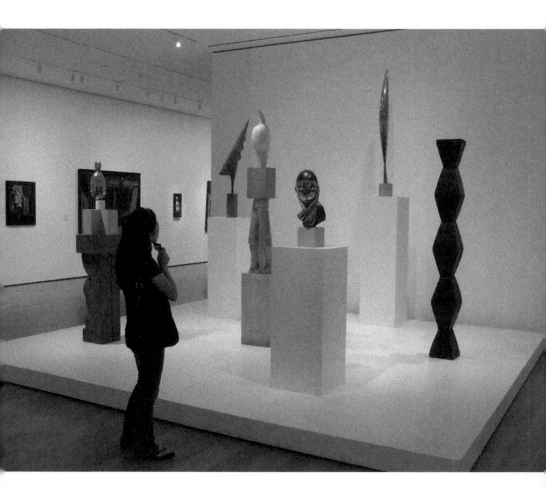

Constantin Brancusi display, Museum of Modern Art, Gotham

PART TWO

5

Andy Goldsworthy

*My art is unmistakably the work of a person – I would not want it otherwise
– it celebrates my human nature and a need to be physically and spiritually
bound to the earth.*

Andy Goldsworthy (*Stone*, 50)

Andy Goldsworthy's forms have become well-known in the art world, and have entered popular culture in important commissions, such as the huge on-going *Sheepfolds* project in Northern Britain, the Digne commission in South France, Royal Mail stamps, and shows at the Metropolitan Museum and Jewish Museum in New York City (the public have also been inspired to create Goldsworthyan art).

Many of Andy Goldsworthy's sculptures are small-scale interventions in the natural world: the artist stitches together leaves to form lines, often placed in water, or along branches, or over rocks. Or he carves circular slabs of snow, or entwines twigs in an arc; he sews together a delicate spiral of chestnut leaves, called *Autumn Horn*; he pins bright yellow dandelions on willowherb stalks in a circle, on top of bluebells; he makes lines and cairns, like Chris Drury or Richard Long, of pebbles; he builds hollow, circular structures, like igloos or archaic shelters, from slate, leaves, driftwood and bracken; he creates long wavy ridges in Arizonan desert sand; he makes arches, globes, hollow spheres, slabs, spires, spirals and star-shapes out of snow and ice. It's all very impressive. The sculptures made of sticks, for instance, stuck together in an arch, or a line, reflected in the mirror-like water of Derwent Water in Cumbria in Northern Britain, are indeed wonderful. The sculptures exude tranquillity, an early morning calm (quite the opposite of another water work, Klaus Rinke's *Water Sculpture*, where a water canon blasted water over visitors as they approached the gallery). Or the superb globe Goldsworthy fashioned from oak leaves in different states of autumnal decay. Or the globe made out of snow, and perched amidst some young trees (putting snow where it shouldn't be, or isn't usually found, is a recurring Goldsworthy preoccupation). Or the slabs of snow, set up in a line with slits cut in them.

All of the examples cited exhibit Andy Goldsworthy's recurrent formal principles: simple geometric forms; change, decay and transience built into each work; the pieces won't last (usually); natural materials; working with whatever is found in the landscape (no glue, string, tape or whatever to fix objects together); spontaneity; a minimal use of tools (a knife, a camera, but not – usually – the heavy machinery – trucks, cranes, and forklifts – of

some land art); sculptures are made alone, not with others, and not as a performance; objects are produced within a few minutes or hours (very occasionally longer, and sometimes Goldsworthy returns to earlier works); working on natural ground (not only in non-urban sites, but usually with a link to grass, soil, trees, water); frontal presentation and Renaissance space; and, crucially, photographing the sculpture from a number of angles.

The eroticism of Andy Goldsworthy's sculpture is readily apparent (and partly accounts for its popularity). The sexuality of sculpture is everywhere affirmed in 'high art', and in 'high art' cultural criticism. It's to do in part with the eroticism of the nude human form, which thousands of sculptors have explored and exploited. The sense of touch is supremely important to sculptors (as it is to most artists, but sculptors fetishize touching to an extraordinary degree, and Goldsworthy is no different in this respect). Goldsworthy said: 'I want an intimate physical involvement with the earth. I must touch'.[1] Touching is 'deeply important'.[2] Only touching gives the artist the deep understanding of his materials and nature, he remarked.[3]

Sculptors speak of the qualities of materials in terms of texture, surface, flexibility, malleability, viscosity, colour, strength, smell, associations, allus-ions, difficulty, weight, accessibility (and not forgetting the cost), and so on. Sculptors know that granite is quite a different material from steel, and certain woods – oak and holly, say – are different from pine or willow (sculptors have their favourite woods – Carl Andre preferred cedar, for instance, while Goldsworthy returns to the sycamore, the oak, the maple, the beech and the elm. He doesn't use just any tree, or any plant; he has his favourites).

Sculptors have a heightened 'haptic' sense, a sense of touch which involves the whole body, not just the hands. Viewers of sculptures also react to them with all the senses, not just sight. Spectators react to a sculpture with the whole body. This haptic sense is

the means of touch *reconsidered to include the entire body rather than merely the instruments of touch, such as the hands... It includes all those aspects of sensual detection which involve physical contact both inside and outsider the body.*[4]

The sensuality of Andy Goldsworthy's art, though, is non-human; there

are no 'human' figures in his work (most of the time), though there are vaguely humanoid forms (fingers, skulls, torsos), vaginal openings, phallic rocks, and stalks that bend gracefully like ballet dancers: if one wants to anthropomorphize Goldsworthy's art, it's easy (anthropomorphization being built-in to human perception). Even the most radically abstract art is always related to the human body in some way or another. Goldsworthy's art, though seemingly 'abstract', is very approachable. Goldsworthy spoke of stones and seeds in terms of phallic tumescence and orgasmic release: 'I found an energy in stone that can best be described as a seed that becomes taut as it ripens – often needing only the slightest of touch to make it explode and scatter its parts' (*Wood*, 23).

Andy Goldsworthy has made more traditional forms of art in galleries (pretty much every land artist – and sculptor – has exhibitions or shows work indoors): his bracken, fern and horse chestnut stalk works, for instance, were made by pinning the materials onto white gallery walls. These works – *Bracken fronds* (Ecology Centre, London, 1985), *Reeds, bracken and horse chestnut stalks* (Centre d'Art Contemporain, Castres, and Galerie Aline Vidal, Paris, 1989) and *Reed line drawing* (Paris, 1990) – were essentially free, open wall drawings, often employing basic motifs such as the circle and open curve. Wall drawings – i.e., drawing directly onto a wall – have been a popular form in contemporary art since the 1950s and 1960s, and some artists (such as Sol LeWitt), have taken it as one of their primary forms.

Some sculptors, such as Donald Judd and Eva Hesse, although they construct 3-D objects, often opt to mount them on walls (and some of Judd's sculptures are fairly large and heavy). Richard Serra chose walls the foundation of his art, with sculptures that lean against them.

Hanging screens of plants (which are related to the wall drawings) that Andy Goldsworthy constructed in galleries include the *Susuki grass* and *Horse chestnut leaf stalks* (both made in Japan in 1993), *Horse chestnut leaf stalks* (1994, Japan), *Yucca blades* (New Mexico, 2000), and *Rushes thorns* (1992, San Francisco). *Rosebay willowherb* (1990) was crafted in Goldsworthy's studio.

In 1995 (and later, in 2003), Andy Goldsworthy was invited to have his art appear on Royal Mail stamps (in the United Kingdom), as part of their

'Springtime' Royal Mail Mint Stamps (the commission was another indication of how Goldsworthy had become 'establishment'). Significantly, the Royal Mail chose Goldsworthy's leafworks for the stamps (these were some of Goldsworthy's most appealing, and most approachable works; their sense of detail and clarity were also suited to the tiny scale of a stamp). The stamps had photographs of five leafworks printed on them in landscape format, with the Queen's head and the price of the stamp printed in silver. The artist's name did not appear on the stamps: instead, the word 'Springtime' was printed in silver. The 19 pence stamp was an open circle of dandelions, with the ubiquitous black Goldsworthy hole at the centre. The first class (25 pence) stamp was a leaf horn made from sweet chestnut leaves.

Andy Goldsworthy's Royal Mail stamps were marketed as small, delicate but ecologically friendly expressions of the pastoral sublime. In the inform-ation card that went with the presentation pack, the blurb, in a flamboyant green script, waxed lyrical about the changing of the seasons, the coming of Spring and Maypole dancing, before introducing Goldsworthy as an artist of the ephemeral and pastoral, a poet who catches the spirit of nature as it changes and grows. The sensitivity, fragility and empathy of Goldsworthy's art were emphasized. 'Andy has celebrated *springtime* in a language that is all his own', claimed the Royal Mail brochure. Pull quotes were placed around the text, with colour photographs of Goldsworthy's sculptures. The Royal Mail commission was another example of the widespread acceptance of Andy Goldsworthy's art. Stamps are a prestigious assignment. Simply in terms of numbers, millions of Royal Mail stamps are printed. Goldsworthy's sculptures appeared on all manner of letters and parcels. The 'transient' nature of Goldsworthy's art was made 'permanent' on a massive scale (and Goldsworthy's art would have dutifully been archived by stamp collectors). A further set of stamps, featuring Goldsworthy's ice works, appeared in 2003, as part of a set of Christmas stamps.

Andy Goldsworthy has always spoken of the significance of the surrounding environment in his works. His sculptures are as much about the surroundings in which they are situated, as about the sculptures themselves. An exhibition inside, under a roof, in a gallery, enclosed by walls

and 'separate' from the natural world, is always going to be a quandary, then. Working inside was problematic for Goldsworthy, he confessed, because he was disconnected from the natural world outside, with its changes, its seasons, animals, people, history. The outside world was alive, while the gallery or public space could all too easily begin to feel dead after a while. 'I am not not sustained by working indoors. I have too much control inside, and after a while I am drained of reasons for being there' (T, 11).

The contemporary art gallery of the Western world, with its sparse settings, white-washed walls, bespoke lighting, racks of artists' prints, posters, trendy magazines and postcards, is a powerfully *cultural,* wholly artificial environment. The contemporary gallery is not 'natural', it is not 'nature', it is not a place of mist, wind, skies and soil. It is as irreducibly, irredeemably 'human' as Kansai International Airport, or the Santa Monica freeway. No wonder, then, that land artists such as Walter de Maria wanted to fill a whole gallery with dark soil (Jannis Kounellis used horses), to bring nature into the contemporary gallery in a big way. Of his Italian horse piece, Jannis Kounellis said the aim was to increase awareness of the 'basic nature of a gallery, of its bourgeois origin', its economic and ideological aspects.[5] Andy Goldsworthy's shows are something of a disappointment, in one view, because the works have to breathe without their usual natural surroundings.

Andy Goldsworthy emulated Walter de Maria in a direct fashion: in November, 1992, he covered the interior of the London gallery of his agent with clay (*Hard earth – Dorset clay smoothed out, left to dry*). The exhibit began as a smooth creamy-white expanse of wet clay/ earth. It looked as if the gallery was empty said Goldsworthy (S, 64), recalling Yves Klein's empty gallery show of 1958. *Hard earth* directly re-echoed de Maria's 1977 *New York Earth Room*: nature was present in the gallery in both works in force: in de Maria's *New York Earth Room* the dark soil had a solemn, weighty, fecund presence; in Goldsworthy's *Hard earth* time and transformation played a part: gradually, the clay dried and cracked, allowing the Goldsworthyan vision of the dark energies of nature to well up: the natural world was erupting into the gallery space. Goldsworthy would later explore similar installations of clay and earth (such as in 1996's *Cracked clay floor*, in

Glasgow), and one of his recurring forms was a wall covered with clay and left to dry (Goldsworthy used it as the backdrop for a dance work, *Le Danse du Temps*, performed by Régine Chopinot's Ballet Atlantique, which took place at LA Rochelle in France in November, 1999, in Paris in 2000, and the Barbican Centre in London in September, 2000).

ANDY GOLDSWORTHY AND WRITING 5.2

Andy Goldsworthy's writings are sometimes simple, sometimes blunt, and always matter-of-fact – in a no-nonsense, Northern English fashion. Goldsworthy comes across a rugged man of the wild, a 'whole earth man', ecologically sensitive, someone 'in touch' with nature, working with his bare hands, in boots and a waterproof, often in Winter, in cold, wind, rain and snow. There is a macho posturing to this (no doubt unintentional), in which the relationship with nature is described by the artist as 'fundamental', 'raw', 'violent', 'intense'. Goldsworthy sees working in the hard conditions of Winter a challenge, a 'test of my commitment to the landscape'.[1] In this view, making art becomes a tough feat of endurance: working for hours in sub-zero temperatures, or fierce wind, or labouring all night in the moonlight to complete a sculpture. Goldsworthy is not crossing the Atlantic ocean or the Sahara desert single-handed, but he does sometimes over-emphasize the physical effort and harsh conditions involved in making art (because all art requires physical effort of some kind).

Andy Goldsworthy has spoken about being 'shocked' by small-scale natural events, about work suddenly becoming 'intense', about the 'raw energy' of colours. Goldsworthy's writings are marked by words such as 'powerful', 'wildness', 'deeper', 'rooted', 'flesh and bone', 'feeling', 'essential', 'sense', 'energy', 'touching' and 'essence' (these words are taken from one page of Goldsworthyan philosophy, in one of Goldsworthy's main art books, 1994's *Stone* [6]).

All this talk of raw, powerful essence in nature recalls one poet in

particular – Ted Hughes, the Yorkshireman and one-time British Poet Laureate whose books (*River, Hawk in the Rain, Lupercal, Wodwo* and *Remains of Elmet*) are full of post-Gerard Manley Hopkinsian) evocations of wild shingle beaches, desolate moorland, ancient forests and craggy heights. If ever there was a poetic equivalent of Andy Goldsworthy's boulders, melting snowballs, slate cairns and red mud 'throws', it is Ted Hughes' muscular, stupendous verse. (The equivalent in the U.S.A. would be a poet like Robert Frost, or perhaps Walt Whitman, though with more blood and guts). Ted Hughes is a towering, tidal force in contemporary British poetry. Goldsworthy likely encountered his poetry at school as a set text, like thousands of other school children (Hughes is one of the few modern poets worthy of being an author employed in examinations. Don't get me started on the subject of mediocre poets celebrated in popular culture, such as, in Britain, Simon Armitage, Carol Ann Duffy, Benjamin Zephaniah, the dreary current Poet Laureate, Andrew Motion, or bloody Phillip Larkin, none of whom are worthy of standing beside Ted Hughes). Hughes' poetry has been rather overshadowed by his biography – that he was married to Sylvia Plath, darling of feminists, the intelligentsia and first-year English students (like T.S. Eliot, Emily Dickinson and Walt Whitman, Plath is one of those poets everyone has to consume at college). A brief glance at a book of Ted Hughes' poems uncovers treasures within seconds, which have deep associations with Andy Goldsworthy's sculpture, for example: the wonderful phrase 'a leaf's otherness' (from 'Egg-Head'). Or these lines from the poem 'A Violet At Lough Aughreberg':

The tide-swell grinds crystal, under cliffs.

Against the opened furnace of the West –
A branch of apple-blossom.

While we're on the subject of poetic equivalents for Andy Goldsworthy's art, Peter Redgrove should be noted here (of course, there are hundreds of candidates: Emily Dickinson, Edward Thomas, Walt Whitman, Rainer Maria Rilke, Aleksandr Pushkin, Arseny Tarkovsky, Arthur Rimbaud and many others). But Redgrove offers a fiercely independent, original, magical and sensual kind of poetry. It's tough, sexy, and soaked in future-looking

spirituality. For my money, Redgrove's up there with the best 20th century British poets (Robert Graves, D.H. Lawrence, Ted Hughes). This is from Redgrove's 'Sunlight, Moonlight, Stonelight' (which's about the Isles of Scilly, in Cornwall):

A heath of turf that bows to the sea at night,
A webwork of sunshine in which the islands are caught;
A black cliff still as a sleeping medium throws out its white cloud-ghost
Miles into the air. The sea contains more lights
Than the sky does, by millions, in fractured waves.[2]

And this is an extract from *A View of the Waterworks* (few contemporary poets have written so gracefully and insightfully of water and its workings):

Mirrors entering each other throughout the river
Flowing with juice like an immensity
Of ripening apple-tasting summer,

The fruits in potentiality
Flowing. Close to the banks
Where the chafe of earth slows the current

Sooty tadpoles wriggling like black fire
By lawns of sluice-wheels like black daisies
And underchambers that throb like muffled bells. (ib., 39)

Another link with Andy Goldsworthy's is nature-man Mellors in *Lady Chatterley's Lover,* the stoic, unflappable outdoor man who is in fact a 'New Man', painfully sensitive and alive (a good man, a dependable man, an earth-man – and a great lover too!). D.H. Lawrence was a big influence on Ted Hughes, and those other poets with affinities with Goldsworthy's art, such as Peter Redgrove. The Lawrence connection with Goldsworthy is emphasized by Goldsworthy himself: in the book *Stone,* Goldsworthy quoted from Lawrence's *The Rainbow,* one of those euphoric, ithyphallic passages about the ecstasy of consummation in an arch. Lawrence's intensely poetic novel about three generations of a Midlands family (his 'Brangwensaga') is a strident inrush of energy into Goldsworthy's otherwise pedestrian prose in *Stone.* Goldsworthy might do better to leave his writing

out of his books, and simply use quotes from John Locke and Lawrence, as he does in *Stone*. His own pontifications are too often uninspiring (to be fair, he is a sculptor, not a poet, so he doesn't have to be a genius with prose, but, like many 3-D artists since the 1960s – Donald Judd, Robert Smithson, Carl Andre, Dan Flavin – Goldsworthy likes to write and theorize about his art too. Goldsworthy doesn't *have* to include written statements with his exhibitions and books, but he clearly considers writing a valuable part of his output).

The arrogance of some of Andy Goldsworthy's pronouncements is inescapable: for all his humble sensitivity, the humility in the face of the power and grandeur of nature, he is a proud and confident artist. For example, of a 12 foot high cairn made beside a river in Illinois, Goldsworthy remarked that the work 'gives a feeling of the weight, power and volume of a river in flood in a way that a marked pole never could' (referring to the poles that mark flood heights [S, 37]). Goldsworthy is so sure of the effect his sculpture will have on the viewer. But this interpretation of the cairn only makes sense if one is primed first about the 1954 flood in reference to this particular cairn and river, and regards a pile of stones as more powerful as a measurer of a river's flood than a marked pole. After all, the idiot punter might remark, one can stand right under a 12 foot pole (if it's in the same place) and see it towering over one's head. A pole may be just as impressive as a stone mound.

'At its most successful, my 'touch' looks into the heart of nature', Andy Goldsworthy affirmed in the late Eighties (WH and AG). This is a pretty self-confident statement. It's like a Hollywood movie director saying 'my films touch the heart of contemporary society • war-torn Vietnam • life on a Mid-West farm', or whatever. Goldsworthy does not say my art *tries* to look at or explore nature, but 'my 'touch' looks into the heart of nature'. It's a formidable æsthetic, one with a self-assurance right-wing philosophers like Friedrich Nietzsche or Plato would be proud of.

Of a cairn made out of scrap steel which was placed next to an old foundry, Andy Goldsworthy said that the cairn 'touches the nature of an urban environment' (S, 35). Does it 'touch the nature' of the place? What is the nature of the place anyway? How can a human 'touch the nature' of the place? What is the quality of this touching? And what is the nature of

'the nature of an urban environment'? How does the artist know he's touched it? Simple: he believes wholeheartedly in his subjective, intuitive feelings.

Of steel, for example, the artist stated, like a modern day shaman: 'I can feel its source' (ibid.). What does this 'source' 'feel' like? And what is the 'source' of steel? The Earth? The energies that formed it? The people that dug the source material out of the ground and shaped it? The foundry that produced it? Further, how does the viewer know about this feeling the artist has for the source of a material? Is it expressed in the work? How can the audience test the authenticity of the artist's feelings? Or how much of the feeling for steel he rendered in the piece? These are questions which one can (and should) fire at any artist. Andy Goldsworthy's art is often unsure about the answers. It knows it is about nature, ecology, place, change, time, organic form, and so on, but its views on these matters, and its relation to them can be often confused, ambiguous, banal or simplistic. Or, to put it another way: Goldsworthy's works are his commentary upon the natural world, his interpretation of nature, his way of interacting with the natural world. So his art doesn't really need the writings – especially when they make claims that his artworks cannot always support. The sculptures do all of the necessary work of commentary and interpretation and representation on their own. (The artist's journals which document the day-to-day creations of the sculptures are something else, and no one can dispute sentences such as 'I covered one boulder with leaves, starting with dark green, which faded from pale green to yellow' (T, 172).) Such simple statements of facts – of what Goldsworthy did on a particular day in a particular place with particular materials – are incontestable (but maybe not that interesting to some viewers). Besides, for much of the time no one else is present when Goldsworthy makes his sculptures, so there's no way to test these statements.

A dandelion work such as *Dandelions* (1993 [S, 21]) highlights the
recurring problems with Andy Goldsworthy's sculpture: it has instant
appeal: the brilliant yellow dandelions are set in a mossy, pitted rock next
to a stream (how can you not enjoy that colour?). The sculpture seems to
emphasize the relative beauty of both the flowers and the setting: the
'organic', individual shape of the rock pool (there's only one *exactly* like this
on the planet, formed by natural forces in just this fashion), the contrasts
in brightness and colour in nature (grey and green rock, yellow dandelions –
pictorial concerns), the transience of nature (time, Goldsworthy's pre-
dominant theme: the dandelions' colour will fade; the flowers will be
pummelled by the next rain, or blown in the wind, or swept away when the
river rises). Yet the sceptical onlooker might come out with the most
common criticism of contemporary art: '*anyone* could make that' (which
could be said of many other Goldsworthy sculptures, although some require
immense skill). In *Dandelions*, there is little (artistic) 'technique' or (craft)
skill involved: the artist has simply placed dandelions in a pool (or rocks on
top of each other, or wrapped boulders in clay, or rubbed the bark off
twigs, and so on). *Dandelions* seems so simple, so easy (so effortless), like
so many of Goldsworthy's sculptures (*Balanced stone, Balanced rocks, Two
Scaur Water snowballs, Red river rock pools, Clay-covered rocks, Red sand
thrown into a blue sky, Orange stones* and *Yellow elm leaves*, to cite some
works from the book *Stone*). Hang on, the sceptic might claim, the
charlatan has simply stuck some flowers in a pool! That ain't 'art'! Easy to
see how Goldsworthy's art can seem a sham, like Carl Andre's bricks, or
Yves Klein's leap, or Andy Warhol's six hour film of someone sleeping.
Come on, the sceptic will complain, you can't be *serious*. (Jan Dibbets said
he liked projects that anyone could do. For example, he chose four sites at
random on a Netherlands map and went to each place and took a photo.
It was '[q]uite stupid. Anybody can do that' Dibbets admitted. It was also
silly for people to buy such works: 'it's stupid for other people to do it, or to
buy it from me. What matters is the feeling.'4)

 Sculptures such as *Yellow elm leaves, Red maple leaves, Beech leaves, Red
river rock pools* and other riverside works by Andy Goldsworthy seem so

modest, so easily put together. But Constantin Brancusi's sculptures of eggs, fish and heads are also very 'simple' shapes and forms: he reduced and rationalized natural forms until he concentrated them down to an 'essence' (the 'essence' of a fish, of a head, of a bird in flight). Yet Brancusi does not get accusations of superficiality and banality thrown at him (well, perhaps not as often as Goldsworthy). Indeed, his sculpture is really powerful precisely because he radically simplified it. Simplicity, as someone once said, is actually very difficult. It's difficult making something look simple and effortless. (What one sometimes forgets it the lengthy developmental process Brancusi undertook to reach that level of radical simplification).

With Andy Goldsworthy's art, though, the simplicity is of a different kind: is the confusion and criticism that Goldsworthy's *œuvre* attracts arise because he utilizes the *actual* material of nature? A real leaf, rock, petal or ice sheet, not an imitation or image or substitute of them? Is it that anti-Goldsworthy critics see a real rock covered with real leaves, not a mock-up or reproduction made in an artist's studio? (If they've only seen Goldsworthy's art in books and photographs, it's more problematic, because there's no way to test if the leaves and rocks were 'real'). Is it that Goldsworthy is getting so 'close' to nature he is using the very material of nature itself, without altering it much at all? Goldsworthy doesn't seem to *do* much with his materials: he sticks 'em in a pool, wraps 'em round a tree, builds a tower out of 'em, takes a photo, and then it's 'art'. Is it that his art does not (seem to) do anything more than this?

Andy Goldsworthy does not, for example, spend hours painting flowers in a meticulous, painstaking fashion, like Leonardo da Vinci. Leonardo also thought of himself as investigating nature (his curiosity attained obsessive levels, and was one of chief ingredients in his personality – his genius, as it's become known in the history of art. Leonardo's insatiable scientific curiosity is always cited in biographies of the artist. In a similar manner, Goldsworthy has often spoken of wanting to investigate the natural world, so that part of his artistic project is to add to his knowledge a little with each work made).

Leonardo da Vinci drew lilies and oak sprigs so beautifully (no artist has ever surpassed Leonardo's drawings for jaw-dropping grace), but the

beauty was partly in the 'faithfulness' of Leonardo's documentation of the plant. That is, the 'beauty' was in the plant (in nature) itself. Leonardo was perhaps revealing again to the viewer what was already there. Goldsworthy too does this: it is one of his aims (and one of the primary reasons for the increasing popularity of his art). But Leonardo made an *image* out of the flower, on a page, within a frame, inscribed with an instrument, while Goldsworthy uses the flower (or plant or rock) itself: he puts the flower into a pool, or takes the petals and wraps them around a boulder. There isn't that same distance between subject and representation (nature and culture) that there is in Leonardo's drawings: the traditional way is to draw, paint, sculpt, film or act the thing. Goldsworthy uses the thing in itself, by itself.

This is how the art of postwar (postmodern) and contemporary artists such as Andy Goldsworthy, Yves Klein, Andy Warhol, Richard Long, Joseph Beuys and Carl Andre differs from traditional Western art. They use the *actual object*, a process begun by Marcel Duchamp and developed by Kurt Schwitters. They preferred the object itself to a representation of it. Instead of using a replica or imitation or image of a flower or a rock or an icicle, Goldsworthy uses the flower, rock and icicle themselves.

The confusions of this relationship between reality and illusion, object and image, life and art in Andy Goldsworthy's *œuvre* are compounded by his use of photography, which instantly renders everything an image, a mode of representation, subject to all the strictures and structures of art, representation and ideology. Goldsworthy's photographs are plainly *not* the object in itself, but a representation, a simulcra, a suggestion of it, which is very different, and much more complicated.

Andy Goldsworthy has written two short statements on the relation between photography and his sculpture (both entitled "The Photograph", and published in *Hand to Earth* [9], and in *Stone* [120]). Both short essays reveal a philosophical confusion and æsthetic ambiguity regarding photography and art. Firstly, Goldsworthy states that the photograph simply records the work, in a direct, clear, routine fashion (how many other artists have stressed that function of photography in their art!). The idea is to capture the art object, which may change at every minute or moment. The photograph, Goldsworthy continues, is the *outcome* of his art, not the

initial reason for it. He quoted Yves Klein on his monochrome pictures (like the all-blue canvases). The photograph is necessary because it brings an outdoor experience into the context of the indoor gallery. The photograph, Goldsworthy asserts, is necessary to communicate something of the outside work in an inside context, even though '[m]uch of the energy is lost' (HE, 9).

This is all very well, this view of Andy Goldsworthy's of the photograph as a necessary documentation of the outdoor work. OK. In *Stone*'s "The Photograph" essay, though, the urge to 'capture' the sculpture out of doors becomes much more anxious. For example, if the roll of film doesn't come out, Goldsworthy feels disappointed: the photograph is needed to '*confirm* the success or failure' of the work (my italics). If the film's ruined, then the sculpture becomes 'dislocated – like a half-forgotten memory', Goldsworthy said. This statement shows just how important photography is for Goldsworthy, and for his art. He is not only a sculptor or land artist: he is also very much a photographer. The photograph is needed by Goldsworthy to keep the work alive – for himself, in his memory: it 'completes' the work, rounds it off. And, crucially, photography shows the work to others. Photography is Goldsworthy's main means of displaying his outdoor work. Rarely are the general public invited to see Goldsworthy making a work of art: 'I am not a performer', he complained (S, 120). The ephemeral, outdoor sculpture 'lies at the core of my art and its making must be kept private' (ib.).

Further confusions arise when Andy Goldsworthy discusses the conceptual aspects of photography: it is appropriate, he said, to use a time-sensitive medium such as photography. (Why not, then, move into video and film and time-based media? Why not record the red mud splashes on film and play them back in slow motion? Too obvious? Too technical? Too distracting? Why not take out stills from the movie of a collapsing arch, and exhibit those? Why not employ time-lapse photography, over a period of a year, to record changes in season, colour, form? Give that project to talented animators, for example, and they could come up with a many ways of depicting time and motion).

In fact, Andy Goldsworthy already has done just some of these things: he has returned to sculptures over a year, photographing them in different seasons (such as a stone, or the hazel stick circle made in 1997 [T, 34-35]).

He has taken motor-wind shots of collapsing stone sculptures (so that the arches and cairns are frozen in the moment of collapse). He has made works on the sites of former works. For his dance collaboration, he had one of his clay walls filmed over ten days to form a backdrop to the performance. He collaborated with German filmmaker Thomas Riedelsheimer on a film (*Rivers and Tides*, 2001). Video was part of the *Time* exhibition (2000) in London, where footage of the snowballs installation of June 21, 2000 was featured. (A footnote; Goldsworthy found he was not wholly happy with the filmed *Clay Wall*: 'I found the flicker and movement of the image as it goes through the projector more disturbing than I had anticipated'. It was the unstable, flickering quality of the footage that unsettled Goldsworthy , the changes in colour and light: 'the physical nature of the film and its projection makes the medium more present that I would like it to be' [T, 84]. That's an interesting remark that suggests that Goldsworthy prefers recording media to be transparent. He doesn't want his photographs drawing attention to themselves as photographs; he wants the viewer to look through them to the sculptures and places he's photographing). Jan Dibbets said that documenting the work wasn't important: 'I've done lots of works without taking photographs'.5

Future developments in Andy Goldsworthy's art over the next decades will include, one imagines, more use of video and film technology. Instead of using large Cibachrome framed photographs, why not project slides onto gallery walls, *à la* installation art? Then 'the visual smell and detail of the work' might be even better expressed than in a Cibachrome print. Or why not play around with digital video technology, like Peter Greenaway and David Hockney, and produce sequences of kinetic sculpture? Surely Yves Klein, Goldsworthy's guru, would have leapt into these new computer/ digital/ video/ film technologies just as vigorously as he 'leapt' into space in his faked *Leap Into the Void*.

Andy Goldsworthy's biggest confusion concerning photography, however, is about that age-old chestnut, the 'reality' of the image. Ever since modern photography was invented, in the early/ mid-19th century, critics have pondered on how 'real' photography is, on photography's relation to reality. Goldsworthy's confusion on this point is illustrated by his last words in *Stone*: '[i]f the photograph were to become so real that it overpowered and

replaced the work outside, then it would have no purpose or meaning in my art' (S, 120).

Aren't photographs already 'real' then? Or are they mere 'illusions'? Surely the photograph is 'real' already, because Andy Goldsworthy admits it is a 'record' of the work, needed to 'confirm' the work? What does he mean, about photography becoming 'so real'? Isn't photography already 'so real', like film and television are 'so real'? Cinema, TV, digital and photographic images are 'so real', in fact, they are consumed as 'real', believed as 'true' (the average viewer in the West, for instance, spends nearly three months of the year continuously consuming TV. Is that not a kind of 'reality' too, in Goldsworthy's æsthetics?) What about other forms of technological recording; are these, too, not yet 'so real'? What about virtual reality, the cyberspace, the internet, or the 'hyperspace' of telephone conversations? Are these, too, still lodged in an archaic argument of being mere 'illusion'? No.

Andy Goldsworthy has to realize that most people know about his art (and love his art) from photographs. Most people who know of Andy Goldsworthy have *not* seen an Andy Goldsworthy exhibition; have *not* seen his art in its outdoor environment; have *not* seen Goldsworthy making a work. They have bought the books *Arch, Midsummer Snowballs, Time* or *Passage*, or seen photos of his art in magazines, websites and books. For the punter who consumes art in books and printed material (or on TV, the web or radio), the 'real' art object doesn't need to exist: what counts is the media representation, the simulcra, the image of it. But this would upset a realist and sensualist like Goldsworthy, who so passionately needs 'to touch' ('I must touch'). A world of digital, virtual, hyper and cyber reality would be abhorrent to him. Yet that is how his art is mainly consumed. Punters have bought the books, seen the photos in magazines, logged onto art/ sculpture websites and that, for them, is what constitutes the art of Andy Goldsworthy. Thus, the *photographs* of Goldsworthy's sculptures are *already* 'so real' that they have, for the consumer, in some cases replaced his art. (Of course, art consumers would like to know that the stones, for instance, really were balanced on top of each other on the Welsh coast. But Yves Klein faked his *Leap*, and invited people to see an empty gallery). In the age of art impresarios and art 'terrorists' (such as Yves Klein, Andy Warhol, Claes Oldenburg, Jeff Koons, Bruce Nauman, Gilbert & George, the KLF),

when artworks are only known through radio, TV, the internet and the press, Goldsworthy could have faked everything.

DECORATIVE ART? 5.4

For Richard Long, Andy Goldsworthy is a 'second generation' artist, and is 'decorative (!)'.1 Being 'decorative' is seen as not a good thing for serious artists. Many art critics, though, tend to admire Goldsworthy. Neil Hedges wrote: '[t]he artist always achieves his goal, establishing and stimulating our own senses to view or touch conversant shapes and materials with much delight' (73). The beech leaves placed in a rock pool at Scaur Water in Dumfriesshire (made in October, 1992) are certainly pretty and decorative. The next Spring, Goldsworthy put dandelions in the same pool. The two works were printed in the art book *Stone*, and look like a diptych of the seasons Fall and Spring. They were an obvious exploration of time and seasons, a reading emphasized by the use of the same viewpoint for each photograph. Handfuls of more dandelions were set on top of a large rock in the midst of Scaur Water (1993, [S. 18]). A different yellow, of elm leaves, was the colour component in another Scaur Water rock work, *Yellow elm leaves* (1991), and also in the long line of *Elm leaves* (1994) running between two trees and over the surface of Scaur Water. And another waterbound boulder sculpture of the same period was covered with red Japanese maple leaves; the colours, yellow and red, stand out dramatically from the subdued greys and greens of the water and surrounding rock of the rivers.

Andy Goldsworthy's output is 'decorative', unquestionably, but the colours and patterns are taken from nature: the seemingly 'pretty' colours of bluebells and dandelions, of maple leaves and the Australian Outback, are colours already present in the natural world: they've been there for millions of years. Rather than finding colour 'decorative', for Goldsworthy it is 'raw with energy' (S, 6). When Goldsworthy placed red Japanese maple

leaves in water their colour 'becomes so intense' he said.2

Many of Andy Goldsworthy's works are built on the 'patterns' found in nature. For example, there are many sculptures of Goldsworthy's which create patterns from leaves or stones which have changed colour. Goldsworthy's fabricated many lines of bramble leaves which have become yellowed and browned. He aligned the coloured sections of the leaves together. There are lines made of cherry leaves, poplar leaves, elm leaves, beech leaves and rosebay willowherb leaves (among many others). The colours of the cherry leaves (Cumbria, 1984) turn from green through yellow to red then brown. These are Autumnal works, rejoicing in the incredible colours of the season. Even in clogged-up, foggy cities (when nature appears to be a relic left behind thousands of years ago in favour of video screens, subway trains and cel phones), the changing colours of Fall leaves may be noticed. In the countryside settings of (most of) Goldsworthy's sculptures, the colours are rich. They can stand out in the metropolis too, when the viewer is torn away from the noise and flux of the city for a moment. The 'shield' of sycamore leaves stitched together on Hallowe'en, 1986, in Glasgow, Scotland, for instance, glowed bright gold. Goldsworthy was excited by the colours of this particular Fall:

I arrived during a week of the most intense autumn weather I have experienced and the most extraordinary range of colours in the leaves scattered everywhere – sycamore, elm, chestnut...3

The suspended leaf shield turned out to be 'one of the best pieces I have ever made', Andy Goldsworthy acknowledged. A year later, Goldsworthy revived the leaf shield, this time from red sycamore leaves, and suspended from an oak tree (Yorkshire, 1987). The suspended leafworks enable light to become a key element in the sculpture: the translucence of the leaves was foregrounded. The sun completed the sculpture, making the leafwork as 'extraordinary as going to the Arctic', Goldsworthy said (HE, 167). The two leafworks of October, 1997, at Storm King Art Center in New York state (orange and yellow stuck onto a rock), were created specifically to catch the morning sunlight.4 Another shield, *Horse chestnut leaves* (Yorkshire, 1987), was deliberately fashioned for darkness, hanging in amongst some rhododendron bushes.

Light is one of the key formal elements that Andy Goldsworthy explores in his sculpture. It's an aspect of his art that some spectators might not immediately acknowledge – partly because it is so obvious. But Goldsworthy is using light as gracefully as the key light artists (James Turrell, Bruce Nauman, Robert Irwin and Dan Flavin). Critics have spoken of Goldsworthy's 'stunning effects of light and atmosphere'.[5] Because place is so important,[6] light (and colour) becomes a primary tool. Some Goldsworthy sculptures pivot very much on luminosity and opacity – not just the leaf shields, but some of the snow walls, the holes and reliefs in sand, or the throws (which're usually side-lit or back-lit, or silhouetted, to pick out the throw), so that without the right sort of lighting, they do not work properly. Some sculptures are created in response to certain lighting conditions – the stick sculpture in England's Lake District (in 1988), made in the pale, liquid light of dawn, for example, or the stick and willowherb stalk lake pieces in Yorkshire (May, 1987), which were completed at twilight. 'When I work with the land I work with the sky. When I work with water I am working with the clouds', stated Goldsworthy (HE, 167). The branches from a mulga tree in Australia (1991) were edged with red sand in order to catch the light of the setting sun: set end to end, the red-edged branches looked like a snake (appropriate for the Australian Outback). Other sculptures are seen in a variety of lighting conditions – stormlight, snowlight, misty skies (the snow wall of 1988 at Blencathra in Cumbria is an obvious instance).

Some of the brightest of Andy Goldsworthy's leafworks were created in Japan, where the maple leaves are dazzling in October and November (in, for example, *Maple patch*, November 22, 1987, or *Japanese maple*, November 21-22, 1987).

Andy Goldsworthy's flower pieces are inevitably 'pretty'. It's difficult to use flowers, in poetry, sculpture, painting or performance, without appearing 'pretty' (Goldsworthy realizes this [S, 6]). Think of Rainer Maria Rilke's many flower poems (to roses, irises, lilies), or the beautiful, sonorous flower watercolours of the German Expressionist painter Emil Nolde. Like Nolde's radiant flowerpieces, like the flowerworks of Flemish and Dutch art, Goldsworthy's flower sculptures are luminous. The dandelion piece (April 28, 1987), which is a spread of flowers making a hole in the middle, is

powerful not because of the shape the artist's made, but because of the vibrant yellow of the flowers.

Flowers are amazing, some of the most exquisite creations on Earth. All Andy Goldsworthy appears to have to do is to arrange them in a simple structure and the beauty of the flowers does the rest. What's also noteworthy about *Dandelions newly flowered* is that the sculpture is set on 'a grass verge between dual carriageways' (highways), so the title informs viewers. If this is so, then this particular sculpture/ photograph is very noisy: there will be cars, coaches, bikes and trucks roaring up and down the roads on either side of the sculpture. Goldsworthy's art reveals, as good poetry does, the incredible beauty of nature, even amongst the inhospitable environment of a major freeway. Even at the verges of roads, in hedges beside shabby highways, on empty intersections, there are remarkable things growing.

Sometimes Andy Goldsworthy goes too far in evoking the beauty of nature. In another dandelion piece, *Dandelion flowers pinned with thorns to wind-bent willowherb stalks laid in a ring held above bluebells with forked sticks* (May 1, 1987), Goldsworthy fashioned a large open circle of dandelions and ranged them above a field of bluebells (S, 11). But it's too much: the incandescent yellow of the dandelions set against the equally rich blue of the bluebells. One doesn't need to do anything to bluebells in a wood to make them look beautiful. Thus, *Dandelion flowers*, is a powerful image, but does nothing to explore nature, Goldsworthy's avowed artistic aim (but maybe *Dandelion flowers* is about nature's unbridled beauty, one intoxicating colour on top of another. Or maybe it's about intensity, or being overwhelmed).

Other dandelion works include a line of dandelions laid on grass growing in a pool (Yorkshire, 1987), dandelion petals edging mud slits (Yorkshire, 1987), a line of dandelions following the outline a rock (Dumfriesshire, 1994), a line of dandelions pressed into the edge of a village lane (Cahors, France, 1996), and dandelions laid along the Capenoch tree (1994).

Andy Goldsworthy has covered solitary branches with poppy petals and leaves in many locations, including Yorkshire (1981), TICKON (1993), Stonewood (1992), and Cornell (1999). Other lines of leaves laid on water include Digne (1998), *Japanese maple* (Japan, 1987), *Horse chestnut leaves*

(Leicestershire, 1987), *Hazel leaves* (Dumfriesshire, 1991), *Elm leaves* (1994, Dumfriesshire), and *Beech leaves* (London, 1985). Goldsworthy has also made many upright drawings on tree trunks and walls in his customary serpentine form, out of sand, clay and water – in Holland, 1999, and Digne, 1998.

Another favourite Andy Goldsworthy sculpture is the serpentine hole (or 'river') carved out of sand, usually on a beach (Holland, 1999), but sometimes inland (Goldsworthy dug quite a few in New Mexico in 1999). Another Goldsworthy motif is to bury tree trunks and branches and boulders within his stone walls (as in New York state [1993], and at Storm King [1996]). On a dry boulder in the lake at Storm King (in October, 1997), Goldsworthy damped the surface with water, making a circle, and photographed it as it dried off (*Wall*, 66-67). Goldsworthy has also released red stone powder above a waterfall (at Scaur Water, 1997), so the pool below turns ochre, and stained other pools or rivers with powder.

The attention to the minute, detailed qualities of nature that Andy Goldsworthy's art rejoices in is mirrored in Romantic and nature poetry. John Cowper Powys, for instance, could get excited by nothing more 'spectacular' than a patch of moss on a wall. Goldsworthy's sculpture has the same delight in the small, seemingly unimportant aspects of the natural world. In his *Autobiography* (1934, one of the great autobiographies, as well as the most unusual), John Cowper Powys wrote: 'I am looking at a patch of moss on a greenish marbly rock and I am aware of a deep sensual pleasure' (41). And in Cambridge, on one of his many walks around the outlying areas of the city (now probably warehouses and housing), Powys remarked that 'certain patches of grass and green moss transported me into a sort of Seventh Heaven' (199).

In his sadly still neglected fiction, John Cowper Powys described the ecstasies that (land) artists can have in when interacting with nature. Powys's characters (like those in the writings of Johann Wolfgang von Goethe, Robert Herrick or Matsuo Basho) are nature mystics, just as land artists such as Andy Goldsworthy, Ana Mendieta, Peter Randall-Page, Mary Miss and Wolfgang Laib are in part nature mystics. Powys reminds readers that some of the most extraordinary phenomena on the planet are very small, and apparently very ordinary. It's the world in a grain of sand vision

of William Blake, the ability to discover miracles anyplace (one of Peter Redgrove's poems is about the beauty of individual grains of sand on a beach, how each one is a different colour – red, blue, black, grey, yellow, not just that overall 'sand' colour). Goldsworthy's art is partly an art of small things, like leaves, stalks, and icicles.

Sam Dekker, in John Cowper Powys's massive nature mysticism novel *A Glastonbury Romance* (1932), experiences a *participation mystique* with the Earth: '[w]hat he felt was a strange and singular reciprocity between his soul and every little fragment of masonry, of stony ground, of mossy ground...'[7] And Dud No-Man in the last of Powys's Wessex quartet books, *Maiden Castle* (1936), when he comes 'on a patch of green moss on a grey wall' gets 'a sensation that's more important than what you call 'love', or anything else, nearer the secret of things too!'[8]

ANDY GOLDSWORTHY THE CELTIC SNOWMAN 5.5

When I work with winter, I work with the North. For me, north is an integral part of the land.

Andy Goldsworthy[1]

Much of Andy Goldsworthy's art is about ice and snow, and is created from ice and snow. Goldsworthy is distinctly a 'Northern' artist (not just 'Northern' in terms of Northern Europe, but in terms of Northern Britain), who makes work in landscapes that come out of the 'Celtic fringe', out of the sort of landscapes that Celtic culture has traditionally exalted: it's the landscape of misty, rocky hillscapes; of damp Autumnal forest floors shin-deep with leaves; of wild snowfields whipped by the wind; of clear, chilly brooks banked with large mossy boulders that never stop flowing; of still lakes at dawn. It's easy to imagine (British) mythical figures such as the Lady of Shallot, Lancelot or King Arthur or Gandalf riding through Goldsworthy's landscapes without altering anything. They are the realms of

Merlin, Taleissin and Morgan Le Fay, of Welsh legends such as *The Mabin-ogion*, of modern legends such as *The Lord of the Rings*, of historical events shrouded in mists, of historical figures such as Robert the Bruce, Owen Glendower, King Edward and Boadiccea.

The places associated with Andy Goldsworthy – his studio at Penpont near Thornhill in Dumfriesshire, Scaur Water and Stone Wood nearby, the Lake District, Carlisle, Yorkshire Sculpture Park, Grizedale in Cumbria, Leeds, Leadgate in Durham – they are all Northern British sites. And the stereotype attributes of Britain's North – grimy towns, constant drizzle, bleak, wind-swept moors, gloomy overcast skies, grim humour, down-to-earth and no-nonsense attitudes – all chime with Goldsworthy's sculpture. (Not *every-thing* to do with Britain's North, however: Goldsworthy's art is not usually associated with heavy industry, with steel, shipbuilding, or mining, for instance. Or the big industrial towns (which are now post-industrial), like Sheffield, Newcastle and Manchester.)

One wonders if Andy Goldsworthy would prefer to work in snow and ice more than in any other medium. His notes and artwork titles record many frustrations stemming from working with snow. In temperate snowlands, though, one feels Goldsworthy is very much at home. Snow has the right sort of qualities Goldsworthy looks for in a material: it is malleable (easy to sculpt), it melts and changes, its whiteness makes for good, contrasty imagery, it's good for small or large works, it is natural, it's freely available, there's lots of it, it changes over time (it seasonally alters the landscape, and later dissolves into it).

In Andy Goldsworthy's snowworks one senses also the sheer fun of working with snow. For people in most of Britain, snow is not a definite event each year, as it is in Northern Russia or Alaska, which an artist can depend upon. For children, snow can be an exciting occurrence (while British adults always gripe about it: for them, snow is disruptive, and dangerous). Goldsworthy speaks like a child of 'the effect, the excitement' of the first snowfall (HE, 165). Some of this excitement comes across in Goldsworthy's snowworks. He has made, for example, patterns in the snow by rolling a snowball around a field, exactly as kids do when it snows (*Snowball trail*, Brough, Cumbria [1982] and Yorkshire Sculpture Park [1987]). Linked to the snowball trails was a rectangular wall of snow built on the hills in Penpont

in March, 1998.

Andy Goldsworthy has been lucky in that there were some good, cold, snowy Winters in Britain around the late 1970s and early 1980s. 1977-78 and 1981-82 I remember were fun, with good falls of snow which lasted days – his art might have developed differently if he had made work during milder, snowless Winters. (Even so, even if there's only a light dusting of snow, Goldsworthy will be out there, making works. A punter looking at Goldsworthy's books might think that Britain is a wildly snowy place. It isn't. It might have been snowbound on a massive scale during the last Ice Age ten or more thousand years ago, or during the 'little ice age' of mediæval times, which lasted up until the 19th century – the most famous image of that centuries-long cold spell were the frost fairs on the River Thames. But it *is* significant that Andy Goldsworthy lives in Scotland, which can often have snow when the rest of Great Britain is snowless).

To demonstrate the grandeur of the setting and the changeability of the weather,[2] Andy Goldsworthy reproduced (in the book *Andy Goldsworthy*) three double page spreads of a snow wall made at a favourite spot, Blencathra in Cumbria. The full title of the work explains some of it:

<div align="center">

Slits cut into frozen snow
stormy
strong wind
weather and light rapidly changing

</div>

The title reads like a *haiku*, like many of Andy Goldsworthy's titles. The title, however, does not convey the Romantic power of these photographs which directly recall the oil paintings of J.M.W. Turner and the British landscapists. Behind the slitted snow wall the spectator sees brooding cloudscapes, with the sun burning through in the second shot. In the third picture, the wall, in the foreground, is in shadow, while the sun shines onto a portion of a distant hill. Above drift clouds with softened edges, as out of Mark Rothko's abstract panels or Emil Nolde's watercolours of North Friesland.

Other Andy Goldsworthy iceworks include icicles stuck onto a wall (made on New Year's Eve, 1992), *Icicles* (2003), *Icicle Spire* (2003) and *Icicles frozen to a rock* (1991). In these works, the icicles are clustered together,

like a mini forest of trees. The icicle works, like the mound of stones which were dipped in water then frozen onto a rockface (S, 44-45), are testaments of endurance: the artist had to keep returning to the same place to pull the work off. *Thin ice* (2004) was sheets of ice frozen to rocks over Scaur Water; *Ice 'fish'* was a flat curve made from little sheets of ice; *Ice column* was also constructed from sheets of ice refrozen together: the result looked like a Naum Gabo tower (both 1991, Dumfriesshire). There was also an *Ice star*, two icicles aimed at each other ('pointing their frozen energies towards each other'),[3] an *Ice hole* made in Yorkshire Sculpture Park, and a hollow *Ice ball*.

The biting cold maybe gives Andy Goldsworthy a sense of heroism, for suffering invariably enhances a work (as in, 'this work was difficult, made under adverse conditions'). After all, Goldsworthy is not an artist who prefers to make work in the 'comfort' of a home or a studio (working indoors doesn't feel 'real' to him). No: he ventures out into the wilderness, where it can be uncomfortable and challenging. He claims to know the landscape around his studio in Penpont, Scotland, very well (he would do – after creating sculptures in the area regularly since the 1986), so that the snow does not hide the world: 'I know what lies under the snow – I know the earth beneath' (HE).

Always Andy Goldsworthy stresses the intimate relationship he has with nature. Part of this intimacy comes from returning to the same patch of land again and again. Through successive visits, layers of touch and meaning in the landscape are uncovered by the artist. An artist returning to the same space always works in time as well as space, for s/he creates a personal history of that place. S/he works with her former selves, as well as in the present – with the artist and ideas s/he had two years ago, ten years ago, twenty years ago. 'Some places I return to over and over again, going deeper – a relationship, made in layers over a long time', commented Goldsworthy (AG).

For an artist like Andy Goldsworthy, the land around Penpont, Thornhill, Burnhead, Keir Mill, Cleuchhead, Carronbridge, Closeburn and Tynron would be very, very familiar. Weeks or perhaps months would be spent each year fashioning sculpture in this part of the South-West Scotland. One can bet that Goldsworthy will be out there making art in the area, if he's not

working on a commission in Digne or California or wherever, or dealing with admin, or on vacation. Goldsworthy's sculptures will be situated all over this part of the world. Some will be extremely ephemeral, and some might last a little longer than a day or so.

The personal dimension is important in Andy Goldsworthy's work. His sculpture is not 'impersonal' in the sense that it could be made 'anywhere'. It is, like most land art, always a product of a relationship between an artist and a particular place. Making the art itself, the doing of it, is important (is everything, really) for Goldsworthy. So that when people ask the eternal question, *but is it art?*, he retorts, well, he doesn't know and doesn't care, but 'it is important and necessary for me as a person.'4 In this sense, an artist is someone who makes art.

Sceptics may claim that many of Andy Goldsworthy's sculptures gain much of their fire from their situation in wilderness landscapes. They would be right. Although Goldsworthy states that many of his sculptures are made in built-up areas, areas of dense population and human activity, a glance through any Andy Goldsworthy book or a visit to a Andy Golds-worthy show will reveal the large proportion of wilderness or rural land-scapes in his art. He expunges all the trash, houses, electricity poles, apartment blocks, cars and roads from his photographs, and presents lush streams, moorland, forests and hillsides. There are no people at all in his art, except Goldsworthy himself, who is sometimes seen, with his beard, sweater and jeans, making a piece of art (very occasionally, one or two other people. Sometimes his assistants; but, if anyone appears in a photo-graph in a Goldsworthy book, it's usually the artist himself).

In this sense, Andy Goldsworthy's work is not at all figurative – but neither is it 'abstract', in the Mark Rothko or Piet Mondrian sense, for real, recognisable objects appear in his work. This is one of the reasons for the growing popularity of his work: apart from the ecological/ green move-ment, the New Agism, and the accessible, decorative quality of his work, it is thoroughly countrified and rural, quite in keeping with primæval desires for escape into the country, that nostalgia for nature that lies behind the pastoral and landscape tradition in the West.

Andy Goldsworthy speaks as poets do of the spirit of place, where the place itself becomes as important as the object: 'the work is the place',

Goldsworthy stated (S, 6). Any number of artworks gain much from their setting, from Greek temples to an Italian master's oil painting discovered in a dark, incense-smoky church in a backstreet in Rome. For the land artist, of course the place becomes (is identical with) the work. In the typical Goldsworthy work, though, there is usually some object at the centre of the landscape or the photograph. Usually a rock covered in leaves, a red pool, or a slate cairn is at the centre. At first glance, the object seems to be the subject of the artwork and the focus for the eye. Not so: the surround-ings are just as important, and these pastoral landscapes help to create the impact of Goldsworthy's art just as much as the woven grass stalks or the sticks wrapped around a boulder.

Andy Goldsworthy's skill is not just to 'touch nature' (whatever that means), but to touch the chords of desire for the natural world in people. Goldsworthy's art is popular partly because of this powerful longing among Western audiences for contact with the natural world, an appetite which is manifested in natural history and gardening shows on TV, in jaunts to zoos, gardens and windswept hillside car lots, in Edward Hopper, Vincent van Gogh and Claude Monet posters and prints, in health and fitness (jogging and walking), in sports like mountain climbing or skiing, in gardening magazines and gardening centres, in plants in the house, and in the popularity of rural novels by George Eliot, Henry David Thoreau and Emily Brontë. The eco/ green movement (and its associated movements in pagan/ New Age/ road, anti-capitalist, anarchist and animal activism), taps into this nostalgic love of an urban-centred culture for all things 'natural'.5 The natural world seems to be green and life-giving and untarnished by the complexities of modern life. The natural world, which is Goldsworthy's preferred world, is a place of leaves, rivers, animals and stones, a place seemingly devoid of people, the ones who mess things up, who complicate things, who introduce the concepts and realities of neurosis, confusion, waste, violence, consumption and politics into the 'pure' natural world.6

It's not like that at all, but these eco/ green/ pastoral feelings are persistent. Andy Goldsworthy's art, like the rural novels of George Eliot and D.H. Lawrence, like green politics or the money-spinning popularity of the French Impressionist painters, trades on the desires for an earlier, ancient Paradise, a time when things seemed to be simpler, richer, deeper. This is

the 'green world' of childhood, a time of playfulness and living close to the Earth, enjoying the seasons passionately but also freely, in a relaxed manner. In mythology, it is the 'Golden Age', *il illo tempore, ab origine*, in the Creation era, at the origin of the world, before the Fall of Adam and Eve into sin, a time before œdipal anxiety and patriarchal psychosis (the sins of the fathers), a Gaia or whole earth time, all 'natural' and recycled and vegetarian, a holistic time, a time of social unity, when everyone felt as one in communities and loved each other, a time of maternal bliss, when women were nurturing Mother Goddesses and men could be sweetly dreaming babies without feeling embarrassed. The fact that none of this ever existed doesn't lessen the desire for it one jot.

Andy Goldsworthy has said that it is important for the viewer of his art to fill in the gap between the photograph of the sculpture and the real sculpture that he made someplace else. The photographs are incomplete on their own, as artworks: they require the spectator to create the rest of the artwork by using their imagination and memory, by remembering what it was like to be cold or wet or in a wood. To recall what it was like to be a child, touching leaves or snow or ice [S, 120]).

The viewer, then, supplies the 'real' experience, the effect ('the real'), which the photographs suggest but cannot complete. This could be another reason for Andy Goldsworthy's popularity: that his art leaves some part of the sculptures incomplete, and the viewer can supply the rest from their many memories of the real world. A kind of art of interactivity, fed by nature photography. There is space for the viewer within the work; the viewer is invited into the work. In other words, Goldsworthy's sculptures offer plenty of the natural world, but not too much. And they are abstract, but not too much. An art of balance, and an art of inclusiveness.

Andy Goldsworthy's art books, commissions and shows trade on this pastoral imagery and desire: they allow stressed, overworked and neurotic city dwellers time out from staring at the control screens (TV, ATMs, computers, cel phones) of the megavisual world, encouraging a little daydreaming into the soft greens and greys of wild moorlands, the life-nourishing liquid of clear brooks. Goldsworthy's art may be increasingly successful because it reminds people that, yes, one does love nature after all: one came from it, one'll go back into it, in the end, in death (ain't no

escape from *that*). Goldsworthy's art may hit home because it does *not* bombard people with telephones, computers, cars, factories, radios, TVs, microwaves, washing machines, vacuum cleaners, clothes irons and faxes, all those machines that connote *labour*, that are the symbols and mechanisms of working life. In Goldsworthy's green world, all is natural, untechnological, with artifacts that evoke a return to basics: stone, wood, leaves, ice.

TOUCHING NORTH (1989) **5.6**

Andrew Goldsworthy's most dramatic work (to date) is probably *Touching North* (1989), four circular arches made of snow. It is dramatic mainly due to its location, that space so thoroughly a masculine 'wild zone', the place of macho adventures and expeditions, colonization and courage: the North Pole. Goldsworthy has made bigger sculptures since *Touching North* (such as the *Sheepfolds* project, or *Garden of Stones*, but as a setting, the North Pole takes some beating.

The project was organized by the Fabian Carlsson Gallery, London (one of Andy Goldsworthy's art dealers at the time), and overseen by Fabian Carlsson. In March and April, 1989, the expedition visited Montréal, Resolute, Grise Fjord, Camp Hazen and the North Pole., and the resulting show travelled to London, Edinburgh and L.A. through 1989.

Andy Goldsworthy's intention with the grandeur of *Touching North* was 'to follow North to its source'. He had already encountered 'North' in 'the cold shadow of a mountain', he said, meaning he had already found the extreme cold associated with the North Pole in Scotland and Northern Britain. But there was a practical reason for going all the way North to the North Pole, and that was so that Goldsworthy could enjoy 'the luxury of constant freezing' (in Britain, snow comes and goes: it does not stay for months on end as it does in the North Pole). As Goldsworthy wrote:

so much that I have made in ice has been frustrated by a rise in temperature. I have held ice seemingly for ages waiting for it to freeze only to let go and see it drop off.[1]

Although the four circular walls were the centrepiece of the *Touching North* project, Andy Goldsworthy made other snowworks during the expedition. The *Snow Spires* sculpture was two groups of pyramid forms between five and seven feet tall (1989, Ellesmere Island), while *Snow slabs* was a long line of slabs, recalling the lines of prehistoric stones at Carnac in France. Other works in the *Touching North* group included a wall constructed from narrow slabs of snow balanced on top of each other; flat wedges of snow piled on top of each other to form a low bridge; a series of free-standing arches placed in a row, recalling the nave of a Gothic cathedral; a cairn made from circular slabs of snow; a low wall of snow with arrow-shaped slits carved in it; another wall consisting of chevrons placed end-to-end.

There were also several narrow walls of snow with slits carved in them: one in the shape of a star; another in a Goldsworthyan serpent; another with parallel zigzag lines. To enhance the grandeur of some of his snow pieces, Andy Goldsworthy's publishers printed them in a large, double-spread format in the book *Andy Goldsworthy* (1990) and the book that accompanied the exhibition, *Touching North* (1989).

All forms are to be found in nature, and there are many qualities within any material. By exploring them I hope to understand the whole.

Andy Goldsworthy, *Winter Harvest*1

One of the problems Andy Goldsworthy's art addresses head-on is the age-old tension between the 'real world' and art, between objects as they are in the everyday world, and objects as they are represented in art. Goldsworthy invites the viewer to look again at nature: not just at the beauty of it, but at the multitudinous variety of forms in nature, and the forces and processes at work in the natural world. Goldsworthy's sculpture is a poetry of natural forms, in which notions of 'representation' seem to be side-stepped, because he uses things 'as themselves' (the use of photography, though, sees a swift return of confusions over the politics of repre-sentation). The snowball in *Midsummer Snowballs* (2000) is not plastic masquerading as a snowball, but a real snowball. Similarly, the twigs and stalks and needles and pebbles folded into the snowballs are real. What's amazing is the actuality of nature: the variety of forms, the way the branches twist, for instance. Goldsworthy would have the viewer look closely at nature again. By using 'real' objects, Goldsworthy aims to demolish notions of representation and mediation. Instead of a picture of snow, one gets in Goldsworthy's art snow itself; rather than paint pebbles, or sculpt them in bronze, Goldsworthy uses real pebbles.

Of course, there are problems with using objects as objects – Marcel Duchamp with his readymade sculptures confronted this problem. The problem is partly one of context: because, placed in a museum, so ob-viously as items to be studied, natural forms become art. The snowballs of Andy Goldsworthy may not be on pedestals, but they are perceived as art objects. The leaf sculptures are more obviously works of art, set on shelves, or photographed against paper backdrops, as bottles of perfume or Swiss watches are photographed in advertizing. If the viewer's looking at a Goldsworthy sculpture in a book or a gallery, the viewer's already anchored in a gallery or æsthetic mode of viewing. If Goldsworthy's sculptures are in a gallery, the spectator sees them as art (and a particular kind of Western,

bourgeois art, the sort of art that is exhibited in Western, bourgeois galleries; i.e., not 'outsider art', or children's art, or amateur art, but professional, commercial art).

Paul Nesbitt, a supporter of Andy Goldsworthy's art, commented of the leafworks:

Throughout these works the dominant theme is one of working with nature, to reveal nature itself – physical, chemical and biological. Goldsworthy uses nature's materials – rock, water (snow and ice, rain and mist), earth and the plants and animals which inhabit these; he uses nature's properties – structure, shape, form and colour; he uses nature's forces which together create, alter and animate those materials and properties – forces of light, heat, wind and gravity. (1990, 49)

Carl Andre explored the relation between real and represented objects with his controversial pile of bricks. The brick sculpture was 'controversial' because the general public (whoever they are) perceived, via the media (the story was chiefly orchestrated by the press), that Andre had simply stuck some bricks into a gallery. Or rather, that taxpayers' money had been used to purchase Andre's bricks (the Tate Gallery was partly publicly funded in the mid-1970s). A pile of bricks on a construction site is... a pile of bricks. A pile of bricks in an art gallery is... sculpture. Context is everything here. This is what Andre explored, whether consciously or not: the *response*, affected by so much of culture, socialization, physical context, education, etc, makes objects sculptures. People make art. A leaf simply exists, but if someone puts it in a gallery or an art book, it becomes art (as well as remaining a leaf). It's the Zen Buddhist *koan* of a tree falling in a forest with no one to hear it (an apt *koan* for Goldsworthy's art). If people think something is art, then it's art, as Donald Judd said. As Garth Evans wrote: 'what happens to a sculpture is determined largely by factors outside of itself'.[2]

Obviously, Andy Goldsworthy's leafworks – the sycamore boxes, the sweet chestnut horns, the maple circles – are sculptures, seen and described as sculptures. That's easy, to see the leafworks as sculptures. The petal-covered rocks or the tidal cairns, those too, are clearly sculptures. There is no mistaking the carefully crafted pieces as anything other than high art. Every artwork creates a multitude of readings, but one of the dominant

readings of Goldsworthy's 'real' objects is that they are high art sculptures.

One of the most beautiful of Andy Goldsworthy's works is *Rosebay willowherb* (1990), a hanging web of willowherb stalks woven together into a circle. At the centre is an open circle made by the stalks: Goldsworthy interlaced the stalks so that they expanded in gentle curves. *Susuki Grass* (1993), made in Japan, was a similar work, a wall or curtain of stalks. Related to *Rosebay willowherb* is *Woven silver birch* (made at Langholm in Dumfriesshire, 1986): again the sticks were woven together to form an open circle at the centre. On the outside of the sculpture, the sticks move off in every direction. It looks like a Catherine Wheel firework, with the sparks frozen in the air. Goldsworthy has produced a few of these 'drawings in air', free-standing sculptures which are practically two-dimensional. They are drawings in space, where Goldsworthy employs the fine bendy stalks to make elegant curves in the air.

These works – *Knotwood stalks* (Holbeck Triangle, 1986), *Rosebay willowherb* and the stalks stuck in the lake bottom in the Lake District (*Early morning calm*, 1988) – are wholly dependent on Renaissance notions of space, perspective, frontality and illusion. They are flat works, best seen from one particular direction, and preferably with contrasting lighting, back-lit, or set against a sky, for instance. One or two stick works, though, break out in all directions, such as *Hazel sticks* (1980), made in Cumbria, where a group of straight sticks, some six or more feet long, are bound together on a pole.

Sumach leaves (1998) created at Storm King, combined three Andy Goldsworthy motifs: leaves blended for colour, a concentric layers around a circular hole, and a hole in the ground. A horizontal line of red sumach leaves was pinned to a willow (at Storm King in 1998). A line of red leaves (*Leaves from spindle-tree*, 1998) were stitched together to a form a line of bright red on thick grass (*Wall*, 53).

A form Andy Goldsworthy has occasionally explored is the serpentine extension of the roots and base of trees, so the roots appear to spread across the ground in the form of snake-shaped tubes a few inches thick (at Drumlanrig, Dumfriesshire [1999] and Holland [1999]). These tree extensions are usually made from sand or mud (and sometimes snow). Goldsworthy has also carved hump-backed tubular forms, from ice and

snow, the loops and humps recalling the Loch Ness monster (Holland, 1984). Of his serpentine form Goldsworthy commented in 1999: 'I have to stop making this form. It is becoming obsessive' (T, 167).

Another favourite Andy Goldsworthy motif was the rectangle of leaves pinned together (usually a foot and a bit by a couple of feet). Sometimes these leaf oblongs were shields hung from trees (Glasgow, 1986); sometimes they were leaves pressed into the bole of a tree (Dumfriesshire [1998], New York state [1998]) or a rock (New York state, 1997); sometimes they were set afloat on rivers (*Leaf sheet*, Digne, 1998).

Andy Goldsworthy's ethics are those of Chris Drury, Hamish Fulton, Richard Long, David Nash (he worked at Nash's Blaenau-Ffestiniog studio) and other British land artists: a mystical feeling for the landscape, expressed by an exquisite sensitivity of *touch*, that all-important component in the eroticism of sculpture:

> *Movement, change, light, growth and decay* [said Goldsworthy] *are the lifeblood of nature, the energies that I try to tap through my work, I need the shock of touch, the resistance of place, materials and weather, the earth as my source.*[3]

As Andy Goldsworthy says, he *must* touch. A world in which he would not be allowed to touch would be hateful. A world in which the trees had 'DO NOT TOUCH' signs on them would be horrendous. Significantly, Goldsworthy works mainly in areas in which the ownership of the land is not contested. He works in landscapes where he has been given permission to work. No 'DO NOT TOUCH' signs for him.

Andy Goldsworthy's art is very 'hands on': he does not delegate much either, preferring to do as much of a work himself if possible. Only when a process is technically difficult does Goldsworthy allow others to assist (such as hollowing out the boulders for *Garden of Stone*), or when it is too much for one person to do within a schedule (such as the *Sheepfolds* project).

For Andy Goldsworthy, as for any number of sculptors, the personal touch, of hands on materials, is crucial:

> *The work itself determines the nature of its making. I enjoy the freedom of just using my hands and 'found' tools – a sharp stone, the quill of a feather, thorns. I am not playing the primitive. I use my hands because this is the best way to do most of my work.*

Indeed, when it comes to drawing on the sand on a beach, Andy Goldsworthy will not use a stick, as many folks would. Instead, he bends over and uses his hands. His *Dark dry sand drawing* (1987) is worked by hand, dribbled onto the sand on the Isle of Wight. The result, all swirls and curves, comes directly from Jackson Pollock (an even spread of a curving pattern over a unified space).

Many sculptors have spoken of the importance of the *making* of the sculpture, its actual construction, with real (and sometimes organic, living) materials. For some artists, the material employed also has a symbolic or added meaning, as in Joseph Beuys' *Fettecke* or 'fat corner', a sculpture with powerful autobiographical and semiotic associations for Beuys. Andy Goldsworthy said he tried to damp down the aspects of his art which could be seen as sculpture, preferring to see his art as something 'organic' (*Wall*, 15).

Land artists and sculptors such as Andy Goldsworthy use their hands, primarily, as their means of making art. Goldsworthy does not go out into the landscape with anything, except a knife.[4] Perhaps he should, to be really purist, make do without even a knife? Anyway, he *does* really go out into the landscape with 'tools' – the camera not least among them (also spare film too, and a spare camera, maybe an extra lens filter or two, spare batteries, and a tripod). Without that camera, the viewer wouldn't know about many of his works. Ditto with Hans Haacke, Mel Chin, Dominique Mazeaud and all land artists. Without the camera, their work is (usually) 'lost'. That is, not really 'lost' (for the artist at least, and maybe one or two onlookers), but the camera means viewers too can share in the work. Without the camera, the spectator would have to rely on written texts, perhaps, as a means of 'recording' artworks.

Photography is also 'a way of communicating', Andy Goldsworthy told an interviewer, 'and we wouldn't be sitting here if I didn't take the photographs.'[5] Here Goldsworthy admits that without the photographs there would be not much communicating going on with his art: it needs photography to work (Goldsworthy could still undertake commissions and installations, and make ephemeral sculptures in the landscape, but photography is central to a large percentage of his output). But, as one can see, Goldsworthy, Richard Long, David Nash, Dennis Oppenheim *et al*, are not

writers. Indeed, their writings are... well, let's just say their writing is often in note or journal form, designed as a record for themselves, or as notes towards some artwork. While there have been some painters and sculptors who were also good writers who provided many insights – Leonardo da Vinci, Ad Reinhardt, Vincent van Gogh – Andy Goldsworthy is not among them. So, relying on photographs, the observer gets to find out about many works of land art that they might otherwise have never known about. The camera is thus an essential tool for the land artist.

Andy Goldsworthy also works outdoors with many other invisible tools of his craft – his awareness of land art, his education, his knowledge of other sculptors and art history, his memory of previous works, and so on. No artist works alone, culturally – and an educated, sophisticated and pro-fessional artist such as Goldsworthy will be acutely aware of other artists, dead and contemporary, and traditions, and history. (Remember that Goldsworthy is a *professional* artist – making art is what he does for a living. So he'll know about current trends in art, in criticism, in culture).

Spontaneity is the key to Andy Goldsworthy's working method – but an intentional kind of spontaneity. Just going out for a walk, with no intention in mind, is not the thing to do. Walking with intention, one might say, or working with a focus (and going out to make work is Goldsworthy's way of getting to know a place. He doesn't feel he really knows a new place until he's made some sculpture there). In Goldsworthy's methodology, one goes out with a sense of direction, of going somewhere in particular, with the intention of making something. Intentionality, a direction or drive, a desire (the Western, Schopenhauerian Will) is crucial. 'It is *very important* that I have a direction', said Goldsworthy.6 The sense of intention or direct-ion primes the artist, encouraging him to look attentively.

> For me [explained Goldsworthy], *looking, touching, material, place and form are all inseparable from the resulting work [commented Goldsworthy]. It is difficult to say where one stops and another begins. Place is found by walking, direction determined by weather and season. I take the opportunities each day offers...*7

Like many land artists (and many artists in general), Andy Goldsworthy speaks enthusiastically of particular places, sites which have a special resonance for him. The Lake District, as for so many British artists, was an

inspiration. It was lovingly described by Goldsworthy in the *Artists in National Parks* show (1988):

> *I have lived for most of the time within sight of the Lake District... The mountains have become important to me not only to visit and work but as a place by which I orientate myself. It has taken on the significance that all mountains, hills, mounds and single trees have to people living nearby. It has become a landmark which creates a sense of presence and location, defining the surrounding landscape... When I first visited the Lake District I was impressed by the mass and space – and the things that made that space active. It offered new experiences on a massive scale, being able to walk up into the clouds and touching snow when I thought winter was over.*[8]

Andy Goldsworthy's sculptures are 'simple', in that there doesn't seem to be much going on, like Minimal art. But, as Donald Judd wrote in his influential essay "Specific Objects":

> *it isn't necessary for a work to have a lot of things to look at, to compare, to analyze one by one, to contemplate. The thing as a whole, its qualities as a whole, is what is interesting.*[9]

Andy Goldsworthy's sculptures are marked by a number of elements familiar in land art: transience, domination, penetration, circular forms (globes, circles, spirals, snakes, cones) and nature mysticism. The ephemerality of the pieces, for instance, is a key component. Snow and ice will melt away, leaves will disintegrate, stones will be blown over or washed away by the tide. Each Goldsworthy sculpture has a date printed with its title. Not just a year, as in the usual artwork, but a specific day (in common with many land artworks). Thus, one of his finest pieces, the delicious poppy-covered boulder, has the title: *Poppy petals wrapped around a boulder held with water*, with the time and place inscribed as: Sibobre, France, June 6, 1989. The petal-covered rock, with its brilliant red colour, nestled in some mossy boulders, looks very much like one of Constantin Brancusi's 'cosmic eggs' (egg-shaped sculptures which Brancusi titled *The Beginning of the World*). The red colour revealed the rock's shape, size and form, its position amongst and relation to other rocks. Not wishing to disturb or move the rock (it's not that small really, and pretty big to lift)), Goldsworthy's act of covering it in wet poppy petals drew

attention to this particular egg-shaped rock, to *this* one and *not* the others (although the surrounding boulders also became the subject of the sculpture: attention was drawn to them as well as to the red rock). In *Poppy petals wrapped around a boulder held with water,* then, the place becomes as crucial as the centrepiece, the red rock.

Another rock enveloped with red, again linked with water and a river, was made at Scaur Water in 1992: *River rock* was created by rubbing a soft red stone over a small rock which was then lowered into the shallow river. Before the sculpture settled it let go a cloud of red colour which was slowly washed away. Again, it was the situation of the rock, as much as the reddening of the rock itself, that did the expressive work in this sculpture. Andy Goldsworthy used red stone ground down as the filling of the final snowball of 2000, causing red water to spread over the floor of the Barbican Centre in London.

Andy Goldsworthy speaks of '[r]hythms, cycles, seasons in nature working at different speeds'.[10] Each date records a particular day (September 24, 1982; December 30, 1987; February 9, 1981; March 11, 1984; October 19, 1988). Each day has its own weather, atmosphere and events, which are important for the artist. Goldsworthy records personal details in his titles sometimes (like Richard Long):

> *Red leaves*
> *difficult to find*
> *held with water*
> *to the tip of a quarried stone*
> *[...]*
> *Fine dry sand*
> *edges and ridges*
> *softened by the breeze.*

Andy Goldsworthy said he is not against long-term art:

> That art should be permanent or impermanent is not the issue. Transience in my
> work reflects what I find in nature and should not be confused with an attitude
> towards art generally. I have never been against the well-made or long-lasting.

Domination and *penetration*. These are familiar terms describing patri-
archal acts, constructions or ideologies used by feminists. Is Andy
Goldsworthy, seemingly so delicate in his touches, dominating nature? He
said he isn't:

> By working large, I am not trying to dominate nature. If people feel small in
> relation to a work, they should not assume that there is an intention to make
> nature itself small. (AG)

Yet, clearly, Andy Goldsworthy, and most land artists (Walter de Maria,
Robert Smithson, Charles Simonds, Alice Aycock) do dominate nature.
James Turrell's vast volcano, *Roden Crater,* or Michael Heizer's gigantic
Double Negative, will clearly be around for a long time, unless someone or
something destroys them. Goldsworthy's stone pieces, too may indeed stay
around for a while (though not all Goldsworthy's stoneworks are 'perman-
ent': trees will alter the stone walls, for instance).

There is a sense of gloating when Andy Goldsworthy said '[f]ourteen
years ago I made a line of stones in Morecambe Bay. It is still there, buried
under the sand, unseen. All my work still exists, in some form.' Hoping not
to change or affect nature, land artists do just that, all the time. They
'interact' with nature, but their 'interactions' or 'interventions', however
small scale, can't help changing the natural world. Even a small object
added to the world changes it. 'I like the idea of using the land without
possessing it', said Richard Long, ever the idealist.[1] Goldsworthy's aim is to
'touch' something in nature, the essence of nature itself, and the identific-
ation of himself within nature.[2] Thus, about the 'lake pieces', the stick and
stalk sculptures he was commissioned to do in the Lake District in the late
Eighties, he said: 'I felt I really got through in the lake pieces. I had touched
it, and understood it'.[3]

Andy Goldsworthy, like James Turrell, Alan Sonfist and Robert Smithson, has made some huge pieces, such as the long 'snake' and the 'pool' or maze, in Country Durham, or the *Storm King Wall,* large works which take up a lot of space, and certainly *dominate* the surrounding landscape. Goldsworthy's large-scale outdoor works often use the serpent coil as a fundamental form. Goldsworthy maintained, however, that his 'snake-like' or serpent-shaped sculptures does not refer directly to snakes.[4] (The famous *Serpent Mound* in Adams County, Ohio, dating from the 10th century AD, is an obvious ancestor of Goldsworthy's snake-shaped forms, as well as that form in other land artists).

Whatever the artistic intention, however, it is impossible to limit readings of sculptures such as *Sidewinder, Lambton Earthwork* or the serpent shape of the enormous *Storm King Wall* to responses to the environment. The serpent as motif or totem connotes time, change, seasons, birth-death-rebirth cycles, eternity, sexuality, evil, the cosmos, and so on. Andy Goldsworthy might wish to determine how viewers read his serpent-shaped forms, and emphasize the response he makes to the natural environment, but consumers of art will make any interpretation they like, and some artists might wish to suppress some of the interpretations (snakes also connote dirt – they slide on the dust; and excrement; the alimentary canal; eating and defecating; poison; reptile life, and so on).

Andy Goldsworthy's large-scale works, like Michael Heizer's or Nancy Holt's or Herbert Bayer's, are monumental works, which sprawl across the landscape. *Sidewinder* and *Seven Spires*, at Grizedale in Great Britain (a Forestry Commission site between Windermere and Coniston Water), are trunks of trees stripped of their branches, and pinned together. In *Sidewinder*, the curved trunks are placed on the ground, to form a lengthy snake-like sculpture: the form rests on the ground then curves into the air. The impression is of sliding, arching kinetic energy. In other words: a huge serpent slithering along the forest floor (or as Goldsworthy might prefer to say, an *equivalence* in sculpture of the *energy* or *motion* of a snake crawling, but not an *actual* snake).

In *Seven Spires* the trees are pined together to form tall spires. The result is a series of enormous edifices made of timber in amongst other trees. It is, at first, not clear which is a tree and which is sculpture. Both, of course,

comprise of wood: Andy Goldsworthy has simply drawn together the surrounding trees, it seems, but in doing so, he redefines the surrounding forest. *Seven Spires* looks at first to be a gentle sculpture, blending in with the surrounding forest. 'In avoiding monumentality, however, Goldsworthy's sculptures do not forego grandeur', wrote critic Andrew Causey.5 Yet they do stand out, really, they are distinctly works of art, existing in a paradoxical relationship with the environment. A 'collaboration' is a polite way of saying what Goldsworthy's *Seven Spires* is about: a 'collaboration with nature', a phrase used about much of his art. (Goldsworthy revived the spire of logs form in 2008 in San Francisco – it's well worth visiting).

Andy Goldsworthy sometimes writes arrogantly about his art. For him, the human touch can improve on nature: combined with human culture and art, nature is made even more significant. It's not enough for nature to be in existence on its own: it requires humans to make it complete. Or as Goldsworthy puts it: '[i]f anything, I am giving nature a more powerful presence in the mass of earth, stone or wood that I use'.6

An example of a snake-like sculpture is the wall Andy Goldsworthy made between his land and a neighbouring farmer's at Stone Wood, Penpont (*The Wall*, 1989), Goldsworthy's first wall (the first wall of many). *The Wall* is a 'monument to walls',7 Goldsworthy said; a neat way of creating, on Goldsworthy's side of the wall, a sculpture, and on the farmer's side, a sheepfold. Goldsworthy's walls have a dual purpose: practical and æsthetic. The walls function as boundaries or sheepfolds as well as artistic objects. Their æsthetic derives from their practical applications (S, 106). While later walls (such as *Room*, the *Storm King Wall* or *The wall that went for a walk* or some of the *Sheepfolds*) did not have a 'practical' or agricultural function, Goldsworthy still related them to the practicalities of stonewalling. Goldsworthy spoke proudly and sentimentally of the practice of stonewalling: he talked about 'tradition', 'history' and 'years of experience' (S, 106).

Another wall, related to the first, was made at Île de Vassivière in France: *Two folds* (1992) comprised two curl-shapes, like two question marks, which mirrored each other, as in the first *Wall*. The upper fold enclosed some trees, as in other Andy Goldsworthy wallworks, while the lower fold became flooded with water. This is a work that will decay, though: the lake

will erode the wall, and the roots of the trees may alter the upper fold. This wall unites three of Goldsworthy's favourite elements: water, stone and earth. The stone curves linked together the earth and the water, and both the seemingly 'weaker', more transient elements – water and trees – will change and even destroy the apparently 'stronger' element, the stone of the wall.

The wall that went for a walk (1990, Grizedale) was a 150-yard long wall that literally snaked through the forest. The serpentine form of *The wall that went for a walk* related to *Lambton Earthwork* and *Sidewinder* (another Grizedale sculpture). *The wall that went for a walk* has no 'proper', practical function. It weaves between the trees and follows the lay of the land. Instead of ploughing through trees or rocks, Andy Goldsworthy's curving wall assiduously avoids them. It is plotted around what is already there, reacting to it, rather than imposing a design on the landscape which was conceived in the studio. The sculpture responds to the landscape, and takes its cue from the landscape. This's what Goldsworthy means by 'collaborating' with nature, rather than imposing human designs upon it. 'The wall itself is an expression of movement; a line moving through the landscape' (Sh, 12). That is also how Goldsworthy describes his other serpentine forms, as a *movement* in or through the landscape (rather than as a snake). However, the wall in *The wall that went for a walk* doesn't need to be there in the first place (a notion that Goldsworthy cannot quite resolve: in *Stone* he relates *The wall that went for a walk* to the old fields that were at Grizedale before the forest, but it's not a convincing argument. Goldsworthy wants his sculpture to have some practical application, but a snaking wall that starts in one arbitrary spot and stops after 150 yards at another arbitrary spot doesn't really serve a practical purpose).

Some of Andy Goldsworthy's wallworks are circular enclosures, derived perhaps, from agricultural sheepfolds. There is no direct agricultural function to these circular enclosures, however, so they must be regarded as, God forbid, 'decorative', as works of art. Though they were built with the assistance of traditional dry stone wallers Joe Smith and Steve Allen (who constructed many of Goldsworthy's walls), the spectator can see immediately that these are not agricultural artifacts, used by farmers. Rather,

Goldsworthy's circular enclosures, such as *Stone gathering* (Northumberland, 1993), *Jack's Fold* (Hertfordshire, 1996), *Slate dome hole* (Edinburgh, 1990) and *Room* (Pennsylvania, 1992), are about creating shelters and particular spaces in an outdoor environment. 'The space is made quiet and intense by the containing wall, giving a sense of protection and care', remarked Goldsworthy (S, 106). Like the sheepfolds, Goldsworthy's circular enclosures are about marking a space separate from, yet a part of, the landscape, a sanctuary from the elements. Indeed, in *Stone gathering*, large boulders were placed inside the circular wall, just like cattle or sheep sheltering from the wind and rain (Michael Heizer had produced the forerunner of this particular form with his deep holes cut in the American desert in which he placed large boulders. The format of placing an object within a cavity is a popular one in land art).

Andy Goldsworthy's *Rock fold* encircled an excavated outcrop of rocks. *Slate dome hole*, in the Royal Botanic Gardens in Edinburgh, combined two Goldsworthyan motifs: the shallow dome with a hole at the summit, made from slate, and the circular dry stone wall. The central, sheltered rock in the Goldsworthy enclosure was compared by a critic to an altar or sacred centre.8

Another stone wall made by Joe Smith from Andy Goldsworthy's drawings was *Room*. This was a human-height stone wall situated in a wood of young, slender trees. It was another of those large-sale works, like those at Grizedale, which Goldsworthy enjoyed building under the trees, so it was always partially obscured by tree trunks. The circular enclosure of *Room* added to the already confined atmosphere of the forest. The use of five, not four, doors, indicated that this work was not about the four cardinal points and directions, like the snow circles at the North Pole: five is the symbolic number of magic, the occult pentacle, the human form (head and four limbs), and the cosmos.

Commissioned by Sustrans and Northern Arts, *Lambton Earthwork* (1988) was a quarter-mile long earth bank which coils along the ground near Chester-le-Street in County Durham in Northern England. The site was associated with railroads and industry, but Goldsworthy turned it into something wholly concerned with æsthetic and religious themes (transforming former industrial spaces into cultural or artistic ones was a

popular drive in the 1980s, part of the Thatcherite project. The oft-unremarked downside of this æstheticization of industry was the massive lay-offs and unemployment, and decimation of communities). The long spiralling banks of soil in *Lambton Earthwork* clearly derived from the earthwork sculptures of Robert Smithson and American land art.

Andy Goldsworthy said he is wary of using the 'overblown spiral', the too-obvious spiral as a shape (HE, 163). Goldsworthy spoke of the serpentine shape as being like a river winding through a valley, or the root of a tree.9 *Lambton Earthwork* was seen by the artist as a 'river of earth', a response to the natural energies of the place (recall how Goldsworthy spoke of black holes and the energy in the Earth erupting from underneath). Certainly *Lambton Earthwork* was not about industrial archæology or nostalgic reminiscences of the bygone railroad era (or even about the economic and social hardships of post-industrial communities): it was a piece of land art which had powerful mythic overtones. For example, Lambton on the River Wear in Durham is associated with one of the great dragon legends of Britain: the Loathly Worm of Lambton.10 Andy Golds-worthy has thus created a dragon – or a quarter-mile earthwork which corresponds with the Loathly Worm of Lambton.11

The other earthwork Andy Goldsworthy constructed at Durham – *Maze*, 1989, at Leadgate – also used ancient mythology and symbolism, this time the labyrinth (again, there were plenty of forerunners of this particular form: Robert Smithson, Robert Morris, Alice Aycock and Richard Fleischner, among many others, had created large earthwork mazes in the late 1960s/ early 1970s). Goldsworthy's *Maze* can seen a part of the resurgence of interest in mazes which occurred in the 1980s (aligned, as ever, with green/ ecological/ occult/ New Age trends). New mazes were commissioned in Albion by zoos, theme parks and country houses, and 1991 was the 'Year of the Maze'. Like *Lambton Earthwork* (but unlike most of Goldsworthy's works), *Maze* was intended to be used by the general public (i.e., for the visitor to interact with it physically, bodily – by walking on it, sitting on it, etc).

Both *Maze* and *Lambton Earthwork* were about responses to the energies in nature – thus the public was invited to explore similar things as they physically walked around the earthworks. The usual experiences of the

maze in history and symbolism were apparent in Andy Goldsworthy's *Maze* – for example: not being able to see the whole plan from above; being enclosed by high banks; encountering a bewildering series of turns and paths. The interwoven series of embankments also recalled Iron Age forts (of which there are many in Britain), such as the complex and enormous array of defences at Maiden Castle in Dorset. The comparison between Goldsworthy's sculpture and Iron Age hillforts, though, is not quite fair: Iron Age earthworks were not made by bourgeois contemporary artists for the purposes of providing an interesting æsthetic experience, but were made to protect small, tough communities (Maiden Castle witnessed some bloody battles – especially when the Romans conquered the site).

Andy Goldsworthy's *Sandstone Shelter/ Staircase/ Tower* (1987) was a studio mock-up for a large hilltop monument (unbuilt). It was basically a spiral staircase, associated with the Scottish Iron Age round tower, called *brochs.* Even in its scaled-down state, *Sandstone Shelter/ Staircase/ Tower* was 'heroic', said Terry Friedman.[12] It was a simple idea on a grand scale – if that equates with 'heroic', then so be it.

Slate stack at Stone Wood was another simple idea, on a grand scale: built next to (in 'partnership' with)[13] a hollow tree, it consisted of a rectangular structure of flat pieces of slate. The slate was set horizontally, but in the middle of the thick wall was a circle shape (actually a cylinder) made by placing the slate vertically. It looks a lot simpler than it sounds in a verbal description. Like many of Andy Goldsworthy's sculptures, the viewer gets the idea instantly. It is simple, but constructed on a 'monumental' scale.

For Andy Goldsworthy's large-scale works there are often drawings made by the artist, usually free, open drawings done in graphite, with heavy blacks (Goldsworthy has the loose, rather rough drawing style of many sculptors. It's not a fussy, self-conscious, or finely detailed drawing style, for instance. Rather, it fulfils a function: to offer a broad idea of a project, with forms described with plain, unadorned strokes. Goldsworthy isn't one of the great draughtsmen when it comes to drawing freehand; one wouldn't place him beside, say, Rembrandt van Rijn or Albrecht Dürer).

Andy Goldsworthy's green romanticism comes over even in his choice of graphite as a drawing material: he likes the fact that graphite occurs

'naturally', is not manufactured, or bought in an art store. A connection was made, Goldsworthy said, with the 'source' (the Earth), by using graphite straight from a mountain. 'I am still drawing with earth', Goldsworthy said, a little pompously.[14] Well, what else could he be using except the 'earth' in some form or another? Everything comes from the Earth (except the odd meteorite). He could hardly be using stuff from a planet in a distant galaxy, could he? But he likes to think he's using 'the earth' in his drawings, just as he thinks he's drawing with 'real' snow or berries when he rubs 'em on a sheet of paper. 'The snowball will melt into a sheet of paper', Goldsworthy said; 'These drawings do not just represent the place – they *are* that place' (HE, 189). What does this statement mean? The berry and snow drawings 'are' a place? No. They are 'of' a place, 'from' a place, they are not the 'place itself'. They are only someone's *interpretation* of a place, someone's *representation* of a place on a bit of paper. In the art statement "Touching North", Goldsworthy equated snow and stone, snow and sand, ice and slate. 'Snow is stone' he said, but it is plainly not. 'Snow is like sand' he added, employing the key word, 'like'.[15] Snow may be *like* stone or sand, but snow is not sand or stone *itself*.

In 1986, Andy Goldsworthy was commissioned by Common Ground (the New Milestones Project) to work at Hooke Park Wood near Beaminster, in West Dorset (Southern England). He constructed *Woven beech*, a large arch that recalls his 'drawing in air' stick sculptures: a demi-circular arch provides an entrance point: but instead of shaping the branches above the arch, Goldsworthy allowed them to splay out in every direction. The inside of the arch is a rough half-circle, but the upper half of the arch is a tangle of branches and slender tree trunks.

For *Entrance* (also 1986), Andy Goldsworthy used the technique of strapping tree trunks and branches together that he employed in *Sidewinder* and *Seven Spires* at Grizedale. Aided by John Makepeace (of Parnham Trust in Dorset) and some students, Goldsworthy created a barrier or gateway to Hooke Park Wood from two circles of overlapping tree trunks. Drop-bar barriers were fixed on each standing circle, so they would cross in the middle, echoing Goldsworthy's icicle sculptures. Goldsworthy's concerns were that the sculptures would blend in with the environment, as well as being functional.

Richard Harris (b. 1954) has produced a wall sculpture, *Dry Stone Passage* (1982), which is similar to Andy Goldsworthy's walls. Harris wrote: 'I want the sculpture to become a living and working part of the existing environment'.16 Goldsworthy's aims are very similar. Another British sculptor, Paul Russell Cooper (b. 1949), has built a distinctly Goldsworthyan sculpture, *Two Circles in a Stone Bridge* (1983). This is a large dry stone work at Portland in Dorset. Two circles were created with the stones, one 'positive', the other 'negative': the 'negative' circle was a large hole like an archway.

Other works by Paul Russell Cooper reveal affinities with Andy Goldsworthy's output: Cooper's *Quincunx*, for instance, is a series of five globes in concrete set in an open space at Rufford Country Park (near Newark, 1983). The globes sit open partially to display something different in each globe: water, rocks, burning detritus from the garden and a sundial. Like Goldsworthy's sculpture, Cooper's *Quincunx* is based on natural forms – in this case, five-petalled plants (although concrete is a material Goldsworthy has always avoided, tempting though it is as a medium for large sculptures).

Other large-scale works by Andy Goldsworthy include the installations *Slate Wall* and *Clay Wall* (1998, Edinburgh), *Clay Wall* (1996, San Francisco) and *Clay Wall* (2000, London). In *Stone sky* (1992, Brussels), flat pieces of slate covered the entire floor of the large space, with a whitish circle in the centre, made by scratching the slate. The circle recalled Richard Long's slate circles and Hans Haacke's *Germania*, but the title, *Stone sky*, referred directly to nature: the circle could be read as the sun, the moon, the heavenly sphere, the orbits of planets, and so on.

2005 saw Andy Goldsworthy installing a group of slate domes in Washington, DC The first phase occurred in the Fall of 2003 on Government Island, Stafford, Virginia, when Goldsworthy spent ten days making ephemeral work on the site of the Aquia Creek sandstone quarry, the source of the stone with which the U.S. Capitol and the White House were originally built. The Buckingham slate came from Arvonia, Virginia (used in other Washington buildings). The low domes were related to John Russell Pope's Neoclassical domes at the National Gallery and the Jefferson Memorial, as well as other domes such as those of the U.S. Capitol and the

National Museum of Natural History.

Sussex in Southern England is another outpost of Goldsworthyania in Britain: the artist has created works for the private sculpture park at Goodwood; a *Night Path* (or *Moonlight Path*) was built near Petworth in 2002; and a *Chalk Stones Trail*, which includes 14 chalk boulders (some weigh 14 tons), situated at intervals over a five mile route.

One or two of Andy Goldsworthy's works directly recall those of Richard Long: Goldsworthy's *Burnt sticks* (1995), for example, is reminiscent of some of Long's and David Nash's installations which form circles from stone slabs on gallery floors. *Burnt sticks* consisted of sticks charred at one end, the blackened parts of the sticks were put together to form a circle on the gallery floor. Pools fashioned out of wood were taken up later by Goldsworthy: *Pool of Light* (2001) was a large-scale private commission built in the Charente region of France for the owners of a country house who wanted to use trees felled by a storm. Goldsworthy placed lengths of split timber in two different directions to create a circular 'pool' within a rectangular frame. The 'pool' would change its appearance throughout the day, depending on where the sunlight came from.

Many of Andy Goldsworthy's cairns are made from slate (such as *Slate cone*, 1987 and 1988); others from branches (*Oak branches*, 1990); or sandstone (*Sandstone*, 1990). There are others which're put into groups (such as the proposals for stone cone groups at Vassivière, Newcastle and Penpont). The cairn form is about the process of growth and energy. It is a form that celebrates 'the fullness, vigour, heavy ripeness and power generated from a centre, deep inside' said Goldsworthy (S, 37). Like D.H. Lawrence and Friedrich Nietzsche, Goldsworthy here makes the age-old links between 'ripeness' in nature and femininity and pregnancy. The Goldsworthy cone, then, can be seen as another expression of female fecundity and plenitude, in the Lawrencean manner, an equivalent for a pregnant woman (like the prehistoric "Stone Venuses", the squat, callipygous figurines): in short, stone Mother-Goddesses.

'Cone' is perhaps not quite the right term for an image or expression of fullness and ripeness: Andy Goldsworthy's 'cones' look more like fruit. The imagery of fruit would accord with Goldsworthy's discourse of 'ripeness'. 'Cairn' is also not quite the right word, though some of the 'cones' on rocky

mountainsides (such as *Cone to mark day becoming night* at Glenleith Fell, and *Cone to mark night becoming day*, Scaur Glen [both 1991]) have affinities with natural cairns and outcrops of rock. Some of the cairns were made at night, to be seen at night, as hymns to the night, or the dawn, or the sunset. Working on the Yorkshire *Ice hole*, Goldsworthy spoke of 'working with the moonlight' which was a 'very strange intense light'.[17] Working at night, Goldsworthy spoke of approaching 'the most beautiful point, the point of greatest tension, as you move towards daybreak'.[18] The *Clearing of Arches* installed at Goodwood in Sussex (1995) was built to be viewed in moonlight, as was the *Night Path* (2002) not far away.

In Australia Andy Goldsworthy constructed cairns 'for the moonlight', or 'for the day' (S, 43). Like the mulga tree branches edged with red sand to catch the setting sun, these stone cairns were made for particular lighting conditions: the orange-coloured stones fashioned into a cairn were associated with (and completed by) the setting sun. The stone cairns were the sculptural equivalent of lighting a fire in order to celebrate Midsummer or sunset; or erecting a little shrine for a minor deity. They were small-scale celebrations of the daily festivals of dawn, moonlight, noon and sunset, sacred moments that occur every day, but which are no less holy for their common recurrence. Here Goldsworthy is working 'with the sky', with large-scale events such as nightfall and moonlight.

Andy Goldsworthy often spoke of searching for the perfect form in his cairns. Every time he built a cairn he said he was looking for the ideal form, and tried to attain it, but always fell short. Goldsworthy seemed more anxious about the shape of his cairns than almost any of his other sculptures. 'I set myself an almost impossible task: to make the perfect form by eye and hand', Goldsworthy said in *Passage* (10). The anxiety perhaps sprang from the fact that the cairns were built by hand and judged by eye, not from architectural plans. They were intuitive forms, and the shape each cairn took was always being negotiated during construction. Thus, Goldsworthy often talked about work starting slowly at first, about getting the foundation level, about working upwards the belly, about wondering exactly when he should start working inwards, about putting particular stones in particular places, and feeling anxious again as the cairn approached completion.

The cairn Andy Goldsworthy built in 1999-2000 was commissioned by the community he had lived in since 1986: Penpont near Thornhill in Dumfriesshire (Goldsworthy being the only artist of international repute in that particular region of Scotland). Goldsworthy acknowledged that he was nervous and self-conscious about making a work that was so close to his home, that he would have to live with, that he'd often see, that would be seen by locals and neighbours (P, 6). It was one sculpture he'd have to get right; if it went wrong, he'd be always reminded of his mistakes. Goldsworthy said he had 'given enormous thought to its making' (P, 6).

Penpont Cairn was sited on the summit of a low hill in a farmer's field. Its situation on the brow meant that it would be visible from many spots in the neighbourhood. It was a site that was very open on all sides: 'I have never made a cairn in a place so open, not just to the view, but to the rising and setting sun', Goldsworthy wrote in *Passage* (P, 8). Goldsworthy wondered if the siting of *Penpont Cairn* was perhaps a little *too* prominent; 'it might be too imposing and appear as if it were shouting for attention in a 'look at me' kind of way', Goldsworthy remarked (12). Silhouetting was particularly strong with the *Penpont Cairn*: because it was raised up from the ground on a large stone, the sky was always visible behind the sculpture. 'Although the making of a sculpture is obviously out of the ordinary, this particular work has a wonderful sense of the normal and everyday about it', Goldsworthy said during the construction of *Penpont Cairn* (P, 8). Two of Goldsworthy's later cairns include the commissions *Logie Cairn* (1999) in Aberdeenshire and *Hollister Cairn* (1999) in California.

Also at Grizedale, contemporary with the pieces Andy Goldsworthy created there, was a large circular enclosure made from wickerwork and larch posts, by Keir Smith (b. 1950). Like Goldsworthy, Smith is sensitive to the work done by people in a landscape, to the sense of labour: thus, Smith includes in the enclosure hints of human activity, such as stag antlers, which suggest human hunting, while a pair of shears allude to 'sheep-shearing and animal husbandry'.[19] Like Goldsworthy, Giuseppe Penone has made sculptures with trees, such as his *I Wove Together Three Trees* (1968), made in the Maritime Alps. How different from Goldsworthy's *Seven Spires* is another group of tree trunks tied together, Jackie Winsor's 1971 piece *30 to 1 Bound Trees*. Here, the binding of the trees, as in much of Winsor's

work, speaks of autobiographical, childhood experiences, often painful, as well as the formal aspects of density, weight and repetition.20 If Goldsworthy's works have similar autobiographical themes, they are hidden: the artist himself rarely talks in a personal, emotional manner.

Andy Goldsworthy does speak in autobiographical terms about his work, however, from time to time. For him (as for many contemporary artists), art and life cannot be easily separated. One feeds the other, in a symbiotic relationship. One cannot say for certain where Goldsworthy's art ends and his life begins. He sees art as a continuation of life, where the feelings artists of the past (for example, J.M.W. Turner, John Constable and the British landscapists), had about the natural world feed on the same source as artists working today (that is, nature itself). Some people made their life their art (or was it the other way around?): Yves Klein, Joseph Beuys and Carolee Schneemann, among artists, and personages such as Quentin Crisp and Anaïs Nin. Goldsworthy is not quite a larger-than-life personality like Anaïs Nin or Quentin Crisp (yet). He does, however, keep a diary or journal, and carefully records the progress of his art, and the manufacture of each work (including information on dates, times, materials, construction, assistance, situation, etc). Around each sculpture, then, is an autobiographical residue, which is partly constructed from the title which includes details of the time and place of creation. For example:

Elm branches
wrapped in elm leaves
laid in a line
crossing the burn
Townhead Burn, Dumfriesshire
November 2003

Icicles, broken, reconstructed
welded with spit and sucked snow-ice
made in the cold of morning
worked until midday sun reached work place
stored icicles in sheep shelter to keep frozen until following day
thawed on third day
February 22-23, 1986

Mysticism is emphasized in Andy Goldsworthy's writing, as also in the 'enigmatic' statements of Robert Smithson, David Nash, Hamish Fulton and Walter de Maria. Goldsworthy's æsthetics have affinities with neo-paganism, shamanism, pantheism and nature worship, the sort of beliefs that other people call Goddess worship, (w)holism or Gaia, and others relate to cultures such as Native American, Maori, Australian bushmen, archaic or pre-Christianity. Goldsworthy speaks of the earth's energies and atmospheres. Goldsworthy wrote:

> The energy and space around a material are as important *as the energy and space within. The weather – rain, sun, snow, hail, mist, calm – is that external space made visible. When I touch a rock, I am touching and working the space around it.* (RSS, 4; my emphasis)

This talk of earth energies recalls ley lines (the British form of earth energy), and the 'dragon lines' or *feng shui* of Chinese geomancy (far older than the British culture of ley lines). 'Every stone that I place on a sculpture contains some of my own energy: the lifting, the cutting, the placing. Part of me stays with the stone, just as part of the stone stays with me', Goldsworthy said (P, 8).

Andy Goldsworthy has emphasized his notions of energy in nature by 'drawing' around stones. He has stuck stalks together to form lines which he curves around rocks – see the photographs of rocks at Scaur Glen and Scaur Water in the book *Stone* (85). These intertwining lines of stalks are meant to link up with the energy 'generated by the rock', as Goldsworthy put it (S, 83), not to tie it up or imprison it. The continuous lines could be associated with the notions of aura or the astral plane of occultism, the envelope of (super)natural energy that surrounds objects and animals.

The aura or astral plane is another manifestation of primæval animism, associated with the concepts of *mana* and charisma. Andy Goldsworthy's sculpture is very much about a primal, animistic response to nature. Animism, defined as 'the belief in spiritual beings', as anthropologists and psychoanalysts (E.B. Tylor) suggest, is the origin of all religion. There is an affinity, then, between Goldsworthy's (and any contemporary artist's or

viewer's) response to rocks and sculptures and the so-called 'primitive' or ancient people's response to certain stones, or hilltops, or rivers, and statues, icons, totem poles, standing stones, and so on. For ancient peoples, rivers could be goddesses and trees were spirits. Goldsworthy's continuous drawings with grass stalks around mossy boulders in Dumfriesshire are not much different from the primæval response to the 'energies' in the natural world of ancient peoples. Goldsworthy's act of lacing the delicate grass stalks around the rocks in swirls and spirals valorizes the human—nature relationship, just as ancient tribes did by calling a river a god, or regarding the buffalo as holy, or speaking of the Earth-Goddess Demeter and her daughter Persephone who was taken by Pluto into the Underworld for half the year and relating it to the seasonal birth-death-rebirth cycle of agriculture and crops.

One can see how Andy Goldsworthy has a 'sacred' relationship with particular objects – Scaur Water, boulders, leaves, cairns – which is often exactly like the shamanic, animistic relationship of ancient peoples (while artists today may not speak in terms of 'sacred' or 'spiritual' relationship with things, in many earlier periods, that's what it amounts to). Goldsworthy goes around the world and makes art not out of places, or out of things, but out of his *relationship* with particular things and places. The continuous grass stalk lines around the boulders are like caresses – a way of, literally, 'touching nature' (he sometimes calls his sculptures 'touches'). Goldsworthy 'touches nature' in this literal manner by rubbing little stones into larger stones – the act of rubbing is like a lover's caress, while the object itself relates to the sexualized or fetish object (art as fetish). Goldsworthy speaks of wanting to explore the space in and around a stone 'with a touch that is a brief moment in its life' (S, 6). Goldsworthy said that if possible 'I make a work every day' (T, 7).

One is reminded again of old John Cowper Powys who, on his morning walks, used to kiss certain stones and trees. In upstate New York in the 1930s (and later in North Wales), Powys went out for walks every day and said his prayers and invocations to particular natural objects. He gave his beloved things names: there was the 'Dead Tree', the 'Skian Gates' (which was some stones), the 'Prometheus Stone', 'the Flotsam', 'the Jetsam', the 'Unknown Stone', the '*Other* Unknown Stone', the 'Noble Wreck', the 'Perdita

Stone', the 'other Apple Tree', the 'Thorn Bush' and the 'Sea Coal'.[1] One doubts if Andy Goldsworthy kneels down and kisses the soil as he says his prayers, as Powys did (Pope John Paul later made this act famous), or whether Goldsworthy has a litany of names he makes up for every stone and tree he encounters, but Goldsworthy's art is very much about this loving, holy relation with the natural world.

Many land artists have their favourite haunts (and not only land artists; plenty of famous poets in history had their special places of inspiration). Andy Goldsworthy says he revisits certain stones 'many times over' (S, 6), and gets very attached to places, which become like homes (HE, 58). He also admits: 'I like touching stones touched many years ago.'[2] Those special places include South-West Scotland, the hills and lakes of Cumbria, and Digne in the South of France. (From the mid-Nineties, Goldsworthy worked increasingly frequently at Digne in South France; it became one of the most valuable places for the sculptor outside of his home in Scotland [T, 82]). Like John Cowper Powys and the Romantic poets, like the archaic shaman, Australian aborigines and 'primitive' people, Goldsworthy goes out into the landscape and communes with it,[3] knows every inch of it, knows this stone and that pool, this place for gathering strong grass stalks and that dramatic hilltop viewpoint.

The spiral and snake employed by so many land artists down the ages (in ancient Peru, or on the doors of Neolithic tombs, or in the Mid-West of America) is associated with the energies of life. The circles and spirals of Andy Goldsworthy, David Nash, Robert Smithson and Dennis Oppennheim are also those of Goddess cults, the ancient Earth Mother. In the eco-neo-pseudo-pagan view, the land artists, then, make marks upon Mother Earth. Goldsworthy inadvertently evoked phallic penetration when he said: 'I want to get under the surface... At its most successful, my 'touch' looks into the heart of nature' (WH). Earth artists cut into nature – Michael Heizer gouging vast chunks out of the American desert, by Walter de Maria thrusting a kilometre-long brass rod into the earth. And Goldsworthy, seemingly so gentle, has cut trenches in the earth, or smashed slabs of slate or pebbles or leaves, to make lines of broken, shattered material on the earth. He has torn leaves apart to form a line, and has broken pebbles,

making a line, like a fault line in geological structures. These are violent gestures, destroying the organic make-up of the natural forms he so adores. Sometimes the violence of a split-apart rock is emphasized by Goldsworthy highlighting the rough edges of the crack with the colour red – as in *Granite boulder found split open* (1990 [S, 76]). The red leaves stuck on the edges of the split make the jagged edge look like a wound. Another rock Goldsworthy marked out with red, the *Soft red stone* at Heysham Head in Lancashire (1991 [S, 82]), was chosen perhaps because it was a rock that had recently fallen from the cliff above. It was not smoothed by water and weather: its sheared-off edges and planes were exaggerated by the red colour. All land artists – all artists – must break up and re-form materials, but these cracks and holes can look like scars.

Land artists often use circular forms, which hide the violence of their gestures. The spiral or circle is an organic, even gentle shape, seemingly in tune with 'earth energies'. Circular structures (igloos, huts, stone circles, tombs, earthworks, pools) seem to be in harmony with the natural world, echoing the circle shapes of the planet itself, or suns, eyes, blood cells, orifices, orbits. The circular structures speak of archaic, more 'authentic' ethics, the 'back to nature' syndrome. There is, then, not only a mystical side to land art of Andy Goldsworthy, Alan Sonfist, Ana Mendieta *et al*, but also a nostalgic element (nostalgia is a key element in any religion). Looking *back* to the land, land artists also look *back* to a former, even ancient era which was, patently, better (but of course it wasn't). This is the hidden subtext in the writings of the land artists, this nostalgia for the better times of archaic cultures, when people lived 'in harmony' with the earth. This is, of course, a widespread nostalgia, but not backed up by the evidence, which is that for ancient and prehistoric peoples life was as hard, if not harder, than it is now. (But nostalgia, like the Paradise myth which is a part of it, never really dies. The nostalgic yearning for an earlier paradisal time, or the utopian urge for a 'better' future, can be discerned throughout contemporary culture, not just in religion or art).

Andy Goldsworthy's main visual motif is the circle, whether as a globe made of leaves, slate or snow, or a cone or cairn (often built from slate, timber or snow), or circles from leaves half-frosted, or stone rubbed with red powder, or circles cut into snow or leaves. The circle is 'such a funda-

mental form, you can never get away from it altogether' said Goldsworthy (HE, 19), though his circles are usually deliberately slightly irregular (he draws them by hand and eye, not with, say, a piece of string) – he avoids the connotations of traditional symbolism.4 There are many 'negative' circles in Goldsworthy's art, which're formed by the surrounding material.

The 'feminine' quality of this primary circular symbol has already been mentioned. It sounds too obvious to say that Andy Goldsworthy's circles, globes, cones and rings should have 'feminine' connotations, but it is precisely in this sort of simple world of equivalents and responses that Goldsworthy operates. The simplicity of the structures, such as a circle, cannot be improved upon, but no matter how 'natural' the circle is as a shape, it always looks humanmade in Goldsworthy's art (and in land art). His circles of white leaves in amongst dark leaves (1981, Yorkshire), or the yellow elm leaves amongst dark leaves (*Elm patch*, 2002), always stand out from the surroundings. The viewer is always aware that a human has made those marks, or arranged the leaves in that way.

The globe made from oak leaves (1985), for instance, is typical of Andy Goldsworthy's melding of the natural and the human realm. Yes, the viewer has perhaps seen oak leaves many times, or any sort of tree leaves. Yes, the viewer has probably admired the multi-coloured leaves of Fall. But Goldsworthy's sphere of leaves in the forest is not an object the viewer might expect to come across on a walk in regular countryside (in a sculpture park or art trail, yes). The oak leaf globe asserts itself instantly as *art*, as a humanmade artifact. Yet how how *right* these globes of ice, snow, slate and leaves look. The simplicity of the structure (the circle/ sphere) makes these sculptures seem curiously 'obvious' and 'natural'. Like a really good pop song or film, one wonders: *why haven't they been made before?*

> The best of my work [explained Goldsworthy], *sometimes the result of much struggle when made, appears so obvious that it is incredible I didn't see it before. It was there all the time.*5

Some artworks seem so clear and 'obvious' (Leonardo da Vinci's cartoons, Rembrandt van Rijn's self-portraits, Johann Sebastian Bach's *B Minor Mass*), it's amazing that they weren't made centuries earlier. Even

ancient stone circles, built c. 1000-500 BC, seem so 'obvious'. People were making flint knives and axes *two million years* ago, one wonders why weren't they also making stone circles? The stone circle seems such an obvious structure, marking off and enclosing a sacred space (Andy Goldsworthy, in his typical idiosyncratic manner, has said he prefers ancient stone walls to stone circles [S, 106]).

Andy Goldsworthy's sculpted globes, whether fashioned from stacked rocks (Blaenau Ffestiniog, 1980), or snow (Lancashire, 1980), or from redwood sticks (California, 1995), seem so 'obvious' to the viewer. They look simultaneously 'out of place' and quite at home in their settings. Or maybe it's just that the viewer is so used to seeing the extraordinary structures humans make (New York City, say, or a passenger jet), that seeing a snowball hanging in some trees or a globe made from stacked ice ain't that amazing.

On the Isle of Wight in 1987, Andy Goldsworthy built a layered circular hole, and dusted the edges with red stone ground into a powder. The use of the colour red accentuated the æsthetic intention to investigate the energies of the Earth. If any colour is to be selected to heighten the livingness of things, it has to be red. 'Looking into a deep hole unnerves me. My concept of stability is questioned and I am made aware of the potent energies with the earth', Goldsworthy wrote in 1984 (in AG).

Andy Goldsworthy has made circular mounds out of leaves, slate, bracken and sticks which echo prehistoric monuments such as Silbury Hill in South-West England, which have been interpreted as 'feminine' or womb images. Other 'feminine' and labial imagery in Goldsworthy's art includes the holes he's dug in the ground: sometimes he lined the edge of holes in the soil with grass stalks (in Cumbria, 1984). Goldsworthy has constructed hollow snowballs – large snowballs, a few feet across, which are hollowed out like fruit: their hollowness is one of their central attributes. Goldsworthy cut a circular hole in them (at Blencathra, Cumbria, 1988 [AG]). Like stone age people who covered the white bones of corpses with red powder (red as the colour of life, of blood, passion, rage, danger, warning), like filmmakers such as Ken Russell and Jean-Luc Godard, Goldsworthy often uses red as a colour in his art (only yellow, among bright colours, occurs as often). He has red leaves, stones rubbed with red stones, a boulder covered

with red poppy leaves, sand dusted with red powder, red rowan berries dropped into pinned together iris blades.

INTO THE BLACK HOLE 5.10

Andy Goldsworthy's attitude towards holes in the ground is anxious and ambivalent, and recalls the views of (usually male) philosophers on the negativity of holes and voids, which are associated with the sexual identity of women. These fears and ambiguities are found in much of Western culture: in Sigmund Freud's castration myth; in the paranoid, misogynist theology of the Christian theologians St Augustine, Tertullian, St Paul and Origen; in the sadomasochistic writings of the Marquis de Sade, Charles Baudelaire and Georges Bataille. In this view, women are vampires, *succubi* and witches, sucking up male desire and energy (they are feared but also desired). Another religious view sees women as Mother Goddesses, identified with nature, the seasons, vegetation and the powers of the Earth.

A deity which some feminists and British poets (such as Robert Graves and Peter Redgrove) have worshipped (though they would not always use that term) is the 'Black Goddess', a divinity of darkness, night, the unknown and the supernatural. The psychologist Jacques Lacan's notion of the 'lack', which subsequent feminists (such as Hélène Cixous, Julia Kristeva and Luce Irigaray) have criticised, is another obvious reference to the hole. What women lack for Lacan is the phallus, the 'transcendent signifier' as cultural theorists call it. The art object is thus (in Julia Kristeva's interpretation) a fetish, a stand-in for the imaginary maternal phallus.

Friedrich Nietzsche had similar views of the 'feminine': it was not menstruation or lactation that scandalized Nietzsche so much as the lack or absence of a visible (sexual) organ. 'What Mother Nature needs so urgently to hide from view is not so much what she has as what she lacks. Nietzsche suspects a void at the center of the body of nature', remarked a critic[1] In French feminist Luce Irigaray's reading of Jacques Lacan's philo-

sophy, what women lack is the ability to speak from or with the phallus: the genital lack suggests an ideological or æsthetic lack, an absence which becomes cultural silence.

This masculinist fear of the black hole or void at the heart of nature is very apparent in Andy Goldsworthy's statements: 'looking into a deep hole unnerves me', he writes; the black holes of his sculptures are openings into the 'deep insecurity in nature – a fragile, unpredictable and violent energy' (S, 64). Goldsworthy is fascinated by holes: 'I enjoy the seductiveness of a hole', he says, 'which always makes me want to explore the spaces inside or beyond' (HE, 61). These are classic masculinist notions – of penetration, of going beyond, of exploration, of wanting *to know*. Goldsworthy admits to being frightened as well as fascinated by the powers of nature. He speaks of the blackness under the Earth rising up and buckling the rim of the holes he makes in the ground and in the floors of art galleries. He fashions a hole in a gallery floor to remind the spectator that just below the building is the unpredictable and immense energy of nature and the Earth.

Andy Goldsworthy created holes in the ground at the Serpentine Gallery (London) in 1981, and at the Frans Hals Museum (in 1984). Sculptures such as the Greenpeace office commission, *Seven Holes* (1991), are obviously about the Earth's energies. The piece *Black Water Stone* (1993) makes explicit the identification between the Earth and 'feminine' discourses: the low cairn with the small hole at the summit is placed under water: the presence of the 'feminine' element, water, adds another layer to the already symbolically rich sculpture (the cairn or mound; the circle; blackness; the hole; the submerged or partially out of sight setting).

Another 'feminine' cairn of Andy Goldsworthy's is the Welsh *Sea cairn* (1993), built on a pile of barnacled rocks right next to the ocean: when the tide came in, it surrounded the cairn (a form Goldsworthy produced more and more through the Nineties and after, most impressively in the American *Three Cairns* exhibit). The sculpture was another 'before and after' work, and could hardly fail: like the cover of *Stone* (*Balanced rocks*), *Sea cairn* was seen against and beside the ocean. The presence of the surging waves and the setting gives the stone sculptures a grandeur they certainly would not possess if they were sited in a slate quarry. (I say that a sculpture by the

sea couldn't fail – of course it could, in ten million different ways. What I mean is that an artwork placed beside the ocean has a massive headstart in terms of grandeur and beauty. The background of water and sky gives objects enormous presence. And even a humble slice of coastline has something).

Some of Andrew Charles Goldsworthy's earliest works were tidal, beach-bound sculptures which relied very much on the power and majesty of the sea to make them work. At Morecambe Bay in Lancashire (Northern England) in October, 1976, Goldsworthy buried a serpentine line of stones and photographed them as the tide came in. Another work, at Heysham Head, comprised the now-familiar Goldsworthy motif: a series of rocks on a tidal pedestal: as the water rose, the sculpture altered. Goldsworthy's later sea sculptures of balanced rocks are essentially no different from these early Lancashire works. The early works, like the latest sea pieces, employ the formal elements of the littoral environment: the presence of the sea, the changing levels in water, the reflectivity of the water, the colour of the sea, and sky, the movement of the water, and so on. These elements are incorporated into Goldsworthy's sea sculptures.

Later tidal works of Andy Goldsworthy's included *Eleven Arches* (1992, Carrick Bay), *Sand Stones* (1992, California), *Beach Holes* (1990, More-cambe), *Balanced Rocks* (1993, Porth Ceiriad, Wales), *Stone Stack* (1996, Carrick Bay), *Sand Holes* (1997, Rockcliffe), *Cairn* and *Stick Dome Hole* (both 1999, Nova Scotia), and the *Three Cairns* project on the East and West coasts (2000-02).

The hole is also associated, of course, with death, mortality and the grave. In a portentous moment, straight out of Greek tragedy or a dour Thomas Hardy novel, Andy Goldsworthy said that '[i]t is possible that the last work I make will be a hole' (HE, 24). Of course the last sculpture he'll make will be a hole: then he will disappear down it, like the White Rabbit in *Alice's Adventures In Wonderland*. The body is returned to the Earth after death, in one way or another (whether it's burnt, buried, or pecked clean by birds). After all, there's nowhere else for it to go (unless one can afford $50 million for a burial in outer space).

Like a gravedigger, then, Andy Goldsworthy scrabbles about in the soil, producing a hole in Hyde Park (1982), a hole in peat (1980), a double hole

in Cumbria (1980), and a hole just under a tree trunk in the Yorkshire Sculpture Park (1983). In 1992, he made a line of holes in California amongst dead grass, and a few days later green shoots of grass came through. 'For me, there is something deeply interesting about a bright green grass blade growing out of a black hole' (W, 15).

The Goldsworthy hole is also a key element of the artist's cairns, domes and cones: the holed cairns are usually low circular structures with a hole on the small flat summit, as in *Black water hole,* or another water hole, in the Thames (1987), or *Slate hole* (1983), or the big Washington installation (2005). Sometimes the holed slate cairns recall hearths or alchemical vessels in which the energies of nature are being harnessed. One thinks of David Nash's 'hearths' and stoves (*Sea Hearth, Snow Stove, Wood Stove, Slate Stove*, etc), Ana Mendieta's fire sculpture, and Chris Drury's shelters. (Andy Goldsworthy has fired up stones in a kiln, in order to release the stone's essence, exactly as mediæval alchemists did. It is not the spectacular quality of fire and flames that intrigues him, though, but 'the slow intense powerful heat that is at the core of nature' [S, 65]. Goldsworthy has also used fire and heat to shape stones – such as the boulders in the *Garden of Stones* installation). The rounded dome with a hole at the top is also a shape that humans *live in*: one thinks not only of Eskimo igloos, Central Asian *yurts* and prehistoric 'beehive' and Iron Age huts, but also modern astrodomes and even camping tents.

The most 'violent' of Andy Goldsworthy's sculptures are not the holes in floors and cairns, though they are related to them: Goldsworthy's trenches or cracks are carved directly in the soil (at Yorkshire Sculpture Park in August, 1987, for example). Significantly, Goldsworthy does not pretty up these cracks by making them into spiral, circle or gentle serpentine shapes. They are jagged cracks, which resemble the fissures earthquakes make, or the trace of a lightning strike in the air. The energy of these trenches does not flow evenly out of the Earth but comes out in ragged pulses. Like the torn stones, Goldsworthy is opening a window in the trenches into the energies of the Earth. Opening up a huge gaping hole may be too simple: the zigzag lightning form is more suited to the unpredictable form Goldsworthy's interpretation of the Earth's energies takes.

Andy Goldsworthy says he is unsettled by holes, by stones cracking open

('a deeply unnerving but beautiful expression of change' [S, 65]), by the potential in the natural realm for destruction as well as birth. What is striking about Goldsworthy's writings, which are sometimes portentous or banal, is the number of times the word 'shock' appears. Goldsworthy is 'shocked' when a landscape is altered by a manmade lake (at Vassivière [S, 106]); he is 'deeply shocked' when a stone he was working on was smashed by another one falling from a cliff above (S, 94); he is 'shocked' when a pool of water is turned to red by rubbing two stones together (S, 83); he is 'deeply unnerved' by a heated stone splitting open (S, 65). The 'shock' of such natural events presumably derives from Goldsworthy's 'sensitivity' (he is portrayed a 'sensitive' artist in the pro-Goldsworthy criticism and media). Only someone with an exquisitely, breathlessly delicate sensitivity could be *shocked* by a little pool of water turning red, or *shocked* when a stone falls off a cliff. The casual onlooker, seeing the tiny pool turn red might then say, well, *so what?* So what, compared to the wars in Bosnia, Vietnam, Ethiopia, Afghanistan, and Iraq. Now *they* were 'shocking', they could have the word 'shock' applied to them. It's a ridiculous and totally unfair comparison to make, of course, but it does reveal the incredibly small and enclosed scale on which artists work. Goldsworthy's project is to show the casual observer that a crack in the ground can be startling, to show that the 'fragile, unpredictable and violent energy' in nature can be discovered even in the smallest areas of nature, as he put it. (The focus in Goldsworthy's art on very small events cannot be emphasized enough. Goldsworthy's main arena is at the scale of a leaf, or a foot-wide boulder, or a trickling brook). Even the little holes in the flattened domes can be windows onto the 'deep insecurity in nature' (S, 64). The casual onlooker might yawn and say, yeah, but Los Angeles, India, Russia and Japan have *real* cracks opening in the planet, earthquakes that kill two thousand people in one day.

Andy Goldsworthy's 1994 London shows (*Stone*) provided 'a one-man invasion on the West End', as critic Richard Cork put it. The exhibitions were very impressive. The stone arches in *Herd of Arches* at 27, Old Bond Street in London's West End loomed out of the semi-darkness. There was no lighting on the ground floor, and even in the bright morning light the interior was dark. The arches were all of the same size and height and type. Each one was different in details only. Goldsworthy had fitted together masses of small slabs of stone, with tiny pebbles and wafer-thin stones wedged in, to hold the arch tightly together. (Roger Partridge has made an arch out of stone which recalls Goldsworthy's *Herd of Arches*.)

The London Bond Street location was not a white-on-white pristine central London gallery space (dubbed 'white cubes'). Nor was it the even whiter, even more pristine interior of Saatchi's London galleries. Andy Goldsworthy's *Herd of Arches* were indeed like living things. The title uses the word 'herd', and Goldsworthy's arches, evenly spaced throughout the ground floor of the gallery, could suggest a herd of animals. In *Herd of Arches* Goldsworthy makes the connection between seemingly inert stone and living animals, between the human-shaped artwork and the nature-shaped organism.

In the course of working outdoors Andy Goldsworthy must encounter many sorts of animals (very likely plenty of rabbits, foxes, voles, cows, horses, sheep, goats, dogs, pigs, mice, pigeons, seagulls, larks, chickens, pheasants, worms, bees, flies, spiders, bugs, etc). They appear in the background of his photographs (even in a tame, thoroughly human-controlled landscape like Britain there are millions of animals – husbanded and wild. In Goldsworthy's stamping ground of Cumbria, for instance, the sheep out-number the humans).

Upstairs at 27, Old Bond Street in 1994 were photographs and snowball prints. The prints were smears of ochre-coloured stone dust and water on large sheets of paper. Like Richard Long, Andy Goldsworthy works in the landscape, so there are numerous problems when he shows work in a city. The city is definitely *not* the main Goldsworthy place (though he makes many works in built-up areas). The photographs and prints, then, point

always towards the outdoors, towards the ideal Goldsworthyan space, which is (usually) some wilderness or uninhabited spot – Scotland above all, and the North Pole, Japan, France, New York state, Iowa, Cumbria, and so on.

The snowball prints (which Andy Goldsworthy makes by allowing snowballs to melt onto big pieces of paper) are disappointing, really (and so are the paper works which Goldsworthy created by allowing sheep to wander over the paper which was placed in a field. Other artists, such as Steven Turner, have tried similar things). A snowball melting on a sheet of paper is too random and easy, perhaps. The combination of a natural act of melting and the framed piece of paper in a gallery, with the gallery's art historical context, is problematic. The viewer might prefer to see Goldsworthy making these prints. Then they would make more sense. Perhaps a photograph of the artist making the print would suffice. As it is, the snowball prints are full of suggestions of things they cannot deliver. They are, like Goldsworthy's photographs, a record of something that occurred elsewhere. And what occurred elsewhere is of course what *really* interests Goldsworthy (and, by extension, the viewer). No land artist can be satisfied with written accounts of art made in the landscape, just as no painter would be satisfied with photographs or written accounts of their paintings. No, they must have the paintings themselves, the actual flesh and blood of the painting, so to speak, the very feel of the oil on canvas, the shape and size and texture and reflectivity and proportion and tactile qualities of the actual painting. Photographs of paintings only disappoint the artist. Ditto with the land artist. Goldsworthy's photographs and prints are not what are really interesting: the work is elsewhere, in the landscape.

Snowballs in Summer (a.k.a. *Midsummer Snowballs,* 2000) was one of
Andy Goldsworthy's larger, more complex installations. Fourteen snowballs
were gathered from the snowfields of Scotland's Dumfriesshire and Perth-
shire in 1999 and 2000, kept in storage, transported to London and
exhibited on the streets of the City of London (the oldest part of London,
and now the financial district). This, coupled with the show *Time,* at the
Barbican Centre (in August-October), made 2000 the most prominent
display of Goldsworthyania for some years in Great Britain. Sites for the
London *Snowballs* show were explored on foot, with Goldsworthy planning
where to position the snowballs by painting white typing correction fluid on
photographs. Installing the snowballs between midnight and dawn on June
21st required a carefully organized effort involving helpers, forklift trucks,
cranes and trucks. The snowballs were placed in the Barbican area of
central London, including the Barbican Centre, Silk Street, Moorgate, St John
Street, Long Lane, Smithfield Market, London Wall, Bunhill Fields cemetery
and Charterhouse Square. The London snowballs were not 'made for
people. They are about people', Goldsworthy commented (MS, 33).

Andy Goldsworthy wanted the snowballs to be in place by dawn, so for
the public they would just seem to have appeared from nowhere. Surprise
was important. Goldsworthy said he aimed the snowball installation at the
workers in the City who'd be travelling to work in the morning, popping out
for lunch, and going home later. At that time, at five or six in the evening,
the contents of the snowballs would be gradually emerging (MS, 34). The
melt would be integrated into the working day of the City.

Time, change and the millennium was another aspect Goldsworthy
wanted to explore in the London *Snowballs* installation: the snow would be
gathered at the end of the 20th century and exhibited at the beginning of
the 21st century. (Remember what a big deal the Millennium was? Seems a
long time ago now!). Goldsworthy made other sculptures, such as arches
and cairns, which were completed either side of New Year's Eve, 1999. Thus,
for Goldsworthy, it was important that the sculptures bridged two centuries
and two millennia (T, 12).

The materials set inside the London snowballs included pebbles, sheep's

wool, cow hair, crow feathers, horse chestnuts, Scots pine cones, beech branches, barley, elderberries, barbed wire, chalk and ash keys. Andy Goldsworthy also placed scraps of farming machinery he'd gathered from near his home in Penpont. Some of the materials contained in each snowball related to where they were situated (cow hair, for example, in the snowball outside Smithfield market). Goldsworthy remarked that he could have easily included sensational materials in the snowballs, to give the project a higher profile (the TV and press were there). The contents in the snowballs in the Glasgow, 1989 show included willowherb stalks, daffodils, pine cones, pebbles, horse chestnut stalks, stones, dogwood, reeds, oak and birch twigs, slate, chestnut leaves, chalk, soil, ash keys and pine needles.

Some of the snowballs melted quickly, some stayed for a day or so (June 21st was a dry, cool day, but the wind eroded the snowballs quicker than anticipated). Some were vandalized, others were moved. The centrepiece of the *Time* show was a large wall of mud, which dried gradually, and *Red Stone*, the last of the London *Snowballs*, which had been packed with red stone powder and allowed to melt in the Barbican's *Curve* gallery, spreading red-stained water over the floor.

Snow was a perennial delight and 'shock' for Andy Goldsworthy. In *Midsummer Snowballs* he wrote that '[e]ven in winter each snowfall is a shock, unpredictable and unexpected' (MS, 31). Goldsworthy retained the child-like enjoyment of snow falling in Britain throughout his life. While much of Great Britain grinds to a halt at the sight of a snowflake, Goldsworthy has the child's joy when it snows (school's cancelled, snowball fights, ice skating, sledging, and making snowmen and snowballs).

Some of Andy Goldsworthy's earliest works with snow were large snowballs. In some of these early snow works, Goldsworthy placed snowballs in areas such as woods or fields which didn't have any snow, so the snowballs stood out against the trees and grass (as in Ilkley, Yorkshire, 1981). Into some snowballs Goldsworthy inserted branches and other material (as at Clapham, Yorkshire [1979], Bentham [1980], and London [1985]). Other artists who have worked with snow include Dennis Oppenheim, Joseph Beuys and Hans Haacke.

An early version of the 'snowballs in Summer' idea had been exhibited at Tatton Park in Cheshire in 1982 (in a group show with David Nash,

Anthony Gormley, Paul Neagu and others). The series of large snowballs for the 1989 show in Glasgow were brought from Craighall near Blairgowrie. Andy Goldsworthy waited and waited for snow to fall during 1988-89. When it did – eventually – he created a series of snowballs which were exhibited in the Old Museum of Transport in Glasgow during the Summer of 1989. The installation was re-made in London in 2000, though mainly on the streets of the city (with one snowball placed in the Barbican Centre). The contrast of snowballs in Summer was part of the conception, Goldsworthy explained:

> Snowballs in summer [wrote Goldsworthy in the catalogue] *is an exploration of snow and an expression of my understanding and feelings gathered over the years I have worked with it. It will bring together qualities of time, space, movement, noise, colour and texture forming the often unpredictable that makes up the character of snow.*[1]

The lines of snowballs, in rows in the museum space, recall directly the Minimal exhibitions of the 1960s. Each snowball was roughly the same size, but, like Minimal artists such as Donald Judd with his cubes and stacks, or Carl Andre with his tile floor-pieces, Andy Goldsworthy made each one slightly different. Within each snowball, Goldsworthy rolled in different elements, most of which were favourite Goldsworthy materials: willowherb stalks, pine needles, pebbles, reeds, oak sticks, etc. Each snowball, then, was not just a sphere of ice melting slowly in Summer, it was a container of natural materials, each with their own properties, which affected the melting of the snow.

The melting of the snowballs itself was a natural process which the environment of a museum and London streets made highly visible. Each snowball melted in a different way. The stalks, cones and pebbles inside the sculptures became gradually more and more apparent, appearing on the outside of the snowball as it decreased in size. A pool of water formed around the snowball. Slowly, webs of stalks appeared, or a covering of old orange pine needles, looking like a cake decoration.

> *The elements of the melt will be best understood in the quiet stillness of an indoor space* [Goldsworthy wrote]. *The snowballs will speak louder having been made in the mountains yet melting in the city.* (in ib.)

Each snowball became an alchemical vessel in which the arcane transmutations of nature were made visible. The secret processes of the natural world became apparent to all who visited the museum in Glasgow or the City of London. Every stage of the melting transformation was captured on film – a record of alchemy. An associated snowwork, *Snow and mud layers* (1987), lasted two weeks: during the day the snow tower melted and slumped; during the night it refroze. Every day, in this cycle of freezing/ thawing, night/ day, the sculpted snow tower looked different (HE, 152-3).

Vision was not the only sense activated by *Snowballs in Summer*, for snow, as one knows, makes noises as it melts. There were other noises, too: Andy Goldsworthy stuck large pebbles in the snowballs, so they clunked when they dropped off the melting sculpture. These are noises that occur all the time in nature: dripping water, rocks falling, twigs cracking. To hear them in a museum context makes the viewer newly aware of the natural world. The alchemical transmutations of the snowballs encourages the viewer to become conscious of nature's processes, for, as always with Goldsworthy's art, the aim is a greater understanding of nature. It's not just the object itself that is important, Goldsworthy said, but also the processes going on inside and behind them that are valuable. Not a single object, but the processes of 'nature as a whole'.[2] For *Snowballs In Summer* (the 2000 version), Goldsworthy's team also employed a link up on the web to images of the snowballs on the streets.

THE *CAPENOCH TREE* SERIES (1994-96) 5.13

In Andy Goldsworthy's art book *Wood* (1996), the largest section is devoted to the *Capenoch Tree* series of works, made between 1994 and 1996 in Dumfriesshire. The 'Capenoch tree' was an old oak tree on private land standing slightly apart from other trees, as oaks often tend to do, being edge trees (Goldsworthy was granted access to the tree and the land). Goldsworthy focussed on one particular branch that grew sideways out

from the tree, horizontally, a few feet above the grass. Nothing was remarkable about that sort of tree or branch, but the branch on its own became a mini-landscape for Goldsworthy to work on (T, 195). The *Capenoch Tree* series was unified by its location: every work was centred on the one tree and its long branch. The unity of the series was enhanced by Goldsworthy photographing each piece from the same angle, the same side of the tree. (Note, though, that Goldsworthy also included the rest of the tree in his photographs, and the surrounding landscape. He could have framed out everything but the branch, but the whole environment was significant. And, again, as in Goldsworthy's other works, the *Capenoch Tree* photographs gained part of their impact from the landscape around the tree and the branch, as well as the branch and the tree themselves).

The *Capenoch Tree* series offered a summary of all of Andy Goldsworthy's land art and sculptural techniques: there were leaves pinned along the branch; wood and snow cairns and globes next to the tree; snowballs set in the tree; arches made out of ice and stone on the branch; screens of willowherb and rosebay; walls of snow, some serpentine, some holed; lines of dandelions; and holes in the ground.

One of the earlier *Capenoch Tree* works was a cluster of lines of oak leaves pinned together and hanging from the branch (July, 1994). The finest works in the *Capenoch Tree* series were made in Winter. Andy Goldsworthy admitted that he found it difficult to make successful works in High Summer, when trees are loaded with leaves. 'I hope one day to make work that touches and understands better that time in the tree's life', he wrote in *Wood* (85). Not only leafful trees but also bright sunlight can make it hard to produce a good work: bright light doesn't always bring out the best in a work, Goldsworthy said. 'Bright sunlight makes the form too much about surfaces' (W, 23). Shadowy light, or the softer light of sunrise or sunset, was favoured. (Sculptor Tony Smith also preferred the softer light of the magic hour, when his familiar big black cube sculptures could resemble prehistoric monuments, and Mark Rothko liked subdued lighting). Later, Goldsworthy learnt more about using hard vertical sunlight in his Southern France sculptures.

Andy Goldsworthy wrote portentously of the Capenoch tree and of trees in general in *Wood*:

The stone grows within the tree – the seed. The column is a growth form, progressive. Tree is stone expressed in wood... The long branch that has grown horizontal to the ground has taught me that the tree is the land. The branch is like the landscape. It is the earth, it is stone... (W, 23, 85)

SCULPTURE IN TIME 5.14

Andy Goldsworthy's snowball prints are the residue of snow melting on a large piece of paper. But it is the melting itself, the way the snow shifts and pours into the paper, that is really interesting. Similarly, with Yves Klein's 'body-paintings', or Kazuo Shiraga's mud 'fights', the intriguing thing was the manufacture of the painting. In Klein's case, this involved nude women being doused with blue paint ('International Klein Blue'), and writhing around on a huge canvas stretched on the floor. Klein's *Anthropometries of the Blue Period* were *avant garde*, self-conscious, ironic art happenings, accompanied by a string chamber orchestra (which played Klein's *Monotone Symphony*). Very French, very trendy and upmarket, very intellectual.[1] Goldsworthy's snowball prints, then, are, like Klein's *Anthropometries*, records of far more intriguing events that occurred elsewhere, during the artwork's manufacture. Kazuo Shiraga made works of art with his body, such as smearing mud on pieces of paper with his feet. His body-art was called 'the art of committing the whole self with the body'.[2]

Andy Goldsworthy produced a series of works, beginning in the 1980s, which directly recall Yves Klein's *Anthropometries*. Goldsworthy lay down on the ground when it was raining or snowing: the result was the outlines of his body left upon the ground. Sometimes he produced frost shadows in the early morning, creating a man-shape on the frosty ground. A typical the title for these works (reproduced in *Andy Goldsworthy* and other books) is:

Lay down as it started raining or snowing
waited until the ground became wet or covered before getting up.

Andy Goldsworthy 'printed' himself onto the ground negatively, his body covered the dry earth, while around his body the earth (usually stones, but also grass and soil) is darkened by the rain. This wasn't a performance, though: Goldsworthy published the finished work, the rain shadow or body print, not the artist in the act of making the work. Goldsworthy also performed these pieces fully clothed, while many another performance artist would be tempted to create these works nude (as Ana Mendieta did in her series of works based upon the Goddess).

The body prints and rain shadows were spontaneous works; they could not be planned; one has to be open to the weather, knowing it is just starting to rain or snow. One could never – in Britain or any country – plan such a work inside, then go outside and execute it. One would have to be already out and about. These works are always dependent on the weather, which is always unpredictable. For this reason, though they appear to be the most 'passive' of Goldsworthy's works – the easiest to produce (the artist just lies on the ground) – Goldsworthy finds them challenging, because the conditions have to be just right. On many occasions, the rain is the wrong sort, or (as in a work planned in New York City), though forecast, it doesn't come at all.

Yves Klein exhibited a gallery full of empty space in 1958 – *Le Vide* (the void) – and Andy Goldsworthy made his own version of Klein's non-sculpture in his *Hard earth*. The Conceptualism and New Realism of Klein and his contemporaries (Joseph Beuys, Bruce Nauman, Piero Manzoni, Victor Burgin and Yoko Ono) seems far removed from Goldsworthy's sculpture and land art. Yet Goldsworthy has acknowledged Klein as an influence, and cites Klein's dramatic leap (which was faked) into the air as a powerful example of catching a moment in time. 'This amazing tension in the moment of suspense! It's like he's been there for ever, or he's gone in a moment. It's like one of my throws'.[3]

For Andy Goldsworthy, moments are intense precisely because they are only momentary: *pace* his icicle spiral sculpture of 1996, Goldsworthy said that:

> intensity can only be shown for a short time. In fact, the moment is intense only because it lasts for a short time, and it would be wrong for such an intensity to last longer than that. (W, 10)

ANDY GOLDSWORTHY: TOUCHING NATURE ● 246

In fact, it's difficult for the spectator, let alone the artist, to sustain that kind of æsthetic intensity.

In many of his photographs, Andy Goldsworthy documents artworks that last for a second or two. There are many photographs in the Goldsworthy corpus, for instance, which record 'throws' and 'splashes', such as a ball of red earth being thrown into a river (July, 1992). Not just one photograph, but many, which were mounted in the 1994 *Stone* exhibition side by side. These were large colour photographs. The red earth made beautiful shapes as it hit the water in Goldsworthy's beloved Dumfriesshire. 'The first splash is white. It's the second I'm after. A red eruption from below', he said (ib.).

Andy Goldsworthy has said that he is really working with time. 'If I had to describe in one word what I do, I'd say I work with *time*'.[4] Although it seems, at first glance, to be all about space, about particular spaces and how materials react with certain locations, time is an important element in Goldsworthy's art. He talked about adding another layer to preceding layers of 'human understanding and character' when he makes work in the landscape.[5] He is conscious of the past and its layers of time in the landscape. 'The land is an expression of its past', he has said (HE, 189). He investigates moments, the instant of a splash or throw; then there are works that last a few minutes or hours: the soil drying after Goldsworthy's laid on it after rain; or days – the rocks covered in clay; then works that study seasons (Autumnal leaves, snow and ice works); and works that explore the slow, cosmic time of enduring media – stones, the sun, the sea. What counts, Goldsworthy remarked, is not the duration of the work, but 'the experience of making.'[6] Goldsworthy saw his art as just another layer of history on top on many layers of human history. 'I work in a landscape made rich by the people who have worked and farmed it. I can feel the presence of those who have gone before me' (T, 8).

> I work directly with the land because it nourishes me [Goldsworthy said in 1999]. It is full of energy and change and growth and I feed on that. I need that. I see myself as the next layer on the many that have made the landscape so rich.[7]

> I understand best the places where I have worked most often. I have a large well to draw on when realising works in Britain and consequently most of my

permanent sculpture has been made there. (*Wall*, 22).

Many of the photographs in Andy Goldsworthy's exhibitions document very short occurrences: the red earth thrown in the river, or mud being thrown in the shallows on a beach or on a misty hillside: *Rainbow splashes* were made with a stick in Yorkshire (1980); *Slate throws* (Cumbria, 1988) consisted of throwing slate into the air, like *Hazel stick throws* (1980) and *Leaf throws* (Tayside, 1989); *Maple leaf throw* was made in Japan in 1990. In 1995, Goldsworthy had the Ballet Atlantique dance troupe throw sticks and soil into the air at the same time. In California (1994), Goldsworthy threw dust into the air against the sun, which he called *Breath of Earth* works.

It is the shapes the mud, sticks, dust and earth make in the air that fascinates Andy Goldsworthy. He is seen in several photos, throwing the mud and earth, his legs and arms raised high, caught in a moment of release. These photos are about time, about letting something go, and capturing the trajectory. Mud, dust and earth is not 'alive', as a bird is, but Goldsworthy seems to throw the dust, mud and earth as if he's releasing a bird. He wants the earth to fly. It doesn't: it arcs back to the ground, but these arcs are elegant, and become the subject of many photographs. Goldsworthy has made fewer throws in later years, though they are still part of his repertoire (for instance, *Red river stones*, 1999).

The 'throws' are also very dependent on particular lighting conditions (usually back-lighting or side-lighting). In the Lake Michigan photographs (1991), Andy Goldsworthy is shot against the light in a dusky sky, so that the trajectories of the wet sand in the air can be clearly seen. The *Rainbow splashes* required low side-lighting. The red mud throws at Scaur Water occur against bright green foliage, which contrasts with the red. Colour contrasts are also central to the Mount Victor Station throws, which were made with red sand ejected into the clear blue Australian sky (1991). Goldsworthy said that the red of the Australian Outback was 'deeply moving spiritually'; 'I have tried to touch that colour not just with my hands, but also with light' (W, 15). One of Goldsworthy's often reproduced early works contrasted red rowan berries inside green iris leaves and laid on a pool (*Parkland*, 1987).

The arcs or trajectories of the thrown earth, mud and dust become the artwork in itself. The curve of the earth or sticks against the sky actually *is* the sculpture. Similarly, Bruce Nauman – who is, like Yves Klein, another celebrated Conceptual artist – photographed himself as a water fountain (1966). Richard Long threw mud against walls, either in a curtain of mud, or in a circle. Kazuo Shiraga wallowed in mud and threw mudballs (*Making a Work With His Own Body*, 1955). Ana Mendieta created her familiar Goddess shape in mud. Andy Goldsworthy's throws and splashes offer plenty of ammunition to critics who dislike his work, because someone making splashes in a river with a stick or throwing sand or leaves in the air is the kind of art denigrated by the tabloid press in Great Britain.

A set of four photographs, *Penpont Stone* (S, 22-23), created between 1991 and 1993 in (where else?) Dumfriesshire, offered one of the most explicit expressions of Andy Goldsworthy's investigations of the cycle of the seasons. Like the British Romantic poets (such as John Keats, Percy Bysshe Shelley, James Thomson and William Wordsworth), who wrote of each season in turn, Goldsworthy produced four pictures of a stone in each of the four seasons. The Winter sculpture showed the boulder covered in dark brown wet ash leaves; the Spring photo revealed light green beech leaves; in Summer, dark green sycamore leaves; and in the Fall, the rock was covered with reddish brown hazel leaves. It was not the rock and the leaves that were intriguing about this work, though, but the sequence of change in nature that was revealed. The background hills and the grass upon which the rock lay were just as interesting as the sculpture in the foreground. There was the dead grass of Winter, the thick, lush grass of Spring, the taller, drier grass of Summer, and the shorter Autumnal grass.

Andy Goldsworthy's photographs, in true modernist style, record Einsteinian periods of time and change, and the dynamics of chaos theory. 'My work decays, because nature decays', he remarked. Goldsworthy loves the precariousness of (his) art, and encourages it.[8] He likes it when his arches collapse. And the sea cairns are built to topple with the incoming tide. Neil Hedges wrote that 'each work evolves with the elements, reaches a peak at which point it is photographed, and then decays as would any other natural phenomenon' (66). Goldsworthy commented:

Sometimes a work is at its best when most threatened by the weather. A balanced rock is given enormous tension and force by a wind that might cause its collapse. I have worked with colourful leaves, delicate grasses and feathers made extra vivid by a dark, rain-laden sky that cast no shadow. (AG)

Andy Goldsworthy said he often returns to an outdoor work in order just to watch it decay (RSS, 4). There are many photographs in his books of visits to older artworks. Sometimes Goldsworthy has photographed an artwork long after its creation, when there is barely anything to see, and it's faded away, or been overgrown with plants. It's common for Goldsworthy to visit a snowwork or icework the day after its construction, to see how it's holding up to the fluctuations in temperature. At any one time, then, there are many artworks in the area around Penpont in Dumfriesshire in different states of newness or decay. Linked to *Penpont Stone* are pieces such as *Stick Hole* (1999) and *Dead Hazel Sticks* (1997), sculptures on the ground which Goldsworthy returned to a number of times to photograph – covered by frost, then grass, then ferns.

Many of Andy Goldsworthy's sculptures are about a 'before' and an 'after', and the interval between – the difference, the changes. For instance, there are two photographs which depict a stick in a 'before' and 'after' setting (an early work, made in January, 1981 [in AG]). In the first photo, the sycamore branch is shown on top of snow; it's one of those images of visual contrast (black stick against white snow) which Goldsworthy likes so much. The second picture shows the stick with its bark now peeled off, so it looks white. Meanwhile the snow has melted, so the white shows up against the dark earth.

I have become aware [said Goldsworthy] *of how nature is in a state of change and how that change is the key to understanding. I want my art to be sensitive and alert to changes in material, season and weather.* (AG)

Sometimes the sense of change is not shown, but is included in the work's title. For instance, one of his snow and ice sculptures, a wall made in Japan on Christmas Day, 1987, is described as 'a wall of frozen snow' which 'collapsed in the sunlight'. While it's obvious that most any snow sculpture made outdoors will (eventually) melt and collapse, Goldsworthy feels the event is significant enough to include in the title of the work. All

the time with Goldsworthy's sculpture one is reminded that he is using (as with David Nash, Chris Drury, Hans Haacke and Wolfgang Laib) materials that will not last: sand, snow, leaves, petals.

This notion of decay and entropy was an important element in Robert Smithson's land art.[9] It's the same for Richard Long: 'my work is partly about change or disappearance, invisibility... all these strange states of matter'.[10] In his book *Stone*, as in the books *Andy Goldsworthy, Passage* and *Hand to Earth*, the viewer finds photographs not only of sculptures that have toppled, but pictures of sculptures that are in the act of falling down. Andy Goldsworthy loves to photograph works that have fallen to bits. 'I like to draw things out to a peak of intensity – hold them there – and let them go', he says.[11] So he has sculptures that are impossibly balanced. A line of rocks, for instance, placed on the slope of a quay that goes into the sea (Wales, 1993). The photographs of this work in the book *Stone* depict not only the artwork as it is 'meant' to be – a line of stones on a quay – but also the different stages of its collapse. The stones fell as the tide came in and the waves pushed them over. Other Cibachrome photographs depict cairns or towers that fall over.

An extract from Andy Goldsworthy's journal explains:

Ice workshop. Made arch over a pile of sticks – waited for it to freeze – temperature going up and down – thawing then freezing – managed to get out most of the sticks – lost concentration for a moment – all sticks lose but somehow knocked arch and caused its collapse.[12]

The moment when the sculpture topples is a moment of crisis, which Andy Goldsworthy believes is a key point in a work. Not only is it an exciting moment, when all that effort is gone in a flash, but it actualizes the cycles and times of change in the natural world which are at the heart of Goldsworthy's ethics. 'The earth as a whole is probably in these cycles, going through different speeds and changing. Understanding those cycles is understanding the processes of nature'.[13] When the sculpture collapses, one of the many transformations of nature is made manifest, is valorized. The collapse is an expression of cyclical change. Goldsworthy, ever the student of nature, knows that the collapse will soon be followed by another building, one stone on top of the other. Similarly, when something dies in

nature, another thing is born. The moment of collapse in Goldsworthy's photographs thus makes vivid the birth-death-rebirth cyclical quality in nature and in his art.

The moment of collapse is also an anxious moment: Andy Goldsworthy is determined to photograph the exact point when the sculpture topples. If the camera jams, or there isn't enough film, or light, to capture the event, Goldsworthy is disappointed, because the collapse is so central to the whole sculpture. Goldsworthy speaks about being dispirited, for instance, if he misses the moment of collapse of a tidal cairn, which he has been watching for hours. Somehow, all of the effort and time spent in constructing a cairn needs to be valorized by capturing the sculpture's collapse. It's a bit like building up to a theatrical performance; the construction of the sculpture is like rehearsals, costume fitting, set painting, and lighting tests, with the tide coming as the first night and sole performance. The climax of the performance is the toppling of the cairn, with the artist (and sometimes assistants) as the audience, waiting further up the beach, cameras ready. But while theatre is live, and exists truly in the moment, Goldsworthy's tidal sculptures are constructed ultimately for the camera and the photograph. Their ultimate form is a photograph, a recording, an account in another media. (Meanwhile, video or film recordings of theatrical performances always seem to lack something. Anyone who's seen a live performance will know that on TV it's not the same. You could say the 'livingness' or presence of the performance hasn't been captured by the TV or movie cameras. Goldsworthy's sculptures, meanwhile, also exist as 'real' events, but what the artist is after is precisely their record in photography).

Other balancing works of Andy Goldsworthy's include the two *Balanced Win-stones*, *Balanced stone* and *Balanced rock*. *Balanced rock* (Cumbria, 1977) – like *Balanced stone* (Heysham Head, 1978) and *Balanced rocks* (High Nick Quarry, Northumberland, 1993) – is basically a 'logan stone', one of those rocks (there is a famous one at Treryn Dinas in West Penwith in Cornwall) which are balanced so delicately they can be rocked by someone pushing them. *Balanced rocks* at Bow Fell and Scafel Pike (Cumbria, 1977) explored problems usually associated with architecture and engineering – the idea of counter-balancing and weight, for example (HE, 22-23). Goldsworthy's *Balanced rock* was shot against the sky, like so

many of Goldsworthy's works, to bring out the fundamental point of the work: a rock which is carefully balanced.

Like Eva Hesse and Richard Serra, Andy Goldsworthy has made wall-standing sculptures, sculptures that require a wall to complete them, such as in the first *Balanced Winstone* (1988). This sculpture is, basically, two largish rocks, both with pointed ends, connected only at their points. One stands on top of the other, with the rest of the upper stone leaning against a studio wall. (Serra, though, has made that particular form his own, and it would be surprising if Goldsworthy's balanced sculpture didn't acknowledge Serra's art as a precursor). The second *Balanced Winstone* is the basic Goldsworthy cairn with a sharp-ended stone at the summit. On top of this balances another stone; the equivalent in large scale would be a huge boulder the size of an apartment block on top of the Great Pyramid of Cheops.

The notion of balance, of objects being held aloft, defying gravity, fascinates Andy Goldsworthy so much it becomes one of the central motifs of his work. He makes arches from thin pieces of slate (such as the *Slate Arch* of 1985 [Cumbria], and *Slate Arch* [Wales, 1982]), or has arches stretching up and over four steps (*Slate Arch*, 1990, Tarbes). *Over the stone* (1993) was a large arch fashioned from loose stones found on the hillside at Scaur Glen: it was built over a large boulder, the internal form of the arch echoing the shape of the boulder. *Over the wall* (1993) was an arch that leapt over a stone wall; *Tree arch – river stones* (1993) was an arch of three components, leaning up against a tree of two trunks; *Between two trees* (1992, Pennsylvania) was a shallow arch wedged between some trees; *Out of the stones* (1993) was an arch leaning against the boulder that Goldsworthy used in *Over the stone*: it was two-thirds of an arch (these arches were made in the Winter of 1992-93 in Dumfriesshire [S, 98-99], apart from *Between two trees*.)

In the children's 'space labs' or 'hands on' workshops at the Science Museum in London and in science museums around the world, visitors can learn how to construct an arch. One finds out how to build that key architectural form using large blocks of wood. The arch form, so simple yet so elegant, appears often in Andy Goldsworthy's art. Before he went to the North Pole, Goldsworthy constructed from stone a circular archway.

Touchstone North (1990) was intended as a pointer to the Arctic from Goldsworthy's home in Scotland. It is a 'landmark that will orientate north', Goldsworthy wrote in his Arctic diary.[14]

Andy Goldsworthy has continued to build arches: it has become one of his most distinctive motifs. No other land artist had employed the arch so often as a key structure in their *œuvre*. Goldsworthy's arch sculptures include the offshoot of the *Sheepfolds* project, the *Arch* project of 1996-97; a number of 'herds' of stone arches (such as *Herd of Arches* and *A Clearing of Arches*); red Scottish sandstone arches exhibited in Montréal (1998); and some large commissioned arches: a stone arch sited in Montréal (1999); *Eleven Arches*, a private commission in New York state (1997), made near the Storm King Art Center; and another in Wiltshire in 2000. Of the *Montréal Arch*, Goldsworthy remarked: '[t]he arch is heavy and strong, expressing permanence, but it is in fact about change, movement and journey' (T, 60).

In *Arch*, Andy Goldsworthy remarked that the stone arch itself was not an animal, but it did have 'interesting rhythms and movements that can be interpreted sculpturally in response to the energy, reactions and movements of an animal' (*Arch*, 16).

The *Arch* project in the *Sheepfolds* project (also known as *Walking Arch* and *Drove Arch*), consisted of a sandstone arch which Andy Goldsworthy constructed at several points along tracks and roads between South-West Scotland and North-West England, places where sheep and cattle were driven. The *Arch* project united many of Goldsworthy's concerns: arches, history, farming, sheepfolds, and a journey.

Intensity is not perhaps a word one would apply to Andy Goldsworthy's sculpture. His art seems so soft and tenderly 'in tune' with the natural world, so ecologically driven. Those delicate leafworks, they are not 'intense', surely? Yet the very nature of Goldsworthy's methodology, the way he goes out into the wilderness, to be alone, to work from dawn to dusk, suggests an intense, determined, creative personality. Further, those towers and arches which collapse are in fact very intense works. As Goldsworthy said, he likes to draw things out to an extreme point. In this he is intense, and is an archetypal Romantic modernist, someone who, like Ad Reinhardt or Max Beckmann, knew one has to go to extremes, artistically, to get results. It's

not the same way of working for everybody. But for some artists, this aspect of intensity is crucial, and is bound up with the utter importance of solitude, concentration, purity and depth of feeling.

Snow melts, and Andy Goldsworthy's sculptures exploit the precariousness and impermanence of snow as a material. He's spoken of being frustrated in making snow sculptures, of snow crumbling before he could complete the piece. Yet his snowworks are some of his most exciting pieces: a snowball, for instance, caught in the branches of a tree (1980 and 1994). It looks great in the photographs, the ball of snow, so heavy and cold, floating, it seems, in the black, leafless branches of a tree. One can only know such works through photographs: these snowballs caught in the leafless branches in some seemingly remote forest are for an audience of one – the artist. Plus maybe his wife Judith, who sometimes took photographs of Goldsworthy's work. (The photos of Goldsworthy at work were often taken by his wife, or an assistant). Maybe one or two friends or his children might see the remoter pieces, but not the 'general public'.

In some sculptures, the snowballs are small and look like seeds placed inside inside the trunks of broken trees (as in the 1993 piece in *Wood*, 24). Other snowball-in-tree works include *Oak tree snowball* and *Beech tree snowball* (both Dumfriesshire, both 1994). Andy Goldsworthy photographed these sculptures from a distance, to include the whole tree and its snowy surroundings (and also carefully composed the pictures so that the snowballs were contrasted with the dark tree trunks or walls). These are atmospheric pieces, with the white of the sky and the snow predominating.

Aligned with the melting snowballs are the clay-covered rocks which Andy Goldsworthy exhibited in 1993 in San Francisco and Japan, and London in 2005 (among other exhibitions). The stones were covered in wet clay which was rubbed smooth: they looked like huge brown dinosaur eggs. As the clay dried, it cracked and fell off. The exhibits highlighted natural processes – such as the apparent randomness of nature (a bit of clay falling off the stone here, but not on that rock over there; a wide crack running around a boulder here, but only fine cracks on the neighbouring stone).

Andy Goldsworthy has tried different methods of actualizing or exploring the space around and within stones, the light and weather around them,

the 'window' that's opened into their secret nature (HE, 167). Sometimes he covers a boulder completely in bark, or branches (as at Lake Tahoe, 1992 [S, 7-9]), or petals, or leaves, or winds slender stalks around them 'drawing' in the air. A boulder wrapped in small sheets of ice becomes a kinetic sculpture as the ice melts and slips off (S, 13).

In mid-September of 1991, Andy Goldsworthy made a sequence of stoneworks at the same site in Laumeier Sculpture Park, St Louis, Missouri: first he layered wet leaves, in the usual Goldsworthyan colours (red, yellow and green), onto a large boulder which was partially buried in the river bank (the boulder was the focus of the work). The Autumnal colours recalled many of Goldsworthy's previous leafworks. Over the next few days Goldsworthy explored different ways of responding to the stone: he walled it in with flat rocks, photographing it when the river was empty then with the tide coming in; a day or so later he wrapped wet green leaves around the rock, in the rain, with the river rising; Goldsworthy returned the following Summer, and wrapped the rock in a circle of sticks (S, 26-33).

Other methods of exploring the energies of a stone that Andy Goldsworthy employed included 'drawing' around the stone with continuous lines of grass stalks; rubbing red stones or dark peat into the stone; covering it with sheep and kangaroo bones; nesting it inside a circular stone wall; balancing one stone on top of another; and building an arch over a stone.

COLOUR 5.15

It is the *colour* of the red 'splashes' or 'throws' that contributes much in making them striking artworks. Andy Goldsworthy has spoken of the significance of using the colour red: in Japan, he remarked, he learnt about a 'deeply disturbing' red (*Wood*, 15), a 'heightened awareness of red. A bright red maple tree in the middle of a green forest, like an open wound' (in ib.). Goldsworthy often uses red in his art – in the boulders covered in

red maple leaves (1991) or the poppy-leaved covered stones (1989), or poppy petal-covered branches (1992), or the ridged holes made on the beach at the Isle of Wight with red edges (1987, AG), or the red-leaf fringed rock in Virginia (2003). Red maple leaves climb up rocks or are layered on top of little rockpools (1993). Goldsworthy relates red to the iron in human blood.

The Harrlemmerhout (Holland) work, *Poppy petals* (1984), was a seven-foot long line of poppy petals held together with spit which was hung from an elderberry. It was, a critic said, 'one of the most impressive and poetic works' that Andy Goldsworthy made during his time at Haarlem.[1] At Hampstead Heath (in London) an associated work, a line of beech leaves, was floated over a pool.[2] Red-tinted water spread like blood over the floor of the Barbican Centre in London, melted from inside a snowball (2000). In Australia the colour red did not arrive in Goldsworthy's work, as one might expect, from flower petals or red stones, but from red sand: Goldsworthy rubbed the sand into the bark of a mulga tree (1991). Gathering rain clouds and a brilliant, low sun created the right lighting conditions to bring out the red tree against the brooding grey sky (S, 54-55). Goldsworthy said that the red of the Australian Outback was 'deeply moving spiritually': 'I have tried to touch that colour not just with my hands, but also with light' (W, 15).

A lot of work Andy Goldsworthy has done in deserts has been with carved sand (in New Mexico, Arizona, California and Australia). In a way, these drawings and sculptures of sand (in the shape of spirals, snakes, zigzags and boulders) are basically developments of the work with sand on the beaches of Northern England Goldsworthy undertook in the late 1970s.

Andy Goldsworthy is using a standard observation of natural science: red does really stand out in a landscape of greens, greys and browns. In the historical Japanese Zen garden, colours are carefully orchestrated, so that a single leaf can set off a vast acreage of predominantly green or ochre. In the Japanese garden, notions of *feng shui* control how a landscape is shaped by humans. In the system of *feng shui*, the elements of a garden or a building must be in harmony with the natural forces of air, water and earth. Get it wrong and the creation is messed up. The Zen or Taoist harmonizing approach is very much that of Goldsworthy's art (and *feng*

shui and Oriental beliefs have entered garden design and interior design in the West). In the manner of the ecologically-friendly follower, Goldsworthy speaks of wanting to be in harmony with nature. Goldsworthy, Herrmann de Vries, Wolfgang Laib and Richard Long, among others, are seen as ecological artists, artists committed to ecological issues.3

Oriental gardens were founded on stone, sand, water, flowers, moss and trees (compare with the materials Andy Goldsworthy favours: ice, water, petals, leaves, stone). In Goldsworthy's art there is an emphasis, as in Zen Buddhist gardens, on asymmetry, on keeping forms as they appear in nature, on contemplation, on valuing objects such as stones as sacred in their own right, with nothing needing to be added to them. Some of Goldsworthy's sculptures recall the 'islands' in Oriental gardens; like contemplation gardens, Goldsworthy's works are usually designed to be viewed from one point (Goldsworthy endorses the single viewpoint in his work in his use of photography, with its monoscopic vision). Goldsworthy can thus be seen as as creating Western versions of Oriental and Zen gardens, in which contemplation is the primary activity for the art consumer.

J.M.W. Turner also knew the beauty and impact of the colour red. Turner's artistic rival, John Constable, recounted an incident where he, Constable, had painted his famous river scene. Not to be outdone, Turner came in to the Royal Academy, when Constable was away, on one of the finishing days, and added a smudge of red to an otherwise grey seascape. The red blob was intended to be a buoy, and it lifted up Turner's painting a few notches. Constable was enraged.

In a similar way, Andy Goldsworthy puts in a red object in amongst the soft, muted colours of green moss and grey, wet rocks of Scotland, Japan or Missouri. The colour red stands out even more on wintry, overcast days, when there is hardly any deep colour in the surroundings. In 1993 Goldsworthy made a number of sculptures in small pools of water he found on the rocks at his beloved Scaur Water in Dumfriesshire (these works were part of his mid-1990s exhibition *Black Stones, Red Pools*, a show which also produced a book).

Andy Goldsworthy stained the pools with some red stones. The manufacture of these sculptures consisted of nothing more elaborate than

rubbing some stones together to stain some water (Goldsworthy also placed coloured leaves or petals in pools, as at the Storm King Art Center in 1995). The results, though (photographed in *Stone*), are dramatic: as Goldsworthy said, often a good sculpture needs only a delicate or small-scale touch in the right place to make it work (S, 95). In amongst the weather- and water-worn boulders of the Scottish stream the mid-red stands out vividly. It reveals the contours of the surrounding rock; the relation between the pool of water in its isolation from the rest of the stream (which formed it); and the elegant ovals and circular shapes of each pool. These are the landscapes of Goldsworthy's art, these bleak, grey, wintry scenes, beside a lake, or the sea, or a river, or halfway up a mountain. Next to a mound of grey slate, the colour red stands out, like 'a wound', as Goldsworthy said, emphasizing the flesh-and-blood nature of his art.

It is the leafworks that are the most colourful of Andy Goldsworthy's sculptures. What the leaf sculptures demonstrate is how beautiful the colours of the natural world are: Goldsworthy shows the viewer these subtle colours by contrasting one leaf with another. *Maple patch* grouped the red/ orange/ yellow of Japanese maple leaves together; *Line to follow colours in maple leaves* (1992, Pennsylvania) placed Autumn leaves along a fallen tree; *Poppy leaves* set the red poppy leaves against the mid-green of an elderberry bush; *Dock* interwove red leaves in green grass stalks; *Elm leaves* (2002) comprised bright yellow Fall leaves on top of a dead elm branch beside a stream. Goldsworthy also pins together two colours of sycamore leaves (a favourite Goldsworthy medium) in *Sycamore leaf sections* (1988), and hangs the line of leaves from a tree.

Shot with the sun behind them, the photograph of the leaves shows them glowing green and gold, the two classic colours of poetry and alchemy. The Autumnal colours connote nostalgia, decadence, sensuality, Romanticism, time passing, the decay of the year, and so on, all those things John Keats eulogized in his famous poem 'Ode: To Autumn' (and in a billion other poets). Andy Goldsworthy's aim in the leaf pieces, though, draws attention to the fragility and delicacy of leaves, as well as their strength and function. A leaf, after all, is a complex biological factory, so the natural scientists suggest. 'There is a whole world in a single leaf',

commented Goldsworthy.4 Goldsworthy's leafworks do not have a scientific agenda. Rather, they celebrate the presence of leaves, the being-in-the-world of leaves, so to speak. In his sketchbook of August 17, 1984, Goldsworthy wrote:

> *I am beginning to get more structure into leaf work – forced to find structure in leaves – No rocks or branches. The key is in the leaf veins – The leaf architecture. Amazing how geometric the structure is.* (HE, 100)

Andy Goldsworthy's leaf sculptures are, like all land art, specific to particular places. The brilliant oranges and reds and yellows in *Maple patch* (1987) or *Line to explore colours in leaves, calm, overcast* (1987) could only occur in Japan, it seems. Place and work are one for Goldsworthy: he does not distinguish between elements in a work: '[l]ooking, touching, material, place, making the form and resulting work are totally integral'.5

The forms that Andy Goldsworthy explored in his 1989 London *Leaves* show included boxes of sycamore and plane leaves (with the stalks sticking out); a 16 inch cube; cones and pyramids; beech shields; seed pods; hollow globes of sweet chestnut; spiral bands; a lengthy serpent form (51 inches long); and probably the most distinctive shape of Goldsworthy's leafworks, the horn.

Andy Goldsworthy weaved in brown leaves with yellow leaves, forming a contrast between the two colours, as in *Yellow and ruddy leaves* (1986). As with so many of Goldsworthy's sculptures, *Yellow and ruddy leaves* includes in its title the mode of its making:

> *[The] Yellow and ruddy leaves[:]*
> *[l] made [the] edge [of the line] by finding [a] ruddy and yellow leaf [which were] the same size[.]*
> *[l] tore [the] yellow leaf in two, [and] spat underneath one half [of it,] [then] pressed it on to the ruddy leaf[.]* (HE, 64)

The leaf sculptures are often at their most effective in the Fall, not surprisingly, as the dates for many of the leaf pieces demonstrate (November 1, 1986, November 22, 1987, November, 1977, December, 2000, and so on).

Sometimes the wind is a problem, blowing away works which Andy Goldsworthy has painstakingly produced. To a viewer who hasn't worked at

the small-scale of leaves in the outdoors, the wind might appear to be a minor irritant. In fact, it is a major presence when working with delicate materials like leaves, stalks or petals. It can destroy painstaking work in an instant.

Making the leafworks enables Andy Goldsworthy to learn about leaves – leaves blown from trees, or cold, brittle leaves, or 'wet frost-fallen' leaves, or freshly grown leaves, or the dead leaves of mid-Winter. Goldsworthy is careful to take only a 'few leaves from each tree' he said.[6] He follows the seasonal development of leaves closely, most especially in and around his studio in Scotland.[7] Leaves are one of his primary materials as a sculptor. Leaves, like stones or snow, teach the artist much, he says:

> *The sycamore has taught me most. The biggest lesson being that so much can be found in something common and ordinary. Its leaf can turn all colours; its stalks can go bright red and within its leaf structure I realised my first leaf construction*[8]

Andy Goldsworthy's art might not work in richly coloured British gardens, such as Sissinghurst Garden in Kent, or Powis Castle in Wales. In amongst the beautiful white lilies and roses, the brilliant yellow daffodils and primroses, the succulent blue of irises and pansies, Goldsworthy's poppy-red stones would not stand out (indeed, in the great gardens at the height of the season for flowers and colour, some of Goldsworthy's sculpture might not even be noticed). Context is crucial, and Goldsworthy's artworks are powerful partly because they are sited in wildernesses, not on housing estates, not on the trash-strewn verges of highways, not in the bleak streets of provincial towns. Set amongst the green grass and slate-grey rocks, Goldsworthy's slabs of snow or stitched sycamore leaves hollow out their space and influence. They could not compete with most urban environ-ments, or with freeways, or out-of-town shopping malls, or power stations. (Goldsworthy said he had always been attracted to the waste ground in urban areas, where he can work 'so long as some growth exists' [in *Flow of Earth*, 1992]).

Andy Goldsworthy sculptures used all the tricks and devices of post-Ren-aissance illusion and representation, including figure-ground relationships, negative space, perspective, selective viewpoint, chiaroscuro, silhouettes,

outlines, and so on. A good example of the strong pictorial element in Goldsworthy's art are the sculptures that use negative space to create the illusion of continuous form: these sculptures typically have loops of ice or sand on two sides of a rock or a tree; in, for instance, *Reconstructed refrozen icicles* (1999 [T, 112]).

Andy Goldsworthy's sculptures require specific (and sometimes controlled) contexts and environments in order to work, to breathe. The foxglove petal sculpture needs, with its delicate pink tones (1977, Leeds), to be set in amongst the grey rocks to work properly. Similarly, pieces such as the russet-coloured dock leaves, woven into bright green grass stems (1978, Morecambe) are small sculptures, requiring close-up photography to make them work. In the case of the dark soil or peat-covered rocks, made in Japan, Lancashire, Dumfriesshire and the Isle of Skye, the close-up photograph is not so successful: it is the context of these large boulders in their wild landscapes that makes them stand out: thus Goldsworthy includes the rural surroundings in the frame.

Andy Goldsworthy's photographs, too, are carefully framed so that they miss out the electricity poles, the trash heaps, the kicked-in fences, the smashed bottles, the abandoned cars, the supermarket carts, that are a feature of every landscape everywhere in the British Isles (and many other places that Goldsworthy visits), no matter how far from the throbbing centres of humanity. However far one goes, one confronts the marks of humans. Go wandering in the wildernesses of central Wales, say – one of the least densely populated places in the British Isles – and one'll find trash. One may be able to purchase a few miles between oneself and the nearest road, so that the sound of cars will fade into the susurrus of the wind. Sky above, grass underfoot, and nothing but the 1,500-foot high system of mountains. Yet, even in the most remote wilderness, humanity is everywhere: an air force jet screams over the rise of a hill, for instance, the sound of the engines booming and echoing all around the valleys and peaks. This is how humanity alters the landscape. A jet appearing from nowhere in Britain's wildernesses might have been regarded as an amazing event in earlier days. For Western, First Worlders, in the early 21st century, it's all so 'normal'.

Andy Goldsworthy's photographs present an idealized world, veritably the

pastoral world of ancient times. Goldsworthy's Arcadia, though, is definitely a Northern European pastoral realm, not the Southern, Mediterranean paradise of satyrs, shepherdesses, gods and wild animals. Goldsworthy's 'pastoral sublime', to use the phrase applied to a category of J.M.W. Turner's works, is a Northern European realm, very much in the tradition of Turner's paintings of the Alps, with lowering, gloomy skies, raging wind, snow-capped mountains and mossy riverbanks. John Martin, Thomas Girtin, John Sell Cotman, John Constable and J.M.W. Turner made many paintings of the landscapes Goldsworthy works in. Apart from Australia and Japan, Goldsworthy's art centres around cold, rain-sodden, Northern landscapes. True, there is much sunlight in his photographs of Australia, photographs that evoke the colonial view of the Outback as a rugged, inhospitable place where the white people sit around camp fires. Goldsworthy's Japan is a more sublime, rarefied place, though it is still rough and distinctly non-human. (From the mid-Nineties onwards, Goldsworthy has been working in the South of France, around Digne: it's a hot climate in Summer, with harsh, intense sunlight – very much a Mediterranean environment).

Andy Goldsworthy photographs his sculptures often looking down on them from above, so the surrounding landscape is not seen. He edits out unsightly buildings or roads, but art has always involved much more editing than many artists would admit. Goldsworthy (as all artists do) knows that what one leaves out is as important as what one puts in. Goldsworthy said that photographs were 'very important to me as a working record', and that he had a record of nearly everything he'd made, which he could look on and use.[9] 'A good work is the result of being in the right place at the right time with the right material', said Goldsworthy.[10]

Andy Goldsworthy can be expected to explore more collaborations, such as live performance, dance, maybe video installations and the like. He has continued with private commissions, some of which are fairly substantial. But the core of his art, the spiritual heart, the essence of his art will continue to be his work within the landscape, conducted mostly on his

own, and mostly in South-West Scotland. 'My art', Goldsworthy noted in the book *Time*, 'is rooted in the British landscape, and this is the source to which I must return' (T, 7).

LIST OF WORKS

Some works cited in the text

Andy Goldsworthy

Slate Stack, 1988, Scaur Water Valley, Penpont, Dumfriesshire, Scotland; *Japanese maple leaves stitched together to make a floating chain*, Nov 21, 1987, Ouchiyama-mura, Japan; *Circular stalks in a lake*, April 29, 1987, Yorkshire Sculpture Park; *Autumn Horn*, Nov, 1986, chestnut leaves, Penpont, Dumfriesshire; *Dandelion Flowers*, May 1, 1987, 'flowers pinned to willowherb stalks laid in a ring held above bluebells with forked sticks', Yorkshire Sculpture Park, West Bretton; *Line and Carin,* May 31 & June 1, 1985, pebbles, St Abbs, the Borders; *Oak Globe*, Sept 15, 1985, branches and oak leaves, Jenny Noble's Gill, Dumfriesshire; *Slits cut into frozen snow*, Feb 12, 1988, Blencathra, Cumbria; *Snowball in Trees*, Feb, 1980, Robert Hall Wood, Lancashire; *Touching North*, April 24, 1989, North Pole; *Touching North*, Fabian Carlsson Gallery, London, 1989; *Leadgate and Lambton Earthworks*, 1989, County Durham; *Snow and Wind Damaged Pine Trees*, Spring, 1985, Grizedale forest; *Leaves torn in two*, Nov 2, 1986, Glasgow Green; *Broken Pebbles*, April 12, 1987, Scaur Water, Dumfriesshire; *Trench*, Aug 6-7, 1987, 'trench edged with clay supported by sticks', Yorkshire Sculpture Park, West Bretton; *Slate Crack Line*, Feb, 1988, Little Langdale, Cumbria; *Scaur Water Stone*, 1992, stone and iron ore and water, Grob Gallery, London; *Herd of Arches*, stone, 1994, London; *Stone*, 1994, Grob Gallery, London; *Wall*, 1998, Storm King Art Center, New York; *Sheepfolds*, 1996-, Cumbria; *Réfuges d'Art*, 1998-, Digne les Bains, France; *Arch*, 1998, Montréal; *Snowballs In Summer*, 2000, London; *Night Path*, 2002, Petworth Park, Sussex; *Garden of Stone*, 2003, Museum of Jewish Heritage, New York, NY; *Stone Houses*, 2004, Metropolitan Museum of Art, New York, NY.

Others

Carl Andre: *Lead Piece (144 Lead Plates)*, overall 75 x 144.8 x 145.5in, Museum of Modern Art, New York; *Last Ladder*, 1959, wood, 214 x 6 x 15.6cm, Tate Gallery, London; *Cedar Piece*, 1959/64, 68.7 x 36.3in, Offentliche Kunstammlung Basel

Alice Aycock: *One Thousand and One Nights in the Mansion of Bliss*, 1983, mixed media, private collection; *The Miraculous Machine in the Garden (Tower of the Winds)*, 1983, mixed media, 16ft high, private collection

Hans Bellmer: *La Poupee*, 1936, painted bronze, 16.8in high, Musee National d'Art Moderne, Paris

Gianlorenzo Bernini: *David*, 1623, Galleria Borghese, Rome

Joseph Beuys: *Lightning*, 1982-85, bronze, Anthony d'Offay Gallery, London

Giovanni da Bologna: *Mercury*, 1564, Museo Nazionale, Florence

Louise Bourgeois: *Nature Study*, 1984, bronze, 30 x 19 x 15in, Serpentine Gallery, London

Constantin Brancusi: *Endless Column*, 1918, 80 x 9.8 x 9.8in, Museum of Modern Art, New York

Reg Butler: *Girl on Red Base*, 1968-72, painted bronze, 32 x 43 x 63.5in, Pierre Matisse Gallery, New York

Alexander Calder: *Red Flock*, c.1949, hanging mobile, metal, 2.8 x 5.5ft, Phillips Collection, Washington DC; *Thirteen Spines*, 1940, sheet steel, rods, wire and aluminium, 84 in, Wallraf-Richartz Museum, Cologne

Canova: *Hercules and Lichas*, 1812-15, marble, 138in high, Gallery of Modern Art, Rome

Benvenuto Cellini: *Perseus with the Head of Medusa*, 1554, bronze, Loggia dei Lanzi, Florence

John Chamberlain: *Toy*, 1961, welded auto parts and plastic, 4 x 3.1 x 2.6ft, Art Institute, Chicago; *Wagon I*, 1963-64, painted steel, 308.6 x 162.6 x 224.8cm, National Gallery of Scotland

Christo: *Surrounded Islands, Biscoyne Bay, Greater Miami*, 1980-83, 6 million square feet of polypropylene fabric; *Valley Curtain*, synthetic fabric, 417m long, 1970-72, Grand Canyon, Colorado; *Running Fence*, 1972-76, steelpoles, steel cables, woven nylon, 18ft high, 24.5 miles long, Sonoma & Marin Counties

Tony Cragg: *Instinctive Reactions*, 1987, cast steel, 8 x 21 x 15ft, Lisson Gallery, London; *New Stones*, 1982, Marian Goodman Gallery, New York; *New Stones - Newton's Tones*, 1978, Arts Council, London; *Five Plates*, 1976, private collection, Belgium

Richard Deacon: *Turning a Blind Eye No.2*, 1984-85, High Museum of Art, Atlanta, Georgia

Edgar Degas: *Dancer Putting On Her Stocking*, bronze, 17in high, Metropolitan Museum of Art, New York

John De Andrea: *Reclining Woman*, 1970, life-size, David Bermant Collection; *Couple*, 1971, acrylic on polyester and hair, man 5.7ft high, woman 5.1ft high, Musee d'Art Moderne, Paris

Anthony Donaldson: *Girl Sculpture "Red 'n' Gold"*, 1970, 75 x 448cm, Rowan Gallery, London

Donatello: *David*, c. 1440-42, bronze, Museo Nazionale, Florence

Marcel Duchamp: *Bottle Rack*, 1914, readymade, galvanized iron, 25.5in, Galleria Schwarz, Milan; *Rotorelief (Revolving Glass)*, 1920, three strips of painted glass on metal frame, 4 x 6ft, Yale University Art Gallery, New Haven

Mary Beth Edelson: *Great Goddess Series*, 1975, collection: the artist; *Blood Mysteries*, 1973, drawing, 91 x 57 in, collection: the artist

Helen Escobedo: *Snake*, 1980-81, painted steel, 49ft high, National University of Mexico Cultural Centre

Barry Flanagan: *Soprano*, 1981, bronze, 80 x 66 x 57cm, Arts Council of Great Britain

Dan Flavin: *Untitled (to the "innovator" of Wheeling Peachblow)*, 1968, 96.5 x 96.5 x 5.7in, Museum of Modern Art, New York; *Untitled*, 1976, pink, blue, green fluorescent light, 96in high, Saatchi Collection, London

Naum Gabo: *Kinetic Construction*, 1920, metal rod with electric vibrator, 24.2in high, Tate Gallery, London

Henri Gaudier-Breska: *Red Stone Dancer*, 1914, waxed stone, 33.5in high, Tate Gallery, London

Alberto Giacometti: *Spoon Woman*, 1926, bronze, 57.2in high, Kunsthaus, Zurich

Nancy Graves: *Zaga*, 1983, cast bronze with polychrome chemical patination, 6' x 4'1" x 2'8", Nelson-Atkins Museum of Art, Kansas City; *Cantileve*, 1983, bronze with polychrome patina, 99 x 67 x 55in, M. Knoedler & Co, New York.

Red Grooms & Mimi Gross: *The City of Chicago*, 1967, mixed media, c. 12 x 25 x 25ft, Art Institute of Chicago

Duane Hanson: *The Tourists*, 1970, polyester resin, polychrome glass fibre, National Gallery of Scotland, Edinburgh; *Bunny*, 1970, fibreglass, life-size, O.K. Harris Gallery, New York

Tim Head: *State of the Art*, 1984, colour photograph, 183 x 274cm, collection: the artist

Michael Heizer: *Double Negative*, 1969-70, 1,500 x 50 x 42 feet, Mormon Mesa, Nevada; *Displaced, Replaced Mass*, 1969, Silver Springs, Nevada

Barbara Hepworth: *Porthmeor: Sea Form*, 1958, bronze, 30.5in high, Hirshhorn Museum and Sculpture Garden, Washington DC; *Pendour*, 1947, painted wood, 10 x 27in, Hirshhorn Museum and Sculpture Garden, Washington DC; *Forms in Movement*, 1956, Barbara Hepworth Museum and Sculpture Garden, St Ives, Cornwall; *Two Forms*, 1937, marble, 26in high, private collection

Eva Hesse: *Contingent*, 1969, reinforced fibreglass and latex over cheesecloth, each of 8 units, 9.5-14 x 3-4ft, Australian National Gallery, Canberra; *Aught*, 1968, double sheets of latex rubber, polyethylene plastic inside, 4 units, each 78in high, collection: the artist; *Ice Piece*, 1969, fibreglass and wire, 62 x 1in, Xavier Fourcade Gallery, New York

Nancy Holt: *Stone Enclosure: Rock Rings*, 1977-8, hand-quarried schist, outer ring 40 feet, inner ring 2 feet across, ring walls 10 feet high, Western Washington University, Bellingham; *Sun Tunnels*, 1973-76, concrete, each pipe 18 ft long, 9ft high, Great Basin Desert, near Lucin, Utah; *Dark Star Park*, 1979-84, concrete, steel, water, earth, 0.67 of an acre, Rosslyn, Virginia

Rebecca Horn; *Ballet of the Woodpecker*, 1986-87, room installation with mirrors, small hammers and a painting machine, 330 x 230cm (4 mirrors), 330 x 125cm (4 mirrors), Eric Franck Gallery, Geneva; *Peacock Machine*, 1982, installation at Documenta 7, Kassel

Valerie Jaudon: *Caile*, 1985, oil on canvas, 48 x 40in, Sidney James Gallery, New York

Donald Judd: *Untitled*, 1970, copper, 5 x 69 x 8.8in, private collection; *Untitled*, 1969, steel with blue Plexiglass, ten units, each 9 x 40.3 x 31.2in, at 9.2in intervals, Norton Simon Museum of Art, Pasadena;*Untitled*, 1978, brass, 10 units, 6 x 27 x 224in, Indiana University Art Museum, Bloomington; *Untitled*, 1969, brass and red fluorescent plexiglass, 10 units, 6.2 x 24 x 27in, Hirshhorn Museum and Sculpture Garden, Washington; *Untitled*, 1971, concrete, min. height 36 in, max. height 48in, external radius 150 in, private collection; *Untitled*, 1968, ten units, each 9 x 40in x 31in, height 14'3", Nelson A. Rockefeller Empire State Plaza Art Collection, New York.

Allan Kaprow: *Fluids*, 1967. Pasadena, California

Lila Katzen: *Guardian*, 1979, bronze, 35 x 15 x 3ft, private collection, Saudi Collection

Edward Kienholz: *Back Seat of a '38 Dodge*, 1964, the Kleiner Foundation, Los Angeles

Philip King: *Call*, 1967, fibreglass and painted steel, two pieces each 14.5 x 0.5 x 0.5ft, two pieces each 5 x 6 x 3 ft, Juda Rowan Gallery, London; *Genghis Khan*, 1963, fibreglass and plastic with steel support, 41 x 56.5 x 34.5in, Tate Gallery, London

Ernst Kirchner: *Standing Nude*, 1908-12, wood, painted yellow, 35.5in, Stedelijk Museum, Amsterdam

Joyce Kozloff: *New England Decorative Arts*, 1985, tile mural, 8 x 83 feet overall, Harvard Square subway station, Cambridge, Mass.

Jannis Kounellis: *Cotton Sculpture*, 1967, steel and cotton, 3.9 x 3.9 x 4.9ft, collection: the artist

Norbert Kricke: *Space Sculpture*, 1958-59, stainless steel, 9.4 ft high, Municipality Leverkusen, Germany

Anish Kapoor: *Half*, 1984, polystyrene, cement, earth, acrylic medium and pigment, 5.6 x 3.1in, Barbara Gladstone Gallery, New York; *Six Secret Objects*, 1983, mixed media, 115 x 425 x 60cm, Lissom Gallery, London

Gaston Lachaise: *Standing Woman*, 1912-27, bronze, 70in high, Whitney Museum of American Art, New York

Wolfgang Laib: *Hazelnut Pollen*, Dokumenta 8

Sol LeWitt: *Untitled Cube*, 1968, 15.5 x 15.5 x 15.5in, Whitney Museum of Art, New York; *Open Modular Cube*, 1966, painted aluminium, 5ft cube, Art Gallery, Ontario

Richard Long: *Avon Mud Circle*, 1986, installation, Guggenheim Museum, New York; *Sandstone Spiral*, 1983, 154 stones, 373cm diam, National Gallery of Canada, Ottawa; *Pine Tree Bark Circle*, 1985, diam. 460cm, collection: FRAC Rhone-Alpes, Lyon; *Six Day Walk Over all Roads, Lanes and Double Tracks Inside a Six Mile Wide Circle Centred on the Giant of Cerne Abbas*, 1975, photograph & map, 36 x 53.5cm and 72.5 x 73.5cm, Tate Gallery

Len Lye: *The Loop*, 1963, stainless steel, 60 x 6in, Art Institute, Chicago; *Fountain II*, 1959, steel, motorized, 7.5 ft high, Howard Wise Gallery, New York

Aristide Maillol: *Desire*, 1903-5, lead relief, Musee Nationale d'Art Moderne, Paris

Paul Manship: *Dancer and Gazelles*, 1916, bronze, 32.2in high, Smithsonian Institute, Washington DC

Agnes Martin: *Night Sea*, 1963, oil and gold leaf on canvas, 72 x 72in, Saatchi Collection, London; *Drift of Summer*, 1965, acrylic and graphite on canvas, 72 x 72in, Saatchi Collection, London; *Mountain II*, 1966, oil and pencil on canvas, 72 x 72in, collection: R. Solomon, New York

John McCracken: *Untitled*, 1967, fibreglass and lacquer, 7.9 x 1.2 x 0.1 ft, Saatchi Collection

Mary Miss: *Field Rotation*, 1981, wood, steel, gravel, earth, 5-acre site, central well 60 ft square and 7 feet deep, Governors' University, Park Forest South, Illinois

Henry Moore: *Reclining Figure*, 1945-46, elmwood, 75in long, collection: Humana Corp, Louisville; *Three Piece Reclining Figure: Draped*, 1975, bronze, 14ft 8in long, Henry Moore Foundation

Robert Morris: *Observatory*, 1971, earth, grass, wood, steel, granite, diameter c. 300 feet, Oosterlijk Flevoland, Holland; *Labyrinth*, 1974, painted masonite, plywood

& two-by-fours, 96 x 360in, Institute of Contemporary Art, University of Pennsylvania, Philadelphia

Elie Nadelman: *Dancer*, c.1918, painted wood, 28.5in high, Robert Isaacson Gallery, New York

David Nash: *Fletched Over Ash Dome*, 1977/9, Caeny-Coed, Maentwrog, Wales; *Sea Hearth*, 1981, Isle of Bute, Scotland; *Slate Stove*, 1988, Blaenau Ffestiniog, Wales; *Wood Stove*, 1979, Maentwrog, Wales; *Snow Stove*, 1982, Kotoku, Japan; *Wooden Boulder*, 1978, oak, Maentwrog, Wales

Louise Nevelson: *Royal Tide IV*, 1960, wood, 1 x 14ft, Ludwig Museum, Cologne; *Sky Cathedral - Moon Garden Plus One*, 1957-60, black painted wood, 9.1 x 10.1 x 1.6ft, collection: A. & M. Glimcher, New York

Barnett Newman: *Broken Obelisk*, 1963-67, Cor-Ten steel, 26 ft high, Institute of Religion and Human Development, Houston

Isamu Noguchi: *Red Cube*, 1969, painted welded steel and aluminium, 28 ft high, 140, Broadway, New York

Dennis Oppenheim: *Annual Rings*, 1968, 150 x 200 feet, Fort Kent, Maine and Clair, New Brunswick; *Branded Mountain*, 1969, 30ft diameter, San Pablo, California

Roger Partridge: *Arch*, 1983, Portland stone, 77 x 91.5 x 20cm, private collection

Beverly Pepper: *Sand Dunes*, 1985, Mylar over wood, approximately 100 feet long, temporary installation for the Atlantic Center for the Arts, New Smyrna Beach, Florida

Picasso: *Bust of a Woman*, 1932, bronze, 25.1in high, estate of the artist

Anne & Patrick Poirier: *Archaeological Model*, 1986, Bath International Festival

Gio Pomodoro: *Tensione*, 1959, black fibreglass, 5.9 x 4.2 x 1.9 ft, David Anderson Gallery, Buffalo

George Rickey: *Peristyle III*, 1966, stainless steel, 40.5 x 102.5 x 60.2in, Corcoran Gallery of Art, Washington DC

Robert Ryman: *Department*, 1981, oil on aluminium, 60 x 60in, collection: Rhona J. Hoffman, Chicago

Lucas Samaras: *Book 4*, 1962, 5.5 x 8.8 x 11.5in, Museum of Modern Art, New York

Niki de Sant-Phalle: *Black Venus*, 1967, painted polyester, 110 x 35 x 24in, Whitney Museum of Art, New York; *Pink Childbirth*, 1964, painted relief, 86.24in high, Moderner Museet, Stockholm; *Un Ensemble de "Les Nanas"*, 1965, Archives Galerie Alexandre Iolas, New York

Miriam Schapiro: *Heartland*, 1985, acrylic, fabric and glitter on canvas, 7.1 x 7.8ft, Bernice Steinbaum Gallery, New York

Kurt Schwitters: *Picture*, 1925, Sammlung Janlet, Brussels

Tim Scott: *Quinquereme* 1966, Tate Gallery

Richard Serra: *Clara-Clara*, 1983, Cor-Ten steel, installation, Jardin des Tuileries, Paris; *Prop*, 1968, 96in high, sheet 60 x 60in, Whitney Museum of Art, New York

David Smith: *Cubi XXVII*, 1965, stainless steel, 9.2ft high, Guggenheim Museum, New York

Tony Smith: *Die*, 1962, 72 x 72 x 72in, Paula Cooper Gallery, New York.

Robert Smithson: *Spiral Jetty*, 1969-70, rock, salt crystal and earth, 1,500 feet long, Great Salt Lake, Utah; *Closed Mirror Square*, 1969, rock salt, mirrors and glass, Blum Helman Gallery, New York, *Amarillo Ramp*, 1973, red sandstone shale,

1800in diameter, estate of the artist; *Floor Piece*, 1964, 17 x 17 x 288in, Green Gallery, New York 1964

Frank Stella: *Ophir*, 1960-61, copper oil paint on canvas, 250.2 x 210.2cm, private collection

Sylvia Stone: *Crystal Palace*, 1971-72, plexiglass, 6.5 x 14 x 16ft, Andre Emmerich Gallery, New York

George Sugarman: *Bardana*, 1962-63, polychromed woof, 8 x 12 x 5.1ft, Galerie Renee Ziegler, Zurich

Andrea del Verrocchio: *David*, *c*. 1475, bronze, Museo Nazionale, Florence

Andy Warhol: *Clouds*, 1966, Leo Castelli Gallery, New York

Lawrence Weiner: *Billowing Clouds...*, 1986, 86.2 x 17.5 in, Anthony d'Offay Gallery, London

Alison Wilding: *Bare*, 1989-90, Newlyn Art Gallery, *Into the Dark*, 1986, limewood, lead and pigment, Newlyn Art Gallery; *Hemlock III*, 1986, lime, hemlock, lead, beeswax, pigment, Karsten Schubert; *Blueblack*, 1984, lime & elm woods, wax, lead, 36 x 28 x 49cm, collection: the artist

Jackie Windsor: *Burnt Piece*, 1977-8, concrete, wire and burnt wood, 36in cube, Paula Cooper Gallery, New York

Bill Woodrow: *Winter Jacket*, 1986, mixed media, collection: Anne MacDonald Walker, San Francisco; *English Heritage - Humpty Fucking Dumpty*, 1987, vaulting box and mixed media, Tate Gallery, London

NOTES

INTRODUCTION

1. See bibliography. Official websites are few on Andy Goldsworthy. There are 3 Sheepfolds sites: sheepfolds.org, sheepfoldscumbria.co.uk, and Striding Arches at stridingarches.com. Also: Andy Goldsworthy Digital Catalogue at goldsworthy.cc.gla.ac.uk, and the *Rivers and Tides* DVD info at: www.skyline.uk.com/riversandtides. (Also worth looking at are: The Artists: www.the-artists.org, Sculpture at Goodwood, CASS: www.sculpture.org.uk, and Crescent Moon Publishing: www.crmoon.com.
2. Other artists who had work at the Storm King Art Center included Richard Serra, Louise Nevelson, David Smith, Mark di Suvero, Isamu Noguchi, Alice Aycock and Alexander Calder.
3. For a detailed discussion of Andy Goldsworthy's exhibitions, see my companion book, *The Art of Andy Goldsworthy*, Crescent Moon, 2010.
4. The student days of artists such as Bruce McLean, Jan Dibbets, Goldsworthy and Richard Long were summarized by David Lee: '[at] St Martin's School of Art... the definition of sculpture was all-inclusively expanded to embrace a hike in the Hindu Kush, a sing song, an OS map with felt tip graffiti, a collection of empty bottles or a stack of horse blankets. Anything, in fact, providing it did not resemble in the smallest particular anything that sculpture had either used or made before'.
5. W. Malpas, *Richard Long: The Art of Walking*, Crescent Moon, 1995/ 2005.

CHAPTER 1 SCULPTURE IN THE MODERN ERA

1.1 BOMBASTIC SCULPTURE

1. D. Judd, 1975, 200f.
2. Mark Rothko wrote of his intentions with regard to scale thus:

 I paint very large pictures... The reason I paint them... is precisely because I want to be very intimate and human. To paint a small picture is to place your-self outside your experience, to look upon an experience as a stereopticon view or with a reducing glass. However you paint the larger picture, you are in it. It isn't something you command. (1951)

3. "Donald Judd", *The New York Times*, Apl 1, 1977, C20.
4. L. Lippard, 1968, 42.
5. See L. Anderson, 1973; *Mary Miss: Interior Works*, Bell Gallery, University of Rhode Island, Autumn ,1981.
6. See N. Holt, 1975, 1977; T. Castle, 1982.
7. See D. Judd, 1975; W. Agee, 1975, 40-49; P. Carlson, 1984, 114-8; D. Kuspit, 1985; B. Haskell, 1988; B. Smith, 1975.
8. See L. Lippard, 1972, G. Baro, 1967, 27-31; E. Greene: "Morphology of Tony

Smith's Work", *Artforum*, April, 1974, 54-59.
9. See I. Licht, 1968, 50-57; W. Wilson: "Dan Flavin: Fiat Lux", *Art News*, Jan, 1970, 48-51; J. Burnham, 1969, 48-55.
10. See R. Krauss, 1972, 38-43; D. Crimp: "Richard Serra: Sculpture Exceeded", *October*, Fall, 1981, 67-78.
11. See K. Baker, 1980a, 88-94; D. Waldman, 1970b, 60-62, 75-79; P. Tuchman, 1978, 29-33; E. Develing, 1969 .

1.2 ALEXANDER CALDER AND BARNETT NEWMAN

1. N. Kricke, *Space Sculpture*, 1958-59, Municipality, Leverkusen, Germany.
2. See H. Rosenberg, 1975; L. Alloway: "The Stations of the Cross and the Subjects of the Artist", in *Barnett Newman: The Stations of the Cross: Lama Sabacthani*, Guggenheim Museum, New York, NY, 1966; E.C. Goossen, 1958.

1.3 SCULPTURE IN MOTION

1. This is not to say that pre-20th century sculpture is immobile: far from it. Take Giovanni da Bologna's *Mercury*, for instance: as the winged messenger of myth-ology, a static depiction of Mercury or Hermes would be a mistake, and da Bologna's statue is full of movement. Bernini's *David* is similarly kinetic: the man's body is twisting, ready for battle, ready to carry out one of the most celebrated acts of murder in the history of art.
2. Jean Tinguely: *Hommage a New York*, 1960, mixed media, motorized, Sculpture Garden of the Museum of Modern Art, New York, NY. Daniel Wheeler described some of the actions of Tinguely's monster machine:

the machine was supposed to beat a steady, thundering din on the bassinet and washing-machine drum, switch on the radio at maximum volume, and send a horizontal roll of paper down a sheet-metal trough, there to be attacked by two large brushes held by an elaborately constructed painting arm and then blown into the audience by the electric fan. (239-240)

1.4 NOGUCHI, SUGARMAN, POMODORO, SAMARAS

1. Quoted in D. Waldman, 1966, 56.

1.5 HYPERREALIST SCULPTURE

1. E. Lucie-Smith: *Sculpture Since 1945*, 33.
2. J. De Andrea, quoted in Le Normand-Romain, 241.

1.6 DAVID NASH AND ANDY GOLDSWORTHY

1. See A. McPherson, 1978; H. Adams, 1979; *Sixty Seasons: David Nash*, Third Eye Centre, Glasgow, 1983; D. Nash, 1980.
2. H. Adams, 1979, 46-47.
3. D. Nash, in Martin, 1990, 66.

CHAPTER 2 WOMEN AND FEMINIST SCULPTORS

1. B. Hepworth, quoted in A.M. Hammacher, 1968, 99.
2. R. Long, 1985, 2, 21.
3. See H. Gresty: *Bare*, Newlyn Art Gallery, Cornwall, 1993.
4. See L. Cooke: *Alison Wilding*, Arts Council, London, 1985; L. Biggs, 1986; W. Beckett, 116; T. Neff, 43-45.
5. A. Wilding, quoted in W. Beckett, 116.
6. A. Wilding, quoted in T. Neff, 45.
7. See B. Barrette: *Eva Hesse's Sculpture*: Catalogue Raissonne, New York, NY, 1989; R. Krauss, 1979; C. Nemser, 1973, 12-13.
8. C. Nemser, 1970, 62.
9. See M. Roustayi: "Getting Under the Skin: Rebecca Horn's Sensibility Machines", *Arts*, May, 1989, 58-68; M. Kimmelman: "A Sculptural Circus of Whips and Suspense", *New York Times*, Sept 23,1988, C29.
10. H. Moore, in *The Listener*, 1937, quoted in H. Chipp, 595.
11. In A. Hammacher, op.cit., 98.
12. M. Schapiro, in D. Wheeler, 285.
13. C. King: "Feminist Arts", in F. Bonner, 185.
14. C. Elwes: "Floating femininity: a look at performance art by women", in S. Kent & J. Morreay, eds. *Women's Images of Men*, Pandora Press, London, 1985, 182.
15. Quoted in L. Lippard, 219; see also L. Lippard, 1980, 122.
16. *Rosarium Philosophorum*, quoted in A. Mann, 87.
17. See D. Bourdon, 1987; J. Mock: *Niki de Sant-Phalle: Exposition Retrospective*, CGP, 1980.
18. See D. Bricker Balken and L. Nochlin: *Nancy Graves: Painting, Sculpture, Drawing 1980-85*, Vassar College Art Gallery, Poughkeepsie, 1986; E.A. Carmean *et al*: *The Sculpture of Nancy Graves*, Fort Worth , TX, 1987; L. Cathcart: *Nancy Graves: A Survey 1969-1980*, Albright-Knox Gallery, Buffalo, NY, catalogue, 1981.
19. D. Wheeler, 1991, 303.
20. L. Tickner: "Body Politic", op.cit., 239.
21. See C. Schneemann: *Interior Scroll*, 1975; *More Than Meat Joy: Complete Performance Works and Selected Writings*, ed. B. MacPherson, Documentext, New York, NY, 1979.
22. C. Carr: "Unspeakable Practices, Unnatural Acts", *Village Voice*, June 24, 1986.
23. See A. Adler: "Dangerous Woman: Karen Finley", *Chicago Reader*, Oct 26,1990; R. Lacayo: "Talented Toiletmouth", *Time*, June 4, 1990; C. Barnes: "Finley's Fury", *New York Post*, July 24, 1990; T. Page: "Karen Finley's Tantrum, Amid Chocolate", *New York Newsday*, July 24, 1990.
25. M. Duffy: *Cutting the Ties that Bind*, 1987; *Stories of a Body*, 1990; see H. Robinson: "The Subtle Abyss: Sexuality and Body Image in Contemporary Feminist Art", unpublished dissertation, RCA, 1987; M. Duffy: "Redressing the Balance", *Feminist Art News*, 3:8, 1991.
26. J. Spence & T. Sheard: *Narratives of Dis-ease*; see J. Spence: *Putting Myself in the Picture: A Political, Personal and Photographic Autobiography*, Camden Press, London, 1986; P. Holland, J. Spence & S. Watney, eds. *Photography/ Politics: Two*, Comedia, London, 1986.

27. C. Elwes, op.cit., 172.

CHAPTER 3 SCULPTURE IN THE 1960S AND AFTER

1. On Minimalism, see M. Tuchman, 1967; F. Tuten: "American Sculpture of the
 Sixties", *Arts Magazine,* 41, 7, May, 1967, 40-44; I. Sandler, 1965, 96-101; R.
 Wollheim: "Minimal Art", *Arts Magazine,* 39, 4, Jan, 1965, 20-21; D. Mayhall,
 1979; R. Krauss, 1973, 43-53; B. Reise, 1969, 166-172; P. Tuchman, 1988.
2. See C. Robins, 1966, 33-37; M. Fried: "Art and Objecthood", 12-23.
3. B. Rose: "ABC Art", 1965, 66.
4. M. Bochner, 1966c, 40.
5. F. Stella: "The Pratt Lecture", 1960, in *Frank Stella: The Black Paintings,*
 Baltimore Museum of Art, Baltimore, MA, 1976, 78.
6. Quoted in D. Waldman, 1970a, 19.
7. B. Flanagan, quoted in catalogue of *Entre el Objeto y la Imagen: Escultura
 britanica contemporanea,* Palacio de Velasquez, Madrid, 1986, 233.
8. R. Williams, 2000, 10.
9. In M. Crichton, 21.
10. In M. Crichton, 28.
11. In D. Wheeler, 1993, 134-5.
12. S. Gablik: "Minimalism", in N. Stangos, 245.
13. J. Winsor, in D. Wheeler, 323.
14. R. Morris: "Notes on Sculpture", 1966, 20-3. See also: P. Patton, 1983, 84-91.
15. See I. Sandler, *American Art,* 245f; L. Lippard, 1966b, 62; R. Morris: "Notes on
 Sculpture", op.cit.; K. McShine, 1966, R. Lund, 1986, 195-7.
16. D. Judd: "Questions to Stella and Judd", in G. Battock, 1995, 159.
17. J. Mellow: "New York Letter", *Art International,* Apl 20, 1966, 89.
18. H. Kramer: "Display of Judd Art Defines an Attitude", *The New York Times,* May
 14, 1971, D48.
19. B. Haskell, *Donald Judd,* 72.
20. R. Morris: "Notes on Sculpture", 1967, 29.
21. D. Judd, in K. McShine, 1966.
22. R. Mangold, in F. Colpitt, 121.
23. See C. Huber: *Robert Ryman,* Kunsthalle, Basel; N. Grimes: "Robert Ryman's
 White Magic", *Art News,* Summer, 1968, 86-92; C. Ratclif, 1986, 92-97.
24. A. Martin, quoted in P. Schjedahl, 26.
25. R. Ryman, in D. Wheeler, 1991, 207.
25. See A.S. Wooster: "Sol LeWitt's Expanding Grid", *Art in America,* 68, 5, May,
 1980, 143-7.
27. S. LeWitt: "Paragraphs on Conceptual Art", *Art Language,* May, 1969. See *Sol
 LeWitt,* Gemeentemuseum, The Hague, 1970; L. Lippard, 1967b; R. Smith, 1975;
 A.S. Wooster, op.cit.
28. D. Judd: "Specific Objects", 1965, 82.
29. D. Bourdon, 1978, 56. See M. Bochner: "Serial Art Systems: Solipsism", *Arts
 Magazine,* 41, 8, Summer, 1967, 39-43.
30. R. Rosenblum: "Notes on Sol LeWitt", in *Sol LeWitt,* Museum of Modern Art,
 New York, NY, 1978, 15-16.
31. C. Andre, in *Carl Andre: Sculpture,* 1984.
31. W. Tucker: "An Essay on Sculpture", *Studio International,* 177, 907, Jan, 1969,

12-13.
32. G. Evans, 1969, 62.
33. C. Andre: "Object v Phenomenon", *Sculpture Today*, Toronto International Sculpture Center, Toronto, 1978, 31.
34. C. Andre, in L. Lippard, ed. *Surrealists on Art*, Prentice-Hall, NJ, 1970, 7.
35. S. LeWitt, in F. Colpitt, 63.

CHAPTER 4 SPIRIT OF PLACE IN LAND ART

1. H. Moore in *The Listener*, Aug, 1937, quoted in H. Chipp, 595.
2. A. Goldsworthy, in N. Hedges, 69.

4.1 SPIRIT OF PLACE

1. Quoted in B. Redhead, 24-25.
2. R. Long, FC VI, 6.
3. J. Campbell, *Power*, 118.
4. ib., 230.
5. On the 'pollen path', see J. Campbell, *The Power of Myth*, 230; on Australian 'dreamtime' see P. Devereux: *The Dreamtime Earth and Avebury's Open Secrets*, Gothic Image, Glastonbury, Somerset, 1992, 7-12.
6. See J. Cowan: *The Mysteries of the Dream-Time*, Prism Press, 1989; B. Chatwin: *The Songlines*, Picador, London, 1988; L. Levy-Bruhl: *Primitive Mythology*, University of Queensland Press, 1983.
7. Rilke wrote in the *Sonnets to Orpheus* : 'Gesang ist Dasein. Für ein Gott ein Leichtes. | Wann aber *sind* wir?' ('Song is Being. It's easy for a god. But when shall we *be*?').
8. In N. Hedges, 77.
9. E. Hesse, in *Eva Hesse*, Guggenheim Museum, New York 1972.
10. Peter Redgrove, letter to the author, March 5 ,1993.
11. J.C. Powys: *In Defence of Sensuality*, Gollancz, London, 1930, 104.
12. From *The Countess of Pembroke's Arcadia*, in G.G. Miller, ed. *Poems of the Elizabethan Age*, Methuen, London, 1977, 215.

4.2 *DEUS LOCI* IN LITERATURE AND LAND ART

1. In *The Big Supposer*, ed. M. Alyn, Grove Press, New York, NY, 1974, 90.
2. L. Durrell, *Nunquam*, Faber, London, 1970, 211.
3. L. Durrell, *Justine*, Faber, London, 1963, 156.
4. L.W. Market: "Symbolic Geography: D.H. Lawrence and Lawrence Durrell", in M. Cartwright, ed. *On Miracle Ground: Proceedings From the First National Lawrence Durrell Conference/ Deus Loci: The Lawrence Durrell Newsletter*, V, 1, Autumn, 1981, 90f.
5. L. Durrell, 1971, 156.
6. H. Fulton, in M. Auping, in *Common Ground*, John & Mable Ringling Museum of Art, Sarasota, 1982.

4.3 THE ALCHEMY OF MATTER

1. *Nature*, 1836, in H. Hugo, 386-7.
2. Wolfgang Goethe, *The Sorrows of Young Werther,* tr. M. Hulse, Penguin, London, 1989, 44.
3. C. Greenberg: "Abstract, Representational, and so forth", in 1961, 133
4. Richard Long commented: 'I just make art in the way that gives meaning, purpose and pleasure for myself. If it is any good I think it will naturally resonate in all manner of ways for other people' (SF).
5. J.C. Powys, 1967, 168-9.

4.4 AMERICAN LAND ARTISTS

1. R. Smithson: "A Sedimentation of the Mind: Earth Projects", in 1979, 85.
2. A. Goldsworthy, interview, Dec 9, 1987, in HE, 164.
3. A. Papadakis, 1991, 250.
4. See A. Sonfist, 1983; J. Beardsley, 1984; D. Wheeler, 1991.
5. See J. Brown, 1984; G. Müller: "Michael Heizer", *Arts Magazine*, Dec, 1969, 42-45.
6. Christo, in A. Haden-Guest, 40.
7. R. McKie: "Why we are so positive", *The Observer*, May 1, 1994.

4.5 JAMES TURRELL AND ANDY GOLDSWORTHY

1. DIA Foundation, the McArthur Foundation, the National Endowment for the Arts, the Lannan Foundation, the Canon Company, the Bohen Foundation, the Martin Bucksbaum Family Foundation, Count Guiseppe Panza di Buimo, Dr Pentti Kouri, Jean Stein, plus other donors.
2. J. Turrell, in A. Benjamin, 47.
3. J. Turrell: *Mapping Spaces*, Peter Blum, New York, 1987.

4.6 ANDY GOLDSWORTHY AND CONCEPTUAL ART

1. "Mel Bochner on Malevich", interview with J. Coplans, *Artforum*, June, 1974, 62.
2. Although Richard Long will, if one commissions him, come round and smear mud on the living room wall for a price: how long it would last, though, is another matter, open to dispute; Goldsworthy too undertakes many private commissions.
3. L. Weiner, in E. Lucie-Smith, 1987, 117.

4.7 LAND ART AS ART-ABOUT-ART

1. S. Mills: "Special Kaye [Tony Kaye]", *Sunday Times Magazine*, June 12, 1994, 55.
2. See R. Long, IC 1, 14.
3. In a series of questions to students, David Smith described the committed artist's stance:

Do you make art your life, that which always comes first and occupies every moment, the last problem before sleep and the first awaking vision? ...How do you spend your time? More talking about art than making it? How do you spend your money? On art materials first – or do you start to pinch here? ...How much of the work day or the work week do you devote to your profession – that which will be your identity for life? (D. Smith, c. 1953-54, in D. Smith, 158.)

4. R. Long, interview, Santa Fe.
5. R. Long, letter to the author, June 18, 1994.
6. Quoted in F. Roh, 133.
7. Quoted in D. Sylvester, op. cit., 15-16. Johns continued: '[a]nd I think I have a kind of resentment against illusion when I can recognize it. Also, a large part of my work has been involved with the painting as object, as real thing in itself. And in the face of that 'tragedy,' so far, my general development... has moved in the direction of using real things as painting. That is to say I find it more interesting to use a real fork as painting than it is to use painting as a real fork.'
8. R. Smithson, in C. Robins, 78.

4.8 SCALE AND GENDER

1. See D. Bourdon, 1968, 39-43, 72; M. Winton: "Sculptures That Blow Away", *Ark*, Spring, 1970, 18-19; R. Smith, 1978, 102-5.
2. See P. Redgrove: *The Black Goddess and the Sixth Sense*, Bloomsbury, London, 1987 and *The Cyclopean Mistress*, Bloodaxe, Newcastle, 1993.
3. P. Redgrove: *The Man Named East and other new poems*, Routledge & Kegan Paul, London, 1985.
4. See M. Gimbutas, 1989.
5. R. Smithson: "The Spiral Jetty", unpublished MS, quoted in R. Krauss, 1977, 282. See R. Hobbs, 1981.
6. R. Long, quoted in S. Gablik: *Has Modernism Failed?*, Thames & Hudson, London, 1984, 44.

4.9 CIRCLES

1. See also M. Berger,1989.
2. Quoted in L. Lippard, 1967c, 26.
3. Richard Long, letter to the author, July 11, 1994.
4. The allusions to prehistory would be quite different if Richard Long had stuck a picture in his book of the Cerne Giant next to himself instead of the Wilmington Man. The meaning then might be that Long was a superstud, for the Cerne Giant has the biggest penis in prehistoric (or any) art – at least in the British Isles.
5. R. Long, 1972, in R. Fuchs, 38.
6. Richard Long suppresses the Stonehenge connection: 'Stonehenge and all the circles in Britain...came about from a completely different culture... They were social, religious art. I make my work as an individual' (Long, 1986, 2, 7).
7. Peter Fuller complained:

It is, I believe, a tragedy that consideration was given to inviting an artist such as Richard Long to create a piece within Lincoln Cathedral. His work, for me, is symptomatic of the loss of both the œsthetic and the spiritual dimensions of art. He shows little trace of imagination, of skill, of the transformation of materials. Seen in contrast to the greatest achievements of the British tradition in art, Long's relationship to the world of nature is simply regressive. His work is sentimental and fetishistic... claims that his work is worthy of 'spiritual' attention are preposterous. (1993, xxxvi-xxxvii)

8. R. Long, IC 2, 17.
9. Quoted in N. Lynton, 1982, 2.
10. M. Eliade: "The Sacred and the Modern Artist", *Criterion*, 4, 1965, and in M . Eliade, 1988,
11. N. Pope, quoted in W. Strachan, 70.

4.10 TREES

1. Writers on the symbolic and religious aspects of trees include Mircea Eliade (*Patterns of Comparative Religion*), Robert Graves (*The White Goddess*), James G. Frazer (*The Golden Bough*), among others.

4.11 INDOORS AND OUTDOORS

1. D. Nash, in A. McPherson, 30.

4.12 CHANGES, CYCLES, SEASONS

1. As Richard Long said in an interview:

 The planet is full of unbelievably permanent things, like rock strata and tides, and yet full of impermanences like butterflies or the seaweed on the beach, which is in a new pattern every day for thousands of years. I would like to think that my work reflects that beautiful complexity and reality.

2. 'Time passes, a place remains. A walk moves through life, it is physical but afterwards invisible. A sculpture is still, a stopping place, visible' (Richard Long, WF).
3. R. Long, FC VI, in WC, 16.
4. See J. Burnham, 1971.
5. Quoted in G. Baro, 1969, 122. Flanagan continued: 'there is a never-ending stream of materials and configurations to be seen, both natural and man-made, that have visual strength but not object or function apart from this. It is as if they existed for just this physical, visual purpose – to be seen.' See C. Harrison: "Barry Flanagan's sculpture", *Studio International*, 175, 900, May, 1968, 266-8; J. Kirshner: "Barry Flanagan", *Artforum*, 23, 10, Summer, 1985, 112.

4.13 LAND ART AS RELIGION

1. M. Basho, *The Narrow Road to the Deep North and Other Travel Sketches*, tr.

N. Yuasa, Penguin, London, 1966, 33.
2. M. Ueda: *Matsuo Basho*, Twayne, New York, NY, 1970, 167.
3. Chuang-tzu, *Basic Writings*, tr. B. Watson, Columbia University Press, New York, NY, 44.
4. Richard Long: 'I have read a few bits and pieces of Beckett's work... he does use things like country lanes and bicycles and stones and doing nothing... like an incredible minimal view of life, which is very attractive and powerful. So I think there are some similarities, in the same way there are similarities with Zen Buddhism.' (IC 2, 7)
5. J. White, 67-69.
6. A. Goldsworthy, *Hand to Earth*, 101-2.
7. As Anne Seymour said of Richard Long: '[h]is approach also corresponds with the Zen view, which recognises human nature as one with objective nature, in the sense that nature inhabits us and we nature' (*Old World, New World*, 54).
8. R. Long, letter to the author, April 20, 1994.
9. R. Long, IC 2, 22.
10. R. Long, "Fragments of a Conversation VI", WC, 16.
11. As Richard Long put it, his work is 'a balance between the patterns of nature and the formalism of human abstract ideas like lines and circles.' (R. Long, interview with R. Cork, in D. Sylvester.)
12. M. Fried, "Art and Objecthood", in G. Battock, 1995, 28.
13. M. Eliade, 1984, 185.
14. M. Eliade: "Sacred Architecture and Symbolism", in *Mircea Eliade*, C. Tacou, ed. L'Herne, Paris, 1978, and in M. Eliade, 1988, 107.
15. M. Eliade, 1988, 107.
16. In A. Papadakis, 1991, 250.
17. C. Hussey, *The Picturesque*, Putnam's, New York, NY, 1927.

CHAPTER 5 ANDY GOLDSWORTHY

5.1 WHOLE EARTH ARTIST

1. A. Goldsworthy, in A. Causey, 1980.
2. A. Goldsworthy, in *Aspects*, 1986.
3. A. Goldsworthy, interview with T. Friedman, *Third Ear*, 1989 in HE, 166.
4. K. Bloomert, 34; see also J. Gibson.
5. J. Kounellis: in W. Sharp: "Structure ad Sensibility", *Avalanche*, 5, Summer, 1972.

5.2 ANDY GOLDSWORTHY AND WRITING

1. A. Goldsworthy, *The Third Ear*, 1989, in HE, 165.
2. Quoted in P. Redgrove, *Sex-Magic-Poetry-Cornwall*, Crescent Moon, 1994, 43.
3. A. Goldsworthy, in WH and AG.

5.3 ANDY GOLDSWORTHY AND PHOTOGRAPHY

1. J. Dibbets, in L. Bear & W. Sharp: "DIBBETTS", *Avalanche*, 1, Autumn, 1970.
2. Ibid.

5.4 DECORATIVE ART?

1. R. Long, letter to the author, June 18, 1994.
2. A. Goldsworthy, *Mountains and Coast, Autumn into Winter*, 1988, in HE, 163.
3. A. Goldsworthy, sketchbook no. 13, and in N. Sinden.
4. A. Goldsworthy, *Wall*, 68-69.
5. K. Carter, 1994-95, 100.
6. 'My strongest work is so rooted in place that it cannot be separated from where it is made', Goldsworthy wrote in *Stone* (6).
7. J.C. Powys, *A Glastonbury Romance*, 926.
8. J.C. Powys, *Maiden Castle*, Cassell, London, 353.

5.5 GOLDSWORTHY THE CELTIC SNOWMAN

1. A. Goldsworthy, in *Andy Goldsworthy*.
2. 'Working in Britain means working close to change: a clear day soon clouds over, snow melts quickly, a calm morning turns windy. These qualities give urgency and energy to what I do.' (Andy Goldsworthy, in AG).
3. A. Goldsworthy, sketchbook, January 22, 1983, HE, 146.
4. A. Goldsworthy, interview, Dec 9, 1987, in HE, 163.
5. 'Urban living has always tended to produce a sentimental view of nature' wrote John Berger (*The White Bird: Writings by John Berger*, London, 1988, 7).
6. 'Nature for me is the clearest path to discover – *uncluttered by personalities* or associations – *it just is*', says Goldsworthy in a telling statement (my emphasis, sketchbook no. 19, 1988, HE, 150).

5.6 *TOUCHING NORTH*

1. A. Goldsworthy: *Touching North*, 1989, and in HE, 75.

5.7 GOLDSWORTHY THE GREEN MAN

1. A. Goldsworthy, HE, 163.
2. G. Evans, 1969, 62.
3. A. Goldsworthy: *Andy Goldsworthy*, Viking, London, 1990, no page numbers; and in N. Hedges, 67; HE, 160-1.
4. A. Causey: "Environmental Sculptures", in HE, 128.
5. A. Goldsworthy, *Third Ear*, 1989, in HE, 168.
6. A. Goldsworthy, *Mountain and Coast, Autumn into Winter*, 1988, in HE, 163, my italics.
7. A. Goldsworthy, in AG; WH; and HE, 162.
8. *Artists in National Parks*, Victoria & Albert Museum, London, 1988, and in HE, 73.
9. D. Judd: "Specific Objects", in G. de Vries, 1974, 128.
10. A. Goldsworthy, *Touching North*, 1989.

5.8 ANDY GOLDSWORTHY'S LARGE-SCALE WORKS

1. R. Long, in *Words After the Fact*, in R. Fuchs, 236.

2. 'Goldsworthy's pieces dig at the roots of our relationship with nature, he is conducting an interrogative process with the fundamentals of our world – water, stone, earth, growing things and – latterly, in his work with volcanic rock and 'fired' stones – fire.' (P. Whitaker, 1995, 109)
3. A. Goldsworthy, in B. Redhead, 19.
4. 'Some works have qualities of snaking but are not snakes. The form is shaped through a similar response to environment.' (Andy Goldsworthy, in AG)
5. A. Causey: "Environmental Sculptures", in HE, 128.
6. A. Goldsworthy, in N. Hedges, 71.
7. A. Goldsworthy, quoted in T. Friedman: "Monuments", in HE, 154
8. A. Causey: "Environmental Sculptures", HE, 140.
9. A. Goldsworthy, unpublished notes, 1988, in HE, 134-5.
10. J. & C. Bord: *Mysterious Britain*, Paladin , London,1974, 240-1.
11. Goldsworthy said he heard about the dragon legend after he had made *Lambton Earthwork* (HE, 135).
12. T. Friedman: "Monuments", HE, 154.
13. A. Goldsworthy, in HE, 147, 189.
14. A. Goldsworthy, sketchbook no. 19, March 3, 1988, HE, 154.
15. A. Goldsworthy, Arctic diary, April, 1989, in *Touching North*, HE, 158.
16. R. Harris, quoted in D. Petherbridge, "Public commissions and the new concerns in sculpture", in P. de Monchaux, 136.
17. A. Goldsworthy, 1987, HE, 147.
18. A. Goldsworthy, in Y. Baginsky, 1989.
19. K. Smith, in W. Strachan, 179.
20. See R. Parker, 1987, 316; L. Lippard, 1976, 203.

5.9 MYSTICISM AND SCULPTURE

1. J.C. Powys: *Petrushka and the Dancer: The Diaries of John Cowper Powys 1929-1939*, Carcanet/ Alyscamps, 1995, 98, 136.
2. A. Goldsworthy, sketchbook no. 22, 1988, HE, 150.
3. 'My days are defined by my work which leaves a trail that marks out my life' said Goldsworthy (S, 82)
4. Goldsworthy dislikes geometry being 'imposed upon nature' (HE, 162), though all his sculpture (like all art) can be seen as something 'imposed upon nature'. Even the most ephemeral and miniscule of Goldsworthy sculptures, such as the tiny flower or leafworks, are impositions and additions to the natural world. They are events which do not happen 'naturally'.
5. A. Goldsworthy, in *Winter Harvest*, HE,162.

5.10 INTO THE BLACK HOLE

1. C. Koelb: "Castration Envy", in P. Burgard, 79.

5.12 *SNOWBALLS IN SUMMER*

1. *Snowballs in Summer Installation*, 1989.
2. J. Beardsley, 1984, 134.

5.14 SCULPTURE IN TIME

1. See D. de Menil *et al*: *Yves Klein: 1958-62: A Retrospective*, Institute for the Arts, Rice University, Houston, TX, 1982.
2. See J. Yoshihara, in B. Bertozzi & K. Wolbert: *Gutai: Japanese Avant-Garde*, Darmstadt, 1991.
3. A. Goldsworthy, in M. Church; and *Stone*, 120.
4. A. Goldsworthy, sketchbook no. 19, Feb, 1988. HE, 150.
5. A. Goldsworthy, *Rain sun snow hail mist calm*, 4.
6. A. Goldsworthy, *Third Ear*, BBC Radio 3, June 30, 1989, in HE, 168.
7. Quoted in *Andy Goldsworthy*, 1999.
8. 'Each work grows, stays, decays – integral parts of a cycle which the photograph shows at its height, marking the moment when the work is most alive' wrote Goldsworthy (AG)
9. R. Smithson: *Writings*, 56-57; C. Robins, 80.
10. R. Long, 1986, 1, 9.
11. A. Goldsworthy, in M. Church.
12. A. Goldsworthy, 1985, quoted in S. Clifford & A. King: "Hampstead Heath and Hooke Park Wood 1985-86", in HE, 57.
13. Arctic diary, in HE, 158.
14. A. Goldsworthy, April 8, 1989, in *Touching North*, 1989, and in HE, 158.

5.15 COLOUR

1. H. Voegls: "Haarlemmerhout", in HE, 54.
2. 1985, HE, 59.
3. Robert Rosenblum wrote:

 There's a German artist Wolfgang Laib who does something of this sort too. He spends a lot of time in the woods gathering such things as pollen and collecting it and forming minimal geometric patterns out of gossamer and natural mater-ials such as honey or dust of various kinds. It is some kind of ecological last gasp of communion with some pure beautiful stuff of nature. I guess this attitude is expiring even though it may, as in the case of Richard Long, still produce some marvellous artists.
 (Quoted in "Romanticism and Retrospective: An Interview with Robert Rosenblum", in A. Papadakis, 1988, 11.)

4. Quoted in P. Nesbit: "Leafworks", in HE, 108.
5. In N. Hedges, 68.
6. Quoted in *Leaves*, Natural History Museum, London, 1989, 18.
7. Quoted in P. Nesbit: "Leafworks", in HE, 108.
8. A. Goldsworthy, *Leaves*, op.cit., 18.
9. In A. Papadakis, 1991, 250.
10. In J. Beardsley, 1984, 134.

BIBLIOGRAPHY

ANDY GOLDSWORTHY

Andy Goldsworthy, Alan Rankle, Nigel Jepson, Brampton Banks, Cumbria, 1982
Rain sun snow hail mist calm: Photoworks by Andy Goldsworthy, Henry Moore
 Centre for the Study of Sculpture, Leeds, Yorkshire, 1985
Land Matters, Blackfriars Arts Centre, Reed Press, 1986
"Hampstead Heath", *Aspects,* 32, Spring, 1986
& J. Fowles. *Winter Harvest,* Scottish Arts Council, 1987
Mountain and Coast: Autumn Into Winter: Japan 1987, Art Data, 1988
Parkland, Yorkshire Sculpture Park, West Bretton, 1988
Touching North, Fabian Carlsson, London, 1989
Snowballs in Summer Installation, Old Museum of Transport, Glasgow, 1989
Garden Mountain, Centre d'Art Contemporain, Castres, 1989
Leaves, Common Ground, London, 1989
Singular Visions, University of Warwick, 1989
Andy Goldsworthy, Viking, London, 1990
Hand to Earth: Andy Goldsworthy, Sculpture, 1976-1990, Henry Moore Centre for
 Sculpture, Leeds, Yorkshire, 1990
interview, *Third Ear,* BBC Radio 3, June 30, 1989, in 1990 (HE)
"Geometry and Nature", interview, *Art & Design,* in A. Papadakis, 1991
Sand Leaves, Arts Club of Chicago, IL, 1991
Ice and Snow Drawings, Fruitmarket Gallery, Edinburgh, 1992
Andy Goldsworthy: Breakdown, Rose Art Museum, 1992
Andy Goldsworthy: Futatsu no aki, Tochigi Kenritsu Bijutsukan, Tokyo, 1993
"Andy Goldsworthy: an artist's diary", *Arts Review,* 45, Sept, 1993
"Andy Goldsworthy", *Art & Design,* 9, 5/6, May/ June 1994
Stone, Viking, London, 1994
Black Stones, Red Pools, Pro Arte Foundation, 1995
Wood, Viking, London, 1996
Sheepfolds, with S. Chettle, P. Nesbitt, A. Humphries, Michael Hue-Williams Gallery,
 London, 1996
Végétal, Ballet Atlantique-Régine Chopinot, La Rochelle, France, 1996
Alaska Works, Anchorage Museum of History and Art, Anchorage, AK, 1996
Andy Goldsworthy: A Collaboration With Nature, Abrams, New York, NY, 1996
Andy Goldsworthy: Jack's Fold, ed. J. Glasman, University of Hertfordshire, St
 Albans, Hertfordshire, 1996
Hand to Earth: Andy Goldsworthy Sculpture, T. Friedman, Thames and Hudson,
 London, 1997 & 2004
Cairns, Musée départemental de Digne, Reserve Geologique de haute Provence,
 1997
Andy Goldsworthy, Musée d'art contemporain de Montréal, Canada, 1998
Arch, with D. Craig, Thames & Hudson, London, 1999

Andy Goldsworthy, with M. Kuipers & T. Karreman, Province Noord-Holland aan Staats-bosbeheer, 1999
Wall, intr. K. Baker, Thames & Hudson, London, 2000
Time, Thames & Hudson, London, 2000
Midsummer Snowballs, intr. J. Collins, Thames & Hudson, London, 2001
Andy Goldsworthy – Réfuges d'Art, Editions Artha, 2002
Passage, Thames & Hudson, London, 2004
Enclosure, Thames & Hudson, London, 2007

OTHERS

H. Adams. "The Woodman", *Art and Artists*, 13, Apl, 1979
—. "Fabian Carlsson Gallery: London: Exhibit", *New Art Examiner*, 15, May, 1988
W.C. Agee. "Unit, Series, Site: A Judd Lexicon", *Art in America*, May, 1975
—. *The Sculpture of Donald Judd*, Art Museum of South Texas, Corpus Christi, TX, 1977
D. Alberge. "Making an impression with the elements", *The Independent*, Feb 18, 1989
L. Aldrich. *Cool Art: 1967*, Museum of Contemporary Art, 1968
L. Alloway. *Systematic Painting*, New York, NY, 1966
—. *Christo*, Abrams, New York, NY, 1969
—. "Robert Smithson's Development", *Artforum*, Nov, 1972
C. Andre. "Frank Stella: Preface to Stripe Painting", in D. Miller, 1959
—. "An Interview with Carl Andre", P. Tuchman, *Artforum*, 8, 10, June, 1970
—. *Carl Andre, Sculpture, 1958-1974*, Kunsthalle, Bern, 1975
—. "Object v Phenomenon", *Sculpture Today*, The International Sculpture Center, Toronto, 1978
—. *Carl Andre: Sculpture*, State University of New York Press, Albany, NY, 1984
—. *Carl Andre: works on land*, Exhibitions International, 2001
C. Andreae. "Art shaped by the weather", *Christian Science Monitor*, Sept 21, 1987
—. "Fire and ice", *Art News*, 89, 7, Sept, 1990
J. Andrews. *The Sculpture of David Nash*, Lund Humphries, London, 1999
M. Andrews. *Landscape and Western Art*, Oxford Paperbacks, Oxford, 1999
E. de Antonio & Mitch Tuchman. *Painters Painting*, Abbeville Press, New York, NY, 1984
"Andy Goldsworthy", *Rambler Magazine*, 16, Summer, 2003
D. Archibald. "Art forms fashioned with the help of mother nature", *Dumfries and Galloway Standard*, Nov 18, 1988
—. "Andy's unique view of nature takes him round the world", *Dumfries and Galloway Standard*, Feb 3, 1988
D. Ashton. *American Art Since 1945*, Thames & Hudson, London, 1982

—. *Modern American Sculpture*, Abrams, New York, NY, 1968

A. Aycock. "Work", "Maze", 1975, in A. Sondheim, 1977

Y. Baginsky. "Sculptor for whom success snowballs", *Scotland on Sunday*, Jan 15, 1989

M. Bailey. "Carve a name in ice", *The Observer*, June 11, 1989

K. Baker. *Minimalism: Art of Circumstance*, Abbeville, New York, NY, 1988

—. "Andy Goldsworthy: Haines", *Art News*, 91, 8, Oct. 1992

—. "Goldsworthy's natural approach", *San Francisco Chronicle*, June 1, 1994

—. "An earthy show", *San Francisco Sunday Examiner*, Feb 19, 1995

—. "Setting the record straight on Yves Klein", *San Francisco Chronicle*, June 11, 1995

—. "Art that knocks and sculpts and rearranges wood", *San Francisco Chronicle*, Oct 20, 1996

—. "A welcome complexity in new shows", *San Francisco Examiner*, Dec 13, 1996

—. "Feat of Clay in the (Un)making: many reverberations in cracking wall at Haines", *San Francisco Chronicle*, Dec 11, 1996

—. "Searching for the window into nature's soul", *Smithsonian*, Feb, 1997

S. Bann & W. Allen, eds. *Interpreting Contemporary Art*, Reaktion Books, London, 1991

—. "Shrines, Gardens, Utopias", *New Literary History*, 24, 4, Autumn, 1994a

—. "The Map As Index of the Real: Land Art and the Authentication of Travel", *Imago Mundi*, 46, British Library, London, 1994b

G. Baro. "Toward Speculation in Pure Form", *Art International*, Summer, 1967

—. "Sculpture made visible: Barry Flanagan in discussion with Gene Baro", *Studio International*, 178, 915, Oct, 1969

M. Bartlett. "A tribe of one: Andy Goldsworthy at Haines Gallery", *ArtWeek*, 23, 19, July 9, 1992

G. Battock, ed. *The New Art*, Dutton, New York, NY, 1966

—. *Idea Art*, Dutton, New York, NY, 1973

—. ed. *Minimal Art: A Critical Anthology*, University of California Press, Berkeley, CA, 1995

G. Beal, ed. *Art In the Landscape*, Chinati Foundation, Texas, 2000

J. Beardsley. *Probing the Earth: Contemporary Land Projects*, Smithsonian Press, Washington, DC, 1977

—. *Art in Public Spaces*, Partners For Liveable Places, Washington, DC, 1981

—. *Earthworks and Beyond: Contemporary Art in the Landscape*, Abbeville Press, New York, NY, 1984/ 1998

M.R. Beaumont. "Romantic Sculpture", in A. Papadakis, 1988

—. "Fabian Carlsson Gallery: London: Exhibit", *Arts Review*, 40, Mch 11, 1988

—. "Andy Goldsworthy", *Arts Review*, 41, July 14, 1989

A. Benjamin, ed. *Installation Art, Art & Design*, 30, 1993

L. Bennett. *The Life and Work of Andy Goldsworthy*, Heinemann, London, 2005

N. Bennett, ed. *The British Art Show: Old Allegiances and New Directions, 1979-1984*, Arts Council/ Orbis, London, 1984

M. Berger. *Labyrinths: Robert Morris, Minimalism and the 1960s*, Harper & Row, New York, NY, 1989

—. *Minimal Politics*, University of Maryland, Fine Arts Gallery

S. Bérubé. "Goldsworthy et Singer: l'art de jouer avec la nature", *La Presse*, Apl 25, 1998

R. Bevan. "A snake in the British Museum", *Art Newspaper.* 5, 43, Dec 1994

W. Bishop. "A corporate collection", *British Journal of Photography*, June 12, 1987

K.C. Bloomert & C.W. Moore. *Body, Memory and Architecture*, New Haven, CT, 1977

M. Bochner. "Art in Process – Structures", *Arts Magazine*, 40, 9, 1966a

—. "Primary Structures", *Arts*, June, 1966b

—. "Systematic", *Arts Magazine*, 41, 1, Nov, 1966c

—. "Serial Art Systems: Solipsism", *Arts Magazine*, 41, 8, Summer, 1967

S. Boettger. *Earthworks*, University of California Press, Berkeley, CA, 2002

D. Bonetti, David. "Facing Eden: 100 years of landscape art in the Bay Area, is a show that limns a strong tradition", *San Francisco Examiner*, June 25, 1995

A. Bonnano. "Andy Goldsworthy", *Art and Design*, 9, 5/6, May/ June 1994

D. Bourdon. "Walter de Maria: The Singular Experience", *Art International*, Dec 20, 1968

—. *Christo*, Abrams, New York, NY, 1971

—"The Mini-Conceptual Age", *Village Voice*, Oct 17, 1974

—. "You Can't Tell a Painter By His Colors", *Village Voice*, Mch 24, 1975

—. *Carl Andre: Sculpture, 1959-1977*, Jaap Rietman, New York, NY, 1978

—. "Andy Goldsworthy at Lelong", *Art in America.* 81, 11, Nov, 1993

—. *Designing the Earth*, Abrams, New York, NY, 1995

C. Brown. "Natural arts", *The Magazine,* July, 1987

D. Brown. "New British sculpture in Normandy", *Arts Review*, Feb 10, 1989

I. Brown. "From urban nightmare to primal scream: Chopinot/ Goldsworthy at the Playhouse", *Electronic Telegraph*, 820, Aug, 23, 1997

J. Brown *et al. Michael Heizer: Sculpture in Reverse*, see M. Heizer, 1984

—. ed. *Occluding Front: James Turrell*, Lapis Press, Larkspur Landing, CA, 1985

P. Buchanan. "The Nature of Goldsworthy", *The Architectural Review*, Feb, 1988

J. Burnham. *Beyond Modern Sculpture*, Braziller, New York, NY, 1968

—. "A Dan Flavin Retrospective in Ottawa", *Artforum*, 8, 4, Dec, 1969

—. "Haacke's Cancelled Show at the Guggenheim", *Artforum*, June, 1971

—. *Great Western Salt Works*, Brazillier, New York, NY, 1974

J. Butterfield. *The Art of Light and Space*, Abbeville Press, New York, NY, 1993

D. Cameron. "When is a door not a door?", *XLIII esposizione Internazionale d'Arte La Biennale di Venezia*, Edizioni La Biennale, Venice, 1988

—. "Art for the new year: who's worth catching?", *Art & Auction*, Jan, 1994

J. Campbell. *The Power of Myth*, with B. Moyers, ed. B.S. Flowers, Doubleday, New York, NY, 1988

—. *The Hero With a Thousand Faces,* Paladin, London, 1988

—. *An Open Life*, Larson Publications, New York, NY, 1988

—. *The Hero's Journey: Joseph Campbell On his Life and Work,* ed. P. Cousineau, Harper & Row, San Francisco, CA, 1990

P. Carlson. "Donald Judd's Equivocal Objects", *Art in America*, Jan, 1984

K. Carter: "*Stone*", *New Welsh Review*, 27, Winter, 1994-95

T. Castle. "Nancy Holt, Siteseer", *Art in America*, Mch, 1982

A. Causey. *Nature as Material: An Exhibition of Sculpture and Photographs Purchased For the Arts Council Collection,* Arts Council, London, 1980

—. "Environmental Sculptures", in A. Goldsworthy, 1990

—. "Space and Time in British Land Art", *Studio International*, 193, 98, Feb, 1977

G. Celant. "Introduction", *Arte Povera*, Praeger, New York, NY, 1969

—. *Conceptual Art, Arte Povera, Land Art,* Galeria Civica d'Arte Moderna, Turin, 1970

C. Chandler. *The Ultimate Seduction,* Quartet, London, 1984

H.B. Chipp, ed. *Theories of Modern Art,* University Press of California, Los Angeles, CA, 1968

A. Christian. "Art of a craftsman: the sculptures of Andy Goldsworthy reflect a deep passion for the natural world", *Resurgence Magazine,* Feb, 1998

B. Christian. "Scottsdale Center present "nature oriented" shows", *Scottsdale Life,* Aug 18, 1994

M. Church. "A shower of stones, a flash in the river", *Sunday Telegraph,* Apl 10, 1994

A. Clabburn. "A sanctuary in the city", *The Age,* Oct, 22, 1997

F. Colpitt. *Minimal Art: The Critical Perspective,* University of Washington Press, Seattle, WA, 1990

R. Cork. "Paying the price", *Listener Guide,* Dec 9, 1985

—. "Burnished in bush country", *The Times,* May 28, 1993

—. "Andy Goldsworthy", *The Times,* Apl 23, 1994

M. Crichton. *Jasper Johns,* Thames & Hudson, London, 1977

C. Dal Canto. "As nature dictates", *Casa Vogue,* 248, Feb, 1993

—. "Stones", *Casa Vogue,* 266, 1994

G. Danto. "A clearing in the woods", *Art News,* 93, 2, Feb, 1994

P. Davey. "Delight", *Architectural Review,* 193, Apl, 1993

R. Davies & T. Knipe, eds. *A Sense of Place: Sculpture in Landscape,* 1984

R. Deakin. "Zen and the art of Andy Goldsworthy", *Modern Painters,* 10, 1, Spring, 1997

W. de Maria. "The Lightning Field", *Artforum,* 18, 8, Apl, 1980

P. de Monchaux, *et al,* eds. *The Sculpture Show,* Arts Council of Great Britain, London, 1983

N. de Oliveira *et al. Installation Art,* Thames & Hudson, London, 1994

—. *et al. Installation Art in the New Millennium,* Thames & Hudson, London, 2003

M. Derby. "Fleeting moments: Andy Goldsworthy at Karekare", *Art New Zealand,* 63, Winter 1992

R. Deutsche *et al. Hans Haacke,* MIT Press, Cambridge, MA, 1986

E. Develing. *Carl Andre,* Gemeentenmeuseum, The Hague, 1969

—. & L. Lippard. *Minimal Art,* Stadtische Kunsthalle, Dusseldorf, 1969

M. Dobson. "Breath of fresh air", *The New Statesman,* Jan 10, 1986

—. "Shared sentiments", *BBC Wildlife,* Jan, 1987

M. Donovan. *The Andy Goldsworthy Project,* Thames & Hudson, London, 2010

L. Dougherty. "Art in nature: a new site for sculpture in Denmark", *Maquette,* Sept, 1994

M. Drabble. "Andy Goldsworthy", *Modern Painters,* 2, 3, Autumn, 1989

C. Drury. *Silent Spaces,* Thames & Hudson, London, 1998/ 2004

—. interview with W. Furlong, in M. Gooding, 2002

A. Dumas. "Andy Goldsworthy at Fabian Carlson Gallery", *Art in America,* May, 1988

M. Duncan. "On site: straddling the great divide", *Art in America.* 83, 3, Mch, 1995

—. "Live from the Getty", *Art in America,* 86, 5, May, 1998

R. Durand. "Andy Goldsworthy", *Le printemps de Cahors: catalogue des expositions,* Marval, Paris, 1996

L. Durrell. *Justine,* Faber, London, 1963

—. *Spirit of Place*, Faber, London, 1971

J.C. Eade, ed. *Projecting the Landscape*, Humanities Research Centre, Canberra, 1987

D. Ebony. "Goldsworthy's Living Memorial", *Art in America*, Nov, 2003

M. Eliade. *Patterns in Comparative Religion*, Sheed & Ward, London, 1958

—. *Shamanism: Archaic Techniques of Ecstasy*, Princeton University Press, Princeton, NJ, 1972

—. *Myths, Dreams and Mysteries*, Harper & Row, New York, NY, 1975

—. *From Primitives to Zen: A Sourcebook*, Collins, London, 1977

—. *A History of Religious Ideas*, I, Collins, London, 1979

—. *Ordeal by Labyrinth*, University of Chicago Press, Chicago, IL, 1984

—. *Symbolism, the Sacred and the Arts*, Crossroad, New York, NY, 1988

G. Evans. "Sculpture and Reality", *Studio International*, 177, 908, Feb, 1969

S. Farr. "Andy Goldsworthy: stone works in America", *Reflex*, 8, 6, Dec, 1995

S. Field. "Touching the Earth", *Art and Artists*, 8, Apl, 1973

A. Fisher & J. Saward. *The British Maze Guide*, Minotaur Designs, 1991

—. & D. Kingham. *Mazes*, Shire Publications, 1991

D. Frankel. "Andy Goldsworthy", *Artforum*, Oct, 2000

M. Fried. "Shape as Form: Frank Stella's New Paintings", *Artforum*, 5, 3, Nov, 1966

—. "Art and Objecthood", *Artforum*, 5, Summer, 1967

R.H. Fuchs. *Richard Long*, text, in R. Long, 1986

P. Fuller. *Peter Fuller's Modern Painters: Reflections on British Art*, ed. J. McDonald, Methuen, London, 1993

H. Fulton. "Specific Places and Particular Events", in B. Tufnell, 2002

S. Gardiner. "Their medium is nature", *Landscape Architecture*, 80, Feb, 1990

M. Garlake. "Andy Goldsworthy", *Art Monthly*, 93, Feb, 1986

J. Gear. "Andy Goldsworthy", *Review*, Dec. 1, 1996

L. Gendron. "Le sculpteur d'éphémère", *L'actualité*, 22, 12, Aug, 1997

J. Gibson. *The Senses Considered as a Perceptual System*, Houghton Mifflin, Boston, MA, 1966

A. Gide. *The Counterfeiters*, tr. D. Bussy, Penguin, London, 1966

P. Giquel. "Andy Goldsworthy: Centre d'art contemporain Midi-Pyrénées", *Art Press*, 158, May, 1991

T. Godfrey. "Richard Wilson's watertable, Andy Goldsworthy", *Burlington Magazine*, 136, 1096, July, 1994

—. *Conceptual Art*, Phaidon, London, 1998

M. Gooding & W. Furlong. *Song of the Earth,* Thames and Hudson, London, 2002

A. Graham-Dixon. "Turning over an old leaf", *The Independent,* Feb 3, 1988

—. "Cutting Ice", *The Independent,* June, 24, 1989

—. "An artist does the strand", *The Independent,* Aug 5, 1989

—. "Great Britain: neo, no: still faithful to the old guard", *Art News*, 88, 7, Sept, 1989

J. Grande. *Balance: art and nature*, Black Rose Books, Montréal, 1994

—. "Back to nature?", *Sculpture*, 13, 4, July/ Aug, 1994

—. *Art Nature Dialogues*, State University of New York Press, NY, 2004

N. Graydon. "Magic in the field", *Ritz*, 133, 1989

C. Greenberg. *Art and Culture,* Beacon Press, Boston, MA, 1961

H. Gresty & D. Reason. *Landscape*, Kettle's Yard, Cambridge, 1986

—. *Bare: Alison Wilding: Sculptures, 1982-1993*, Newlyn Art Gallery, Cornwall,

1993

G. Greig. "Circular Tours In the Name of Art", *Sunday Times*, June 16, 1991

C. Grout. "Andy Goldsworthy: une esthétique pragmatique", *Art Press*, 192, May. 1994

A. Haden-Guest. "The King of Wrap", *The Sunday Times Magazine*, Jan, 1994

C. Hagen. "Art in review", *New York Times*, Sept 17, 1993

J. Haldane. *A Road From the Past To the Future*, Crawford Arts Centre, St Andrews, 1997

—. "Images After the Fact", *Modern Painters*, 11, 3, Fall, 1998

—. "Back To the Land", *Art Monthly*, June, 1999

C. Hall. "Shared earth", *Arts Review*, 43, June 14, 1991

—. "Site lines", *Arts Review*, 46, Oct, 1994

J. Hamlin. "Andy Goldsworthy: artist lets nature take its course", *San Francisco Chronicle*, May 4, 1994

A.M. Hammacher. *The Sculpture of Barbara Hepworth*, Abrams, New York, NY, 1968

B. Haskell. *BLAM! The Explosion of Pop, Minimalism, and Performance, 1958-64*, Whitney Museum of American Art, New York, NY, 1984

—. *Donald Judd*, Whitney Museum of American Art, New York, NY, 1988

J. Hattam. "Restoration art focussing on nature's power to reclaim [Andy Goldsworthy]", *Sierra*, May-June, 2003

M. Hayde. "Nature is his studio: Great Britain's Andy Goldsworthy, master of the ephemeral "earth sculpture", will give a free lecture at Stanford", *Palo Alto Weekly*, Jan 27, 1995

N. Hedges. "Growth, decay and the movement of change", *World Magazine*, 45, Jan, 1991

M. Heizer, D. Oppenheim & R. Smithson. "Discussion", *Avalanche*, 1, Autumn, 1970

—. *Sculpture in Reverse*, Museum of Contemporary Art, Los Angeles, CA, 1984

A. Henri. *Environments and Happenings*, Thames & Hudson, London, 1974

—. *Total Art*, Praeger, New York, NY, 1974

C. Henry. "Lumps of the Landscape", *The World of Interiors*, Oct, 1987

—. "A style with natural life", *Glasgow Herald*, Aug 21, 1987

—. "Artist in love with nature puts down roots", *Glasgow Herald*, July 19, 1988

—. "Goldsworthy at Work or Paving the Way", *Artline*, 14, 33, Nov, 1988

—. "Royal Botanic Garden: Edinburgh: Exhibit", *Arts Review*, 40, July 15, 1988

—. "Melting moments", *Glasgow Herald*, July 28, 1989

—. "Natural History Museum: London: Exhibit", *Arts Review*, 41, Oct 6, 1989

—. "Andy Goldsworthy: Stone shapes a life", *The Herald*, Apl 22, 1994

—. "Only branching out", *The Herald*, Jan, 18, 1997

A. Hess. "Technology Exposed", *Landscape Architecture*, May, 1992

R. Hill. "Ice and snow drawings", *Crafts*, 119, Nov/ Dec, 1992

E. Hilliard. "In tribute to the wild bunch", *The Independent*, June 22, 1988

A. Hindry. "Sculpture anglaise: le clavier de l'imagination", *Art Press*, 214, June, 1996

R.C. Hobbs. *Robert Smithson: Sculpture*, Cornell University Press, Ithaca, NY, 1981

—. "Earthworks", *Art Journal*, 42, Fall, 1982

N. Hodges ed. *Art and the Natural Environment*, Art & Design, 36, 1994

—. ed. *The Contemporary Sublime*, Art & Design, 40, 1995

N. Holt. "Amarillo Ramp", *Avalanche*, Fall, 1973

—. "Hydra's Head", *Arts Magazine*, Jan, 1975

—. "Sun Tunnels", *Artforum*, Apl, 1977

S. Howell. "Kingdom of the ice man", *Observer Magazine*, June 28, 1987

—. "Goldsworthy: the ice-man cometh", *World of Interiors*, July/ Aug, 1989

S. Hubbard & R. Sandall. "Peter Gabriel's *US*: the artists' boxes project: artists' statements", C*ontemporary Art*, 1, 2, Winter, 1992

—. intr. *Sculpture At Goodwood: A Vision For 21st Century British Sculpture*, Sculpture At Goodwood, Sussex, 2002

S. Huchet. "Un exercise de la terre: le travail d'Andy Goldsworthy", *Ligeia*, 11/12, Dec, 1992

G. Hughes. "Artists in parks", *Arts Review*, 40, July 15, 1988

—. ed. *Arts Review Yearbook, 1989,* Arts Review Magazine, London, 1989

—. *Arts Review Yearbook, 1990*, Arts Review Magazine, London, 1990

R. Hughes. *Nothing If Not Critical: Selected Essays on Art and Artists*, Collins Harvill, London, 1990

—. *The Shock of the New*, Thames & Hudson, London, 1991

T. Hughes. *Poetry in the Making*, Faber, London, 1969

—. *New Selected Poems, 1957-1994*, Faber, London, 1995

H.E. Hugo, ed. *The Portable Romantic Reader,* Viking Press, New York, NY, 1957

L. Hull. "In residence: Grizedale Forest sculpture park", *Maquette*, May/ June 1993

M. Hutchinson. "So follow him, follow him, down to the hollow", *Hampstead and Highgate Express*, Dec, 13, 1985

L. Iizawa. "Earth work", *Studio Voice*, Mch, 1988

P. Inch. "Andy Goldsworthy", *Arts Review*, 42, July 13, 1990

R. Ingleby. "Visual arts: Andy Goldsworthy", *The Independent*, Nov 8, 1996

D. Isaac. "When leaves turn to gold", *Echoes*, Mch 24, 1992

Y. Ishii. "Creating beauty from nature", *Chubu Yomiuri Shimbun*, 21, Feb 2, 1988

W. Januszczak. "The Heath Robinson", *The Guardian*, Jan, 5, 1986

—. "The magic of icicle works", *The Guardian*, July 7, 1987

W. Johnson. *Riding the Ox Home: A History of Meditation from Shamanism to Science*, Rider, London, 1982

J. Johnston. "Walling into Art", *Art in America,* 75, 4, Apl, 1987

B. Jones. "A New Wave in Sculpture", *Artscribe*, 8, Sept, 1977

J. Jones. "Something nasty in the woods", *The Guardian*, Mch 4, 2001

C. Joyce. "Walling into History", *Flash Art*, Summer, 1989

D. Judd. "Frank Stella", *Arts Magazine*, 36, Sept, 1962

—. "Specific Objects", *Arts Yearbook*, 8, Art Digest, New York, NY, 1965

—. *Complete Writings, 1959-1975*, Nova Scotia College of Art and Design, Halifax, Canada, 1975

—. *Complete Writings, 1975-1986*, Van Abbemuseum, Netherlands, 1987

E. Juncosa. "Landscape as experience", *Lapiz*, 61 Oct, 1989

J. Kastner, ed. *Land and Environmental Art*, Phaidon, London, 1998

R. Katz. *Naked By the Window: The Fatal Marriage of Carl Andre and Ana Mendieta*, Atlantic Monthly Press, New York, NY, 1990

S. Kemal & I. Gaskell, eds. *Landscape, natural beauty and the arts*, Cambridge University Press, Cambridge, 1993

M. Kemp. "Doing what comes naturally: morphogenesis and the limits of the genetic code", *Art Journal*, 55, 1, Spring 1996

G. Kepes, ed. *Arts of the Environment*, Brazillier, New York, NY, 1972

N. Khan. "Beating nature", *Art Express*, 25, Mch, 1986

C. Kino. "Andy Goldsworthy: Galerie Lelong", *Art News*, 95, 10, Nov, 1996

M. Kirby. *Happenings*, Dutton, New York, NY, 1966

D. Kozinska. "Stones in motion: show of Andy Goldsworthy's work gives a preview of colossal rock arch coming here soon across the Atlantic", *The Gazette*, Apl 18, 1998

R.E. Krauss. "Richard Serra: Sculpture Redrawn", *Artforum*, May, 1972

—. *Passages in Modern Sculpture*, Thames & Hudson, London, 1977

—. "Sculpture in the Expanded Field", *October*, 8, Spring, 1979

—. *Eva Hesse*, Whitechapel Art Gallery, London, 1979

Z. Kraus, ed. *From Nature to Art, From Art to Nature*, Venice Biennale, Milan, 1978

D. Krug. "Ecological Design: Andy Goldsworthy, Ballet Atlantique", ArtsEdNet, Getty Education Institute for the Arts, 1997

S. Lacey. "Putting yin and yang into the landscape", *Electronic Telegraph*, 549, Nov 23, 1996

I. Lamaitre. "Interview with Tony Cragg", *Artefactum*, 2, Dec, 1985

T. Lang. "News from the imagination", *Issues in Architecture, Art & Design*, 3, 1, 1993

Land Marks, Edith C. Blum Art Institute, Bard College, Annadale-on-Hudson, 1984

F. Laughlin. "Andy Goldsworthy, the geometrician", *Landscape Architecture*, Dec, 1997

B. Laws. "Where Art and Nature Meet", *The Telegraph Weekly*, Nov 12, 1988

C. Lebowitz. "Andy Goldsworthy", *Art in America*, Oct, 2000

D. Lee. "Serial Rights", *Art News*, 66, 8, Dec, 1967

—. "London Ecology Centre, Exhibit", *Arts Review*, 38, Jan 17, 1986

—. "Great art of the outdoors: bio-degrading sculptures", *Country Life*, 181, 35, Aug 27, 1987

—. "Pure, ephemeral spires", *The Times*, June 26, 1989

—. "In profile: Goldsworthy", *Arts Review*, 47, Feb 1995

A. Legg, ed. *Sol LeWitt*, Museum of Modern Art, New York, NY, 1978

B. Le Messurier. *Dartmoor Artists*, Halsgrove, Tiverton, Devon, 2002

G. Lewis. "No sculpture like snow sculpture", *This is London*, 1709, July 7, 1989

F. Licht. "Dan Flavin", *Artscanada*, Dec, 1968

D. Lillington. "Andy Goldsworthy: organic chemistry", *Time Out*, Apl 13, 1994

L. Lippard. "New York Letter: Apl-June, 1965", *Art International*, 9, 6, 1965

—. "New York Letter: Recent Sculpture as Escape", *Art International*, Feb, 1966a

—. "An Impure Situation", *Art International*, May 20, 1966b

—. *Ad Reinhardt*, Jewish Museum, New York, NY, 1966c

—. *Pop Art*, Oxford University Press, New York, NY, 1966d

—. "The Silent Art", *Art in America*, 55, 1, Jan-Feb, 1967a

—. "Sol LeWitt: Non-Visual Structures", *Artforum*, Apl, 1967b

—. "Tony Smith", *Art International*, Summer, 1967c

—. "Rebelliously Romantic?", *New York Times*, June 4, 1967d

—. "Escalataion in Washington", *Art International*, 12, 1, Jan, 1968

—. *Tony Smith*, Thames & Hudson, London, 1972a

—. *Grids*, Philadelphia Institute of Contemporary Art, PA, 1972b

—. *Six Years: The Dematerialization of the Art Object from 1966 to 1972*, Praeger, New York, NY, 1973

—. *From the Center: feminist essays on women's art*, Dutton, New York, NY, 1976

—. *Eva Hesse*, New York University Press, New York, NY, 1976
—. *et al. Sol LeWitt*, Museum of Modern Art, New York, NY, 1978
—. "Complexities: Architectural Sculpture in Nature", *Art in America*, Feb, 1979
—. *Ad Reinhardt*, Abrams, New York, NY, 1981
—. *Overlay*, Pantheon, New York, NY, 1983
R. Long. *Richard Long: In Conversation*, Parts 1 & 2, MW Press, Noordwijk, Holland, 1985-86
—. *Richard Long*, text by R.H. Fuchs, Thames & Hudson, London, 1986
—. *Old World New World*, Anthony d'Offay, London, 1988
—. *Richard Long: Walking in Circles*, Hayward Gallery/ Thames & Hudson, London, 1992
—. *Mountains and Water*, Anthony d'Offay, London, 1992
—. *Richard Long: a Moving World*, Tate Publishing, London, 2002
—. *Richard Long – Walking the Line*, Thames and Hudson, London, 2002
M. Lothian. "Distant thunder", *Arts Review*, 40, Sept 9, 1988
O. Lowenstein. "Natural Time and Human Experience", *Sculpture*, 22, 5, June, 2003
E. Lucie-Smith. *Sculpture Since 1945*, Phaidon, London, 1987
A. Lund. "Landskab og skultur", *Landskab*, Dec, 1989
R. Lund. "Why Isn't Minimal Art Boring?", *Journal of Aesthetics and Art Criticism*, 45, 2, Winter, 1986
N. Lynton. introduction to *Tony Cragg*, Fifth Triennale India, British Council, 1982
—. *David Nash: Sculpture, 1971-90*, Serpentine Gallery, London, 1990
C. Maclay. "Grounds for exploration", *San Jose Mercury News*, Feb 5, 1995
D. Macmillan. "David Nash: Brancusi Joins the Garden Gang", *Art Monthly*, 65, Apl, 1983
L. MacRitchie. "Ancient Egypt", *Financial Times*, Dec 12, 1994
—. "Residency on earth", *Art in America*, 83, 4, Apl, 1995
S. Madoff. "Andy Goldsworthy", *Garden Design*, 13, June, 1994
W. Malpas. *Richard Long: The Art of Walking*, Crescent Moon, 1995/ 1998
—. *Land Art, Earthworks, Installations, Environments, Sculpture*, Crescent Moon, 1996/ 1998/ 2004
—. *The Art of Richard Long*, Crescent Moon, 2005
—. *The Art of Andy Goldsworthy*, Crescent Moon, 2005
A.T. Mann. *Sacred Architecture*, Element Books, Shaftesbury, Dorset, 1993
J. van der Marck. *Wrapped Museum*, Museum of Contemporary Art, Chicago, IL, 1969
R. Martin. "Andy Goldsworthy: Fabian Carlsson, London", *Flash Art*, 140, May/ June, 1988
—. *The Sculpted Forest: Sculpture in the Forest of Dean*, Redcliff, Bristol, 1990
D. Matless & G. Revill. "A solo ecology: the erratic art of Andy Goldsworthy", *Ecumene*, 2, 4, 1995
K. Matsui. "Column people", *Asahi Shimbun*, Feb 2, 1988
J. May. "Landscape Fired by Ice", *Landscape*, Dec, 1987
D. Mayhall. *The Minimal Tradition*, The Aldrich Museum of Contemporary Art, Ridgefield, CT, 1979
B. McAvera. "Public art: site sensitivities", *Art Monthly*, 215, Apl, 1998
A. McGill. "Portrait of the artist as a bent twig", *London Standard*, Jan 22, 1984
D. McKinney. *Yves Klein, Brice Marden, Sigmar Polke*, Hirschl & Alder Modern, New York, NY, 1989

A. McPherson. "David Nash: interviewed by Allan McPherson", *Artscribe*, 12, June, 1978

K. McShine. *Primary Structures*, Jewish Museum, New York, NY, 1966

—. *Information*, Museum of Modern Art, New York, NY, 1970

—. *An International Survey of Recent Painting and Sculpture*, MOMA, New York, NY, 1984

W. Messer. "A tale of two festivals: Printemps de Cahors: Les rencontres d'Arles", *Art World*, 12, Winter, 1997

L. Metrick. "Disjunctions In Nature and Culture: Andy Goldsworthy", *Sculpture*, 22, 5, June, 2003

R. Millard. "The sculptor Andy Goldsworthy is turning part of Cumbria into a sculpture park", *The Independent*, Mch 25, 1996

D.C. Miller, ed. *Sixteen Americans*, Museum of Modern Art, New York, NY, 1959

M. Miller. *The Garden as an Art*, State University of New York Press, Albany, NY, 1993

T. Mizutani. "Conversation with nature", *Bijutsu Techo*, Mch, 1988

—. "Close relation with nature", *Mainichi Shimbun*, Jan 29, 1988

A. Morgan. "Maze and labyrinth", *Sculpture*, 14, 4, July/ Aug, 1995

J. Morland. *New Milestones: Sculpture, Community and the Land*, Common Ground, London, 1988

H. Morphy & M. Boles, eds. *Art from the Land*, University of Washington Press, 2000

R. Morris. "Notes on Sculpture", *Artforum*, Feb, 1966; Oct, 1966; June, 1967; Apl, 1969

—. "Aligned with Nazca", *Artforum*, Oct, 1975

—. *Robert Morris: Mirror Works, 1961-1978*, Leo Castelli Gallery, New York, NY, 1979

—. et al. *Earthworks*, Seattle Art Museum, Seattle, WA, 1979

—. *Selected Works*, Contemporary Arts Museum, Houston, TX, 1981

—. *Continuous Project Altered Daily*, MIT Press, Cambridge, MA, 1993

S. Morris. "A Rhetoric of Silence: Redefinitions of Sculpture in the 1960s and 1970s", in S. Nairne, 1981

J. Morrison. "Landmatters", *British Journal of Photography*, 133, June 6, 1986

D. Morse. "At Runnymede Farm, the crop is sculptures", *San Francisco Examiner*, May 2, 1997

A. Murphey. "White magic", *The Observer*, Dec, 1996

S. Nairne & N. Serota. *British Sculpture in the Twentieth Century*, Whitechapel Art Gallery, London, 1981

H. Nakamura. "Andy Goldsworthy and Anthony Green", *Ikebana Ryusei*, 38, Apl, 1988

D. Nash. *Fletched Over Ash*, AIR Gallery, 1978

—. "David Nash", *Aspects*, 10, Spring, 1980

—. *Stoves and Hearths*, Duke Street Gallery, London, 1982

T.A. Neff, ed. *A Quiet Revolution: British Sculpture Since 1965*, Thames & Hudson, London, 1987

B. Nemitz. *Trans Plant: Living Vegetation in Contemporary Art*, Hatje Cantz, Stuttgart, 2000

C. Nemser. "An interview with Eva Hesse", *Artforum*, May, 1970

—. "My Memories of Eva Hesse", *Feminist Art Journal*, Winter, 1973

P. Nesbitt. "At Home with Nature: Andy Goldsworthy in Scotland", *Alba*, Spring, 1989

—. "A Landscape Touched by Gold", in G. Hughes, 1990

E. Newhall. "Andy Goldsworthy", *New York Magazine*, Sept 13, 1993

M. Newman. "New Sculpture in Britain", *Art in America*, Sept, 1982

R. Nilsen. "Show only a nibble of Goldsworthy art", *Arizona Republic*, Sept 25, 1994

M. Nixon. *Eva Hesse*, MIT Press, Cambridge, MA, 2002

I. Noguchi. *A Sculptor's World*, Harper & Row, New York, NY, 1968

J. Norrie. "Andy Goldsworthy", *Arts Review*, July 3, 1987

B. Oakes, ed. *Sculpting the Environment*, Van Nostrand Reinhold, New York, NY, 1995

P. Oakes. "The Incomparable Andy Goldsworthy", *Country Living*, 48, Dec, 1989

S. Oksenhorn. "Art, naturally", *The Aspen Times*, 116, 50, Dec 9, 1995

W. Oliver. "A natural at work", *Yorkshire Post*, Feb 24, 1986

D. Oppenheim. *Dennis Oppenheim*, Musée d'Art Contemporain, Montréal, 1978.

—. *Selected Works, 1967-1990*, Abrams, New York, NY, 1992

E. Osaka. *Andy Goldsworthy: Mountain and Coast: Autumn Into Winter*, Gallery Takagi, Nagoya, 1987

W. Packer. "Andy Goldsworthy's Transient Touch", *Sculpture*, July, 1989

—. "Sculpture from the countryside", *Financial Times*, July 7, 1987

A.C. Papadakis, ed. *The New Romantics*, *Art & Design*, 4, 11/12, Academy Group, London, 1988

—. *et al*, eds. *New Art*, Academy Group, London, 1991

R. Parker & G. Pollock. *Old Mistresses: Women, Art an Ideology*, Routledge & Kegan Paul, London, 1981

—. *Framing Feminism*, Pandora Press, London, 1987

J. Partridge. "Forest work", *Craft*, 81, July/ Aug, 1986

T. Passes. "Rain sun snow hail mist calm", *Venue Magazine*, Sept 11, 1986

P. Patton. "Robert Morris and the Fire Next Time", *Art News*, 82, 10, Dec, 1983

E. Pavese, ed. *Christo: Surrounded Islands*, Abrams, New York, NY, 1986

N. Pennick. *Mazes and Labyrinths*, Hale, London, 1990

C. Peres. "Arte: collaborare con la natura, *Casa Vogue*, 228, Mch, 1991

K. Petersen & J.J. Wilson: *Women Artists: Recognition and Reappraisal from the Early Middle Ages to the Twentieth Century*, Women's Press, London, 1978

C. Peterson. "Inside the Goldsworthy installation", *Aspen Times*, Dec 16, 1995

P. Piguet. "Vassivière: une île pour la sculpture: an island for the sculpture", *Cimaise*, 41, 228, Jan, 1994

R. Pincus-Witten. *Postminimalism*, Out of London Press, New York, NY, 1977

—. *Post-Minimalism into Maximalism*, UMI Research Press, Ann Arbor, MI, 1987

G. Pollock. *Vision and Difference: femininity, feminism and histories of art*, Routledge, London, 1988

J.C. Powys. *Maiden Castle*, Cassell, London, 1937

—. *A Glastonbury Romance*, Macdonald, London, 1955

—. *Wolf Solent*, Penguin, London, 1964

—. *Autobiography*, Macdonald, London, 1967

G. Prince. "With mud on their hands, growth, decay and the movement of change", *World Magazine*, Jan, 1991

E. Rankin. "Popularising public sculpture in Britain: from landscape gardens to forest trails", *de Arte*, 53, Apl, 1996

C. Ratcliff. *In the Realm of the Monochrome*, Renaissance Society, University of
 Chicago, Chicago, IL, 1979
—. "The Compleat Smithson", *Art in America*, Jan, 1980
—. *Out of the Box*, Allworth Press, London, 2001
B. Redhead. *The Inspiration of Landscape: Artists in National Parks*, Phaidon,
 London, 1989
M. Regimbald. "L'homme qui plantait des arches [The man who planted arches]",
 Espace, 45, Autumn, 1998
B. Reise. "'Untitled 1969': A Footnote on Art and Minimal Stylehood", *Studio
 International*, 179, 910, Apl, 1969
N. Reynolds. "Lottery aid elevates sheep pens to fine art", *Electronic Telegraph*, 436,
 July 26, 1996
C. Robins. "Object, Structure or Sculpture: Where Are We?", *Arts Magazine*, 40, 9,
 1966
—. *The Pluralist Era: American Art, 1968-1981*, Harper & Row, New York, NY, 1984
P. Rodaway. *Sensuous Geographies*, Routledge, London, 1994
B. Rose. "New York Letter", *Art International*, Feb 15, 1964
—. "Looking at American Sculpture", *Artforum*, 3, Feb, 1965a
—. "ABC Art", *Art in America*, 53, 5, Nov, 1965b
—. *A New Aesthetic*, Washington Gallery of Modern Art, Washington, DC, 1967
—. *American Art Since 1900*, Thames & Hudson, London, 1967
—. *American Painting*, Skira/Rizzoli International, New York, NY, 1986
—. *Robert Morris*, Corcoran Gallery, Washington, DC, 1990
H. Rosenberg. *The De-Definition of Art*, Horizon Press, New York, NY, 1972
R. Rosenblum. *Modern Painting and the Northern Romantic Tradition*, Thames &
 Hudson, London, 1978
—. "Romanticism and Retrospective: An Interview with Robert Rosenblum", in A.
 Papadakis, 1988
—. "A postscript: some recent neo-romantic mutations", *Art Journal*, 52, 2,
 Summer, 1993
C. Ross. *Star Axis*, University of New Mexico Press, Albuqerque, NM, 1992
S. Ross. "Gardens, earthworks, and environmental art", in S. Kemal, 1993
—. *What Gardens Mean*, University of Chicago Press, Chicago, IL, 1998
M. Roth. "Robert Smithson on Duchamp", *Artforum*, Oct, 1969
M. Rothko. *Mark Rothko in New York*, Guggenheim Museum, New York, NY, 1994
R. Rubinstein. "Andy Goldsworthy: Galerie Lelong", *Art News*, 92, 10, Dec, 1993
T. Sakurai. "Here comes the gold light'. *Ikebana Ryusei*, 10, Jan, 1988
—. "Goldsworthy with snow", *Ikebana Ryusei*, 10, Feb, 1988
I. Sandler. *American Art of the 1960s*, Harper & Row, New York, NY, 1988
—. *Art of the Postmodern Era: From the 1960s to the Early 1990s*, HarperCollins,
 London, 1997
P. Schjeldahl. *Art in Our Time: The Saatchi Collection*, Lund Humphries, London,
 1984
P. Schuck. "Interview: Earth, Water, Wind", *Contemporanea*, Apl, 1990
W. Scott. "In the gallery", *New York Post*, Dec 21, 1996
A. Seymour. "Old World New World", in R. Long, *Old World New World*
E. Shanes: *Constantin Brancusi*, Abbeville, New York, NY, 1989
G. Shapiro. *Earthworks: Robert Smithson and After Babel*, University of California
 Press, Berkeley, CA, 1995

W. Sharp *et al. Earth Art*, Andrew Dickson White Museum of Art, Cornell University, Ithaca, NY, 1969

A. Sherman. "Bound to earth", *Metro*, Feb 23, 1995

N. Shulman. "Monday at the North Pole", *Arts Review*, June 2, 1989

N. Sinden. "Interview: Art in Nature: Andy Goldsworthy", *Resurgence*, 129, Aug, 1988

H.J. Smagula. *Currents: Contemporary Directions in the Visual Arts*, Prentice-Hall, Englewood Cliffs, NJ, 1983

B. Smith. *Fluorescent Light, etc, from Dan Flavin*, National Gallery of Canada, Ottawa, 1969

—. *Donald Judd*, National Gallery of Canada, Ottawa, 1975

D. Smith. *Sculpture and Drawings*, ed. J. Merkert, Prestel-Verlag, Munich, 1986

R. Smith. "Sol LeWitt", *Artforum*, Jan, 1975

—. "Review", *Artforum*, Dec, 1975

—. "De Maria: Elements", *Art in America*, May, 1978

—. review, *New York Times*, Sept, 2004

R. Smithson. "Entropy and the New Monuments", *Artforum*, 4, 10, June, 1966

—. "Incidents of Mirror-Travel in the Yucatan", *Artforum*, Sept, 1967

—. The Monuments of Passaic", *Artforum*, Dec, 1967

—. "Toward the Development of an Air Terminal Site", *Artforum*, Summer, 1967

—. "A Museum of Language in the Vicinity of Art", *Art International*, 12, 3, Mch, 1968

—. *The Writings of Robert Smithson*, ed. N. Holt, New York University Press, New York, NY, 1979

—. *Robert Smithson*, ed. J. Flam, University of California Press, Berkeley, CA, 1996

—. *Robert Smithson: A Collection of Writings*, Pierogi Galery New York, NY, 1997

A. Sondheim, ed. *Post-Movement Art in America*, Dutton, New York, NY, 1977

A. Sonfist. *Alan Sonfist*, Neuberger Museum, New York, NY, 1978

—. ed. *Art in the Land: A Critical Anthology of Environmental Art*, Dutton, New York, NY, 1983

N. Stangos, ed. *Concepts of Modern Art*, Thames & Hudson, London, 1981

N. Stapen. "Bringing nature inside the museum", *Boston Sunday Globe*, Mch 29, 1992

J. Stathatos. "Andy Goldsworthy's Evidences", *Creative Camera*, 255, Mch, 1986

J. Steele. "In a natural mould", *Farmers Weekly*, May 13, 1988

F. Stella. *Working Space*, Harvard University Press, Cambridge, MA, 1986

K. Stiles & P. Selz, eds. *Theories & Documents of Contemporary Art: A Sourcebook of Artists' Writings*, University of California Press, Berkeley, CA, 1996

S.L. Stoops. *Andy Goldsworthy: Breakdown*, Rose Art Museum, 1992

W.J. Strachan. *Open Air Sculpture in Britain*, Zwemmer, London, 1984

E. Suderburg, ed. *Space, Site, Intervention*, University of Minnesota Press, Minneapolis, MN, 2000

G. Sutton. "Land art", *Landskab*, Dec, 1989

D. Sylvester. *About Modern Art*, Chatto & Windus, London, 1996

L. Talbot. "Fleeting beauty from the elements forger", *Hampstead and Highgate Express*, Feb 12, 1988

H. Teague. "Good as Goldsworthy", *Aspen Magazine*, 1996

M. Thomas. "Monkeys and guerrillas", *Photofile*, 35, May, 1992

J. Thym. "An artist by nature" *Oakland Tribune*, Feb 8, 1995

G. Tiberghien. *Land Art*, Art Data, London, 1995

S. Tillim. "Earthworks and the New Picturesque", *Artforum*, Dec, 1968

M. Treib. "Frame, moment and sequence: the photographic book and the designed landscape", *Journal of Garden History*, 15, 2, Summer, 1995

M. Tromble. "A conversation with Andy Goldsworthy", *ArtWeek*, 23, 19, July 9, 1992

—. "A conversation with Robin Lasser", *ArtWeek*, 24, 20, Oct 21, 1993

E. Tsai. *Robert Smithson Unearthed*, Columbia University Press, New York, NY, 1991

M. Tuchman. *American Sculpture of the Sixties*, Los Angeles County Museum of Art, 1967

P. Tuchman. "Minimalism and Critical Response", *Artforum*, 15, 9, May, 1977

—. "Background of a Minimalist: Carl Andre", *Artforum*, Mch, 1978

—. "Minimalism", *Three Decades: The Oliver-Hoffmann Collection*, Museum of Contemporary Art, Chicago, IL, 1988

W. Tucker. *The Language of Sculpture*, Thames & Hudson, London, 1974

B. Tufnell & A. Wilson. *Hamish Fulton: Walking Journey*, Tate Publishing, London, 2002

C. Turnbull. "Beautiful Behaviour: The Photoworks of Andy Goldsworthy", *The Green Book*, 2, 6, 1987

J. Turrell. *Mapping Spaces*, Peter Blum, New York, NY, 1987.

—. interview, in B. Oakes, 1995

G. de Vries, ed. *On Art: Artists' Writings on the Changed Notion of Art After 1965*, Cologne, 1974

A.M. Wagner. *Three Artists (Three Women): Modernism and the Art of Hesse, Krasner and O'Keeffe*, University of California Press, Berkeley, CA, 1996

D. Waldman. "Samaras", *Art News*, Oct, 1966

—. *Carl Andre*, Guggenheim Museum, New York, NY, 1970a

—. "Holding the Floor", *Art News*, Oct, 1970b

J. Watkins. "In the artist's studio: Andy Goldsworthy: touching North", *Art International*, 9 Winter, 1989

—. "Andy Goldsworthy: Touching North", *Art International*, Winter, 1989

M. Webster. "Andy Goldsworthy at San Jose Museum of Art", *ArtWeek*, 26, 4, Apl, 1995

S. Webster. "Art in the Woods [Andy Goldsworthy]", *Arts & Activities*, Sept, 2000

U. Weilacher *et al. Between Landscape Architecture and Land Art*, Birkhauser Verlag AG, 1999

L. Weiner. *Lawrence Weiner, Works*, Anatol AV und Filmproduktion Hamburg, 1977

Welsh Sculpture Trust. *Sculpture in a Country Park*, Welsh Sculpture Trust, 1983

C. West. "From genesis to box", *Modern Painters*, 5, 4, Winter, 1992

D. Wheeler. *Art Since Mid-Century: 1945 to the Present*, Thames & Hudson, London, 1991

P. Whitaker. "Andy Goldsworthy", *London Magazine*, 34, 10, Jan, 1995

J. White. *The Birth and Rebirth of Pictorial Space*, Faber, London, 1981

O. Wick *et al. James Turrell*, Turske & Turske Gallery, Zurich, 1990

G. Widdicombe. "Andy Goldsworthy: between a rock and a hard place", *The Independent*, Apl 13, 1994

A. Wilding: *Alison Wilding*, with M. Tooby, Tate Gallery, St Ives, Cornwall, 1994

R. Williams. *After Modern Sculpture: Art in the United States and Europe 1965-70*, Manchester University Press, Manchester, 2000

A. Windsor, ed. *British Sculptors of the 20th Century*, Ashgate, Aldershot, Hants.,

2003
C. van Winkel. "The Crooked Path, Patterns of Kinetic Energy", *Parkett*, 33, 1992
R. Wishart. "Andy Goldsworthy: art without additives", *Scotsman*, Apl 16, 1994
K. Withers. "Is it art?", *Venue Magazine*, Dec, 1989
G. Woods *et al*, eds. *Art Without Boundaries*, Thames & Hudson, London, 1972
S. Wrede & W. Adams. *Denatured Visions: Landscape and Culture in the 20th Century*, Abrams, New York, NY, 1991
S. Yard. *Sitings*, La Jolla Museum of Contemporary Art, La Jolla, CA, 1986
M. Yule. "Andy Goldsworthy, a Lake District photowork", *National Art-Collections Fund Review*, 88, 1992

WEBSITES

Andy Goldsworthy, Sheepfolds site: <www.sheepfolds.org>
 <sheepfoldscumbria.co.uk>
Striding Arches <stridingarches.com>
Andy Goldsworthy, *Rivers and Tides* DVD <www.skyline.uk.com/riversandtides>
Andy Goldsworthy Digital Catalogue <goldsworthy.cc.gla.ac.uk>
Crescent Moon Publishing: <www.crmoon.com>
Earthworks <www.earthworks.org>
The Artists: <www.the-artists.org>
Sculpture at Goodwood, CASS: <www.sculpture.org.uk>
Robert Smithson <www.robertsmithson.com>
Walter de Maria <www.lightningfield.org>
Christo <www.christojeanneclaude.net>
James Turrell <www.rodencrater.org>
Mary Miss <www.marymiss.com>
Hamish Fulton <www.hamish-fulton.com>
Chris Drury <www.chrisdrury.co.uk>
Donald Judd <www.chinati.org>
Richard Long <www.richardlong.org>
Richard Long Newsletter <therichardlongnewsletter.org>

MAURICE SENDAK

& the art of children's book illustration

L.M. Poole

Maurice Sendak is the widely acclaimed American children's book author and illustrator. This critical study focuses on his famous trilogy, *Where the Wild Things Are, In the Night Kitchen* and *Outside Over There*, as well as the early works and Sendak's superb depictions of the Grimm Brothers' fairy tales in *The Juniper Tree*. L.M. Poole begins with a chapter on children's book illustration, in particular the treatment of fairy tales. Sendak's work is situated within the history of children's book illustration, and he is compared with many contemporary authors.

Fully illustrated. The book has been revised and updated for this edition.

ISBN 9781861714282 Pbk ISBN 9781861713469 Hbk

CRESCENT MOON PUBLISHING

ARTS, PAINTING, SCULPTURE

The Art of Andy Goldsworthy
Andy Goldsworthy: Touching Nature
Andy Goldsworthy in Close-Up
Andy Goldsworthy: Pocket Guide
Andy Goldsworthy In America
Land Art: A Complete Guide
The Art of Richard Long
Richard Long: Pocket Guide
Land Art In the UK
Land Art in Close-Up
Land Art In the U.S.A.
Land Art: Pocket Guide
Installation Art in Close-Up
Minimal Art and Artists In the 1960s and After
Colourfield Painting
Land Art DVD, TV documentary
Andy Goldsworthy DVD, TV documentary
The Erotic Object: Sexuality in Sculpture From Prehistory to the Present Day
Sex in Art: Pornography and Pleasure in Painting and Sculpture
Postwar Art
Sacred Gardens: The Garden in Myth, Religion and Art
Glorification: Religious Abstraction in Renaissance and 20th Century Art
Early Netherlandish Painting
Leonardo da Vinci
Piero della Francesca
Giovanni Bellini
Fra Angelico: Art and Religion in the Renaissance
Mark Rothko: The Art of Transcendence
Frank Stella: American Abstract Artist
Jasper Johns
Brice Marden
Alison Wilding: The Embrace of Sculpture
Vincent van Gogh: Visionary Landscapes
Eric Gill: Nuptials of God
Constantin Brancusi: Sculpting the Essence of Things
Max Beckmann
Caravaggio
Gustave Moreau
Egon Schiele: Sex and Death In Purple Stockings
Delizioso Fotografico Fervore: Works In Process 1
Sacro Cuore: Works In Process 2
The Light Eternal: J.M.W. Turner
The Madonna Glorified: Karen Arthurs

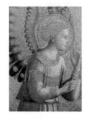

LITERATURE

J.R.R. Tolkien: The Books, The Films, The Whole Cultural Phenomenon
J.R.R. Tolkien: Pocket Guide
Tolkien's Heroic Quest
The *Earthsea* Books of Ursula Le Guin
Beauties, Beasts and Enchantment: Classic French Fairy Tales
German Popular Stories by the Brothers Grimm
Philip Pullman and *His Dark Materials*
Sexing Hardy: Thomas Hardy and Feminism
Thomas Hardy's *Tess of the d'Urbervilles*
Thomas Hardy's *Jude the Obscure*
Thomas Hardy: The Tragic Novels
Love and Tragedy: Thomas Hardy
The Poetry of Landscape in Hardy
Wessex Revisited: Thomas Hardy and John Cowper Powys
Wolfgang Iser: Essays and Interviews
Petrarch, Dante and the Troubadours
Maurice Sendak and the Art of Children's Book Illustration
Andrea Dworkin
Cixous, Irigaray, Kristeva: The *Jouissance* of French Feminism
Julia Kristeva: Art, Love, Melancholy, Philosophy, Semiotics and Psychoanalysis
Hélene Cixous I Love You: The *Jouissance* of Writing
Luce Irigaray: Lips, Kissing, and the Politics of Sexual Difference
Peter Redgrove: Here Comes the Flood
Peter Redgrove: Sex-Magic-Poetry-Cornwall
Lawrence Durrell: Between Love and Death, East and West
Love, Culture & Poetry: Lawrence Durrell
Cavafy: Anatomy of a Soul
German Romantic Poetry: Goethe, Novalis, Heine, Hölderlin
Feminism and Shakespeare
Shakespeare: Love, Poetry & Magic
The Passion of D.H. Lawrence
D.H. Lawrence: Symbolic Landscapes
D.H. Lawrence: Infinite Sensual Violence
Rimbaud: Arthur Rimbaud and the Magic of Poetry
The Ecstasies of John Cowper Powys
Sensualism and Mythology: The Wessex Novels of John Cowper Powys
Amorous Life: John Cowper Powys and the Manifestation of Affectivity (H.W. Fawkner)
Postmodern Powys: New Essays on John Cowper Powys (Joe Boulter)
Rethinking Powys: Critical Essays on John Cowper Powys
Paul Bowles & Bernardo Bertolucci
Rainer Maria Rilke
Joseph Conrad: *Heart of Darkness*
In the Dim Void: Samuel Beckett
Samuel Beckett Goes into the Silence
André Gide: Fiction and Fervour
Jackie Collins and the Blockbuster Novel
Blinded By Her Light: The Love-Poetry of Robert Graves
The Passion of Colours: Travels In Mediterranean Lands
Poetic Forms

POETRY

Ursula Le Guin: Walking In Cornwall
Peter Redgrove: Here Comes The Flood
Peter Redgrove: Sex-Magic-Poetry-Cornwall
Dante: Selections From the Vita Nuova
Petrarch, Dante and the Troubadours
William Shakespeare: Sonnets
William Shakespeare: Complete Poems
Blinded By Her Light: The Love-Poetry of Robert Graves
Emily Dickinson: Selected Poems
Emily Brontë: Poems
Thomas Hardy: Selected Poems
Percy Bysshe Shelley: Poems
John Keats: Selected Poems
Joh n Keats: Poems of 1820
D.H. Lawrence: Selected Poems
Edmund Spenser: Poems
Edmund Spenser: Amoretti
John Donne: Poems
Henry Vaughan: Poems
Sir Thomas Wyatt: Poems
Robert Herrick: Selected Poems
Rilke: Space, Essence and Angels in the Poetry of Rainer Maria Rilke
Rainer Maria Rilke: Selected Poems
Friedrich Hölderlin: Selected Poems
Arseny Tarkovsky: Selected Poems
Arthur Rimbaud: Selected Poems
Arthur Rimbaud: A Season in Hell
Arthur Rimbaud and the Magic of Poetry
Novalis: Hymns To the Night
German Romantic Poetry
Paul Verlaine: Selected Poems
Elizaethan Sonnet Cycles
D.J. Enright: By-Blows
Jeremy Reed: Brigitte's Blue Heart
Jeremy Reed: Claudia Schiffer's Red Shoes
Gorgeous Little Orpheus
Radiance: New Poems
Crescent Moon Book of Nature Poetry
Crescent Moon Book of Love Poetry
Crescent Moon Book of Mystical Poetry
Crescent Moon Book of Elizabethan Love Poetry
Crescent Moon Book of Metaphysical Poetry
Crescent Moon Book of Romantic Poetry
Pagan America: New American Poetry

MEDIA, CINEMA, FEMINISM and CULTURAL STUDIES

J.R.R. Tolkien: The Books, The Films, The Whole Cultural Phenomenon
J.R.R. Tolkien: Pocket Guide
The *Lord of the Rings* Movies: Pocket Guide
The Cinema of Hayao Miyazaki
Hayao Miyazaki: *Princess Mononoke*: Pocket Movie Guide
Hayao Miyazaki: *Spirited Away*: Pocket Movie Guide
Tim Burton
Ken Russell
Ken Russell: *Tommy*: Pocket Movie Guide
The Ghost Dance: The Origins of Religion
The Peyote Cult
Cixous, Irigaray, Kristeva: The *Jouissance* of French Feminism
Julia Kristeva: Art, Love, Melancholy, Philosophy, Semiotics and Psychoanalysis
Luce Irigaray: Lips, Kissing, and the Politics of Sexual Difference
Hélene Cixous I Love You: The *Jouissance* of Writing
Andrea Dworkin
'Cosmo Woman': The World of Women's Magazines
Women in Pop Music
Discovering the Goddess (Geoffrey Ashe)
The Poetry of Cinema
The Sacred Cinema of Andrei Tarkovsky
Andrei Tarkovsky: Pocket Guide
Andrei Tarkovsky: *Mirror*: Pocket Movie Guide
Andrei Tarkovsky: *The Sacrifice*: Pocket Movie Guide
Walerian Borowczyk: Cinema of Erotic Dreams
Jean-Luc Godard: The Passion of Cinema
Jean-Luc Godard: *Hail Mary*: Pocket Movie Guide
Jean-Luc Godard: *Contempt*: Pocket Movie Guide
Jean-Luc Godard: *Pierrot le Fou*: Pocket Movie Guide
John Hughes and Eighties Cinema
Ferris Bueller's Day Off: Pocket Movie Guide
Jean-Luc Godard: Pocket Guide
The Cinema of Richard Linklater
Liv Tyler: Star In Ascendance
Blade Runner and the Films of Philip K. Dick
Paul Bowles and Bernardo Bertolucci
Media Hell: Radio, TV and the Press
An Open Letter to the BBC
Detonation Britain: Nuclear War in the UK
Feminism and Shakespeare
Wild Zones: Pornography, Art and Feminism
Sex in Art: Pornography and Pleasure in Painting and Sculpture
Sexing Hardy: Thomas Hardy and Feminism

In my view *The Light Eternal* is among the very best of all the material I read on Turner. (Douglas Graham, director of the Turner Museum, Denver, Colorado)

The Light Eternal is a model monograph, an exemplary job. The subject matter of the book is beautifully organised and dead on beam. (Lawrence Durrell)

It is amazing for me to see my work treated with such passion and respect. (Andrea Dworkin)

CRESCENT MOON PUBLISHING
P.O. Box 1312, Maidstone, Kent, ME14 5XU, Great Britain. www.crmoon.com

CPSIA information can be obtained
at www.ICGtesting.com
Printed in the USA
LVHW052119161221
706397LV00004B/182